AFTER THE END OF ART

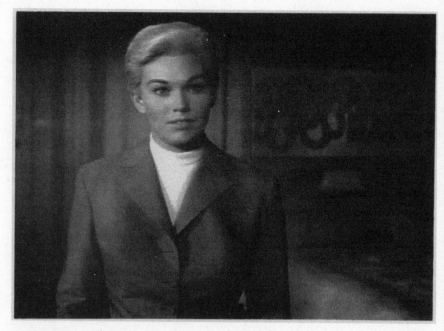

STILL FROM ALFRED HITCHCOCK'S *VERTIGO* (1958), IN WHICH DAVID REED HAS INSERTED HIS PAINTING #328 (1990).

ARTHUR C. DANTO

AFTER THE END OF ART

CONTEMPORARY ART AND THE PALE OF HISTORY

WITH A NEW FOREWORD BY LYDIA GOEHR

THE A. W. MELLON LECTURES IN THE FINE ARTS, 1995

THE NATIONAL GALLERY OF ART, WASHINGTON, D.C.

BOLLINGEN SERIES XXXV · 44

PRINCETON UNIVERSITY PRESS, PRINCETON AND OXFORD

This is the forty-fourth volume of the A. W. Mellon Lectures in the Fine Arts,
which are delivered annually at the National Gallery of Art, Washington.
The volumes of lectures constitute Number xxxv in Bollingen Series,
sponsored by Bollingen Foundation.

First Princeton Classics edition, with a new foreword, 2014

ISBN: 978-0-691-16389-5

Library of Congress Control Number: 2014943658

This book has been composed in Dante

Princeton University Press books are printed on acid-free paper and meet the guidelines
for permanence and durability of the Committee on Production Guidelines for
Book Longevity of the Council on Library Resources

press.princeton.edu

Printed in the United States of America

10 9 8 7 6 5 4 3 2

■ ■ ■ ■ ■

For ROBERT MANGOLD *and* SYLVIA PLIMACK MANGOLD

and for BARBARA WESTMAN

■ ■ ■ ■ ■ CONTENTS

List of Illustrations ix

Foreword to the Princeton Classics Edition xi

Preface xvii

Acknowledgments xxi

CHAPTER ONE. Introduction: Modern, Postmodern, and
 Contemporary 3

CHAPTER TWO. Three Decades after the End of Art 21

CHAPTER THREE. Master Narratives and Critical Principles 41

CHAPTER FOUR. Modernism and the Critique of Pure Art: The
 Historical Vision of Clement Greenberg 61

CHAPTER FIVE. From Aesthetics to Art Criticism 81

CHAPTER SIX. Painting and the Pale of History: The Passing
 of the Pure 101

CHAPTER SEVEN. Pop Art and Past Futures 117

CHAPTER EIGHT. Painting, Politics, and Post-Historical Art 135

CHAPTER NINE. The Historical Museum of Monochrome Art 153

CHAPTER TEN. Museums and the Thirsting Millions 175

CHAPTER ELEVEN. Modalities of History: Possibility and Comedy 193

Index 221

▪ ▪ ▪ ▪ ▪ ILLUSTRATIONS

frontispiece	Still from Alfred Hitchcock's *Vertigo* (1958), with David Reed's *#328* inserted, 1990–93
2	Mike Bidlo, *Not Andy Warhol (Brillo Box)* (1995)
20	Ad Reinhardt, *Black Painting* (1962)
27	Installation photograph, 1st International Dada Exhibition, Berlin 1921
40	Pablo Picasso, *Daniel-Henry Kahnweiler* (1910)
60	Photograph of Jackson Pollack, *Life Magazine*, 9 August 1949
80	Robert Morris, *Box with the Sound of Its Own Making* (1961)
100	The library of the artist Arman
116	Roy Lichtenstein, *The Kiss* (1961), as it appeared in *Art News*, March 1962
134	Sean Scully, *Homo Duplex* (1993)
149	Cindy Sherman, Untitled Film Still (1978)
152	Barbara Westman, *The Monochrome Show* (1995)
166	Photograph of Malevich lying in state, beneath his *Black Square*
174	Joseph Beuys in his performance, *The Scottish Symphony: Celtic Kinloch Rannock* (1980)
192	Cover page, *The Nation*, 14 March 1994. Graphic by Paul Chudy
208	Russell Connor, *The Kidnapping of Modern Art by the New Yorkers* (1985)
214	Vitaly Komar and Alexander Melamid, *America's Most Wanted* (1994)
219	Anthony Hayden-Guest, *Professor Arthur Danto Showing the Peak of Late 20th Century Philosophy to his Colleague, Dr. Hegel, Art & Auction*, June 1992

■ ■ ■ ■ ■ *FOREWORD TO THE PRINCETON*
CLASSICS EDITION

Philosophy before the End of Art

Arthur Coleman Danto was born January 1, 1924, in Detroit, Michigan, and died October 25, 2013, in Manhattan, New York. He spent much of his life as a professor of philosophy at Columbia University and, from 1984 on, as art critic for *The Nation* magazine. He wrote more than thirty books and more than a hundred articles and art-critical pieces. When he started out in the postwar period, he wrote on the analytical philosophies of action, mind, knowledge, and history; on Nietzsche and Sartre; and, drawn into "Eastern" currents, he dipped his pen into a philosophy of Zen as he heard it espoused by Dr. D. T. Suzuki in lessons offered at Columbia University. A voracious reader, he explored German and French idealism, phenomenology, and existentialism as much as Anglo-American positivism. However, he never relinquished engaging analytical philosophy as his way to explore how far philosophy can take one before it oversteps its limits. *After the End of Art* describes an end to which art came in virtue of a philosophical passage, after which it freed itself from philosophy's grip, so that, from that moment forward, it would call not for philosophical justification but for criticism. That Danto became an art critic was a response, woven through a philosophical narrative, to what the times demanded of him. But the turn also perfectly suited his talent as a writer.

Early on as a professional philosopher, he wrote in a rather dry style, a decision, he notes in this book, that was somewhat forced upon him (and others) by the need to get tenure in the philosophy department of an American university. Nevertheless, even then, one could see his need to become an essayist. Through the essay, he showed his sparkle and wit, his enormous capability to describe, and his impressive knowledge of contemporary art. Walking through museums and galleries was how he came to understand how artworks could serve as more than examples supporting readymade philosophical theories. He became an essayist who could think like a philosopher through the different mediums and challenges of art. His contribution to how we think about art in philosophical terms and beyond those terms was enormous.

Before he became a professor of philosophy, he was a maker of woodcuts. Toward the end of his life, his prints were collected and exhibited much to his pleasure and pride. Having given up the life of an artist, he did not turn straightaway to the philosophy of art, but somewhat bracketed this interest until he was asked,

rather by accident, to give a lecture on art at the American Philosophical Association in place of someone else. When the lecture was published in 1964 in the *Journal of Philosophy*, it was titled "The Artworld," a phrase and idea for which he became famous. "To see something as art," he argued, does not rely on what is given to the merely seeing eye, but requires a world or "atmosphere of artistic theory, a knowledge of the history of art." He built his "Artworld" first off from what he was witnessing around him in the city where he lived, but when he gave it its philosophical sense, its dependence on knowledge more than on the merely seeing eye, he drew parallels to all the other areas of analytical philosophy that he had already pursued. Through these parallels, he came to see that the basic metaphysical question about identity—the "what is X" question—could only be answered by taking seriously the experience of indiscernibility: that two quite different kinds of things can sometimes look exactly the same. Let me explain.

Influenced by Descartes and Leibniz, he argued that the identity of things cannot be reduced to how things appear. Since different things can look alike in virtue of the base or commonplace material from which they are made, their identity cannot be reduced to their material constitution. Wherever he looked in the world, he found things that are meaningful as products of human making or culture that nevertheless sometimes look like "mere," "basic," or "commonplace" things bearing either the most minimal properties of human significance or no such properties at all. What gives things their identity or essence, he claimed, is the transfigurative engagement of the human mind, the existence of those things in forms of life that are saturated by the presence of human spirit, atmosphere, and intellect. He asked us to consider, first, what is shared between a narrative historical sentence and a mere description of an event; a dream and a wakeful experience; an authentic and inauthentic action; an original wife and a machine-made duplicate; the blood of Christ and a glass of red wine; a wink of a desiring eye and an uncontrolled blink; a revolutionary salute and an unwilled movement of the arm; or a piece of music and a string of mere noises. Once you have accounted for all that causes each of these pairings to be indiscernible, then ask yourself wherein their differences lie and you will be drawn into worlds of love, personhood, history, politics, morality, religion, and art.

In the late 1960s, Danto achieved considerable renown in the philosophy of history for his systematic determination of what he called "narrative sentences." He explored the logic of reference and description to explain how historical statements or narratives could assume a significance that was neither inflated to the German heights of a teleological world-history nor yet reduced to a merely empirical chronicle of events. At the core of his theory lay the observation that a given event that occurred in a certain year might be noticed but not understood

fully, or marked as a piece of history, until some later event occurred. Given the later event, the first event could be brought under a description or interpretation to which it could not have always or earlier submitted. To repeat Danto's favorite example: one could not have known or said that the year 1618 marked the beginning of the Thirty Years' War until 1648, when the war had come to its end. "The Thirty Years' War" picked out something that was more than merely factual, an event in a mere chronicle of events. It became, through the interpretation of events, loaded with human significance and, with this, it became historical.

What Danto said about history, he later adapted to art, but now with a Hegelian turn. To take account of Hegel allowed him to overcome in a true passage of dialectical thinking an arrogant teleology that had so dominated philosophy, history, and art up to his time. Art as a *concept*, he argued, reached its end, realization, or self-understanding in an event that happened in the Artworld in 1964, which he actually witnessed. Walking into the Stable Gallery on East 74th Street, he saw Andy Warhol's *Brillo Boxes* stacked up on the floor such as one might see in any supermarket or warehouse. Struck by the indiscernibility, he was able, he said, to raise the question of discernibility as the only way to come to understand the identity of art. And yet, two decades had to pass before he could understand this event as also having marked "the end of art." Only in 1984 (in an article that became the basis for the present book) could he read the event of 1964 historically in a way consistent with what, by then, he had worked out as his analytical philosophy of art. To understand "the end of art" was to enter "the Artworld," freed from the assumption that art is defined according to how artworks look, knowing now that all manner of "embodied meaning" is found in an Artworld that includes all and everything that is art.

One way to understand what happened in the two decades in between would be to dig deep into Danto's intellectual biography. A far more immediate way would be to read *After the End of Art*. For step-by-step through this book, Danto explores the three decades of his thinking philosophically about art. He begins with temporal and historical categories, periods and movements, after which he turns to the movement between the philosophy of art, aesthetics, and art criticism. Toward the end, he turns to the philosophy and politics of a modernist art, which, by tending toward a pure monochrome or a pure materiality, threatened most to turn the museum away entirely from the eye to cater only to the mind. How should we understand this last movement if not as prompting thought about the end and ends of art?

In contrast to some of his later books, this book does not show what Danto did "after" philosophy when he turned to art criticism. Instead, it retraces the passage that led him, in 1984, to declare with a deliberately provocative slogan that

art had come to its end. Yet, in every part of this book, we are reminded that "the end of art" marked the end not of art's production, but only of thinking about art in a historicist way, according to what he described as a "disenfranchising" master narrative. As art, "after Hegel," had gradually moved into its "modernist period," its production had increasingly come to be held hostage—in servitude—to a misguided philosophical pursuit to answer the question: "what is art?" As Danto described the situation, the pursuit was misguided, first, because too many definitions of art turned on how art appeared, on what was made either materially manifest or made manifest to sight, and second, because too many definitions proved, in one "whiggish" way or another, exclusionary. The commitment to a teleological history had led too many artists and theorists to produce definitions that would include some art—as the correct way for art now to be or appear—and then to exclude all the rest—as "beyond the pale." What lay beyond the pale was all art that was deemed historically aged or artistically insignificant because it did not advance the project of coming to know art's essence: what art *is*.

When Danto declared the end of art, his purpose was to stop the movement of this master narrative. Looking at all the contemporary art of pop and ready-mades, cartons and cartoons, slogans and proclamations, Danto showed how none of this art fits any existing definition of art. The only definition that would include all this, he argued, and then all and only everything that is art, would be one that brought down all the historicist, normative, and evaluative walls of the museum. To bring down these walls would be to release art, in Danto's terms, from a mistaken "generic cleansing," as he termed it, that had gone on too long and too often in parallel with the ethnic cleansing of persons in the wider world. *Nothing* about art's appearance, meaning, place or time of origin would have anything anymore to do with art's definition, its essence, as it falsely had before. For art to be art, he argued, it had to have a meaning that was embodied in a way that made sense in the art world, but no restriction or specification of sense beyond that. Only by withdrawing all content from the definition of art could one take what Warhol had brought to consciousness: the fact that artworks could now look like anything ordinarily found in the world and yet, as artworks, never be identical to these commonplace things. From the earliest to the latest art, from the highest and most sacred to the lowest and most banal, and from every place in the world, the new world of art would show an art that was free and equal to present itself any way it wanted to the public. If and when judgments of value then followed, they would do so from a pluralistic approach to criticism equally freed from the inflated posture of any philosophically grounded exclusive vision of art.

The chapters of this book presuppose but do not make fully explicit many of Danto's philosophical views. They were written as lectures primarily for art his-

torians and, accordingly, show Danto's engagement with those he regarded as the primary contributors to perpetuating or ending the master narrative of the Western history of art: from Vasari through Wölfflin, Riegl, Gombrich, Panofsky, Fry, and Kahnweiler, to Greenberg, Belting, Krauss, and Crimp. To be sure, we see Danto often reading their views strikingly against their own grain—what Greenberg, for example, worried about, Danto took as Greenberg's view. But this he did, I believe, to express the urgency and excitement that he clearly felt when, in the postwar culture of New York, he saw a liberation of art that might signal a freedom for the world as a whole from all manner of segregation. He never forgot that urgency. It allowed him, until the end of his life, to stay in a place, *at* the end of art, convinced that through repetition, the signal—the demand for freedom—would become ever stronger.

Lydia Goehr

THE IMAGE I have chosen as frontispiece for this book is a still from a modified clip from a famous and familiar movie, Alfred Hitchcock's *Vertigo*, of 1958. The modification was made by the painter David Reed, who has inserted into the shot of a hotel bedroom one of his own paintings—*#328* done in 1990—in place of whatever nondescript hotel picture Hitchcock may have had above the bed to add authenticity, if indeed there was anything above the bed: who remembers such details? The still itself is from 1995.

Reed transformed the clip into a loop, which played repeatedly on a television set, by rights as nondescript as the items of furniture in the hotel bedroom in San Francisco occupied by Judy, the main female character in *Vertigo*, played by Kim Novak. Nineteen fifty-eight was probably too early for cheap hotels routinely to have been provided with television sets, but of course, together with beds, these constitute the minimal furnishings of such lodgings today. The television set, showing Reed's modified clip, was placed by the artist next to a bed which would be quite as nondescript as the one in the film save for the fact that it exactly replicates the latter, and was fabricated for the occasion by Reed himself. With one further item, they formed an installation in Reed's retrospective exhibition at the Kölnischer Kunstverein—an art space in Cologne. The further item was the actual painting, *#328*, hung over the bed on a temporary wall. The painting enjoys two modes of being—it has what the medieval philosophers would distinguish as *formal* and *objective* reality, existing, one might say, as image and reality. It occupies the space of the viewer and the fictive space of a character in a movie.

The modified clip represents two of David Reed's obsessions. He is enough obsessed with *Vertigo* that he once made a pilgrimage to all the remaining sites in San Franciso that appear in Hitchcock's film, and in 1992 he placed an ancestor of the Cologne installation in the San Francisco Art Institute, with bed, a painting (*#251*), and a video screen placed on a steel dolly—a piece of equipment rather too professional looking for the hotel room—which shows the scene in Hitchcock's film in which Judy, standing in her bedroom, reveals to her lover her identity as "Madeleine." In the 1992 installation, the film is unmodified: that idea had not as yet occurred to him.

The other obsession is with the idea of what he terms "bedroom paint-ings." The expression was used by his mentor, Nicholas Wilder, in con-nection with the paintings of John McLaughlin. Buyers of those paintings would initially hang them in one of the more public spaces of the home, but in time, Wilder said, "They would move the painting to their bed-room where they could live with it more intimately." Reed responded as if to a revelation: "My ambition in life was to be a bedroom painter." The modified video implies that Judy lives intimately with #328, and by put-ting #328 in the viewer's space with a bed (in an installation at Max Pro-tetch Gallery in New York, a replica of Scotty's bathrobe was flung casu-ally across the bedspread) Reed directs the viewer how to relate to #328 should he or she happen to acquire it, or any painting by Reed.

Reed has one further obsession worth mentioning, namely, Mannerist and Baroque painting, and one of his recent works is a set of studies, executed after a painting for a lost altarpiece by Domenico Feti, for the Walters Gallery of Art in Baltimore, Maryland, in an exhibition titled *Going for Baroque*. An altarpiece includes a painting set in a complex framework, usually with other paintings, the purpose of which is to de-fine what we should call the user's (not the viewer's) relationship to the painting. The common practice, of couse, is to pray to whomever the painting is of. There is an analogy between the installation Reed has devised and the complex piece of furniture in which the altarpiece con-sists, in that it, too, defines what one's relationship to the painting should be. One should live with it, intimately, as its position in the bedroom implies.

The frame of a painting, the architecture of the altarpiece, the installa-tion in which a painting is set like a jewel have a common logic to which, as a philosopher, I am very sensitive: they define pictorial attitudes to be taken toward a painting, which does not, on its own, suffice for these purposes. A preface is no place to work this logic out, and my aim in any case is best served by going directly to what it seems to me Reed's use of the apparatus of the film loop, the mechanism of pictorial dubbing, and the monitor—not to mention the bed, the robe, even the picture seen as part of a bedroom installation—exemplifies in terms of contemporary artistic practice. It is a practice in which painters no longer hesitate to situate their paintings by means of devices which belong to altogether different media—sculpture, video, film, installation, and the like. The degree to which painters like Reed are eager to do this is evidence of how far contemporary painters have departed from the aesthetic orthodoxy of modernism, which insisted upon the purity of the medium as its defining

agenda. Reed's disregard of modernist imperatives underscores what I speak of in one of the chapters of this book as "the passing of the pure." Contemporary art might be thought of as impure or nonpure, but only against the haunting memory of modernism in its virulence as an artistic ideal. And it is in particular remarkable that it should be David Reed whom I am taking as my exemplar of the contemporary moment in the visual arts—for if there were a painter today whose work might seem to exemplify the highest virtues of pure painting, it would be Reed. I have had printed on the jacket of the book the painting one would see if one were standing within the installation—Reed's #328—and so were to see, outside the video and on the wall in full color, the painting scratchily seen in filmic space, behind beautiful Judy as she reveals that it was she who had misled the hero into believing she was someone else.

This book grew out of the 1995 Mellon Lectures in Fine Art, which I delivered in the spring of that year at the National Gallery of Art in Washington under the awkward title *Contemporary Art and the Pale of History*, now enlisted as the subtitle for this book. The first part of the title made plain that my lectures were to be concerned with contemporary art—itself an unusual topic for the Mellon Lectures—but concerned with it in a way that sharply differentiates contemporary and modern art. It requires a particular imagination to see Reed's installation as having a precedent in the history of painting, but it requires more than imagination to see how such a work is to be approached aesthetically. The aesthetics of purity will certainly not apply, and to say what will apply requires laying bare enough of the comparative anatomy of the modern and the contemporary work of art to see how, for example, Reed's work differs, whatever the outward resemblances, from an abstract expressionist painting which happens to use the sweeping gestural brushstrokes of which, undoubtedly, Reed's are refined and sophisticated descendents.

As for the second part of the lectures' title, that connects with a curious thesis I have been urging for a number of years concerning the end of art—a somewhat dramatic way of declaring that the great master narratives which first defined traditional art, and then modernist art, have not only come to an end, but that contemporary art no longer allows itself to be represented by master narratives at all. Those master narratives inevitably excluded certain artistic traditions and practices as "outside the pale of history"—a phrase of Hegel's to which I more than once have recourse. It is one of the many things which characterize the contemporary moment of art—or what I term the "post-historical moment"—that there is no longer a pale of history. Nothing is closed off, the way Clement

Greenberg supposed that surrealist art was no part of modernism as he understood it. Ours is a moment, at least (and perhaps only) in art, of deep pluralism and total tolerance. Nothing is ruled out.

Contemporary art, as it has evolved, could hardly have been imagined when the first Mellon Lectures were delivered in 1951—mine were the forty-fourth set in the series. Reed's modified film still illustrates a certain historical impossibility which has somewhat obsessed me as a philosopher. His painting of 1989 cannot have found a place in 1958 bedrooms for the obvious reason that it would not exist for another thirty-eight years. (Reed was twelve years old when Vertigo was made.) But more important than this bare temporal impossibility are the historical ones: there would have been no room in the art world for his paintings in 1957, and certainly none for his installations. The unimaginability of future art is one of the limits which holds us locked in our own periods. And of couse there would have been scant room for imagining, when the Mellon lectures were first delivered in 1951, that art would evolve in such a way that the forty-fourth set of Mellon Lectures would be devoted to art such as is implied by the modified still. My aim, of course, is not to address this art in the spirit of connoisseurship, nor in terms of the preoccupations of the art historian, namely, iconography and influence. My interests are speculative and philosophical, but also practical, since a substantial portion of my professional life is given over to art criticism. I am anxious to identify what critical principles there can be when there are no narratives, and where, in a qualified sense, anything goes. The book is devoted to the philosophy of art history, the structure of narratives, the end of art, and the principles of art criticism. It undertakes to ask how art like that of David Reed became historically possible and how such art is critically thinkable. Along the way my text is concerned with the end of modernism, and it seeks to assuage sensibilities which had finally adjusted to the indignities modernism visited on the traditional aesthetic postures toward art, and to show something of what it means to take pleasure in post-historical reality. There is a certain comfort in knowing where it had all been heading as a matter of history. To glorify the art of previous periods, however truly glorious it was, is to will an illusion as to the philosophical nature of art. The world of contemporary art is the price we pay for philosophical illumination, but this, of course, is but one of the contributions to philosophy for which the latter is in art's debt.

New York City, 1996

▪ ▪ ▪ ▪ ▪ ACKNOWLEDGMENTS

Until a graciously worded, handwritten letter arrived from Henry Millon, Dean of the Center for Advanced Studies in the Visual Arts, inviting me to deliver the Forty-Fourth Andrew W. Mellon Lectures in the Fine Arts at the National Gallery, I had no particular antecedent intention to write another book, philosophical or otherwise, on art. I had had ample opportunity to speak my mind on conceptual questions in philosophical aesthetics since the publication of my main book on the subject, *The Transfiguration of the Commonplace*, in 1981; and since having become the art critic for *The Nation* in 1984, I had been able to say my say on many of the main events and changes in the art world itself. *The Transfiguration of the Commonplace* had in fact been followed by two pendant volumes of philosophical pieces on art, and the critical essays had been collected as well. Notwithstanding all this, I knew this was not an opportunity to miss, quite apart from the honor of having been selected to this prestigious lectureship. For I had a subject that I felt merited sustained treatment over a course of lectures, namely a philosophy of art history I had sloganized as "the end of art." I had in the course of ten years of reflection arrived at a very different view of what the end of art meant than I had when that concept first possessed me.

I had come to understand this doubtless incendiary expression to mean, in effect, the end of the master narratives of art—not just of the traditional narrative of representing visual appearance, which Ernst Gombrich had taken as the theme of his Mellon Lectures, nor of the succeeding narrative of modernism, which had all but ended, but the end of master narratives altogether. The objective structure of the art world had revealed itself, historically, now to be defined by a radical pluralism, and I felt it urgent that this be understood, for it meant that some radical revision was due in the way in which society at large thought about art and dealt with it institutionally. Added to this urgency was the subjective fact that in dealing with it, I would be able to connect my own philosophical thinking in a systematic way, bringing together the philosophy of history with which it had begun and the philosophy of art with which it had more or less culminated. All these benefits notwithstanding, I am reasonably certain I would not have undertaken to write the present

book without the quite unanticipated opportunity opened up by Hank Millon's invitation, which was like the answer to an unwhispered prayer. I am in the first instance uncommonly indebted to the generosity of CASVA—as its members call their great center—for bidding a philosopher, and then one whose immediate artistic interests are far from its customary scholarly foci, to deliver its prized set of lectures.

The lectures were to be presented on six successive Sundays in the spring of 1995, unless I were energetic enough to produce a seventh or an eighth, which neither I nor any of my predecessors in fact succeeded in doing. There were occasions for other lectures before and after this period, however, and I was able to take advantage of these to produce, in the end, a book consisting of the equivalent of about eleven lectures, all told, allowing the impulses of the Mellon theme to expand and evolve into a single trajectory of thought about art, narrative, criticism, and the contemporary world. The Mellon Lectures proper are here represented by chapters 2, 3, 4, 6, 8, and 9. But chapters 2 and 4 evolved out of earlier lectures given under auspices special enough to merit acknowledgment here. Chapter 2 was presented, in its general outlines, as the Werner Heisenberg Lecture for the Bavarian Academy of Sciences, under the sponsorship of the Siemens Foundation in Munich. I am greatly indebted to Dr. Heinrich Meyer for arranging this remarkably stimulating event, enhanced by the participation of my friend, the great philosophical scholar Dieter Henrich, with whom I had the most memorable public dialogue during the question period that followed. Chapter 4 was delivered as part of the proceedings of a colloquium devoted to the work of Clement Greenberg, held at the Centre Georges Pompidou in Paris, organized by Daniel Soutif. I had finally gotten to know Greenberg as a person before the colloquium took place, and had become sufficiently impressed with his originality as a thinker that there is a respect in which the present work might be regarded as in the tradition of John Stuart Mill's *An Examination of Sir William Hamilton's Philosophy* or C. D. Broad's exemplary *An Examination of MacTaggart's Philosophy*. There may be moments when the reader feels that this is *An Examination of Greenberg's Philosophy*, so central did his thinking prove to the narrative of modernism I see him as having discovered. What "Clem" would have said had he lived to read the book—he was too sick to travel to Paris, as had been planned, to respond to criticisms and allow himself to be lionized a bit—is difficult to construct in detail. But he cheerfully told me he disagreed with pretty much everything he had read of mine, much as he enjoyed reading

it—and there is little reason to picture him falling to his knees in gratitude for having at last been understood. Still, the book would have been vastly different without him, and probably impossible.

Chapter 1 began life as the Emily Tremaine Lecture, given on a wintry afternoon at the Hartford Atheneum in celebration of the twenty-fifth anniversary of that institution's Matrix Gallery, which, under the guidance of its curator, Andrea Miller-Keller, has been specifically hospitable to contemporary art. Experimental galleries are far fewer in the United States than in Europe, surprisingly enough, but in any case it seemed an appropriate occasion on which to seek to differentiate contemporary from modern art in general, and to attempt to come to terms with postmodernism as a stylistic enclave within the former.

Chapter 5 was delivered as a plenary address at the Sixth International Congress of Aesthetics in Lahti, Finland, under the auspices of the University of Helsinki. The theme of the congress was "Aesthetics in Practice," and it was felicitous that its organizer, Sonya Servomaa, considered art criticism to be an example of practical aesthetics, and thought of me as being ideally situated to discuss the relationship between aesthetics as a philosophical discipline and criticism as thinkably one of its applications. Certainly that would have been Greenberg's way of viewing the matter, with me, perhaps predictably, on the opposing side. The paper was modified for presentation as a Rubin Lecture at the Baltimore Museum of Art at the invitation of the Art History Department of Johns Hopkins University, and again as one of a pair of lectures honoring George Heard Hamilton at Williams College. I am keenly appreciative of Professor Herbert Kessler at the former institution and Professor Mark Haxthausen at the latter for their interest and hospitality, and of course Sonya Servomaa for her initiative and her formidable organizational powers. I am grateful as well to Philip Alperson, editor of *The Journal of Aesthetics and Art Criticism*, for printing the original version of this chapter as after all uniting the two topics of that periodical's title, but by the time it was fitted into the overall masonry of the present book, it acquired of necessity a somewhat different shape.

Chapter 7 was written at the urging of Sherri Gelden, the director of the Wexner Center at The Ohio State University, to be part of a lecture series on pop art held in conjunction with an exhibition of the work of Roy Lichtenstein. Sherri is someone to whom I find it almost impossible to say no, but I must say I growled under my breath when I said yes. Still, once the text began to emerge, it was plain to me that it belonged to the

book, which would have been poorer without it, and it gave me a chance to put the pop movement, which meant a great deal to me personally, in a deeper perspective than I had found before.

Chapter 10, "Museums and the Thirsting Millions," was written specifically for a conference on art and democracy, sponsored by the Department of Political Science at Michigan State University, though the essential argument was initially worked out as part of a symposium on the role of the contemporary museum, held in 1994 to mark the twenty-fifth anniversary of the Art Museum of the University of Iowa, in Iowa City. I am grateful to Professor Richard Zinman of Michigan State for stimulating the meeting he organized, and for his enthusiasm. The essay appears here in a somewhat different form from the one it bears in the official publication of that symposium, to which it nevertheless owes its entire existence.

Chapter 11 contains that part of this book for the sake of which I really wrote it: a philosophical exploration of the historical modalities—of possibility, impossibility, and necessity—which have gnawed at me for a long time indeed. But it contains two sections that have an extrinsic genealogy. David Carrier had written a supportive critique of my ideas to which Philip Alperson invited a response for the pages of *The Journal of Aesthetics and Art Criticism*, and the criticism touched so deep a place in my thought that I have taken advantage of it to motivate this final discussion. And I borrowed freely from a text I had written on the extraordinary artists Vitaly Komar and Alexander Melamid, whose "research" had been sponsored by The Nation Institute. Komar and Melamid turned out to exemplify the contemporary condition of art to perfection, and provided just the note of comedy with which I felt a book on the end of art should itself properly end.

The Center for Advanced Studies in the Visual Arts was unfailingly supportive and even enthusiastic about the somewhat unusual suite of lectures these turned out to be, which were resolutely speculative when not philosophical, and no less resolutely addressed to contemporary rather than to traditional, let alone modern, art. The first of my lectures was held on the last day of one of the most extraordinary exhibitions I have ever seen, consisting of wooden models of Renaissance churches. These quite took the breath away, by their scale and daring and beauty. The exhibition was the work of Henry Millon, and I think it represented the true spirit of the Center, which accordingly proved its adventurousness in sponsoring my lectures, coming as they did from a very different spirit. Hank Millon and his wife Judy are among the most marvelous people I have ever met, and it is impossible to know them without loving

them. Therese O'Malley, Associate Dean, was unfailingly helpful and genuinely interested in my project. And I was grateful for the assured efficiency of Abby M. Krain, who helped me with so many practical matters, including chasing down slides, and Karen Binswanger, who was like an angelic presence, meeting me on each occasion and helping to get the slides set up. I enjoyed choosing, with Paavo Hantsoo, the projectionist, appropriate music to be played while the audience chose its seats. And I profoundly responded to the deep democracy of the lecture hall itself, open to one and all, with visitors to the National Gallery sitting unselfconsciously with the philosophers and the art historians, curators, and art-world people who made up the professional audience. My own morale was especially sustained by the presence and the responses of Amelie Rorty, Jerrold Levinson, and Richard Arndt, a comrade from my Fulbright days in France. I greatly enjoyed a merry dinner with Elizabeth Cropper and Jean Sutherland Boggs, senior faculty at the Center.

It has been a source of immense reassurance that I have not been alone in speaking of the end of art, but have had the independent corroboration of the hardy and learned art historian Hans Belting. Hans and I have been like paired dolphins, frolicking in the same conceptual waters for over a decade, and I was able to insert a thin slice of chapter 8 into a tribute I wrote for a celebratory volume on his sixtieth birthday. My great friends Richard Kuhns and David Carrier read through the manuscript of the six Mellon Lectures, and made extensive and helpful observations. My life in art has been immeasurably enhanced by the constant communication back and forth between the three of us over many years. I have learned a great deal from certain art writers, especially Michael Brenson, Demetrio Paparoni, and Joseph Masheck. But I have received a special reassurance from the qualified interest which artists themselves have taken in my ideas. Sean Scully and David Reed in fact came down to Washington to hear one or two of the lectures, and both of them play a role in the book itself—David especially, one of whose installations serves as a kind of overture (to write in the Proustian mood) to the book as a whole. I am grateful to him and to the Max Protetch Gallery—as well as to the Galerie Rolf Ricke in Cologne—for permission to use his #328 for the jacket illustration. I thank Udo Kittelman, of the Kölnischer Kunstverein, for the invitation to write an essay on David's work for his retrospective exhibition in Cologne. My Tremaine Lecture coincided with the retrospective exhibition at the Atheneum of the work of Sylvia Plimack Mangold—with whose work the Matrix Gallery began its brilliant career—and it is to Sylvia and her husband, Robert Mangold, by now old friends, to whom

this book is dedicated. Contemporary art has been the site of extraordinary experiment, immeasurably richer than the unaided philosophical imagination could possibly have arrived at. At least for a philosopher with an interest in the arts, it has been a wonderful time to be alive. I have been the beneficiary of the extraordinary ideas of Cindy Sherman, Sherrie Levine, Mike Bidlo, Russell Connor, Komar and Melamid, Mark Tansey, Fischli and Weiss, Mel Bochner, and many others, not all of whom are explicitly present in the book, but whose example and occasional conversations are part of the book's chemistry.

As regards the transformation of the manuscript into a book, I am grateful in the first instance to Elizabeth Powers, representing Princeton University Press, who attended the lectures and offered some exceedingly valuable suggestions before turning custodianship of the text over to Princeton's editor-in-chief, Ann Himmelberger Wald. Ann Wald has a philosophical background, and indeed a special interest in aesthetics, and I was reassured by her enthusiastic reception of the book. I am grateful to Helen Hsu for her calm patience in handling the pictorial accompaniments to the text, and to Molan Chun Goldstein, who oversaw the book's production, for her professionalism tempered by her sympathetic understanding of an author's doubtless irrational obsession with his own way of putting things.

It was quite magical to shuttle from New York to Washington on six Sundays in the spring months of 1995; to settle into a hotel and then to walk to the National Gallery with time to spare, to look at some of its wonders before waiting for the sound of the chosen music to die down and the curtain to rise in front of the screen; and to begin another of the lectures before the audience that had somehow materialized to hear it. My companion in this was my wife, the artist Barbara Westman, who enhanced the entire experience as she brightens everything else. Her unparalleled zest, her gift for comedy, her powers of friendship and of love must have acted as some sort of leavening in the texts which follow. She shares the dedication with the Mangolds.

AFTER THE END OF ART

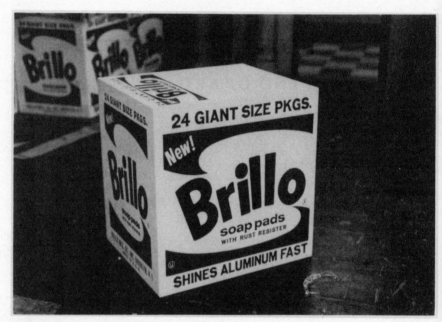

NOT ANDY WARHOL (BRILLO BOX) (1995) BY MIKE BIDLO. COURTESY: THE ARTIST AND BRUNO BISCHOFBERGER GALLERY, ZURICH.

■ ■ ■ ■ ■ CHAPTER ONE

Introduction: Modern, Postmodern, and Contemporary

AT ROUGHLY the same moment, but quite in ig-
norance of one another's thought, the German art historian Hans Belting
and I both published texts on the end of art.[1] Each of us had arrived at a
vivid sense that some momentous historical shift had taken place in the
productive conditions of the visual arts, even if, outwardly speaking, the
institutional complexes of the art world—the galleries, the art schools,
the periodicals, the museums, the critical establishment, the curatoriat—
seemed relatively stable. Belting has since published an amazing book,
tracing the history of devotional images in the Christian West from late
Roman times until about A.D. 1400, to which he gave the striking subtitle
The Image before the Era of Art. It was not that those images were not art
in some large sense, but their being art did not figure in their production,
since the concept of art had not as yet really emerged in general con-
sciousness, and such images—icons, really—played quite different role in
the lives of people than works of art came to play when the concept at
last emerged and something like aesthetic considerations began to gov-
ern our relationships to them. They were not even thought of as art in
the elementary sense of having been produced by artists—human beings
putting marks on surfaces—but were regarded as having a miraculous
provenance, like the imprinting of Jesus's image on Veronica's veil.[2]
There would then have been a profound discontinuity between artistic
practices before and after the era of art had begun, since the concept of
the artist did not enter into the explanation of devotional images,[3] but of
course the concept of the artist became central in the Renaissance, to the
point that Giorgio Vasari was to write a great book on the lives of the
artists. Before then there would at best have been the lives of the dabbling
saints.

If this is at all thinkable, then there might be another discontinuity, no
less profound, between the art produced during the era of art and art

produced after that era ended. The era of art did not begin abruptly in 1400, nor did it end sharply either, sometime before the mid-1980s when Belting's and my texts appeared respectively in German and in English. Neither of us, perhaps, had as clear an idea as we now might have, ten years later, of what we were trying to say, but, now that Belting has come forward with the idea of art before the beginning of art, we might think about art *after* the end of art, as if we were emerging from the era of art into something else the exact shape and structure of which remains to be understood.

Neither of us intended our observations as a critical judgment regarding the art of our time. In the eighties, certain radical theorists had taken up the theme of the death of painting and had based their judgment on the claim that advanced painting seemed to show all the signs of internal exhaustion, or at least marked limits beyond which it was not possible to press. They were thinking of Robert Ryman's more or less all-white paintings, or perhaps the aggressive monotonous stripe paintings of the French artist Daniel Buren; and it would be difficult not to consider their account as in some way a critical judgment, both on those artists and on the practice of painting in general. But it was quite consistent with the end of the era of art, as Belting and I understood it, that art should be extremely vigorous and show no sign whatever of internal exhaustion. Ours was a claim about how one complex of practices had given way to another, even if the shape of the new complex was still unclear—*is* still unclear. Neither of us was talking about the *death* of art, though my own text happens to have appeared as the target article in a volume under the title *The Death of Art*. That title was not mine, for I was writing about a certain narrative that had, I thought, been objectively realized in the history of art, and it was that narrative, it seemed to me, that had come to an end. A story was over. It was not my view that there would be no more art, which "death" certainly implies, but that whatever art there was to be would be made without benefit of a reassuring sort of narrative in which it was seen as the appropriate next stage in the story. What had come to an end was that narrative but not the subject of the narrative. I hasten to clarify.

In a certain sense, life really begins when the story comes to an end, as in the story every couple relishes of how they found one another and "lived happily ever after."[4] In the German genre of the *Bildungsroman*— the novel of formation and self-discovery—the story is told of the stages through which the hero or heroine progresses on the way to self-awareness. The genre has almost become a matrix of the feminist novel in

which the heroine arrives at a consciousness of who she is and what being a woman means. And that awareness, though the end of the story, is really "the first day of the rest of her life," to use the somewhat corny phrase of New Age philosophy. Hegel's early masterpiece, *The Phenomenology of Spirit*, has the form of a *Bildungsroman*, in the sense that its hero, *Geist*, goes through a sequence of stages in order to achieve knowledge not merely of what it itself is, but that without the history of mishaps and misplaced enthusiasms, its knowledge would be empty.[5] Belting's thesis too was about narratives. "Contemporary art," he wrote, "manifests an awareness of a history of art but no longer carries it forward."[6] And he speaks as well of "the relatively recent loss of faith in a great and compelling narrative, in the way things *must* be seen."[7] It is in part the sense of no longer belonging to a great narrative, registering itself on our consciousness somewhere between uneasiness and exhilaration, that marks the historical sensibility of the present, and which, if Belting and I are at all on the right path, helps define the acute difference, of which I think that awareness only began to emerge in the mid-1970s, between modern and contemporary art. It is characteristic of contemporaneity—but not of modernity—that it should have begun insidiously, without slogan or logo, without anyone being greatly aware that it had happened. The Armory show of 1913 used the pine-tree flag of the American Revolution as its logo to celebrate a repudiation of the art of the past. The Berlin dada movement proclaimed the death of art, but on the same poster by Raoul Hausmann wished long life to "The Machine Art of Tatlin." Contemporary art, by contrast, has no brief against the art of the past, no sense that the past is something from which liberation must be won, no sense even that it is at all different as art from modern art generally. It is part of what defines contemporary art that the art of the past is available for such use as artists care to give it. What is not available to them is the spirit in which the art was made. The paradigm of the contemporary is that of the collage as defined by Max Ernst, with one difference. Ernst said that collage is "the meeting of two distant realities on a plane foreign to them both."[8] The difference is that there is no longer a plane foreign to distinct artistic realities, nor are those realities all that distant from one another. That is because the basic perception of the contemporary spirit was formed on the principle of a museum in which all art has a rightful place, where there is no a priori criterion as to what that art must look like, and where there is no narrative into which the museum's contents must all fit. Artists today treat museums as filled not with dead art, but with living artistic options. The museum is a field available for constant rearrangement, and

indeed there is an art form emerging which uses the museum as a repository of materials for a collage of objects arranged to suggest or support a thesis; we see it in Fred Wilson's installation at the Maryland Historical Museum and again in Joseph Kosuth's remarkable installation "The Play of the Unmentionable" at the Brooklyn Museum.[9] But the genre is almost commonplace today: the artist is given free run of the museum and organizes out of its resources exhibitions of objects that have no historical or formal connection to one another other than what the artist provides. In some way the museum is cause, effect, and embodiment of the attitudes and practices that define the post-historical moment of art, but I do not want to press the matter for the moment. Rather, I want to return to the distinction between the modern and the contemporary and discuss its emergence into consciousness. In fact, it was the dawning of a certain kind of self-consciousness that I had in mind when I began to write about the end of art.

In my own field, philosophy, the historical divisions went roughly as follows: ancient, medieval, and modern. "Modern" philosophy was generally thought to begin with René Descartes, and what distinguished it was the particular inward turn Descartes took—his famous reversion to the "I think"—where the question would be less how things really are than how someone whose mind is structured in a certain way is obliged to think they are. Whether things really are the way the structure of our mind requires us to think they are is not something we can say. But neither does it greatly matter, since we have no alternative way of thinking about them. So working from the inside outward, so to speak, Descartes, and modern philosophy generally, drew a philosophical map of the universe whose matrix was the structure of human thought. What Descartes did was begin to bring the structures of thought to consciousness, where we could examine them critically and come to understand at one and the same time what we are and how the world is, for since the world is defined by thought, the world and we are literally made in one another's image. The ancients simply went ahead endeavoring to describe the world, paying no attention to those subjective features modern philosophy made central. We could paraphrase Hans Belting's marvelous title by talking about the self before the era of the self to mark the difference between ancient and modern philosophy. It is not that there were no selves before Descartes, but that the concept of the self did not define the entire activity of philosophy, as it came to do after he had revolutionized it and until reversion to language came to replace reversion to the self. And while "the linguistic turn"[10] certainly replaced questions of what

we are with how we talk, there is an undoubted continuity between the two stages of philosophical thought, as is underscored by Noam Chomsky's description of his own revolution in the philosophy of language as "Cartesian linguistics,"[11] replacing or augmenting Descartes's theory of innate thought with the postulation of innate linguistic structures.

There is an analogy to the history of art. Modernism in art marks a point before which painters set about representing the world the way it presented itself, painting people and landscapes and historical events just as they would present themselves to the eye. With modernism, the conditions of representation themselves become central, so that art in a way becomes its own subject. This was almost precisely the way in which Clement Greenberg defined the matter in his famous 1960 essay "Modernist Painting." "The essence of Modernism," he wrote, "lies, as I see it, in the use of the characteristic methods of a discipline to criticize the discipline itself, not in order to subvert it but in order to entrench it more firmly in its area of competence."[12] Interestingly, Greenberg took as his model of modernist thought the philosopher Immanuel Kant: "Because he was the first to criticize the means itself of criticism, I conceive of Kant as the first real Modernist." Kant did not see philosophy as adding to our knowledge so much as answering the question of how knowledge was possible. And I suppose the corresponding view of painting would have been not to represent the appearances of things so much as answering the question of how painting was possible. The question then would be: who was the first modernist painter—who deflected the art of painting from its representational agenda to a new agenda in which the means of representation became the object of representation?

For Greenberg, Manet became the Kant of modernist painting: "Manet's became the first Modernist pictures by virtue of the frankness with which they declared the flat surfaces on which they were painted." And the history of modernism moved from there through the impressionists, "who abjured underpainting and glazes, to leave the eye under no doubt as to the fact that the colors they used were made of paint that came from tubes or pots," to Cézanne, who "sacrificed verisimilitude, or correctness, in order to fit his drawing and design more explicitly to the rectangular shape of the canvas." And step by step Greenberg constructed a narrative of modernism to replace the narrative of the traditional representational painting defined by Vasari. Flatness, the consciousness of paint and brushstroke, the rectangular shape—all of them what Meyer Schapiro speaks of as "nonmimetic features" of what may still have been residually mimetic paintings—displaced perspective,

foreshortening, chiaroscuro as the progress points of a developmental sequence. The shift from "premodernist" to modernist art, if we follow Greenberg, was the shift from mimetic to nonmimetic features of painting. It was not, Greenberg asserts, that painting had to become itself nonobjective or abstract. It was just that its representational features were secondary in modernism where they had been primary in premodernist art. Much of my book, concerned as it is with narratives of the history of art, must perforce deal with Greenberg as the great narrativist of modernism.

It is important that the concept of modernism, if Greenberg is right, is not merely the name of a stylistic period which begins in the latter third of the nineteenth century, the way in which Mannerism is the name of a stylistic period which begins in the first third of the sixteenth century: Mannerist follows Renaissance painting and is followed by the baroque, which is followed by rococo, which is followed by neoclassicism, which is followed by the romantic. These were deep changes in the way painting represents the world, changes, one might say, in coloration and mood, and they develop out of and to some degree in reaction against their predecessors, as well as in response to all sorts of extra-artistic forces in history and in life. My sense is that modernism does not follow romanticism in this way, or not merely: it is marked by an ascent to a new level of consciousness, which is reflected in painting as a kind of discontinuity, almost as if to emphasize that mimetic representation had become less important than some kind of reflection on the means and methods of representation. Painting begins to look awkward, or forced (in my own chronology it is Van Gogh and Gauguin who are the first modernist painters). In effect, modernism sets itself at a distance from the previous history of art, I suppose in the way in which adults, in the words of Saint Paul, "put aside childish things." The point is that "modern" does not merely mean "the most recent."

It means, rather, in philosophy as well as in art, a notion of strategy and style and agenda. If it were just a temporal notion, all the philosophy contemporary with Descartes or Kant and all the painting contemporary with Manet and Cézanne would be modernist, but in fact a fair amount of philosophizing went on which was, in Kant's terms, "dogmatic," having nothing to do with the issues which defined the critical program he advanced. Most of the philosophers contemporary with Kant but otherwise "precritical" have dropped out of sight of all save scholars of the history of philosophy. And while there remains a place in the museum for painting contemporary with modernist art which is not itself modernist—

for example, French academic painting, which acted as if Cézanne had never happened, or later, surrealism, which Greenberg did what he could to suppress or, to use the psychoanalytical language which has come naturally to Greenberg's critics, like Rosalind Krauss or Hal Foster,[13] "to repress"—there is no room for it in the great narrative of modernism which swept on past it, into what came to be known as "abstract expressionism" (a label Greenberg disliked), and then color-field abstraction, where, though the narrative did not necessarily end, Greenberg himself stopped. Surrealism, like academic painting, lay, according to Greenberg, "outside the pale of history," to use an expression I found in Hegel. It happened, but it was not, significantly, part of the progress. If you were snide, as critics schooled in Greenbergian invective were, it was not really *art*, and that declaration showed the degree to which the identity of art was internally connected with being part of the official narrative. Hal Foster writes: "A space for surrealism has opened up: an *impensé* within the old narrative, it has become a privileged point for the contemporary critique of this narrative."[14] Part of what the "end of art" means is the enfranchisement of what had lain beyond the pale, where the very idea of a pale—a wall—is exclusionary, the way the Great Wall of China was, built to keep the Mongol hordes outside, or as the Berlin Wall was built, to keep the innocent socialist population protected from the toxins of capitalism. (The great Irish-American painter Sean Scully delights in the fact that "the pale," in English, refers to the Irish Pale, an enclave in Ireland, making the Irish outsiders in their own land.) In the modernist narrative, art beyond the pale either is no part of the sweep of history, or it is a reversion to some earlier form of art. Kant once spoke of his own era, the Age of Enlightenment, as "mankind's coming of age." Greenberg might have thought of art in those terms as well, and seen in surrealism a kind of aesthetic regression, a reassertion of values from the childhood of art, filled with monsters and scary threats. For him, maturity meant purity, in a sense of the term that connects exactly to what Kant meant by the term in the title of his *Critique of Pure Reason*. This was reason applied to itself, and having no other subject. Pure art was correspondingly art applied to art. And surrealism was almost the embodiment of impurity, concerned as it was with dreams, the unconscious, eroticism, and, in Foster's vision of it, "the uncanny." But so, by Greenbergian criteria, is contemporary art impure, which is what I want to talk about now.

Just as "modern" is not simply a temporal concept, meaning, say, "most recent," neither is "contemporary" merely a temporal term, meaning whatever is taking place at the present moment. And just as the shift

from "premodern" to modern was as insidious as the shift, in Hans Belting's terms, from the image before the era of art to the image *in* the era of art, so that artists were making modern art without realizing they were doing anything different in kind until it began to be retrospectively clear that a momentous change had taken place, so, similarly, did it happen with the shift from modern to contemporary art. For a long time, I think, "contemporary art" would have been just *the modern art that is being made now.* Modern, after all, implies a difference between now and "back then": there would be no use for the expression if things remained steady and largely the same. It implies an historical structure and is stronger in this sense than a term like "most recent." "Contemporary" in its most obvious sense means simply what is happening now: contemporary art would be the art produced by our contemporaries. It would not, clearly, have passed the test of time. But it would have a certain meaning for us which even modern art which *had* passed that test would not have: it would be "our art" in some particularly intimate way. But as the history of art has internally evolved, contemporary has come to mean an art produced within a certain structure of production never, I think, seen before in the entire history of art. So just as "modern" has come to denote a style and even a period, and not just *recent* art, "contemporary" has come to designate something more than simply the art of the present moment. In my view, moreover, it designates less a period than what happens after there are no more periods in some master narrative of art, and less a style of making art than a style of using styles. Of course, there is contemporary art in styles of a kind never before seen, but I do not want to press the matter at this stage of my discussion. I merely wish to alert the reader to my effort to draw a very strong distinction between "modern" and "contemporary."[15]

I don't especially think that the distinction was sharply drawn when I first moved to New York at the end of the forties, when "our art" was modern art, and the Museum of Modern Art belonged to us in that intimate way. To be sure, a lot of art was being made which did not as yet make an appearance in that museum, but it did not seem to us then, to the degree that the matter was thought about at all, that the latter was contemporary in a way that distinguished it from modern. It seemed a wholly natural arrangement that some of this art would sooner or later find its way into "The Modern," and that this arrangement would continue indefinitely, modern art being here to stay, but not in any way forming a closed canon. It was not closed, certainly, in 1949, when *Life* magazine suggested that Jackson Pollock might just be the greatest

American painter alive. That it is closed today, in the minds of many, myself included, means that somewhere between then and now a distinction emerged between the contemporary and the modern. The contemporary was no longer modern save in the sense of "most recent," and the modern seemed more and more to have been a style that flourished from about 1880 until sometime in the 1960s. It could even be said, I suppose, that some modern art continued to be produced after that—art which remained under the stylistic imperatives of modernism—but that art would not really be contemporary, except again in the strictly temporal sense of the term. For when the stylistic profile of modern art revealed itself, it did so because contemporary art itself revealed a profile very different from modern art. This tended to put the Museum of Modern Art in a kind of bind no one had anticipated when it was the home of "our art." The bind was due to the fact that "modern" had a stylistic meaning *and* a temporal meaning. It would not have occurred to anyone that these would conflict, that contemporary art would stop being modern art. But today, as we near the end of the century, the Museum of Modern Art has to decide whether it is going to acquire contemporary art that is not modern and thus become a museum of modern art in the strictly temporal sense or whether it will continue to collect only stylistically modern art, the production of which has thinned down to perhaps a trickle, but which is no longer representative of the contemporary world.

In any case, the distinction between the modern and the contemporary did not become clear until well into the seventies and eighties. Contemporary art would for a long time continue to be "the modern art produced by our contemporaries." At some point this clearly stopped being a satisfactory way of thinking, as evidenced by the need to invent the term "postmodern." That term by itself showed the relative weakness of the term "contemporary" as conveying a style. It seemed too much a mere temporal term. But perhaps "postmodern" was too strong a term, too closely identified with a certain sector of contemporary art. In truth, the term "postmodern" really does seem to me to designate a certain style we can learn to recognize, the way we learn to recognize instances of the baroque or the rococo. It is a term something like "camp," which Susan Sontag transferred from gay idiolect into common discourse in a famous essay.[16] One can, after reading her essay, become reasonably adept at picking out camp objects, in just the same way it seems to me that one can pick out postmodern objects, with maybe some difficulties at the borderlines. But that is how it is with most concepts, stylistic or otherwise, and with recognitional capacities in human beings and in

Venturi

animals. There is a valuable formula in Robert Venturi's 1966 book *Complexity and Contradiction in Architecture*: "elements which are hybrid rather than 'pure,' compromising rather than 'clean,' 'ambiguous' rather than 'articulated,' perverse as well as 'interesting.'"[17] One could sort works of art out using this formula, and almost certainly you would have one pile which consisted pretty homogeneously of postmodern works. It would have the works of Robert Rauschenberg, the paintings of Julian Schnabel

Gehry

and David Salle, and I guess the architecture of Frank Gehry. But much contemporary art would be left out—say the works of Jenny Holzer or the paintings of Robert Mangold. It has been suggested that perhaps we should simply speak of postmodernisms. But once we do this, we lose the recognitional ability, the capacity to sort out, and the sense that postmodernism marks a specific style. We could capitalize the word "contemporary" to cover whatever the disjunction of postmodernisms was intended to cover, but there again we would be left with the sense that we have no identifiable style, that there is nothing that does not fit. But that in fact *is* the mark of the visual arts since the end of modernism, that as a period it is defined by the lack of a stylistic unity, or at least the kind of stylistic unity which can be elevated into a criterion and used as a basis for developing a recognitional capacity, and there is in consequence no possibility of a narrative direction. That is why I prefer to call it simply *posthistorical* art. Anything ever done could be done today and be an example of post-historical art. For example, an appropriationist artist like Mike Bidlo could have a show of Piero della Francescas in which the entirety of Piero's corpus was appropriated. Piero is certainly not a post-historical artist, but Bidlo is, and a skilled enough appropriationist as well, so that his Pieros and Piero's paintings could look as much alike as he cared to make them look—as much like Piero as his Morandis look like Morandis, his Picassos like Picassos, his Warhols like Warhols. Yet in an important sense, not easily believed accessible to the eye, Bidlo's Pieros would have more in common with the work of Jenny Holzer, Barbara Kruger, Cindy Sherman, and Sherrie Levine than with Piero's proper stylistic peers. So the contemporary is, from one perspective, a period of information disorder, a condition of perfect aesthetic entropy. But it is equally a period of quite perfect freedom. Today there is no longer any pale of history. Everything is permitted. But that makes the historical transition from modernism to post-historical art all the more urgent to try to understand. And that means that it is urgent to try to understand the decade of the

How?

1970s, a period in its own way as dark as the tenth century.

The seventies was a decade in which it must have seemed that history had lost its way. It had lost its way because nothing at all like a discernible direction seemed to be emerging. If we think of 1962 as marking the end of abstract expressionism, then you had a number of styles succeeding one another at a dizzying rate: color-field painting, hard-edged abstraction, French neorealism, pop, op, minimalism, *arte povera*, and then what got to be called the New Sculpture, which included Richard Serra, Linda Benglis, Richard Tuttle, Eva Hesse, Barry Le Va, and then conceptual art. Then what seemed to be ten years of nothing much. There were sporadic movements like Pattern and Decoration, but nobody supposed they were going to generate the kind of structural stylistic energy of the immense upheavals of the sixties. Then all at once neo-expressionism arose, in the early eighties, and gave people the sense that a new direction had been found. And then again the sense of nothing much so far at least as historical directions were concerned. And then the dawning sense that the absence of direction was the defining trait of the new period, that neo-expressionism was less a direction than the illusion of one. Recently people have begun to feel that the last twenty-five years, a period of tremendous experimental productiveness in the visual arts with no single narrative direction on the basis of which others could be excluded, have stabilized as the norm.

The sixties was a paroxysm of styles, in the course of whose contention, it seems to me—and this was the basis of my speaking of the "end of art" in the first place—it gradually became clear, first through the *nouveaux realistes* and pop, that there was no special way works of art had to look in contrast to what I have designated "mere real things." To use my favorite example, nothing need mark the difference, outwardly, between Andy Warhol's *Brillo Box* and the Brillo boxes in the supermarket. And conceptual art demonstrated that there need not even be a palpable visual object for something to be a work of visual art. That meant that you could no longer teach the meaning of art by example. It meant that as far as appearances were concerned, anything could be a work of art, and it meant that if you were going to find out what art was, you had to turn from sense experience to thought. You had, in brief, to turn to philosophy.

In an interview in 1969, conceptual artist Joseph Kosuth claimed that the only role for an artist at the time "was to investigate the nature of art itself."[18] This sounds strikingly like the line in Hegel that gave support ⟨Hegel⟩ to my own views about the end of art: "Art invites us to intellectual

consideration, and that not for the purpose of creating art again, but for knowing philosophically what art is."[19] Joseph Kosuth is a philosophically literate artist to an exceptional degree, and he was one of the few artists working in the sixties and seventies who had the resources to undertake a philosophical analysis of the general nature of art. As it happened, relatively few philosophers of the time were ready to do this, just because so few of them could have imagined the possibility of art like that being produced in such dizzying disjunctiveness. The philosophical question of the nature of art, rather, was something that arose within art when artists pressed against boundary after boundary, and found that the boundaries all gave way. All typical sixties artists had that vivid sense of boundaries, each drawn by some tacit philosophical definition of art, and their erasure has left us the situation we find ourselves in today. Such a world is not, by the way, the easiest kind of world to live in, which explains why the political reality of the present seems to consist in drawing and defining boundaries wherever possible. Nevertheless, it was only in the 1960s that a serious philosophy of art became a possibility, one which did not base itself on purely local facts—for example, that art was essentially painting and sculpture. Only when it became clear that anything could be a work of art could one think, philosophically, about art. Only then did the possibility arise of a true general philosophy of art. But what of art itself? What of "Art after Philosophy"—to use the title of Kosuth's essay—which, to make the point, may indeed itself be a work of art? What of art after the end of art, where, by "after the end of art," I mean "after the ascent to philosophical self-reflection?" Where an artwork can consist of any object whatsoever that is enfranchised as art, raising the question "Why am I a work of art?"

With that question the history of modernism was over. It was over because modernism was too local and too materialist, concerned as it was with shape, surface, pigment, and the like as defining painting in its purity. Modernist painting, as Greenberg defined it, could only ask the question "What is it that I have and that no other kind of art can have?" And sculpture asked itself the same kind of question. But what this gives us is no general picture of what art is, only what some of the arts, perhaps historically the most important arts, essentially were. What question does Warhol's *Brillo Box* ask, or one of Beuys's multiples of a square of chocolate stuck to a piece of paper? What Greenberg had done was to identify a certain local style of abstraction with the philosophical truth of art, when the philosophical truth, once found, would have to be consistent with art appearing every possible way.

What I know is that the paroxysms subsided in the seventies, as if it had been the internal intention of the history of art to arrive at a philosophical conception of itself, and that the last stages of that history were somehow the hardest to work through, as art sought to break through the toughest outer membranes, and so itself became, in the process, paroxysmal. But now that the integument was broken, now that at least the glimpse of self-consciousness had been attained, that history was finished. It had delivered itself of a burden it could now hand over to the philosophers to carry. And artists, liberated from the burden of history, were free to make art in whatever way they wished, for any purposes they wished, or for no purposes at all. That is the mark of contemporary art, and small wonder, in contrast with modernism, there is no such thing as a contemporary style.

I think the ending of modernism did not happen a moment too soon. For the art world of the seventies was filled with artists bent on agendas having nothing much to do with pressing the limits of art or extending the history of art, but with putting art at the service of this or that personal or political goal. And artists had the whole inheritance of art history to work with, including the history of the avant-garde, which placed at the disposition of the artist all those marvelous possibilities the avant-garde had worked out and which modernism did its utmost to repress. In my own view, the major artistic contribution of the decade was the emergence of the appropriated image—the taking over of images with established meaning and identity and giving them a fresh meaning and identity. Since any image could be appropriated, it immediately follows that there could be no perceptual stylistic uniformity among appropriated images. One of my favorite examples is Kevin Roche's 1992 addition to the Jewish Museum in New York. The old Jewish Museum was just the Warburg mansion on Fifth Avenue, with its baronial associations and connotations of the Gilded Age. Kevin Roche brilliantly decided to duplicate the old Jewish Museum, and the eye is unable to tell a single difference. But the building belongs to the postmodern age perfectly: a postmodern architect can design a building which looks like a Mannerist chateau. It was an architectural solution that had to have pleased the most conservative and nostalgic trustee, as well as the most avant-garde and contemporary one, but of course for quite different reasons.

These artistic possibilities are but realizations and applications of the immense philosophical contribution of the 1960s to art's self-understanding: that artworks can be imagined, or in fact produced, which look exactly like mere real things which have no claim to the status of art at all,

for the latter entails that you can't define artworks in terms of some particular visual properties they may have. There is no a priori constraint on how works of art must look—they can look like anything at all. This alone finished the modernist agenda, but it had to wreak havoc with the central institution of the art world, namely the museum of fine arts. The first generation of great American museums took it for granted that its contents would be treasures of great visual beauty and that visitors would enter the tresorium to be in the presence of spiritual truth of which the visually beautiful was the metaphor. The second generation, of which the Museum of Modern Art is the great exemplar, assumed that the work of art is to be defined in formalist terms and appreciated under the perspective of a narrative not remarkably different from the one Greenberg advanced: a linear progressive history the visitor would work through, learning to appreciate the work of art together with learning the historical sequences. Nothing was to distract from the formal visual interest of the works themselves. Even picture frames were eliminated as distractions, or perhaps as concessions to an illusionistic agenda modernism had outgrown: paintings were no longer windows onto imagined scenes, but objects in their own right, even if they had been conceived as windows. It is, incidentally, easy to understand why surrealism has to be repressed in the light of such an experience: it would be too distracting, not to mention irrelevantly illusionistic. Works had plenty of space to themselves in galleries emptied of everything but those works.

In any case, with the philosophical coming of age of art, visuality drops away, as little relevant to the essence of art as beauty proved to have been. For art to exist there does not even have to be an object to look at, and if there are objects in a gallery, they can look like anything at all. Three attacks on established museums are worth noting in this respect. When Kirk Varnedoe and Adam Gopnick admitted pop into the galleries of the Museum of Modern Art in the "High and Low" show of 1990, there was a critical conflagration. When Thomas Krens deaccessioned a Kandinsky and a Chagall to acquire part of the Panza collection, a good bit of it conceptual and much of which did not exist as objects, there was a critical conflagration. And when, in 1993, the Whitney compiled a Biennial consisting of works that really typified the way the art world had gone after the end of art, the outpouring of critical hostility—in which I am afraid I shared—was by an inestimable factor unprecedented in the history of Biennial polemics. Whatever art is, it is no longer something primarily to be looked at. Stared at, perhaps, but not primarily looked at. What, in view of this, is a post-historical museum to do, or to be?

It must be plain that there are three models at least, depending upon the kind of art we are dealing with, and depending upon whether it is beauty, form, or what I shall term engagement that defines our relationship to it. Contemporary art is too pluralistic in intention and realization to allow itself to be captured along a single dimension, and indeed an argument can be made that enough of it is incompatible with the constraints of the museum that an entirely different breed of curator is required, one who bypasses museum structures altogether in the interests of engaging the art directly with the lives of persons who have seen no reason to use the museum either as tresorium of beauty or sanctum of spiritual form. For a museum to engage this kind of art, it has to surrender much of the structure and theory that define the museum in its other two modes.

But the museum itself is only part of the infrastructure of art that will sooner or later have to deal with the end of art and with art after the end of art. The artist, the gallery, the practices of art history, and the discipline of philosophical aesthetics must all, in one or another way, give way and become different, and perhaps vastly different, from what they have so far been. I can only hope to tell part of the philosophical story in the chapters that follow. The institutional story must wait upon history itself.

NOTES

1. "The End of Art" was the target essay in a book, *The Death of Art*, edited by Berel Lang (New York: Haven Publishers, 1984). The program of the book was that various writers would respond to the ideas set out in the target essay. I went on to elaborate on the end of art in various essays. "Approaching the End of Art" was delivered as a lecture in February 1985, at the Whitney Museum of American Art, and was printed in my *The State of the Art* (New York: Prentice Hall Press, 1987). "Narratives of the End of Art," was delivered as a Lionel Trilling Lecture at Columbia University, printed first in *Grand Street* and reprinted in my *Encounters and Reflections: Art in the Historical Present* (New York: Noonday Press, Farrar, Straus, and Giroux, 1991). Hans Belting's *The End of the History of Art*, trans. Christopher S. Wood (Chicago: University of Chicago Press, 1987) first appeared under the title *Das Ende der Kunstgeschichte?* (Munich: Deutscher Kunstverlag, 1983). Belting has since dropped the question mark in his amplification of the 1983 text in *Das Ende der Kunstgeschichte: Eine Revision nach zehn Jahre* (Munich: Verlag C. H. Beck, 1995). The present book, also written ten years after the original statement, is my effort to bring the somewhat vaguely formulated idea of the end of art up to date. It may be mentioned that the idea must have been in the air in the mid-eighties. Gianni Vattimo has a chapter, "The Death or Decline of Art," in his *The End of Modernity: Nihilism and*

Hermeneutics in Post-Modern Culture (Cambridge: Polity Press, 1988), originally published as *La Fine della Modernita* (Garzanti Editore, 1985). Vattimo sees the phenomena which Belting and I address from a perspective wider by far than either of us occupies: he thinks of the end of art under the perpective of the death of metaphysics in general, as well as of certain philosophical responses to aesthetic problems raised by "a technologically advanced society." "The end of art" is only a point of intersection between the line of thought Vattimo follows and that which Belting and I seek to draw out of the internal state of art itself, considered more or less in isolation from wider historical and cultural determinants. Thus Vattimo speaks of "earth-works, body art, street theater, and so on [in which] the status of the work becomes constitutively ambiguous: the work no longer seeks a success which would permit it to position itself within a determinate set of values (the imaginary museum of objects possessed of aesthetic quality)" (p. 53). Vattimo's essay is a fairly straightforward application of Frankfurt School preoccupations. Still, the "in the airness" of the idea, whatever the perspective, is what I am remarking.

2. "From the point of view of their origins, it is possible to distinguish two kinds of cult images that were publicly venerated in Christendom. One kind, initially including only images of Christ and a cloth imprint of St. Stephen in North Africa, comprises 'unpainted' and therefore especially authentic images that were either of heavenly origin or produced by mechanical impression during the lifetime of the model. For these the term *a cheiropoieton* ('not made by hand') came into use, in Latin *non manufactum*" (Hans Belting, *Likeness and Presence: A History of the Image before the Era of Art*, trans. Edmund Jephcott [Chicago: University of Chicago Press, 1994], 49). In effect, these images were physical traces, like fingerprints, and hence had the status of relics.

3. But the second class of images gingerly admitted by the early church were those in fact painted, providing the painter was a saint, like Saint Luke, "for whom it was believed that Mary sat for a portrait during her lifetime. . . . The Virgin herself was made to finish the painting, or a miracle by the Holy Spirit occurred to grant still greater authenticity for the portrait" (Belting, *Likeness and Presence*, 49). Whatever the miraculous interventions, Luke naturally became the patron saint of artists, and Saint Luke portraying the Mother and Child a favorite self-celebratory theme.

4. Thus the title of one of the best-selling texts of my youth, *Life Begins at Forty*, or the Jewish contribution, as recounted in a joke one hears now and again, to a debate on when life begins: "When the dog dies and the children leave home."

5. To the best of my knowledge, this literary characterization of Hegel's early masterpiece was first given by Josiah Royce in his *Lectures on Modern Idealism*, ed. Jacob Loewenberg (Cambridge: Harvard University Press, 1920).

6. Hans Belting, *The End of the History of Art?*, 3.

7. Ibid., 58.

8. Cited in William Rubin, *Doda, Surrealism, and Their Heritage* (New York: Museum of Modern Art, 1968), 68.

9. See Lisa G. Corrin, *Mining the Museum: An Installation Confronting History* (Maryland Historical Society, Baltimore), and *The Play of the Unmentionable: An Installation by Joseph Kosuth at the Brooklyn Museum* (New York: New Press, 1992).

10. As the title of a collection of essays by diverse philosophical hands, each representing an aspect of the somewhat massive shift from question of substance to questions of linguistic representation which marked twentieth-century *analytical* philosophy, see Richard Rorty, *The Linguistic Turn: Recent Essays in Philosophical Method* (Chicago: University of Chicago Press, 1967). Rorty, of course, made a counterlinguistic turn not long after this publication.

11. Noam Chomsky, *Cartesian Linguistics: A Chapter in the History of Rationalist Thought* (New York: Harper and Row, 1966).

12. Clement Greenberg, "Modernist Painting," in *Clement Greenberg: The Collected Essays and Criticism*, ed. John O'Brian, vol. 4: *Modernism with a Vengeance: 1957–1969*, 85–93. All citations in the present paragraph are from the same text.

13. Rosalind E. Krauss, *The Optical Unconscious* (Cambridge: MIT Press, 1993); Hal Foster, *Compulsive Beauty* (Cambridge: MIT Press, 1993).

14. Greenberg, *The Collected Essays and Criticism*, 4:xiii.

15. "The problem of the status of modern over against contemporary art demands the general attention of the discipline—whether one believes in postmodernism or not" (Hans Belting, *The End of the History of Art?*, xii).

16. Susan Sontag, "Notes on Camp" in *Against Interpretation* (New York: Laurel Books, 1966), 277–93.

17. Robert Venturi, *Complexity and Contradiction in Architecture*, 2d ed. (New York: Museum of Modern Art, 1977).

18. Joseph Kosuth, "Art after Philosophy," *Studio International* (October 1969), reprinted in Ursula Meyer, *Conceptual Art* (New York: E. P. Dutton, 1972), 155–70.

19. G. W. F Hegel, *Hegel's Aesthetics: Lectures on Fine Art*, trans. T. M. Knox (Oxford: Clarendon Press, 1975), 11.

BLACK PAINTING (1962) BY AD REINHARDT. OIL ON CANVAS. 60" X 60". PHOTOGRAPH COURTESY OF
PACEWILDENSTEIN. PHOTO CREDIT: ELLEN PAGE WILSON.

Three Decades after the End of Art

It TOOK a full decade after I published an essay that endeavored to place the situation of the visual arts in some kind of historical perspective for it to strike me that the year in which that essay appeared—1984—had a symbolic meaning that might give pause to someone venturing onto the uncertain waters of historical prediction. The essay was somewhat provocatively titled "The End of Art," and, difficult as it might have been for someone at all familiar with the unprecedented surge in artistic activity in that year and for some years thereafter to believe, I really meant to proclaim that a certain kind of closure had occurred in the historical development of art, that an era of astonishing creativity lasting perhaps six centuries in the West had come to an end, and that whatever art was to be made from then on would be marked by what I was prepared to call a *post-historical* character. Against the background of an increasingly prosperous art world, in which it all at once no longer seemed necessary for artists to undergo the period of obscurity, poverty, and suffering that the familiar myth of the paradigmatic artistic biography required, and in which instead painters fresh from art schools like the California Institute of the Arts and Yale anticipated immediate recognition and material happiness, *my* claim must have appeared as incongruently out of touch with reality as those urgent forecasts of the immanent end of the world inspired by the Book of Revelations. By contrast with the exultant, even feverish art market of the mid-1980s, which a certain number of grudging but not altogether misguided commentators at the time likened to the famous tulip mania that swamped the characteristic thrift and caution of the Dutch with a kind of speculative fever, the art world of the mid-1990s is a triste and chastened scene. Artists who looked forward to a lifestyle of princely real estate and opulent restaurants are scrambling to find teaching positions to tide them over what in fact may be a very long dry spell indeed.

Markets are markets, driven by demand and supply, but demands are subject to causal determinants of their own, and it is not unthinkable that

the complex of causal determinants that accounted for the appetite to acquire art in the 1980s may never recombine in the form they assumed in that decade, driving large numbers of individuals to think of owning art as something that belonged within their vision of a meaningful style of life. So far as one can tell, the factors that combined to drive the price of tulip bulbs up beyond rational expectation in seventeenth-century Holland never exactly fell together in that way again. Of course, there has continued to be a market in tulips, fluctuating as those flowers have risen and fallen in gardeners' favor, and so there is reason to suppose that there will always be a market in art, with the kinds of rise and fall in individual reputations familiar to students of the history of taste and fashion. Art collecting may not go back as far in historical time as gardening, but collecting is perhaps as deeply ingrained a disposition in the human psyche as gardening is—I am not talking after all about farming but about gardening as a form of art. But the art market of the 1980s may possibly never recur, and the expectations of artists and gallerists of that time may never again be reasonable. Of course, some different constellation of causes may bring about an outwardly similar market, but my point is that, unlike the natural cycles of rise and fall that belongs to the concept of a market, such an occurrence would be strictly unpredictable, say like the abrupt intervention of a meteor in the orderly swing of planets that make up the solar system.

But the thesis of the end of art has nothing to do with markets, or, for that matter, with the kind of historical chaos which the emergence of the fast art market of the 1980s exemplified. The dissonance between my thesis and the heady market of the eighties is as little relevant to my thesis as is the ending of that market in the present decade, which might mistakenly be supposed to confirm it. So what would confirm or disconfirm it? This returns me to the symbolic importance of 1984 in world history.

Whatever the annals and chronicles of world history record as having happened in 1984, far and away the most important event of that year was a nonevent, much in the way in which the most important event of the year A.D. 1000 was the nonending of the world, contrary to what visionaries had supposed guaranteed by the Book of Revelations. What did *not* happen in 1984 was the establishment of a political state of world affairs of the sort George Orwell's novel *1984* forecast as all but inevitable. Indeed, 1984 turned out to be so different from what *1984* predicted for it that one cannot but wonder, a decade later, how a prediction regarding the end of art stands up against historical

reality as we experience it a decade after it was made: if the flattening out of the curves of artistic production and demand do not count against it, what can? Orwell introduced a simile into the language—"like 1984"— which readers of his novel would have no difficulty in applying to certain flagrant invasions by governments into private affairs. But by time that year came round, the simile would have had to be rephrased as "like 1984"—like the novelistic representation of history rather than like history itself, with a discrepancy between the two that would surely have astonished Orwell when, in 1948 (1984 with the last two digits reversed), the novelistic forecast seemed so inscribed in the political weave of world history that the cold dehumanized terror of a totalitarian future seemed a destiny nothing could impede or abort. The political reality of 1989, when the walls were to fall and European politics to take a direction far from imaginable even in fiction in 1948, was hardly yet discernible in the world of 1984, but that world itself was an easier, less threatening place. The scary language of nuclear testing, by means of which hostile superpowers sent signals back and forth when one of them did something the other perceived as threatening, had been replaced with the no less symbolic language of exchanged exhibitions of impressionist and post-impressionist paintings. After World War II, the official exhibition of national treasures was a standard gesture through which a nation expressed to another that hostilities were over, and that it could be trusted with objects of inestimable value. It is difficult to think of objects at once more physically fragile and yet more precious than paintings of a certain sort: the 1987 sale of Van Gogh's *Irises* for 53.9 million dollars merely underscores the implication of trust conveyed by the act of placing one's prized canvases in the hands of those who, shortly before, would have seized and held them hostage. (I might observe in parenthesis that the gestural importance of exhibitions remains viable, even when a nation has no stock of national treasures to entrust: today one establishes one's readiness to be part of the commonwealth of nations by sponsoring a biennial. No sooner had apartheid ended in South Africa than Johannesburg announced its first such show, inviting the governments of the world to sponsor exhibitions in acknowledgment of its moral acceptability).[1] In 1986, forty impressionist and post-impressionist works from our National Gallery went on tour in the then Soviet Union, and during that same year works of comparable quality—works one had never hoped to see outside the Soviet Union—served as aesthetic ambassadors in major American museums. Orwell's Big Brother seemed less and less a political possibility and more and more a fictional being inspired by what in 1948 seemed an

historical inevitability. Orwell's fictional forecast was a great deal closer to historical reality when it was made, in 1948, than my art-historical forecast seemed in 1984, by which time 1984 seemed decisively falsified by history. The circumstances of a collapsed art world in 1994, by contrast, seemed really quite supportive of a thesis of the end of art, but, as I am seeking to explain, that collapse is causally independent of whatever it is that explains the end of art, and it is thinkable that the same collapsed market could be compatible with a robust period of artistic production.

In any case, the end of art, as I am thinking about it, had come well before the market of the 1980s had so much as been imagined. It came a full two decades before I published "The End of Art." It was not a dramatic event, like the falling walls that marked the end of communism in the West. It was, like many events of overture and closure, largely invisible to those who lived through it. There were, in 1964, no front-page articles in *The New York Times*, no "just-in" bulletins on the evening news. I certainly noticed the events themselves, but did not perceive them as marking the end of art, not, as I say, until 1984. But that is typical of historical perception. The really important descriptions of events are often, even typically, unavailable to those who see those events happen. Who, knowing that Petrarch was ascending Mount Ventoux with a copy of Saint Augustine in his hand, could have known that with that event the Renaissance had begun? Who, visiting the Stable Gallery on East 74th Street in Manhattan to see the Warhols, could have known that art had come to an end?[2] Someone might have uttered that as a critical judgment, despising the *Brillo Boxes* and all that pop art stood for. But the end of art was never advanced as a critical judgment at all, but as an objective historical judgment. The structure of beginnings and endings, which almost defines historical representation construed narratively, is difficult to apply even in retrospect. Did cubism begin with Picasso's *Demoiselles d'Avignon*? Or with his little paper sculpture of a guitar in 1912, as Yves-Alain Bois claims in his book *Painting as Model*?[3] Abstract expressionism, in the late 1960s, was said to have ended in 1962, but did anyone in 1962 believe that it had ended? Cubism and abstract expressionism, of course, were movements; the Renaissance was a period. With both of these kinds of temporal entities, it at least makes sense to say that they have endings. My claim, on the other hand, is about *art* as such. But that means that I too am thinking about art itself as naming less a practice than a movement or even a period, with marked temporal boundaries. It is of course a fairly long movement or period, but there are a good many historically sustained periods or movements so universally embodied in human activ-

ities that we sometimes forget to think of them historically at all, but which, once we do, we can imagine coming to one or another end—science and philosophy, for example. They could come to an end without it following that people would stop philosophizing or doing science. After all, they came, so to speak, to *beginnings*. Recall the subtitle of Hans Belting's great text *Likeness and Presence: The Image before the Era of Art.* The "era of art" begins in about A.D. 1400, on Belting's view, and though the images made before then are "art," they were not conceived as such, and the concept of art played no role in their coming into being. Belting argues that until (about) A.D. 1400 images were venerated but not admired aesthetically, and he clearly then has built aesthetics into the historical meaning of art. I shall argue in a later chapter that aesthetical considerations, which climaxed in the eighteenth century, have no essential application to what I shall speak of as "art after the end of art"—i.e., art produced from the late 1960s on. That there was—and is—art before and after the "era of art" shows that the connection between art and aesthetics is a matter of historical contingency, and not part of the essence of art.[4] But I am getting very far ahead of my story.

 I want to link these questions with another event of 1984, fateful certainly for me but scarcely so for the history of the world. In October of that year, my life took a sharp turn away from the orthogonal of professional philosophy: I began to write art criticism for *The Nation*, a turn so at right angles to any path I might have predicted for myself that it could not even have been the result of an intention to become an art critic. It was an episode of nearly pure chance, though once embarked on this career, I found that it answered to some very deep impulse in my character, so deep, I suppose, that it would never have surfaced had chance not intervened. So far as I know, there was no serious causal connection between publishing "The End of Art" and becoming an art critic as events, but there are connections of another kind. In the first place, people raised the question of how it was possible to proclaim the end of art and then begin a career of art criticism: it seemed that if the historical claim were true, the practice would shortly become impossible for want of a subject. But of course I had in no sense claimed that art was going to *stop being made!* A great deal of art has been made since the end of art, if it were indeed the end of art, just as, in Hans Belting's historical vision, a great deal of art had been made before the era of art. So the question of an empirical disconfirmation of my thesis cannot rest on the fact of art continuing to be produced, but at best on what kind of

art it is, and then on what one might, to borrow a term from the philosopher I have taken as my sometime master in this inquiry, Georg Wilhelm Friedrich Hegel, speak of as the *spirit* in which the art was made. In any case, it was consistent with art having come to an end that there should go on being art and hence there should go on being plenty of art to write about as a critic.[5] But then the kind of criticism it would be legitimate to practice must be very different from the kind licensed under some view of history other than mine—under views of history, for example, which identify certain forms of art as historically mandated. Such views are the equivalent, so to speak, of a chosen people with whom the meaning of history is supposedly bound up, or a specific class, like the proletariat destined to be the vehicle of historical destiny, and in contrast with which, no other class or people—or art—has any ultimate historical meaning. In a passage that would certainly land him in hot water today, Hegel writes about Africa as "no historical part of the world. . . . What we properly understand by Africa, is the Unhistorical, undeveloped Spirit, still involved in the conditions of mere nature."[6] Hegel similarly, and with a gesture no less sweeping, dismisses Siberia as lying "out of the pale of history." Hegel's vision of history entailed that only certain regions of the world, and then only at certain moments, were truly "world historical," so that other regions, or the same region at other moments, were not really part of what was historically taking place. I mention this because the views of the history of art that I want to contrast mine with similarly define only certain kinds of art as historically important, and the rest as not really being at the present moment "world historical," and hence not really worth consideration. Such art—for example, primitive art, folk art, craft—is not, as partisans characteristically say, really art, just because, in Hegel's phrase, it lies "out of the pale of history."

These kinds of theories have been especially prominent in modernist times, and they have defined a form of criticism against which I am anxious to define my own. In February 1913, Malevich assured Matiushin that "the only meaningful direction for painting was Cubo-Futurism."[7] In 1922, the Berlin dadaists celebrated the end of all art except the *Maschinekunst* of Tatlin, and that same year the artists of Moscow declared that easel painting as such, abstract or figurative, belonged to an historically superseded society. "True art like true life takes a *single road*," Piet Mondrian wrote in 1937.[8] Mondrian saw himself as on that road in life as in art, in life because in art. And he believed that other artists were leading false lives if the art they made was on a false path. Clement Greenberg, in an essay he characterized as "an historical apology for abstract art"—

INSTALLATION PHOTOGRAPH, 1ST INTERNATIONAL DADA EXHIBITION, BERLIN 1921.

PHOTO CREDIT: JOHN BLAZEJEWSKI.

"Toward a Newer Laocoön"—insisted that "the imperative [to make ab-
stract art] comes from history" and that the artist is held "in a vise from
which at the present moment he can escape only by surrendering his
ambition and returning to a stale past." In 1940, when this was published,
the only "true road" for art was abstraction. This was true even for artists
who, though modernist, were not fully abstractionists: "So inexorable
was the logic of the development that in the end their work constituted
but another step towards abstract art."[9] "The one thing to say about art
is that it is one thing," Ad Reinhardt wrote in 1962. "The one object of
fifty years of abstract art is to present art-as-art and as nothing else . . .
making it purer and emptier, more absolute and more exclusive."[10]
"There is just one art," Reinhardt said over and over, and he believed
fervently that *his* paintings—black, matte, square—are what art essen-
tially is.

To claim that art has come to an end means that criticism of this sort
is no longer licit. No art is any longer historically mandated as against any
other art. Nothing is any more true as art than anything else, nothing
especially more historically false than anything else. So at the very least
the belief that art has come to an end entails the kind of critic one cannot

be, if one is going to be a critic at all: there can now be no historically mandated form of art, everything else falling outside the pale. On the other hand, to be that kind of critic entails that all the art-historical narratives of the kind of I have just cited must be henceforward false. They are false, one might say, on philosophical grounds, and this requires a certain comment. Each of the narratives—Malevich's, Mondrian's, Reinhardt's, and the rest—are covert manifestos, and manifestos were among the chief artistic products of the first half of the twentieth century, with antecedents in the nineteenth century, preeminently in connection with the ideologically retrograde movements of the pre-Raphaelites and the Nazarenes. An historian of my acquaintance, Phyllis Freeman, has taken the manifesto as her topic of research, of which she had unearthed roughly five hundred examples, some of which—the surrealist manifesto, the futurist manifesto—are nearly as well known as the works they sought to validate. The manifesto defines a certain kind of movement, and a certain kind of style, which the manifesto more or less proclaims as the only kind of art that matters. It is a mere accident that some of the major movements of the twentieth century lacked explicit manifestos. Cubism and fauvism, for example were both engaged in establishing a new kind of order in art, and discarded everything that obscured the basic truth or order the partisans supposed themselves to have discovered (or rediscovered). "That was the reason," Picasso explained to Francoise Gilot, that the cubists "abandoned color, emotion, sensation, and everything that had been introduced into painting by the Impressionists."[11] Each of the movements was driven by a perception of the philosophical truth of art: that art is essentially X and that everything other than X is not—or is not essentially—art. So each of the movements saw its art in terms of a narrative of recovery, disclosure, or revelation of a truth that had been lost or only dimly acknowledged. Each was buttressed by a philosophy of history that defined the meaning of history by an end-state which consisted in the true art. Once brought to the level of self-consciousness, this truth reveals itself as present in all the art that ever mattered: "To this extent," as Greenberg remarks at one point, "art remains unchangeable."

The picture then is this: there is a kind of transhistorical essence in art, everywhere and always the same, but it only discloses itself through history. This much I regard as sound. What I do not regard as sound is the identification of this essence with a particular style of art—monochrome, abstract, or whatever—with the implication that art of any other style is false. This leads to an ahistorical reading of the history of art in which all

art is essentially the same—all art, for example, is essentially abstract—once we strip away the disguises, or the historical accident that do not belong to the essence of "art-as-art." And criticism then consists in penetrating these disguises, in getting to the alleged essence. It also, unfortunately, has consisted in denouncing whatever art fails to accept the revelation. With whatever justification, Hegel claimed that art, philosophy, and religion are the three moments of Absolute Spirit, so that the three are essentially transforms of one another, or modulations in different keys of the identical theme. The behavior of art critics in the modern period seems almost uncannily to have borne this out, for their endorsements have been, as it were, *autos-da-fe*—enactments of faith—which is perhaps an alternative meaning of "manifesto," with the further implication that whoever does not adhere must be stamped out, like heretics. The heretics impede the advance of history. In terms of critical practice, the result is that when the various art movements do not write their own manifestos, it has been the task of critics to write manifestos for them. Most of the influential art magazines—*Artforum, October, The New Criterion*—are so many manifestos issued serially, dividing the art world into the art that matters and the rest. And typically the critic as manifesto writer cannot praise an artist she or he believes in—Twombly, say—without denouncing another—Motherwell, say. Modernism, overall, was the Age of Manifestos. It is part of the post-historical moment of art history that it is immune to manifestos and requires an altogether critical practice.

I cannot deal further at this point with modernism so construed—the last era of art history before the end of art, the era in which artists and thinkers scrambled to nail down the philosophical truth of art, a problem not truly felt in the previous history of art when it was more or less taken for granted that the nature of art was known, and an activity necessitated by the breakdown of what, since the great work of Thomas Kuhn in systematizing the history of science, has been thought of as a paradigm. The great traditional paradigm of the visual arts had been, in fact, that of mimesis, which served the theoretical purposes of art admirably for several centuries. And it defined, as well, a critical practice quite different from that entailed by modernism, which had to find a new paradigm and to extirpate competing paradigms. The new paradigm, it was supposed, would serve future art as adequately as the paradigm of mimesis had served past art. In the early fifties, Mark Rothko told David Hare that he and his peers were "producing an art that would last for a thousand

years."[12] And it is important to recognize how historical this conception really was: Rothko was not talking about producing works that would last a thousand years—that would stand the test of time—but a *style* that would define artistic production for a thousand years—for as long a period as that specified by the mimetic paradigm. In this spirit Picasso told Gilot that he and Braque were endeavoring to "set up a new order,"[13] one which would do for art what the canon of rules of classical art did, but which broke down, he thought, with the impressionists. That the new order was to be universal was marked by the fact that the paintings of early cubism were anonymous, and hence pointedly anti-individual because unsigned. Of course, this did not last especially. The manifestoed movements of the twentieth century had lifetimes of a few years or even just a few months, as in the case of fauvism. The influence naturally lingered longer, as did that of abstract expressionism, which even today has adherents. But no one today would be prepared to celebrate it as the meaning of history!

The point about the Age of Manifestos is that it brought what it took to be philosophy into the heart of artistic production. To accept the art as art meant accepting the philosophy that enfranchised it, where the philosophy itself consisted in a kind of stipulative definition of the truth of art, as well, often, as a slanted rereading of the history of art as the story of the discovery of that philosophical truth. In that respect my own conception of things has a great deal in common with these theories, with whose implied critical practice my own necessarily differs, but in a way different from that in which they differ from one another. What my theory has in common with them is, first, that it too is grounded in a philosophical theory of art, or better, in a theory as to what the right philosophical question is concerning the nature of art. Mine is also grounded in a reading of the history of art, according to which the question of the right way to think philosophically about history was only possible when history made it possible—when, that is to say, the philosophical nature of art arose as a question from within the history of art itself. The *difference* lies here, though I can only state it schematically at this point: my thought is that the end of art consists in the coming to awareness of the true philosophical nature of art. The thought is altogether Hegelian, and the passage in which Hegel enunciates it is famous:

> Art, considered in its highest vocation, is and remains for us a thing of the past. Thereby it has lost for us genuine truth and life, and has rather been transferred into our *ideas* instead of maintaining its earlier necessity

in reality and occupying its higher place. What is now aroused in us by works of art is not just immediate enjoyment, but our judgment also, since we subject to our intellectual consideration (i) the content of art, and (ii) the work of art's means of presentation, and the appropriateness or inappropriateness of both to one another. The philosophy of art is therefore a greater need in our day than it was in days when art by itself yielded full satisfaction. Art invites us to intellectual consideration, and that not for the purpose of creating art again, but for knowing philosophically what art is.[14]

"In our days" refers to the days in which Hegel delivered his tremendous lectures on fine art, which took place for the last time in Berlin in 1828. And that is a very long time indeed before 1984, when I reached my own version of Hegel's conclusion.

It would certainly seem that the subsequent history of art must have falsified Hegel's prediction—just think of how much art was made after that, and how many different kinds of art, as witness the proliferation of artistic differences in what I have just called the Age of Manifestos. But then, given the question of the status of my prediction, is there then not some grounds for supposing that the same thing that happened with Hegel's startling declaration will happen with mine, which is after all almost a repetition of Hegel's? What would be the status of my prediction if the subsequent century and half were as filled with artistic incident as the period that followed Hegel's? Would it not then be not only false but ignominiously false?

Well, there are many ways of looking at the falsification through subsequent artistic incident of Hegel's thesis. One way is to recognize how different the next period in the history of art was, say from 1828 to 1964. It contained, precisely, the period I have just been characterizing, the period of modernism construed as the Age of Manifestos. But since each manifesto went with another effort to define art philosophically, how different after all is what happened from what Hegel said it would be? Instead of providing "immediate enjoyment," does not almost all of this art appeal not to the senses but to what Hegel here calls judgment, and hence to our philosophical beliefs about what art is? So that it is almost as if the structure of the art world exactly consisted not in "creating art again," but in *creating art explicitly for the purpose of knowing philosophically what art is?* The period from Hegel down, so far as the philosophy of art as practiced by philosophers was concerned, was singularly barren, making of course an exception for Nietzsche, and perhaps for Heidegger, who

argued in the epilogue to his 1950 "The Origins of the Artwork" that it was far too early to say whether Hegel's thought was true or false:

> The judgment that Hegel passes in these statements cannot be evaded by pointing out that since Hegel's lectures in aesthetics were given for the last time in the winter of 1828–1829. . . . we have seen many new art works and art movements arise. Hegel did not mean to deny this possibility. The question however remains: is art still an essential and necessary way in which truth that is decisive for our historical existence happens, or is art no longer of this character?[15]

The philosophy of art after Hegel may have been barren, but art, which was seeking to break through to a philosophical understanding of itself, was very rich: the richness of philosophical speculation, in other words, was one with the richness of artistic production. In the ages before Hegel, nothing like this had occurred at all. There were style wars, of course, between *disegno* and *colorito* in Italy in the sixteenth century, or between the schools of Ingres and of Delacroix in France at around the time of Hegel's discourse. But in the light of the philosophical disputation carried out in the name of artistic imperatives in the modernist period, these differences turned out to be minor and negligible: they were differences over the how of painterly representation, not differences which questioned the entire premiss of representation that disputants took for granted. In New York in the first decade of this century, the great style war was between the Independents, led by Robert Henri, and the academy. The squabble concerned manner and content, but an astute art critic observed in 1911, after seeing an exhibition of Picasso at Stieglitz's Gallery 291, that "the poor Independents must look to their laurels. Already they are back numbers and we shall look soon to see them amalgamate with the much abused old National Academy of Design."[16] Picasso differed from them more radically than the ways they differed from one another: he differed from them in the way that philosophy and art differ. And he differed from Matisse and the surrealists in the way that one philosophical position differs from another. So it is altogether possible to view the history of art subsequent to Hegel's pronouncement as a confirmation rather than a falsification of his prediction.

One possible analogy for the thesis of "end of art" is to be found in Alexandre Kojève's argument that history came to an end in 1806 with Napoleon's victory at the Battle of Jena.[17] By history, of course, he meant the grand narrative Hegel lays out in his book on the philosophy of his-

tory, according to which history is really the history of freedom. And there are definite stages of that historical achievement. What Kojève meant was that Napoleon's victory established the triumph of the values of the French Revolution—liberty, equality, fraternity—in the heartland of aristocratic rule in which only a few were free and inequality defined the political structure of society. In one way, Kojève's thesis sounds insane. So much took place, historically, after Jena: the American Civil War, the two world wars, the rise and then the fall of communism. But these, Kojève insisted, were merely the working through of the establishment of universal freedom—a process that even finally brought Africa into world history. What others would see as a crushing refutation Kojève saw instead as a massive confirmation of the realization in human institutions of freedom as the driving force of history.

Of course, not all the visual art of the post-Hegelian era is philosophical in the way in which manifesto-driven art is. Much of it really does arouse what Hegel termed "immediate enjoyment," by which I understand him to mean enjoyment not mediated by philosophical theory. Much nineteenth-century art—and I am thinking of the impressionists especially, despite the uproar they at first aroused—does give unmediated pleasure. One does not need a philosophy to appreciate the impressionists, simply the subtraction of a misleading philosophy, which prevented their first viewers from seeing them for what they were. Impressionist work is aesthetically pleasing, which explains in part why it is so widely admired by people who are not especially partisans of avant-garde art, and also why it is so expensive: it carries the memory of having outraged the critics, at the same time being so enjoyable that it gives those who collect it a sense of terrific intellectual and critical superiority. But the philosophical point to make is that there are no sharp right angles in history, no stopping, as it were, on a dime. Painters worked in the abstract expressionist style long after the movement came to its end, mainly because they believed in it and felt that it was still valid. Cubism defined an immense amount of twentieth-century painting long after the great period of cubist creativity was over. Theories of art give meaning to artistic activities in the modernist period, even after the theories have played their historical role in the dialogue of manifestos. The mere fact that communism ended as a world-historical movement does not entail that there are no more communists in the world! There are still monarchists in France, and Nazis in Skokie, Illinois, and communists in the jungles of South America.

But similarly, there are still modernist philosophical experiments in art since the end of art, as if modernism had not ended, as indeed it has not in the minds and practices of those who continue to believe in it. But the deep truth of the historical present, it seems to me, lies in the Age of Manifestos being over because the underlying premiss of manifesto-driven art is philosophically indefensible. A manifesto singles out the art it justifies as the true and only art, as if the movement it expresses had made the philosophical discovery of what art essentially is. But the true philosophical discovery, I think, is that there really is no art more true than any other, and that there is no one way art has to be: all art is equally and indifferently art. The mentality that expressed itself in manifestos sought in what it supposed was a philosophical way to distinguish real art from pseudo-art, much as, in certain philosophical movements, the effort was to find a criterion for distinguishing genuine questions from pseudo-questions. Pseudo-questions appear to be genuine and crucial, but they are questions only in the most superficial grammatical sense. In his *Tractatus Logico-Phlosophicus*, for example, Ludwig Wittgenstein wrote that "most propositions and questions that have been written about philosophical matters, are not false but senseless. We cannot, therefore, answer questions of this kind at all, but only state their senselessness."[18] This view was transformed into a battle cry by the logical positivist movement, which vowed the extirpation of all metaphysics through demonstrating its nonsense. It was nonsense, the positivists (though not Wittgenstein) claimed, because it was unverifiable. In their view the only meaningful propositions were those of science, and science was marked by its verifiability. That of course left the question of what philosophy itself was to do, and the truth was that the verifiability criterion inevitably turned against its defenders, dissolving itself as nonsense. For Wittgenstein, philosophy vanished, leaving behind only the activity of demonstrating its senselessness. A parallel position in art would have left as the only meaningful art, because the only art that was essentially art, the monochrome black or white canvas, square and flat and matte, over and over again, as in the heroic vision of Ad Reinhardt. Everything else was not art, difficult as it would have been to know what, if not art, it was. But in the period of competing manifestos, declaring that something was not—was not *really*—art was a standard critical posture. It was matched in the philosophy of my early education by the declaration that something was not—not really—philosophy. The best such critics would allow would be that Nietzsche—or Plato, or Hegel—might have been poets. The best their counterparts in art might allow is that something which

was not really art was illustration, or decoration, or some lesser thing. "Illustrational" and "decorative" were amongst the critical epithets of the Age of Manifestos.

In my view, the question of what art really and essentially is—as against what it apparently, or inessentially is—was the wrong form for the philosophical question to take, and the views I advanced in various essays concerning the end of art endeavor to suggest what the real form of the question should be. As I saw it, the form of the question is: what makes the difference between a work of art and something not a work of art when there is no interesting perceptual difference between them? What awoke me to this was the exhibition of *Brillo Box* sculptures by Andy Warhol in that extraordinary exhibition at the Stable Gallery on East 74th Street in Manhattan in April of 1964. Appearing as those boxes did in what was still the Age of Manifestos they finally did so much to overthrow, there were plenty who then said—who, as remnants of that age still say—that what Warhol had done was not really art. But I was convinced that they were art, and for me the exciting question, the really deep question, was wherein the difference lies between them and the Brillo cartons of the supermarket storeroom, when none of the differences between them can explain the difference between reality and art. All philosophical questions, I have argued, have that form: two outwardly indiscernible things can belong to different, indeed to momentously different, philosophical categories.[19] The most famous example is the one with which the era of modern philosophy itself opens in the First Meditation of Descartes, where he finds that there is no internal mark by which dream and waking experience can be told apart. Kant tries to explain the difference between a moral action and one that exactly resembles it but merely conforms to the principles of morality. Heidegger shows, I think, that there is no outward difference between an authentic and an inauthentic life, however momentous the difference may be between authenticity and inauthenticity. And the list can be extended to the very boundaries of philosophy. Until the twentieth century it was tacitly believed that works of art were always identifiable as such. The philosophical problem now is to explain why they are works of art. With Warhol it becomes clear that there is no special way a work of art must be—it can look like a Brillo box, or it can look like a soup can. But Warhol is but one of a group of artists to have made this profound discovery. The distinction between music and noise, between dance and movement, between literature and mere writing, which were coeval with Warhol's breakthrough, parallel it in every way.

These philosophical discoveries emerged at a certain moment in the history of art, and it strikes me that in a certain way the philosophy of art was hostage to the history of art in that the true form of the philosophical question regarding the nature of art could not have been asked until it was historically possible to ask it—until, that is, it was historically possible for there to be works of art like *Brillo Box*. Until this was an historical possibility, it was not a philosophical one: after all, even philosophers are constrained by what is historically possible. Once the question is brought to consciousness at a certain moment in the historical unfolding of art, a new level of philosophical consciousness has been reached. And it means two things. It means, first, that having brought itself to this level of consciousness, art no longer bears the responsibility for its own philosophical definition. That, rather, is the task of philosophers of art. Second, it means that there is no way works of art need to look, since a philosophical definition of art must be compatible with every kind and order of art—with the pure art of Reinhardt, but also with illustrative and decorative, figurative and abstract, ancient and modern, Eastern and Western, primitive and nonprimitive art, much as these may differ from one another. A philosophical definition has to capture everything and so can exclude nothing. But that finally means that there can be no historical direction art can take from this point on. For the past century, art has been drawing toward a philosophical self-consciousness, and this has been tacitly understood to mean that artists must produce art that embodies the philosophical essence of art. We now can see that this was a wrong understanding, and with a clearer understanding comes the recognition that there is no further direction for the history of art to take. It can be anything artists and patrons want it to be.

Let us return to 1984 and the lessons of that year as against what had been predicted for it in Orwell's shattering novelistic vision of the shape of things to come. The terrifying monolithic states Orwell foresaw were in at least two of the three cases manifesto-driven, and the manifesto was the most celebrated of manifestos, Marx and Engels's *Communist Manifesto*. What the actual year 1984 demonstrated was that the philosophy of history embodied in that document had broken down, and that history was less and less likely to be found embodying the historical laws "working with iron necessity toward inevitable results" of which Marx wrote in his preface to the first edition of *Capital*. Marx and Engels did not really characterize the "inevitable result" of history save negatively, that it would be free of the class conflict that had been the driving force

of history. They felt that history would stop in a sense when class contradictions were all resolved, and that the post-historical period would in a certain sense be utopian. They somewhat gingerly offered a vision of life in the post-historical society in a famous passage in their *German Ideology*. Instead of individuals being forced into "a particular, exclusive sphere of activity," they wrote, "each can become accomplished in any branch he wishes." This "makes it possible for me to do one thing today and another tomorrow, to hunt in the morning, fish in the afternoon, rear cattle in the evening, criticize after dinner, just as I have a mind, without ever becoming hunter, fisherman, shepherd, or critic."[20] In a 1963 interview, Warhol expressed the spirit of this marvelous forecast this way: "How can you say any style is better than another? You ought to be able to be an Abstract Expressionist next week, or a Pop artist, or a realist, without feeling that you have given up something."[21] This is very beautifully put. It is a response to manifesto-driven art, whose practitioners' essential criticism of other art was that it was not the right "style." Warhol is saying that this no longer makes sense: all styles are of equal merit, none "better" than another. Needless to say, this leaves the options of criticism open. It does not entail that all art is equal and indifferently good. It just means that goodness and badness are not matters of belonging to the right style, or falling under the right manifesto.

That is what I mean by the end of art. I mean the end of a certain narrative which has unfolded in art history over the centuries, and which has reached its end in a certain freedom from conflicts of the kind inescapable in the Age of Manifestos. Of course, there are two ways for there to be freedom from conflict. One way is really to eliminate whatever does not fit one's manifesto. Politically, this has its form in ethnic cleansing. When there are no more Tutsis, there will be no conflict between Tutsis and Hutus. When there are no Bosnians left, there will be no conflicts between them and Serbs. The other way is to live together without the need for cleansing, to say what difference does it make what you are, whether Tutsi or Hutu, Bosnian or Serb. The question is what kind of person you are. Moral criticism survives into the age of multiculturalism, as art criticism survives into the age of pluralism.

To what degree is my prediction borne out in the actual practice of art? Well, look around you. How wonderful it would be to believe that the pluralistic art world of the historical present is a harbinger of political things to come!

NOTES

1. South Africa sponsored its first biennial in 1995, the centennial year of the first Venice Biennale. But it was invited to participate in the 1993 Venice Biennale for the first time since adopting its repugnant political system. Invitations to exhibit have the same meaning in the code of national morality that sponsoring biennials does.

2. I call such descriptions *narrative sentences*—sentences that describe an event with reference to a later event of which those contemporary with the first event could not have known. Examples of narrative sentences, as well as their analysis, can be found in my *Analytical Philosophy of History* (Cambridge: Cambridge University Press, 1965).

3. "If the principal rupture in this century's art was indeed that of cubism, this break was probably not made by the *Demoiselles d'Avignon* nor by analytical cubism, but in the collusion between the Grebo mask and the *Guitar*" (Yves-Alain Bois, *Painting as Model* [Cambridge: MIT Press, 1990], 79).

4. I have sought to demonstrate this philosophically in *The Transfiguration of the Commonplace* (Cambridge: Harvard University Press, 1981), chap. 4; and in *The Philosophical Disenfanchisement of Art* (New York: Columbia University Press, 1986), chap. 2.

5. And of course, there have been plenty of exhibitions of art made before the end of art.

6. G. W. F. Hegel, *The Philosophy of History*, trans. J. Sibree (New York: Wiley Book Co., 1944), 99.

7. *Malevich* (Los Angeles: Armand Hammer Museum of Art and Cultural Center, 1990), 8.

8. Piet Mondrian, "Essay, 1937," in *Modern Arts Criticism* (Detroit: Gale Research Inc., 1994), 137.

9. Greenberg, *The Collected Essays and Criticism*, 1:37.

10. *Art-as-Art: The Selected Writings of Ad Reinhardt*, ed. Barbara Rose (Berkeley and Los Angeles: University of California Press, 1991), 53.

11. Françoise Gilot and Carleton Lake, *Life with Picasso* (New York: Avon Books, 1964), 69.

12. James Breslin, *Mark Rothko: A Biography* (Chicago: University of Chicago Press, 1993), 431.

13. Gilot and Lake, *Life with Picasso*, 69.

14. Hegel, *Aesthetics*, 11.

15. Martin Heidegger, "The Origin of the Artwork," trans. Albert Hofstadter, in Albert Hofstadter and Richard Kuhns, *Philosophies of Art and Beauty* (Chicago: University of Chicago Press, 1964), 701–703.

16. Steven Watson, *Strange Bedfellows: The First American Avant-Garde* (New York: Abbeville Press, 1991), 84.

17. Alexandre Kojève, *Introduction à la lecture de Hegel*, 2d ed. (Paris: Gallimard, 1968), 436n; trans. J. H. Nichols, Jr., *Introduction to the Reading of Hegel* (New York: Basic Books, 1969), 160ff.

18. Ludwig Wittgenstein, *Tractatus Logico-Philosophicus* (London: Routledge and Kegan Paul, 1933), proposition 4.003. The abusive "pseudo-question" was standard in logical positivist discourse, as was "pseudo-statement," which appears in Rudolph Carnap's "The Elimination of Metaphysics through Logical Analysis of Language," trans. Arthur Pap, in A. J. Ayer, *Logical Positivism* (Glencoe, Ill.: Free Press, 1959), 61 and passim.

19. I develop this concept at length in my *Connections to the World: The Basic Concepts of Philosophy* (New York: Harper and Row, 1989).

20. Karl Marx and Friedrich Engels, "The German Ideology," in Robert C. Tucker, ed., *The Marx-Engels Reader* (New York: W. W. Norton, 1978), 160.

21. G. R. Swenson, "What Is Pop Art?: Answers from 8 Painters, Part 1," *Art News* 64 (November 1963), 26.

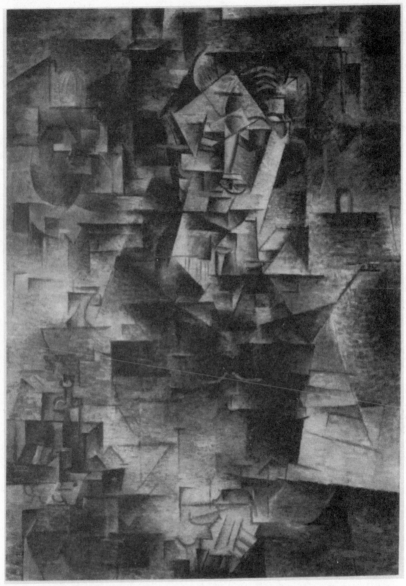

■ ■ ■ ■ ■ CHAPTER THREE

Master Narratives and
Critical Principles

THE STORY of anyone's life is never the simple unfolding through time of an internally programmed narrative, even if it exhibits what one might call a standard episodic structure—for example, Shakespeare's "seven ages of man." What makes biography worth writing and reading are the accidents, the intersection of crossed causal histories that produce events not strictly predictable from either chain. Thus we say, "As chance would have it, I did not go out for lunch that day," or, "On an impulse, I decided to stop into the bookstore on my way downtown." And in both cases something happened of immense importance to the speaker's life which might never have taken place and never even have been imagined. Now someone might ask me to put next to my story of how I came to be an art critic the story of how, in my view, art came to an end, and then go on to ask how, if the former story seems to pivot on an element of utter chance and complete unpredictability, at least from within the boundaries of my life-story considered internally, I can say with any confidence that the story of art is over and that no matter of chance is possible which might lead to a continuation of the story of art along lines now as unpredictable as my own story proved to be. The objection might go further and insist that art is almost paradigmatically unpredictable, the very embodiment of human freedom and creativity. Picasso painted *La famille des saltimbanques* in 1905, but who, including Picasso himself, could have believed that just over a year later he would do something as strictly unimaginable in 1905 as *Les demoiselles d'Avignon* was to be? Who in 1955, when abstract expressionism was at the flood, could have predicted it would be fundamentally over as a movement in 1962 and replaced by something, pop art, which, while imaginable in one sense because its objects were so familiar, would not have then been imaginable *as art*? For that matter, who, in the time of Giotto, could have predicted the art of Masaccio? Certainly, Giotto could not have, or, one

feels, he would already have found a way of using what we credit Masaccio with having discovered. Indeed, if he had been able to predict the perspectival devices so central to Masaccio's representation of the world and *not* have used them, then we would be obliged to see his own work very differently from the way we in fact see it. It would now exemplify an artistic choice, and involve an artistic rejection. Giotto's case would parallel that of the Chinese artists of the Qing dynasty who knew about perspective from the missionary painter Father Castiglione, but who felt that there was no room in their artistic agenda for its assimilation. But this meant that the structure of Chinese paintings, now a matter of choice since there were clear, known alternatives to it, had become a deliberate manner.

After all, perspective would not be the kind of thing one could predict would be discovered without ipso facto knowing how to do it. There was a time when someone could predict that human beings would someday be able to land on the moon, without knowing what technologies would be required in order to do this. With perspective, by contrast, just knowing what one was predicting would be to have it already available if one cared to use it. As Confucius cleverly observes, just to want to be moral is already to have taken the first step.[1] Nor would one be able, I think, to say that like the Chinese, Giotto would have had no use for the discovery, not if we are at all right in thinking of him as "the father of naturalism." Had someone in the days of high abstract expressionism predicted that one day artists would be painting soup cans and Brillo boxes, the knowledge would not have been usable at the time the prediction was made, just because there really was no room, or in any case not a great deal of room, for a precocious assimilation into the art of the New York School of the strategies of pop. Motherwell, to be sure, used torn labels from Gauloises packages in his collages at least as early as 1956, but I would hesitate classing this as anticipatory pop: it is, rather, late *Merzbild*, and belongs to an altogether different artistic impulse. Motherwell, aesthetically and sentimentally, loved Gauloise *bleu*, but he had little use for pop art when it emerged: he did not see it as fulfilling an agenda he had begun, nor did the practitioners of pop regard him as a predecessor. David Hockney's early paintings, which Lawrence Alloway had specifically in mind when he coined the expression "pop art," have a certain outward resemblance to the Gauloise collages of Motherwell, since he uses the Alka-Selzer logo (probably as a jokey emblem for heartburn and hence the burning heart he pictures in "The Most Beautiful Boy"), but they belong to different historical structures and carry different meanings

and fulfill different intentions. The artist who calls himself simply "Jess" turns up in almost every history of pop art because of his altered Dick Tracy comic strips, but when we see these in the context of his program of collages, we recognize that his impulses were as remote from pop as Motherwell's were. One cannot establish historical affinities on the basis of resemblances, and it is one task of these lectures to identify something of the logic of the kinds of historical structures to which I am tacitly appealing in making such claims.

I shall be obliged to do that in any case, if only for reasons of systematic consistency. The claim that art has ended really is a claim about the future—not that there will be no more art, but that such art as there will be is art after the end of art, or, as I have already termed it, *post-historical art*. But in my first serious philosophical work, *Analytical Philosophy of History*, I argued that it was certain claims about the future which render what I there termed substantive philosophies of history illegitimate. Those claims tended to treat history as if it were an objective story, only part of which has been disclosed, and that the substantive philosopher of history, as it were, claims some kind of cognitive privilege—claims to have looked at the end of the book to see how it is going to come out, like readers unable to stand the suspense. This of course is prophecy rather than prediction, as Sir Karl Popper so usefully distinguished these for us—and of course the prophet himself would acknowledge the distinction, without at all feeling defeated by it: his claim is based not on some grounded prediction of things to come, but on a revelation of how they will end. Is my claim about the future a prediction? Or a prophecy? And what makes it legitimate if substantative philosophies of history are illegitimate? Well, I must say that I am likely today to take a more charitable view of substantive philosophies of history than I would have done in 1965, when my book was written in the late stages of high positivism. But that is because it has seemed more and more plausible to me that there are objective historical structures—objective in the sense that, to use the example just cited, there was no objective possibility that the works which Motherwell's Gauloises collages later resembled could have fit into the historical structure to which those works of Motherwell belonged, and no way in which the latter could have fit into the historical structures defined by pop. The earlier historical structure defined a closed range of possibilities from which the possibilities of the latter structure were excluded. So it is as if the former structure were replaced by the latter structure—as if a range of possibilities opened up for which there had been no room in the earlier structure, and hence, again, as if there were

a kind of discontinuity between the two structures, a discontinuity sufficiently abrupt that someone living through the change from the one to the other might feel that a world—in our case an art world—had come to an end and another one begun. And that means, philosophically, there is a problem in analyzing both historical continuity and historical discontinuity. In the first instance there is the problem of what is continuous in a period of continuity, which immediately yields an answer to the question what changes when discontinuity takes place. One natural candidate for the answer would be *a style*. This takes me well ahead of my story, but in the loose and tentative way in which I have introduced the idea, one mark of art having ended is that there should no longer be an objective structure with a defining style, or, if you prefer, that there should be an objective historical structure in which *everything is possible*. If everything is possible, nothing is historically mandated: one thing is, so to say, as good as another. And that in my view is the objective condition for post-historical art. There is nothing to be replaced: one can, to return to Warhol's phrase, be an abstract expressionist, or a pop artist, or a realist, or anything else. And that is pretty much the end-of-history condition Marx and Engels described in *The German Ideology*.

In the foreword to the sixth edition of his *Principles of Art History* of 1922, Heinrich Wölfflin wrote:

> Even the most original talent cannot proceed beyond certain limits which are fixed for it by the date of its birth. Not everything is possible at all times, and certain thoughts can only be thought at certain stages of the development.[2]

Strikingly, Matisse said very much the same thing in one of his conversations with Teriade:

> The arts have a development which comes not only from the individual, but also from an accumulated strength, the civilization, which precedes us. One cannot just do anything. A talented artist cannot do just as he likes. If he used only his talents, he would not exist. We are not the masters of what we produce. It is imposed upon us.[3]

This is no less true today than it ever was: we live and produce within the horizon of a closed historical period. Some of the limitations are technical: one cannot produce easel paintings before the easel painting is invented. One cannot make computer art before the invention of the computer. In speaking of the end of art, I am not foreclosing the possibility of undreamt of technologies that will put at the disposition of artists the

same range of creative possibilities the easel painting and the computer exemplify. How, seriously, could I? And some of the limitations are stylistic: it was possible, in 1890, if you were an African artist, to produce masks and fetishes in forms not available to the European artist just because, in Wölfflin's sense, it was not possible to be a European artist if one produced masks and fetishes. One had to fit into a closed system of possibilities, different from the possibilities which excluded an African artist from painting easel pictures, just because the technology was unknown, say, to the Baule in 1890. Today one can be an American or a European artist who makes masks and fetishes, as one can be an African artist who paints perspective landscapes. In the sense that certain things were not possible for a European or an African in 1890, everything is possible today. Still, we are locked into history. We cannot have the system of exclusionary beliefs that prevented artists in Europe from making masks and fetishes. We cannot be such a European for the same reason that such a European could not have been an African. But there are no forms today that are forbidden us. All that is forbidden us is that they should have the kind of meaning they had when they were forbidden us. But these are limitations well lost. It is no limit on the idea of freedom that we are not free to be prisoners!

In both conditions—the end of history and the end of art—there is a state of freedom in two senses of the term. Human beings, in Marx and Engels's picture, are free to be what they want to be, and they are free from a certain historical agony which mandates that at any given stage there is an authentic and an inauthentic mode of being, the former pointing to the future and the latter to the past. And artists, at the end of art, are similarly free to be what they want to be—are free to be anything or even to be everything, as with certain artists I take to exemplfy the present moment in art to perfection: Sigmar Polke, Gerhard Richter, Rosemarie Trockel, Bruce Nauman, Sherrie Levine, Komar and Melamid, and any number of others who refuse to be bounded by the limits of a genre—who have rejected a certain ideal of *purity*. They would correspond in a way to academics who refuse to be limited by a parallel sense of disciplinary purity, and whose work takes them across the lines professionalism has drawn. And artists are free as well from the kind of historical prejudice pitching some historically favored form—abstraction in the most developed philosophy of art history—against a form which belongs to an outworn past—naturalism, say. They no longer need to believe, like Mondrian, that there is only one true form for art to practice at any given moment. The difference between the Marxian

prophecy and mine is that the condition of unalienated human life Marx but sketched lay in some distant historical future. Mine is what one might call a *prophecy of the present*. It sees the present, so to speak, as revealed. My only claim on the future is that this *is* the end state, the conclusion of an historical process whose structure it all at once renders visible. So it is, after all, very like looking at the end of the story to see how it came out, with this difference: we have not skipped anything, but have lived through the historical sequences which led us here: that this is the end of the story of art. And in particular what is required is some demonstration that this really is an end state and not a stage on the way to a future as yet undreamt of. This returns me to the matter of objective historical structures, with their ranges of possibilities and impossibilities, and the concomitant matter of style.

I am going to use the word style in a somewhat eccentric way in order to get my story told. I shall use it this way: a style is a set of properties a body of artworks share, but which is further taken to define, philosophically, what it is to be an artwork. For an extended historical period, it was taken for granted that to be an artwork, especially a work of visual art, was to be mimetic: to imitate an external reality, actual or possible. No doubt this was but a necessary condition, inasmuch as there were mimetic representations—mirror images, shadows, reflections in water, the imprinted face of Jesus on Veronica's veil, the imprinted body of Christ on the Shroud of Turin, simple snapshots after the invention of photography, and doubtless many others not worth going into here—which were not artworks. "Imitation" was the standard philosophical answer to the question of what art is from Aristotle down into the nineteenth century, and well into the twentieth. Hence mimesis, on my use, is a style. In the period in which it defined what it was to be art, there was no other style in this sense. Mimesis became *a* style with the advent of modernism, or, as I termed it, the Age of Manifestos. Each of these manifestos sought to find a new philosophical definition of art, so cast as to capture the art in question. And, because there were so many definitions in this age, it was inevitable that these should be urged with a certain dogmatism and intolerance. Mimesis did not become ideologized until the age of modernism, but certainly those who after that subscribed to it were prepared to dismiss *as not art at all* the paradigmatic works of modernism. The Age of Manifestos, as I see it, came to an end when philosophy was separated from style because the true form of the question "What is art?" emerged. That took place roughly around 1964. Once it was determined that a philosophical definition of art entails no stylistic imperative whatever,

so that anything can be a work of art, we enter what I am terming the post-historical period.

Thus sketched, the master narrative of the history of art—in the West but by the end not in the West alone—is that there is an era of imitation, followed by an era of ideology, followed by our post-historical era in which, with qualification, anything goes. Each of these periods is characterized by a different structure of art criticism. Art criticism in the traditional or mimetic period was based on visual truth. The structure of art criticism in the age of ideology is the one from which I sought to disengage myself: it characteristically grounded its own philosophical idea of what art is on an exclusionary distinction between the art it accepted (the true) and everything else as not really art. The post-historical period is marked by the parting of the ways between philosophy and art, which means that art criticism in the post-historical period must be as pluralistic as post-historical art itself. It is quite striking that this tripartite periodization corresponds, almost uncannily, to Hegel's stupendous political narrative in which, first only one was free, then only some were free, then, finally, in his own era, everyone was free. In our narrative, at first only mimesis was art, then several things were art but each tried to extinquish its competitors, and then, finally, it became apparent that there were no stylistic or philosophical constraints. There is no special way works of art have to be. And that is the present and, I should say, the final moment in the master narrative. It is the end of the story.

Often, since my first reflections on the end of art were published, philosophers have sought to counter the thesis by observing, on whatever empirical grounds, that the propensity of human beings to express themselves through making art is inextinguishable, and that, in that sense, art is "everlasting."[4] There would be no incompatibility between the thesis of the everlastingness of art and the thesis that art has ended, for the latter is a story about stories: the story of art in the West is in part the story of different stories rather than merely the sequential appearance of works of art over time. It is quite possible that human beings will always express joy or loss through dance and song, that they will ornament themselves and their dwellings, or that they will always mark with rituals that verge on art the momentous stages of life—birth, the passing into adulthood, marriage, and death. And it may perhaps be true that with any degree of the division of labor, there will emerge some who will provide these services because of natural aptitude and become the group's artists. There may even be theories of art to account for the importance art is perceived to have in the common course of things. I have nothing to say

about this at all. Mine is not a theory of the "origins of the artwork," to use Heidegger's phrase, but of the historical structures, the narrative templates, so to speak, within which artworks are organized over time, and which enter into the motivations and attitudes of artists and audience who have internalized these templates. My thesis is, rather, akin (but only akin) to that of a spokesman for the so-called Generation X, who said of his peers that "they have no narrative structure to their lives," and then, after listing some of these, went on to say, "All these narrative templates have eroded."[5] The narrative structures of traditional representational art, and then of modernist art, have eroded in at least the sense that they have no longer an active role to play in the production of contemporary art. Art today is produced in an art world unstructured by any master narrative at all, though of course there remains in artistic consciousness the knowledge of the narratives that no longer apply. Artists today are at the end of a history in which those narrative structures have played a role, and thus they have to be distinguished from the artists I have somewhat sentimentally imagined who first emerge as specialists in the early division of labor which enable gifted individuals to take on the aesthetic responsibilities of society: to dance at marriages, sing at funerals, and decorate the spaces in which the members of the tribe commune with spirits.

With this, I return to my own narrative, and begin with the first great story of art, namely Vasari's, according to which art was the progressive conquest of visual appearances, of mastering strategies through which the effect of the visual surfaces of the world on the visual system of human beings could be replicated by means of painting surfaces that affect the visual system in just the way the world's visual surfaces affect it. It was this story that Sir Ernst Gombrich sought to explain in his important text *Art and Illusion*. Now Vasari's book was titled the *Lives of the Most Eminent Painters, Sculptors, and Architects*, but in terms of its epic theme, it is the painters who create the history. Architecture is not easily regarded as a mimetic art, and though a case could be made that Renaissance architecture sought to emulate classical architecture, this is the wrong kind of imitation to bring architecture and painting into parallel with one another. That kind of imitation, rather, would mark the history of painting in China, where artists sought to imitate the ancients, rather than, as in the Renaissance, to advance beyond the ancients by making better pictures, judged by the criterion of better matches to an external reality. It is painting, by and large, of which Gombrich's model is true, the model of "making and matching," which explains progress in

terms of doing better than one's predecessors what those predecessors themselves sought to do, namely "capture" reality on a painted or drawn surface. That model serves not at all for architecture, though it could conceivably serve for sculpture (Cellini argued that drawing consists in showing the boundaries of sculpture, and that painting is but colored drawing, so that sculpture is the basic agency of progress).[6] Still, sculpture already has what painting has to achieve, namely, objects in real or physical space as well as real lights and shadows. But there is still a sculptural need for discoveries like perspective and chiaroscuro, and even foreshortening, as well as for physiognomy, broadly speaking, and anatomy, once the imperative of illusion applies. Taking Gombrich's account at face value, the progress is possible mainly because there are two components, one manual and the other perceptual. It is the latter which reveals discrepancies in representational adequacy, and it is important to take account of the fact that perception itself undergoes relatively little change over the period in question—let's say from about 1300 to 1900—otherwise there would be no possibility of progress: the progress has to be in representations that look more and more like visual reality, and hence is a matter of painters handing down their craft from generation to generation. We don't in that sense hand down how we have learned to see, because we haven't learned anything new to hand down: the perceptual system is importantly impenetrable to cognition. Of course, we certainly learn new things about what we are seeing, and we learn to see new things, without this in any way entailing that seeing itself is something subject to change, for seeing is a lot more like digesting than it is like believing. Hence the thesis often attributed to Gombrich, namely that "perception has a history," needs to be carefully distinguished from his true topic, namely, "why representational art has a history" (which he sometimes elides into "why art has a history").[7] As I see it, the history of the art of painting is the history of the art of making, which in the Vasarian period was pretty much governed by perceptual truth, which did not change from one end of the period to the other, though the art of making clearly did.

Gombrich sees the history of art as rather parallel to the history of science as construed by his colleague and countryman Sir Karl Popper. Popper's view of science is that it involves the rejection of one theory in favor of another because the first has been falsified, and the sequence of conjectures, falsifications, and further conjectures is very like Gombrich's sequence of representational schemata rejected in favor of more adequate ones on the grounds of mismatch with visual reality. And just as

science does not derive its hypotheses by induction from observations, but by a creative intuition which is *then* checked against observation,[8] so the artist, Gombrich contends, "begins not with his visual impression but with his idea or concept."[9] And this is checked against reality and adjusted step by step until a satisfactory match is found. "Making comes before matching"[10] in pictorial representation as theory comes before observation in scientific representation. Both theorists are concerned with what Popper speaks of as the "growth" of knowledge, and hence with an historical process representable via a narrative.

But the difference is that the representations in science themselves progress, themselves get increasingly adequate, not by virtue of matching perceived reality—to which they may not even finally be analogous—but by passing the falsification tests. Gombrich at one point speaks of the pictures on the sides of cereal boxes, which would have caused Giotto's contemporaries to gasp, so far would they have been beyond the power of the best artists of the time to capture them.[11] It would be like the Virgin taking pity on Saint Luke and manifesting herself on the panel on which he had at best been able to set down a wooden "likeness." How to *make* an image that convincing was something Saint Luke could not have known. But he knew that it was convincing: his eyes did not have to be taught *that*. He lacked the art of convincing image making. But he had as much of the "art" of perception as he or anyone would ever have. Gombrich himself cites a wonderful piece of perceptual wisdom from Plato's *The Greater Hippias*: "our sculptors say that if Daidalos were born today and created such works as those that made him famous, he would be laughed at."[12] The same people who laughed at the reincarnate Daidalos would laugh at someone who found his archaic effigies convincing. The assumption would be that such a person had not yet seen Praxiteles's work, not that his perceptual system was as undeveloped as Daidalos's mimetic skills; shown both artists' works, anyone would see the difference immediately, and without special education. There is nothing in science, I think, that plays the role the visual system does in art. So in science there is not just a progress in the art. There is a progress in the representations, which need not, except at the peripheries, connect with experience. The world science tells us about is not at all required to *match* the world our senses reveal. But that was the entire point of the history of Vasarian painting.

Painting as an art, then, to use the expression of my colleague Richard Wollheim, at least under the Vasarian narrative, is a system of learned strategies for making more and more adequate representations, judged

by unchanged perceptual criteria. It was this model of painting that immediately led people to say of modernist painting that it was not art. It really wasn't, as the term had been understood. And the spontaneous response was that modernist painters really had not mastered art—did not know how to paint—or that they did know how to paint but were addressing an unfamiliar visual reality. This was one of the responses to abstract painting, and interestingly it was one congenial to Gombrich: one had to imagine a new visual reality for the painting to represent. These efforts testify to the great power of the Vasarian model, and of course, of its overall mimetic premises. They served to preserve the model, very much as if it were a scientific model one could not readily imagine abandoning, and ways then had to be found for explaining away art that failed to fit it. It is striking that these efforts were in the form of criticisms, and it is worth dwelling briefly on the kind of critical principles the Vasarian model in fact generates.

For Vasari, critical praise consists in claiming, sometimes against all evidence, that the painting in question so exactly resembled reality that one would believe one was in the presence of reality. Of the *Mona Lisa*, for example—a painting there is strong reason for believing he never saw—he wrote, "The nose, with its beautiful and delicately roseate nostrils, might be easily believed to be alive . . . the carnation of the cheeks does not appear to be painted, but truly of flesh and blood; he who looks earnestly at the pit of the throat cannot but believe he sees the beating of the pulses."[13] But Vasari used the same formula in praising Giotto: "Among other figures," he writes of the fresco cycle in Assisi, "that of a thirsty man stooping to drink from a fountain, is worthy of perpetual praise: the eager desire with which he bends toward the water is portrayed with such marvelous effect, that one could almost believe him to be a living man actually drinking."[14] Dispraise, in the nature of the case, is representation one would *not* be disposed to believe was actual rather than depicted. And usually that sort of dispraise would be available only when the art of painting had been advanced beyond that which prevailed when a given earlier level was in force. I have often used Guercino's marvelous painting of Saint Luke displaying his own painting of the Mother and Holy Child to make this kind of point. Guercino was enough of an art historian to know that representations have a history, and that Saint Luke could hardly have known how to paint with the exact verisimilitude available to a seventeenth-century master. So the image Saint Luke displays so proudly is executed by Guercino in what he takes to be an archaic style. Wooden as the image is, an angel in Guercino's painting

is sufficiently compelled by its realism—laughable, almost, when compared with that of Guercino himself—that he (or she) reflexively reaches out to touch the Virgin's garment. But if the angel could step outside the painting and contrast what Saint Luke is capable of with what Guercino is, she (or he) would know the limits under which an artist of Saint Luke's time had to struggle to get a likeness, so far as this was at all relevant to an artist then working. Hans Belting, for example, has instructed us in how little relevant to the power of images of the Virgin representational adequacy actually was. But in any case, there would be scant inclination, from the stage occupied by Guercino, to say of the Virgin as depicted by Saint Luke that you could almost see her breathing (as my brother recently said of a cheerleader by Duane Hanson he encountered in a gallery). So Vasari is being extremely charitable to Giotto, or Giotto has in the instances at hand transcended the schemata that defined his stage in the progressive history of painting.

But the criticisms I have indicated—that the artists did not know how to paint, or that they were trying to shock—are of a different order. They are defending rather than applying the Vasarian model since there is no other model at hand. The artists are not trying to paint and failing. They are violating the rules of painting altogether, and it is surely the mark of something profound having happened in the history of art that Vasari would never have had occasion to deal with issues of this sort. Nor would anyone, really, before the advent of modernism have had occasion to do so.

What interests me more than these efforts to save a narrative are endeavors to tell a new kind of story in acknowledgment, one might say, of a new kind of reality. Roger Fry's preface to the 1912 catalog of the Second Post-Impressionist Exhibition at the Grafton Galleries London, begins: "When the first Post-Impressionist Exhibition was held in these galleries two years ago the English public became for the first time fully aware of the existence of a new movement in art, a movement which was the more disconcerting in that it was no mere variation upon accepted themes but implied a reconsideration of the very purpose and aim as well as the methods of pictorial and plastic art." Fry noted that "accusations of clumsiness and incapacity were freely made" by a public "which had come to admire above everything in a picture the skill with which the artist produced illusion [and which] resented an art in which such skill was completely subordinated to the direct expression of feeling." And it was his view, in 1912, that the artists shown were "attempting to express by pictorial and plastic form certain spiritual experiences." Thus the art-

ists "do not seek to imitate form, but to create form; not to imitate life, but to find an equivalent for life. . . . In fact, they aim not at illusion but at reality."[15] Under such claims it was important, typically, to establish two things: that the artist could draw, if he cared to, so that the work in question was not *faute de mieux*, and that the artist was *sincere*. These were issues of a kind which had no special application in the previous six hundred years of Western art. And beyond that Fry had to find a way of enfranchising the work of Rousseau, who clearly could not draw in the accepted sense of the term but who had gained the great admiration of artists who could.

It is impossible too greatly to admire Fry for endeavoring to find a new model for art which clearly was not endeavoring to prolong the Vasarian history, but it is no less to his credit that he saw it necessary to rise to a level of generality which would enable him to survey and to respond critically to art of both periods, and even to suggest that there were principles that the new art embodied more perfectly than the kind of art that had, irrelevantly it turns out, been admired for the kinds of reasons Vasari gave. Toward the end of his text, Fry characterizes the new French art as "markedly classical." By this he means that it answers to "a disinterestedly passionate state of mind." And one cannot help hearing the echo of Kantian aesthetics here, all the more so in that this "disembodied functioning of the spirit," as he puts it, is "completely free and pure, with no tincture of practicality." This "classical spirit is common to the best French work of all periods from the twelfth century," Fry claims, shifting the center of artistic gravity away from Italy. "Though no one could find direct reminiscences of a Nicholas Poussin here, his spirit seems to revive in the work of artists like Derain." It is clear that Fry's critical program will differ from Vasari's—it will be formalist, spiritual, aesthetic. But like Vasari, a single critical approach will apply throughout the history of art. It will be superior to Vasari's in that Fry's aestheticism can, as Vasari's illusionism cannot, accommodate the art of the French post-impressionists. Fry has a story, and possibly a progressive story to tell: the French post-impressionists may, especially in view of the nonnarrative character of their art, consisting as it did primarily of landscapes and still lifes, have found a way of presenting the classical spirit in its purest form. And the history of art is the slow stripping away of whatever is inessential until what is essential to art shines forth for those prepared to receive it. Fry is not hesitant, however, but eager to identify classicism, which defines the art he especially admires, with the essence of art itself, leaving it a serious problem what to do with art that is *not* "French." He is able

to explain how the art he admires is art despite its not doing what had been expected of art, by insisting that what had been expected of art was in the end not essential to art at all. But that leaves pretty much everything in the Vasarian epic cast into outer darkness unless it can somehow be thought of as "classical." Unless, that is, it is thoroughly aestheticized. Whatever the case, Fry's was a powerful counterresponse to the effort to discount modern art as inept or perverse, and was thus among the first theories to try to connect modernism with traditional art under a new narrative.

The inessentiality of imitation is argued for in Fry's catalog essay through the fact that a work of visual art is thinkable which does not imitate at all. Kandinsky is credited with having invented abstract art in 1910, two years before the exhibition at the Grafton Galleries, and while it is difficult to know with what velocity art news traveled in those years, Fry uses the term "abstraction." He speaks, abstractly as it were, of the "attempt to give up all resemblance to natural form, and to create a purely abstract language of form—a visual music," and he proposes that "the later works of Picasso" at least show this possibility. Fry is unclear whether such abstraction is successful, and it is instructive that he should write that "this can only be decided when our sensibilities to such abstract forms have been more practiced than they are at present." Note that perceptual matching, which does not have to be learned, has been replaced with mastering a language, which does. It is not clear that Fry in fact did master the "language." When, in 1913, he saw Kandinsky's painting *Improvisation 30 (Cannons)*, he claimed it was "pure visual music. . . . I cannot any longer doubt the possibility of emotional expression by such abstract visual signs."[16] Fry simply ignored the weapons that give the painting its parenthetical subtitle.

The concept of a "language," which may have been a poetic metaphor in Fry, was put forward as a seriously literal theory by one of the first theoreticians of cubism, Daniel-Henry Kahnweiler, in a text of 1915: "A new manner of expression, a new 'style' in the fine arts, often appears illegible—as impressionism in its time and now cubism: the unaccustomed optical impulses do not evoke memory images in some viewers because there is no formation of associations until finally the 'writing,' which initially appeared strange, becomes a habit and, after frequently seeing such pictures, the associations are finally made."[17] It is possibly an insight to think of cubism as a language, or, better, as a kind of "writing"—a suggestion altogether congenial to the poststructuralist mentality nourished on Jacques Derrida's concept of *ecriture*. The difficulty

with it is that Kahnweiler appears to treat *all* styles as forms of writing, in particular the impressionist style, and argues by analogy that with practice cubism will become as legible to us as impressionism. In truth, this has not happened. I think that while we have become habituated to cubism in one sense (the cubist landscape, portrait, or still life is common museum stock), and while nobody has great difficulty in "reading" cubist pictures, they have resisted becoming as transparent as a language with whose writing we are familiar. Picasso's portrait of Kahnweiler has not succeeded in looking, as it were, photographic. Familiarity has not made it natural at all. Fry's and Kahnweiler's theories really conjure up an image of someone acquiring fluency in reading a difficult language, hence the reference to "practice." But no one today has to practice in order to read impressionist canvases: they look altogether natural, and that is because they are altogether natural. Impressionism is, after all, a continuation of the Vasarian agenda; it is concerned with the conquest of visual appearances, with natural differences between light and shade.

The post-impressionists no longer generate outrage, but they look no more natural than cubist paintings do. Familiarity has not reduced the differences between them and paintings of the Vasarian tradition. But one has to honor those pioneer thinkers who sought to reduce that difference by rethinking art of the tradition, and addressing it by other than illusionistic criteria. Of course the reception of modern art did not always involve the effort to bring the new art under some sort of explanatory theory of the kind we find in Fry's and in Kahnweiler's work. People became enthusiasts for it without feeling the need to frame an enfranchising theory. Here is a contemporary response to the Salon d'Automne of 1905 by Etta and Claribel Cone:

> We now come to the most stupefying gallery in this Salon so rich in astonishment. Here all description, all reporting as well as all criticism become equally impossible since what is presented to us here—apart from the material employed—has nothing whatever to do with painting: some formless confusion of colors: blue, red, yellow, green: some splotches of pigment crudely juxtaposed: the barbaric and naïve sport of a child who plays with the box of colors he just got as a Christmas present. . . . this choice gallery of pictorial aberration, of color madness, of unspeakable fantasies produced by people who, if they are not up to some game, ought to be sent back to school.[18]

I draw attention to the "has nothing whatever to do with painting" in this passage, and to the fact that the expression of indignation is exactly that

emitted by visitors to the exhibition of post-impressionists Fry describes in his essay. Here, by the way, is a confirming patch of critical prose aroused by the very show so creatively responded to by Fry:

> Nothing but the gross puerility which scrawls indecencies on the walls of a privy. The drawing is on the level of an untaught child, the sense of colour that of a tea-tray painter, the method that of a schoolboy who wipes his fingers on a slate after spitting on them. They are works of idleness and impotent stupidity, a pornographic show.

This bluster, the prose equivalent of actual defacing, was written by a poet, Wilfred Scawen Blunt, to a show made up of Cézanne, Van Gogh, Matisse, and Picasso, but it was a standard reflex to say (as he does) that "the exhibition is either an extremely bad joke or a swindle."[19] The *Munchner Neueste Nachrichten* had this to say of the exhibition of the New Artists' Association in Munich in 1909: "There are only two possible ways to explain this absurd exhibition: either one assumes that the majority of the members and guests of the Association are incurably insane, or else that one deals here with brazen bluffers who know the desire for sensation of our time only too well and are tryng to make use of the boom."[20] I do not know whether, like the Cone sisters and Gertrude Stein, Blunt lived through a transformation of aesthetic consciousness to become an enthusiast for the works that moved him to such singular indignation, but I rather doubt it. "I am old enough to remember the pre-Raphaelite pictures in the Royal Academy of 1857 and 1858," he wrote, and the exhibition at the Grafton Galleries was half a century later. Nor am I clear that the Cones's transformation was accompanied by a new way of thinking about painting of the kind that Fry undertook to develop. They simply adapted to a new artistic reality and learned how to respond to it aesthetically once they abandoned the theories that disqualified these works as painting in the first place, even if they had no new theories to put in place. It is always possible to adjust in this way, to learn to respond sensitively and with discrimination to works nothing in one experience especially prepared one for. For someone whose interaction with art is of this order, a theory about the end of art makes no sense at all: one continues adjusting and responding to whatever comes along, without benefit of theory. In the 1980s a great many collected art because it was art, without anything like an empowering definition of what made it art or why it was important.

At some level, Fry and Kahnweiler must have been of this sort as well, responding pretheoretically, so to speak, to work that struck them as

powerful and important, even if it violated every principle they must have accepted. For that matter, the painters who made the art in question probably did so with no clear sense of what they were after, or why they produced work they had to know would produce the kinds of revulsion I have illustrated. What our two theorists undertook to do was to fill in a blank in practice, to explain to artist and audience alike what was taking place, and to impose a new narrative template. In both cases, it seems to me, the effort was to soften the differences, to explain, in the case of Kahnweiler, that it was only a matter of getting used to a new form of writing, without explaining why a new form of writing was required; and, in the case of Fry, to demonstrate the continuities between what Derain or Picasso were doing and what Poussin had done, without explaining again why Poussin experienced nothing like the resistance these painters did. And I think they perhaps would have said that the mimetic features of the earlier painting disguised what was really true of it, and which remained true of the new art although the disguises of mimesis had been torn away. It was as though the new art were arrived at by subtraction—subtracting mimesis, or distorting it to the point where it no longer seemed the point of the art. Neither Fry nor Kahnweiler, it seems to me, was prepared to say that the new art was really new, or new in a new kind of way. The only thinker I am aware of who rose to that level of vision was Clement Greenberg, who merits a chapter of his own. It is interesting that when Greenberg brought modernism to a level of philosophical consciousness, it was nearly over as a moment in the grand narrative of the visual arts. Modernism ended in a way Greenberg had no room for in his account.

NOTES

1. "The Master said, Is Goodness indeed so far away? If we really wanted Goodness, we should find that it was at our very side" (*The Analects of Confucius*, trans. Arthur Waley [New York: Vintage Books, N.D.], book 7, no. 29).

2. Heinrich Wölfflin, *Principles of Art History: The Problem of the Development of Style in Later Art*, trans. M. D. Hottinger (New York: Dover Publications, n.d.), ix.

3. Henri Matisse, "Statements to Teriade, 1929–1930," in *Matisse on Art*, trans. Jack Flam (London: Phaidon, 1973), 58.

4. Joseph Margolis, in "The Endless Future of Art," endeavors to argue that "past" and "future" belong to narratives, which are "constructions," and hence not to art itself. But this is tantamount to arguing that art is eternal and *cannot* have a beginning, since beginnings belong to narratives. I seek to counter his views in my own "Narrative and Never-

Endingness: a Reply to Margolis," in Arto Haapala Jerrold Levinson, and Veikko Rantala, eds., *The End of Art and Beyond* (New York: Humanities Press, 1996).

5. Steve Lohr, "No More McJobs for Mr. X," *The New York Times*, 29 May 1994, sec. 9, p. 2.

6. John Pope-Hennessy, *Cellini* (New York: Abbeville Press, 1985), 37.

7. Ernst Gombrich, *Art and Illusion: A Study in the Psychology of Pictorial Representation* (Princeton: Princeton University Press, 1956), 314, 388.

8. Karl Popper, *The Logic of Scientific Discovery* (New York: Basic Books, 1959).

9. Ernst Gombrich, *Art and Illusion*, 73.

10. Ibid., 116.

11. Ibid., 8.

12. Ibid., 116.

13. Giorgio Vasari, *Lives of the Most Eminent Painters, Sculptors, and Architects*, trans. Mrs. Jonathan Foster (London: Bell and Daldy, 1868), 2:384.

14. Ibid., 1:98.

15. Roger Fry, "The French Post-Impressionists," in *Vision and Design* (London: Pelican Books, 1937), 194.

16. Roger Fry, cited in Richard Cork, *A Bitter Truth: Avant-Garde Art and the Great War* (New Haven: Yale University Press, 1994), 18.

17. Daniel-Henry Kahweiler, cited in Bois, *Painting as Model*, 95.

18. Brenda Richardson, *Dr. Claribel and Miss Etta: The Cone Collection* (Baltimore: The Baltimore Museum of Art, 1985), 89.

19. Wilfred Scawen Blunt, *My Diaries: Being a Personal Narrative of Events, 1888–1914*, (London: Martin Secker, 1919–20), 2:743.

20. Cited in Bruce Altshuler, *The Avant-Garde in Exhibition: New Art in the Twentieth Century* (New York: Abrams, 1994), 45.

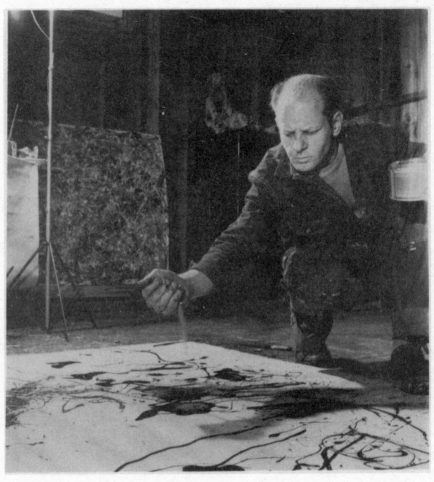

PHOTOGRAPH OF JACKSON POLLOCK BY MARTHA HOLMES. REPRODUCED BY PERMISSION FROM *LIFE MAGAZINE*, AUGUST 9, 1949. © TIME INC.

Modernism and the Critique of
Pure Art: The Historical Vision
of Clement Greenberg

IN THE PREFATORY pages of his *Problems of Style*, published in 1893, Alois Riegl preempts what he feels is certain to be an incredulous response on the part of his readers to the very idea that ornament has a history, and in so doing reveals how the concept of having a history must have been understood a century ago in art-historical circles. The paradigm of something having a history was painting, construed as the art of mimetic representation, so that the history of painting could then be understood in terms of an internal development in representational adequacy. Artists got better and better at representing visual appearances through constructing visual arrays that corresponded to what reality itself presented; and from this perspective there is a developmental asymmetry in the sequence of painterly representation from, say, Cimebue and Giotto to (just to stay within Vasarian boundaries), Michelangelo, Leonardo, and Raphael. In finding it incredible that ornament should have what Riegl explicitly terms "a progressive development,"[1] Riegl's audience, in his view, was "paralyzed" by a thesis against which he polemicizes tirelessly throughout his book: the thesis of "the materialist interpretation of the origins of art" derived from the writings of Gottfried Semper. The materialist sees ornament primarily in term of surface decoration, and surface decoration primarily in terms that derive from, and refer to, ways of meeting certain material needs of human beings, specifically clothing and shelter, both of which involve weaving. Ornament derives from the under-and-over, in-and-out criss-cross and zigzag of textile and wickerwork, the same wherever human beings make clothing and enclosures. In effect, because of its elementary and universal character, ornament must have as little possibility of having a history as, say, reproduction does, or, more controversially, perception. Riegl felt

obliged to destroy this model in order to establish the possibility of a progressive development, which means, as with painting, that later stages in the sequence of ornamental styles go beyond earlier ones in meeting the same artistic goals, and earlier ones enter into the explanation of the later ones. It was the parallel structure in the "progressive development" of painting that Ernst Gombrich sought, with some considerable success, to explicate through the mechanisms of "making and matching," which is marked by progress only because the later figures in the history could compare their representations with those of their predecessors, from whom they learned and beyond whom they progressed, as well as with appearances which presumably remained the same from stage to stage of that history. Needless to say, if earlier work were not preserved and studied, there would be no possibility of a progressive developmental history, only a kind of natural evolution. But even in Upper Paleolithic times, on the cavern walls of Lascaux, later painters had their predecessors as models, since the ritual decision that there should be a fixed place to paint, just as there was a fixed place to build fires,[2] made the wall a kind of anticipatory pedagogic museum. Of course no one knows what progress meant to our paleolithic forebears twenty thousand years ago.

Such was the idea of what it was to have a history circa 1893, when Riegl's *Problems of Style* was published, and it remained, so far as I can tell, the conception of having a history that prevailed when, in 1983, the historian Hans Belting published his profound but elusive *The End of Art History?*, in which he registered the fact that art did not seem, in that objective sense, any longer to have the possibility of a developmental progressive history. And the question for Belting then was how there could be an art history of the present if this objective condition failed? There would, no doubt, be interpretation of individual works, hence art criticism; and one could practice, perhaps, a kind of scholarship constrained by limits of the kind Riegl describes in connection with the philological study of ornament in his own era, marked by an extreme reticence "to propose any sort of historical interrelationships, and even then, only in the case of limited periods and closely neighboring regions."[3] That would be one meaning of not having a history, and, in the case of the visual arts, even one meaning of art having come to an end, since art, understood primarily as painting, once exemplified what it meant to have a history in the progressive developmental sense. In his subsequent *Likeness and Presence*, a masterpiece by any imaginable criterion, Belting proposes to write the history of the devotional image in the West "before the

era of art." It is interesting that his posture and polemic are very similar to Riegl's. He has to defend the claim that the devotional image has a history against what he takes as a claim that the image itself has no history, much as Riegl had to defend the view that ornament had a history against Semper's view that it is everywhere grounded in the same material processes. Belting somewhat misleadingly villainizes the thought of David Freedberg's important study *The Power of Images* by ascribing to Freedberg the thought that, since making images is a universal human propensity, everywhere and always the same, image making cannot have a history. In much the same way, really, Riegl villainized Semper, who was a far richer thinker than Riegl makes him out to be. In any case, Belting wants to present an historical explanation of how the devotional image came to play so central a role in a religion—Christianity—that originally accepted the commandment against graven images. This is not, Belting goes on to say, a proper history, in the sense of being developmentally progressive, since "we have as yet no suitable framework for structuring the events which shaped the image in the era before the Renaissance."[4] Moreover, it is unclear that an art criticism of the devotional image is in order, since these were works created before the era of art and were not in any sense offered for aesthetic enjoyment. So Belting's view of "having a history" appears to remain very much the standard one, original as his ideas and his investigations have been. His problem is to conceive of the history of something that lacks a "proper" history.

Between the time Vasarian structure seemed no longer to apply to the art that was being made and the present moment of narrative disorder in the art scene to which Belting refers in his text on the end of art, there is the intermediate period I think of as modernism, during which artists stopped being guided by the imperative that made it possible for art to have the kind of history Riegl more or less took for granted in the last decade of the nineteenth century, though modernism, as I understand it, had well begun by that time. It had begun, according to Clement Greenberg, in the work of Manet, or, in my own sense of beginnings, with the radical deviations from an orthogonal defined by Vasarian criteria, in the work of Van Gogh and Gauguin in the late 1880s. It should not be held against Riegl that he had not noticed what even those close to painting must have paid very little attention to in those years, even if Riegl might have been struck at the time by the way in which the histories of ornament and of painting were beginning to mingle with the advent of art

nouveau, by the way in which decoration had become an artistic motivation in the work of those who followed Gauguin, and by the opening of the Paris Salon up to craft and even studio furniture in the 1890s.

The problem was how to continue the "developmental progressive" narrative with painting that no longer appeared to be continuing the Vasarian history, and the solution initially took the form, as we saw in the last chapter, of saving the appearances either by denying that it *was* painting save in the most reduced and material sense of the term, or by attributing subversive motives to the artists themselves—motives of the kind that drove the dadaists after World War I, but which hardly figured in the explanatory drives of the early modernists. I am not unsympathetic with those who sought to explain away the new art in this manner, but it is worth remarking that it was not a strategy, so far as I know, that had to be resorted to in any earlier phase of art history, where any development could be justified under Vasarian terms. And I mention this to underscore my conviction that the change from the mimetic to the modern moments in the history of art was a change of a different kind and order from that which characterized the development from Renaissance pictorial strategies to those of Mannerism, the baroque, the rococo, the neoclassical, the romantic, and even, radical as it may have appeared at the time, the impressionist. Indeed, in my view, the change from modern to postmodern was again a change of a different sort from those changes. For those changes more or less left the basic structure of painting undisturbed: one could see deep continuities from Raphael through Correggio, the Carracci, Fragonard and Boucher, Ingres, Delacroix, to Manet, and hence, from the vantage point of 1893, continue to believe in a progressive developmental history. Those changes would, one might say, lie outside the pale of the kind of history I am seeking to tell, where there are breaks in the development, first with modernism, and finally with postmodernism.

The early theorists who sensed that there had been a change of a different order than those which could be grasped as stages in a linear development, Roger Fry, for example, or Daniel-Henry Kahnweiler, can be understood in two different ways. One way would be: the story had ended and a new story had begun. A new system of signs had replaced the old system, in Kahnweiler's view, and it might be replaced in turn. And this more or less meant that the larger history of art was after all not developmental, since there seemed to be no obvious sense in which cubism represented a development beyond impressionism. In this respect, Kahnweiler's thesis bears a distant resemblance to the remarkable view

of art's history articulated by Erwin Panofsky, according to which it consists in a sequence of symbolic forms that replace one another but do not, as it were, constitute a development. Panofsky's almost breathtaking move consisted in taking a discovery that had virtually emblematized progress, that of linear perspective, and transforming it instead into what he termed a symbolic form, where it simply represented a different way of organizing space. And, as a way of organizing space, it belonged to a certain underlying philosophy manifest in other aspects of a culture, like its architecture, its theology, its metaphysics, even its moral codes, which formed cultural wholes of a kind to be studied through what Panofsky called *iconology*. But as between these cultural wholes, and hence as between the art which expressed them, there was no continuous developmental history. Rather, as I see it, having a developmental history belonged to the art of *one* of these cultural wholes, namely that which belonged to Western art from roughly 1300 to 1900. Then, with modernism, we move into a new cultural whole that lasts, roughly, for eighty years, say from 1880 to 1965. And , faithful to the philosophy of symbolic forms, we will find expressions of the same underlying structure in everything that defines our culture: our science, our philosophy, our politics, our codes of moral conduct. I am by no means unsympathetic with this view, as I shall explain in due course. It is in any case one way of representing the difference between what one might call an internal change and an external change in the history of art. An internal change is within a cultural whole, leaving the underlying complex intact. An external change is from one cultural whole to another.

The other response, articulated by Roger Fry, was that the artists were no longer concerned to imitate reality but to give objective expression to the feelings reality elicited in them: "Peindre non la chose mais l'effet qu'elle produit," as Stephan Mallarmé wrote in a phrase that continued to have a great deal of meaning for modernist abstractionists such as Robert Motherwell. This move, from the eye to the psyche, and from mimesis to expression, brought into critical discourse a number of factors which would have had no special relevance earlier—sincerity, for example. There perhaps could be a developmental progressive narrative of expression, as artists learned to express their feelings better and better—but this, one feels, would almost be the story of lowered inhibitions or of giving vent to feelings heretofore repressed and stifled. It would be a history of freedom, construed as the freedom of expression. No doubt there is a possible technology of expression—we find something like it in theatrical training, for example. But one would have

wanted to be far surer than I think anyone was of the truth of Fry's account before one would have undertaken to rethink the history of art in the terms it recommends.

In neither of these ways of reading the theorists was the narrative carried forward, and indeed it should be clear that the idea of a progressive developmental history is somewhat limited if these theories should be true. But there is another way of reading them. What they sought to do, on *this* reading, was to move the narrative to a new level, where the problem was to redefine art, and to say what philosophically art is, thus fulfilling, through art itself, the Hegelian injunction. It was on this reading as if the narrative now moved forward not in terms of increasingly adequate representations, but rather in terms of increasingly adequate philosophical representations of the nature of art. There could now be a developmental progressive story to tell, but it would be the story, as it were, of a progressive degree of *philosophical* adequacy. What they did not have, it seems to me, was a sense of what caused the shift to a new, reflective level to take place—or a sense of a narrative structure in which the new—or modern—art continued to fall under a narrative form but on a new level. For that recognition we have to turn to the writing of Clement Greenberg, who achieved, one might say, a self-consciousness of the ascent to self-consciousness, and whose thought was guided by a quite powerful and compelling philosophy of history. What is interesting to note is that all these theorists were also critics, responding, as I see it, to the question of how, if Vasari's thesis was no longer philosophically adequate, art criticism was to be practiced.

The ascent to a level of philosophical self-consciousness may be far more culturally prevalent than just within art, and quite possibly it is one of the marks through which modernism, understood as one of Panofsky's cultural wholes, may be defined. In an early passage in *Being and Time*, Martin Heidegger observes that "the real 'movement' of the sciences takes place when their basic concepts undergo a more or less radical revision. . . . The level which a science has reached is determined by how far it is *capable* of a crisis in its basic concepts."[5] Heidegger writes further, "Among the various disciplines everywhere today there are freshly awakened tendencies to put research on new foundations." He enumerates cases of this sort across a wide spectrum, and I dare say he counts his own work a contribution to just such a revision in philosophy. And I am proposing that we might think of modernism in general in those terms, as a moment in which it seemed as though things could not continue as they had been, and fresh foundations had to be sought if they were to continue

at all. This would explain why modernism so often took the form of issuing manifestos. All the main movements in philosophy of the twentieth century addressed the question of what philosophy itself was: positivism, pragmatism, and phenomenology each undertook radical critiques of philosophy, and each sought to reconstruct philosophy on firm foundations. In one way postmodernism is marked by antifoundationalism, as in the thought of Richard Rorty or Jacques Derrida, or at least by the recognition that if there are to be foundations, they must be consistent with an art world as unstructured as Hans Belting has found ours to be. "Western civilization is not the first civilization to turn around and question its own foundations," Greenberg wrote in 1960. "But it is the one that has gone furthest in doing so."[6] Greenberg sees "this self-critical tendency" as beginning with Kant, whom he somewhat archly classes as "the first real Modernist" because the first "to criticize the means itself of criticism." And he sees the "essence of modernism" to lie "in the use of the characteristic methods of a discipline to criticize the discipline." This is *internal* criticism, and it in effect means, in the case of art, that art under the modernist spirit, at every point, is self-questioning: and this in turn means that art is its own subject and, in the case of painting, which was essentially Greenberg's concern, the subject of painting was painting. And modernism was a kind of collective inquiry from within by painting into painting in the effort to exhibit what painting itself is. What makes Heidegger a "modernist" philosopher is that he takes the ancient question of Being, and, rather than confront it head on, he asks what kind of being it is for whom that question arises, so that in effect his inquiry is about itself. What makes Modernist painting modern is, on Greenberg's account, its taking upon itself the task of determining "through its own operations and works, the effects exclusive to itself." This essence of art coincided, Greenberg thought, "with all that was unique in the nature of its medium." And to be true to its essence each modernist work was obliged to "eliminate . . . any and every effect that might conceivably be borrowed from or by the medium of any other art." In consequence, each art, under self-criticism, would be "rendered pure," a concept perhaps Greenberg really did borrow from Kant's notion of *pure reason*. Kant called a mode of knowledge pure when "there is no admixture of anything empirical," that is, when it was pure a priori knowledge.[7] And *pure reason* is the source of the "principles whereby we know we know anything absolutely a priori."[8] Each modernist painting, in Greenberg's view, would then be a critique of pure painting: painting from which one should be able to deduce the principles peculiar to painting as painting.

Greenberg, notoriously, identifies the essence of painting with flatness: "It was the stressing of the ineluctable flatness of the surface that remained ... more fundamental than anything else to the processes by which pictorial art criticized and defined itself under Modernism." While emphasizing flatness did not exclude representation from painting, it did exclude illusion, which requires the use of three-dimensional space, itself a borrowing from another art and hence a contaminant of painting construed as pure. The Vasarian project was in effect a project of encroachment: painting had a developmental and progressive history only by usurping the prerogatives of sculpture.

Whatever one thinks of Greenberg's positive characterization of modernist painting, my interest in it here lies in the powerful historical vision of modernism that it expresses. It is overwhelmingly to Greenberg's credit that he perceived the post-Vasarian history as a history of self-examination, and identified modernism with this effort to put painting, and indeed each of the arts, on an unshakable foundation derived from discovering its own philosophical essence. But Greenberg is typical of the period he tries to analyze in that he has his own definition of what the essence of painting must be. In this he is belongs to the Age of Manifestos, as much so as Mondrian, or Malevich, or Reinhardt, though each of these sought to define pure painting by example. The point is that, in general, providing a philosophical definition of art was what marked the drives of modernism. Greenberg both recognized this as a general historical truth, and, at the same time, tried to provide his own philosophical definition.

Before examining Greenberg's thought in detail, let us seek to get a view of the overall history of art with which it fits. And here is an analogy of sorts. The history of art is structurally parallel with the developmental history of individual human beings like you and me. Our first period is marked by mastering ways to get more and more reliable pictures of the external world, just as the history of painting in the West was. No doubt this history could go on and on, but a moment arrives when we have mastered the skills of representation and have a fairly reliable picture of the world. We move to a new level of thought when we begin to see ourselves as part of the story and try to get a certain clear picture of what we are. This corresponds to the moment of self-consciousness when painting, for reasons I have not at all endeavored to identify, undertakes to ask what it itself is, and so the act of painting becomes simultaneously a philosophical investigation into the nature of painting. There is a beautiful moment in the dialogue *Phaedrus* when Socrates, precocious as al-

ways, deflects a certain line of questioning by saying that he has no time for such matters: "I can't as yet 'know myself,' as the inscription at Delphi enjoins, and so long as that ignorance remains, it seems to me ridiculous to inquire into extraneous matters."[9] In the introduction to his *Essay Concerning Human Understanding*, Locke writes, "The understanding, like the eye, whilst it makes us see and perceive all other things, takes no notice of itself; and it requires art and pains to set it at a distance and make it its own object."[10] Modernism was a collective move of this sort, all across the face of culture, to make the activities and enterprises of culture objects for themselves. In a spirited defense of modernism against the usual kind of attack, this time against the *Neue Kunstlervereinigung Munchen* exhibition of 1909, Franz Marc spoke of the movement then spreading across Europe as "defiantly self-aware,"[11] hence not a pathology of a few sick minds. Modernism is thus the age of self-critique, whether in the form of painting, or science, or philosophy, or morals: nothing is taken for granted any longer, and it is hardly matter for wonder that the twentieth century is the age par excellence of upheaval. Art is a mirror of this cultural whole, but so is everything else. Greenberg as a philosopher and critic belongs, in this sense, to high modernism, whose painterly dimension he articulated more forcefully than anyone else: his is a critique of pure painting, or of painting as pure.

The internal drives of modernism, as Greenberg saw them, were through and through foundationalist. Each of the arts, painting as well as others, had to determine what was peculiar to itself—what belonged only to it. Of course painting would "narrow its area of competence, but at the same time it would make its possession of that area all the more certain." Hence the practice of an art was at the same time a self-criticism of that art, and that means the elimination, from each of the arts, of "any and every effect that might conceivably be borrowed from or by the medium of any other art. Thus would each art be rendered 'pure,' and in its purity find the guarantee of its standards as well as of its independence. 'Purity' meant self-definition." Note the art-critical agenda implicit here: it is a criticism of a work of art that it is impure, namely, that it contains an admixture of any medium other than itself. It becomes a standard critical reflex to say of such mixed art that it is not really painting, or even not really art. This kind of essentialism is the matrix for a great deal of what passes for moral criticism in our time. That its opposite is also a matrix is a mark of having entered a new historical era. Alongside "Be a man!" it becomes an acceptable imperative to let one's feminine side come through.

The history of modernism is the history of purgation, or generic cleansing, of ridding the art of whatever was inessential to it. It is difficult not to hear the political echoes of these notions of purity and purgation, whatever Greenberg's own politics actually were. These echoes still crash back and forth across the tormented fields of nationalist strife, and the notion of ethnic cleansing has become a shuddering imperative of separatist movements the world round. It is not surprising, simply shocking, to recognize that the political analog of modernism in art was totalitarianism, with its ideas of racial purity and its agenda to drive out any perceived contaminant. "The more closely," Greenberg writes, "the norms of a discipline become defined, the less freedom they are apt to permit in many directions. The essential norms or conventions of painting are at the same time the limiting conditions with which a picture must comply in order to be experienced as a picture." And, as if to underscore the depth of the political analogy, Greenberg wrote explicitly, apropos of an exhibition at the Museum of Modern Art in New York, "The extreme eclecticism now prevailing is unhealthy, and it should be counteracted, even at the risk of dogmatism and intolerance."[12] Greenberg was an intolerant and dogmatic person, but dogmatism and intolerance belong to the symptomatology (to follow him in using medical imagery) of the Age of Manifestos. You cannot use the idiom of purity, purgation, and contamination and at the same time take easily to the postures of acceptance and toleration. Because Greenberg's views drew their energy from what we might speak of as the spirit of the times, he was not alone in his denunciatory stance, which remains a feature of critical discourse in New York even today—even in our age of relativism and multiculturalism, when one might expect a degree of toleration and openness.

Greenberg's comment about "intolerance and dogmatism" was in fact written in 1944, sixteen years before the great formulations of "Modernist Painting," and for that matter before the true emergence of abstract expressionism and the painting of the New York School, with which Greenberg is inextricably associated, and whose espousal of which was to give him so high a degree of credibility. The *Life* magazine article on Jackson Pollock, which credited a "formidably highbrow New York critic" with claiming him to be the "greatest American painter of the Twentieth Century," appeared on 8 August 1949. Greenberg had in fact expressed the view, in 1947, that Pollock was "the most powerful painter in contemporary America and the only one who promises to be a major one." And as early as 1943 he praised Pollock's canvases at Peggy Guggenheim's Art of

This Century Gallery as "among the strongest abstract canvases I have yet seen by an American." But Greenberg was in possession of his basic philosophy of history already in 1939, when he published his epochal essay "Avant-Garde and Kitsch." Pollock at that time was working through the influence of Mexican art, especially the idiom of José Clemente Orozco, and the only American abstraction to speak of was the geometrical Neo-Plasticism of the followers of Mondrian. Here is how Greenberg characterized avant-garde art at that time:

> It has been in search of the absolute that the avant-garde has arrived at "abstract" or non-objective art—and poetry too. The avant-garde poet or artist tries in effect to imitate God by creating something valid solely on its own terms, in the way nature itself is valid, in the way in which a landscape—not its picture—is aesthetically valid: something *given*, increate, independent of meanings, similars, or originals. Content is to be dissolved so completely into form that the work of art or literature cannot be reduced in whole or part to anything not itself.[13]

It is indeed as if the goal of the avant-garde was to collapse the distinction between reality and art by making an adjunct reality, with no more meaning than reality itself possesses, and the aesthetic qualities of which are analogous to those of sunsets and surf, mountains and woods, actual flowers and beautiful bodies. A work of art, to paraphrase the famous line, must not *mean* but *be*. In philosophical truth, this is an impossible theory, and its impossibility became manifest in the 1960s when artists produced objects so like real objects—I am thinking of the *Brillo Box* once again—that it became clear that the real philosophical question was how to prevent them from simply collapsing into reality. One small step toward a solution was to recognize that, just as Greenberg says, reality has no meaning, but that, contrary to his posture, art does. At the most one can say that reality defines a limit art can be said to approach—but which it cannot reach on penalty of no longer being art. In a discussion of Picasso, in 1957, Greenberg wrote, "Like any other kind of picture, a modernist one succeeds when its identity as a picture, and as a pictorial experience, shuts out the awareness of it as a physical object."[14] But this is just a leap of faith: how would a monochrome red painting show its difference from a flat surface just covered with red paint? Greenberg believed that art alone and unaided presents itself to the eye as art, when one of the great lessons of art in recent times is that this cannot be so, that artworks and real things cannot be told apart by visual inspection alone.

Greenberg seems to have become sensitive to this dilemma. In his famous essay "The Crisis of the Easel Picture" of 1948 he describes a consequence of projecting the impulses which led to modernism. These tended—"but only tended," he cautions—"to reduce the picture to a relatively undifferentiated surface." So the most advanced painting—the all-over painted flat surface—approaches the condition of the wall or at the very best the condition of "decoration—to wallpaper patterns capable of being extended indefinitely."[15] This "dissolution of the picture into sheer texture, sheer sensation, into the accumulation of smaller units of sensation, seems to answer to something deep-seated in contemporary sensibility," he noted, going on to draw a fascinating political correspondence: "It corresponds perhaps to the feeling that all hierarchical distinctions have been exhausted, that no area or order of experience is either intrinsically or relatively superior to any other." Whatever it means, Greenberg felt that the consequences for the easel picture, which had been the vehicle of the history of art regarded progressively and developmentally, was that artists driving to overcome the philosophical boundaries of the picture was something they "cannot help doing" but through which "these artists are destroying it."

"Cannot help doing" returns me to the conception of historical inevitability which motivates my discussion of Greenberg's philosophy of art. The theory goes somewhat as follows, using Greenberg's own words so far as possible. "In turning his attention away from the subject matter of common experience, the poet or artist turns it upon the medium of his own craft." This in effect means a transformation, in the case of painting at least, from representation to object, and from content, accordingly, to surface, or to paint itself. This, Greenberg insists "is the genesis of the abstract," but it is a special kind of abstractness, what one might call the *material* abstract, where the physical properties of the painting—its shape, its paint, its flat surface—become the inevitable essence of painting as art. I contrast this with what one might call the *formal* abstract, with which Greenberg's name is indissolubly associated. Neo-Plasticism is formally abstract. Pollock, in a certain sense, was the material abstract. In his 1943 review Greenberg talks about the "mud" from which Pollock got such effect (and which he traces back to Ryder and to Blakelock in American painting): "The mud abounds in Pollock's larger works." And he talks about "the chalky incrustations" as if describing geological examples. The artists upon whom, in 1939, Greenberg sought to rest his argument fit, it seems to me, a materialist aesthetic very poorly. "Picasso, Braque, Mondrian, Miró, Kandinsky, Brancusi, even Klee, Matisse, and

Cézanne," he wrote, "derive their chief inspiration from the medium they work in." In "Towards a Newer Laocoön," published in 1940, he wrote, "Guiding themselves ... by a notion of purity derived from the example of music, the avant-garde in the last fifty years [note that this returns us to 1889, which is when it seems to me high modernism really did begin] achieved a purity and a radical delimitation of their fields of activity, for which there is no previous example in the history of culture." And purity itself is characterized as it will be twenty years later: "the acceptance, the willing acceptance, of the limits of the medium of the specific art." This, like the Vasarian narrative, is progressive and in a way developmental: it is the story of "the progressive surrender of the resistance of the medium." "So inexorable was the logic of this development," Greenberg writes—and I will not conclude the sentence, for I want only to draw attention to the concept of historical inevitability contained in his account of a progress which ends with the destruction of the easel picture and the dissolution of the distinction between paintings and mere walls. So Greenberg too had his own notion of the end of art, as must anyone who perceives the history of art under a developmental narrative.

It perhaps is neither here nor there in the unfolding of Greenberg's narrative that his examples would have resisted his characterization. Picasso, whatever he had in mind in painting *Guernica*, was little concerned with the limits of the medium: he was more concerned, by an inestimable degree, with the meaning of war and suffering. Miró, who conceived of his *Still Life with Old Shoe* as his own *Guernica*, did not conceive of it as abstract in any sense whatever: "The [Spanish] civil war was all bombings, deaths, firing squads, and I wanted to depict this very dramatic and sad time."[16] And Miró vehemently rejected the label of abstractionist, and went so far, in a late interview, as to deny that Mondrian was really an abstract painter at all. All this, I think, may be granted, without this deeply affecting Greenberg's overall materialism, which he expresses in a widely discussed passage in "Modernist Painting."

> Realistic, naturalistic art has dissembled the medium, using art to conceal art. Modernism used art to call attention to art. The limitations that constitute the medium of painting—the flat surface, the shape of the support, the properties of the pigment—were treated by the old masters as negative factors that could be acknowledged only implicitly or indirectly. Under Modernism these same limitations came to be regarded as positive factors, and were acknowledged openly. Manet's became the first Modernist pictures by virtue of the frankness with which they declared the flat surfaces

on which they were painted. The Impressionists, in Manet's wake, abjured underpainting and glazes, to leave the eye under no doubt as to the fact that the colors they used were made of paint that came from tubes or pots. Cézanne sacrificed verisimilitude or correctness, in order to fit his drawing and design more explicitly to the rectangular shape of the canvas.[17]

This, if true, helps us understand what the overwhelming resistance to the impressionists when they first exhibited came from. But I want to underline the identification of Manet as a beginning as evidence of Greenberg's extraordinary historical intuition. For it was precisely with Manet that Oswald Spengler associated the *end* of painting in the decline of West: "with the generation of Manet, all has ended again." End or beginning, it was clear in any case that Manet marked a deep change. "Has painting lived, after all, two centuries more?" Spengler asks. "Is it still existing? But we must not be deceived by appearances." It is striking that the demise of modernism has been identified in very recent times with the "death of painting," which I shall confront in due time. But for now my concern is only to acknowledge Greenberg's tremendous achievement in moving the narrative of art history onto a new plane, even if there may be some resistance to his close identification of the essence of the medium of painting with the flatness of surfaces.

Let me address myself at this point to the brushstroke (and by implication to its expressionist affines, the drip, the smear, the swipe, the wipe, etc.), as partial confirmation of Greenberg's view, but also as something he might have used instead of flatness as a criterion of painting as painting. It strikes me that the brushstroke must have been very largely invisible throughout the main history of Western painting, something one might know was there but which one saw through or past, roughly in the way in which we see through or past the raster of the television monitor: like the raster, the brush would have been a means for bringing an image before the eyes, without itself forming part of the meaning of that image; and where, again as with television, the aspiration would have been toward higher and higher resolutions until the raster literally disappears from visual consciousness, this time as a matter of optical mechanics rather than as a matter of aesthetic convention. By "aesthetic convention," I mean a tacit agreement not to pay attention to brushstrokes. This is easily achieved, since there would in ordinary cases be no way in which the brushstroke could be construed as part of the images it facilitates, but also because of the tremendous power of mi-

metic theories of pictorial representation, and finally because of the role the concept of illusion played throughout the history of painting down through the first two-thirds of the nineteenth century. Let me offer something of an argument for this.

When photography was invented, in 1839, the painter Paul Delaroche famously pronounced that painting was dead. When he learned the news about Daguerre's invention, he was at work on a thirty-foot canvas depicting the history of art. Whatever that canvas shows about the use of the brush, it had a surface that looked photographic, that is, unbrushed. Hence it must have seemed to Delaroche that all the skilled reflexes he had mastered could be built into a mechanism that, once the question of scale had been solved, could produce a work indiscernible from his. It did not occur to him to say "What about the brushstrokes?" That would have implied that the camera was incapable of attaining the quality of surface and touch that the visible, palpable brushstroke can. Delaroche's art exemplifies what I mean by the invisibility of the brushstroke, and his famous declaration could not have been made had he invested the brushstroke with any aesthetic importance.

The brushstroke became salient in impressionist painting, but that was not the intention of the movement. It counted on optical rather than physical mixing, and juxtaposed dabs of color to achieve chromatic intensity, but the dabs did not fuse. They were stridently visible, the way they might be in an oil sketch, when these were exhibited as finished paintings, a concept which implied the disguise of the brushstroke. So it seems to me transparent that the brushstroke became important only when illusionism receded as the basic aim of painting and mimesis receded as the defining theory of art, which in my view gave a retroactive validity to impressionist canvases, now accepted for what the impressionists would have regarded as the wrong reasons. One is not supposed to look at the dots in pointillist painting; ideally they are to disappear in favor of a luminous image, which never happens, of course, because the eye has its limits. In my view, these validations happened when the painting itself became an end rather than a means, and when the brushstroke indicated that the painting was to be looked at rather than through, in the sense of "through" which implies transparency. I tend to believe that the distinction between insider and outsider, between specialist and audience, itself dimmed as this happened. To see the painting as paint-*ing* meant to see it from the artist's point of view, with this difference: the impressionist applied brushstrokes intending that they fuse in the viewer's perception, so to see things from the artist's point of view would

have meant seeing it as determined by what the artist supposed the viewer's point of view would be if the illusion worked. It would be analogous to theatrical production, where the stage is set in such a way as to achieve what the *metteur en scene* believes will promote illusion. Naturally, the same artistic impulse which brings the brushstroke to the audience's conscious attention has its counterparts in letting the mechanisms of theatrical production be part of theatrical experience, letting us, as it were, see backstage and frontstage at once. But no dramaturge to my knowledge went so far as to put on a production consisting only of stagehands pulling ropes and moving flats: that would be the proper analog of making a painting which consists exclusively of brushstrokes, such as came to be standard in abstract expressionist painting. In any case, with impressionist painting, for the first time the insider's perspective in fact became the outsider's perspective. And, just possibly, paint took over, and the artist decided the pleasures of the painter could be delivered over as pleasures for the viewer, who, like the painter, became a sensualist of paint.

An argument could be made that modernism began with the impressionists, if we accept Greenberg's materialist aesthetic, just because they made the dab and daub visible, even if, as is almost certainly true, they set themselves to capture the pleasures of bourgeois life, as art historians have in recent years maintained. And something of the same sort remains true of Van Gogh, whose gouged and plowed surfaces are incapable of being sublated, however gripped we may be by the images of his art. Indeed, the sense we have from those unmistakable surfaces of the artist's passionate gestures is an important component, given the abiding energy of the romantic image of "the artist" even in our own time, an important component in the popularity of his painting.

Greenberg stresses the flatness of painting—"the ineluctable flatness of the surface"—since "flatness was the only condition painting shared with no other art," and modernism was a drive (on his view) that defines each medium through what it and only it possesses, and what differentiated it accordingly from ever other medium. It is difficult to think of anything more unique to painting than the brushstroke—even the lack of brushstrokes is a property of painting of a certain sort, by contrast with poetry (or Western poetry at least—Oriental poetry is of course another matter), which lacks brushstrokes as a matter of genre. Little matter. The point is that Greenberg defines a narrative structure which is naturally continuous with the Vasarian narrative, but one in which the substance of art slowly becomes the subject of art. And this happened insidiously, without

those who affected what we might, following Professor Quine, speak of as the ascent to media, realizing that they had done so. "Manet began modernism" is a sentence much like "Petrarch opened the Renaissance," what I designate a narrative sentence, and it is marked by the fact that Manet no more than Petrarch knew he was doing what he did under these crucial historical descriptions. An ascent to a new level of consciousness had been made without those who made it necessarily having been aware that they did so. They were revolutionizing a narrative they believed themselves to be continuing. "Art gets carried on under modernism in much the same way as before."

Modernism came to an end when the dilemma recognized by Greenberg between works of art and mere real objects could no longer be articulated in visual terms, and when it became imperative to quit a materialist aesthetics in favor of an aesthetics of meaning. This, again in my view, came with the advent of pop. Much in the way in which modernism was resisted in its early phase by claiming that its practitioners were unable to paint, postmodernism was not perceived by Greenberg as the beginning of a new era, but as a blip in the materialist history of art, whose next episode instead was post-painterly abstraction. But perhaps nothing better defines the transition from modernism to our present age than the decreasing applicability of classical aesthetic theory to the art of the present moment. I accordingly turn to that next.

NOTES

1. "How many of you are now shrugging your shoulders in disbelief merely in response to the title? What, you ask, does ornament also have a history?" (Alois Riegl, *Problems of Style: Foundations for a History of Ornament* trans. Evelyn Kain [Princeton: Princeton University Press, 1992], 3).

2. Meyer Schapiro, "On Some Problems in the Semiotics of Visual Art: Field and Vehicle in Image-Sign," in his *Theory and Philosophy of Art: Style, Artist, and Society* (New York: George Braziller, 1994), 1.

3. Riegl, *Problems of Style*, 3.

4. "If one consults David Freedberg's book on *The Power of Images*, one even finds a warning against attempting to devise a history of the image at all, as the author considers the image to be an ever-present reality to which mankind has responded in ever the same way" (Hans Belting, *Likeness and Presence*, xxi). I have my difficulties with Freedberg's book, but he almost certainly never maintains something like this.

5. Martin Heidegger, *Being and Time*, trans. John Macquarrie and Edward Robinson (New York: Harper and Row, 1962), 29.

6. Greenberg, "Modernist Painting," *The Collected Essays and Criticism*, 4:85. Unless otherwise specifically indicated, references are to this text.

7. Immanuel Kant, "Introduction," *Critique of Pure Reason*, trans. Norman Kemp Smith (London: Macmillan, 1963), 43.

8. Ibid., 58.

9. Plato, *Phaedrus*, trans. R. Hackforth, in *Plato: The Collected Works*, ed. Edith Hamilton and Huntington Cairns (Princeton: Princeton University Press, 1961), 229e–230a. Plato, here as elsewhere, is sly. Compare the disclaimer to Phaedrus with his earlier utterance in the dialogue: "I know my Phaedrus. Yes indeed, I'm as sure of him as of my own identity" (228a). How sure can that be? I owe to my former student, Elinor West, the strategy of looking in the dialogues for these tensions, which, in her view, are the keys to the dialogues' meaning. I hope she succeeds in bringing her discoveries systematically together.

10. John Locke, *An Essay Concerning Human Understanding*, ed. A. C. Frazier (Oxford: Clarendon Press, 1894), 1:8.

11. Franz Marc, "Letter to Heinrich Thannhauser," cited in Bruce Altschuler, *The Avant-Garde in Exhibition: New Art in the 20th Century* (New York: Abrams, 1994), 45.

12. Greenberg, "A New Installation at the Metropolitan Museum of Art, and a Review of the Exhibition *Art in Progress*," *The Collected Essays and Criticism*, 1:213.

13. Greenberg, "Avant-Garde and Kitsch," *The Collected Essays and Criticism*, 1:8.

14. Greenberg, "Picasso at Seventy Five," *The Collected Essays and Criticism*, 4:33.

15. Greenberg, "The Crisis of the Easel Picture," *The Collected Essays and Criticism*, 2:223.

16. Joan Miró, *Selected Writings and Interviews*, ed. Margit Rowell (Boston: G. K. Hall, 1986), 293.

17. Greenberg, "Modernist Painting," *The Collected Essays and Criticism*, 4:87.

18. Oswald Spengler, *The Decline of the West: Form and Actuality*, trans. C. F. Atkinson (New York: Knopf, 1946), 1:288. I am grateful to Chares Haxtausen for drawing Spengler's discussion to my attention.

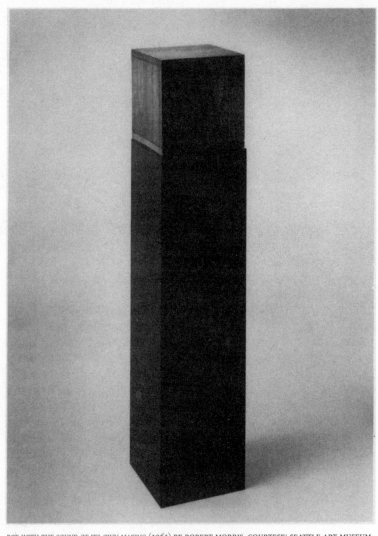

BOX WITH THE SOUND OF ITS OWN MAKING (1961) BY ROBERT MORRIS. COURTESY: SEATTLE ART MUSEUM AND MR. AND MRS. BAGLEY WRIGHT. PHOTO CREDIT: PAUL MACAPIA.

■ ■ ■ ■ ■ CHAPTER FIVE

From Aesthetics to Art Criticism

I BEGIN by citing a passage from Arthur Schopen-
hauer's philosophical masterpiece *The World as Will and Idea*, in which he
speaks of the relationship between two, as he sees it, antithetical values—
beauty and utility. He is discussing the romantic notion of genius, which
he identifies as the intellect working independently of the will, so that
"the productions of genius serve no useful purpose":

> The work of genius may be music, philosophy, painting, or poetry; it is
> nothing for use or profit. To be useless and unprofitable is one of the
> characteristics of works of genius; it is their patent of nobility. All other
> human works exist only for the maintenance and relief of our existence;
> only those here discussed do not; they alone exist for their own sake, and
> are to be regarded in this sense as the flower . . . of existence. Our heart is
> therefore gladdened at the enjoyment of them, for we rise out of the heavy
> earthly atmosphere of need and want.[1]

This powerful distinction drawn in one of the great originating works of
philosophical aesthetics, between aesthetic and practical considerations,
has tended to stultify any propensity to ask what practical utility aesthetic
experience itself might have. For questions of practicality are defined by
the interests an individual or group might have—by what Schopenhauer
refers to as the will—but Kant, in the work that generated a tradition
which included Schopenhauer and which extended, which *extends*, well
into modern times, writes that "taste is the faculty of judging of an object
or a method of representing it by an *entirely disinterested* satisfaction or
dissatisfaction. The object of such satisfaction is called *beautiful*."[2]

Schopenhauer contended that, analogous to the way in which aesthet-
ics and utility are disjoint from one another, "we rarely see the useful
united with the beautiful. . . . The most beautiful buildings are not the
useful ones; a temple is not a dwelling house." Modernism has not been
quite so rigorous. The Museum of Modern Art displays objects of ac-
knowledged utility which exemplify the principle of aesthetic high style.

The Barnes collection displays amidst the masterpieces of painting and sculptures objects of unmistakable utility. The furniture of the Shakers seems clearly to fuse beauty and utility. Still, Schopenhauer might ask to what degree the beauty is related to the utility. A spark plug might be considered by some a beautiful object, with its knurled and polished surfaces and its exquisitely proportioned distribution of metal and ceramic parts, but it would, so far as beautiful, satisfy no interest of the sort sparkplugs exist to serve: if you were anxious to have one which worked, issues of spark plug beauty would be beside the point, for to judge it beautiful would be, according to Kant, as an "object of an entirely disinterested satisfaction," since "every interest spoils the judgment of taste."[3] And the puzzling question would certainly be: what kind of satisfaction could that be? For what would constitute satisfaction if there were no interest to be served?

Let us follow Kant in speaking as if there were a kind of satisfaction *an sich* (in itself), a distant philosophical relative of the thing *an sich*. Just as the thing in itself exists independently of everything else, satisfaction in itself depends, as the classical aestheticians insisted, upon no possible practical interest nor on its satisfaction. It immediately follows, of course, that aesthetic considerations are extruded from the realm of function and utility, a momentous consequence which has been taken to justify the elimination of ornament and decoration from the domain of architectural design and the elimination of art subsidies from the federal budget as frill by definition, so far as artworks fall under the category of the aesthetic. Like the (limited) beauty of the sparkplug, beauty may be an accidental by-product of features, for each of which there is a good clear practical justification. But the beauty plays no further role in accounting for how the sparkplug works.

No distinction is especially drawn between natural and artistic beauty in Kant: "Nature is beautiful because it looks like art, and art can only be called beautiful if we are conscious of it as art while yet it looks like nature."[4] So the judgment of beauty may be invariant as to whether it is beautiful art or natural beauty , and though we may be mistaken, in the event of illusion, as to whether or not it is art, we are not mistaken in point of its beauty—"Beautiful art must *look* like nature." Schopenhauer, for all his emphasis upon genius, sees the disjunction between beauty and utility in objects which would not ordinarily be attributed to genius: "Tall and fine trees bear no fruit; fruit trees are small, ugly, and stunted. The double garden rose is not fruitful, but the small, wild, almost scentless rose is." There is something scary in this line of thought, which seems to

want to connect usefulness and plainness if not ugliness Perhaps you can get a sense of what is scary in Schopenhauer's way of thinking if you consider the German contrast between *gut* and *schlecht*, different from the contrast between *gut* and *böse*. "Good" contrasts with both "bad" and "evil," and Nietzsche, who was Schopenhauer's great disciple, shows us in *The Genealogy of Morals* how "good" designated what the masters claimed they were by virtue of the traits that defined them—traits the slaves of course called "evil." But at least they were not *schlecht*, like the slaves who were the human equivalent of the "small, ugly, stunted fruit trees." But my interest lies in drawing out the thought, common to Kant and to Schopenhauer, that there is no special line to draw between the beautiful in art and in nature. For this leads, by a path worn smooth by those who have taken the disjunction between beauty and utility as a deep truth, from philosophical aesthetics to a highly influential form of the practice of art criticism, construed as the discrimination of good art from bad. In any case, there is nothing, other than the knowledge that it is art one is experiencing, which distinguishes what Greenberg called "quality in art"[5] from the beautiful in nature: beautiful art is *gut*. If art lacks beauty or "quality," it is *schlecht*.

The qualification "knowledge that it is art that one is experiencing" ought to sound a warning that if the beautiful is invariant to artworks and other things, beauty forms no part of the concept of art, though in Kant's time it would have been taken as a matter of course that artworks as a class aimed at beauty, and that beauty was implied by their existence, even though they might fail in their aim.[6] Once more consider the displayed spark plug. Spark plugs could not have existed in Kant's time, nor, contrary to historical fact, could they have been artworks if they had existed. They could not have existed because the state of industrial ceramics and of metallurgy was not evolved enough to have produced them, quite apart from the fact that the mechanism which gave rise to the spark plug—the internal combustion engine—had not as yet been thought of. But imagine, even so, that a spark plug slipped through a time warp and was found by a woodcutter just outside Koenigsburg in 1790. It would be incapable of satisfying any interest at the time, since the *Zeugganz* in which it could do so was not to be in place for a century and a half, so it would have value only as a curiosity, like the coconuts that would, rarely, wash up on European shores in the sixteenth century, to be credited with magical attributes. The time-displaced spark plug might very well find a place in Frederick the Great's *Wunderkammer*, where it

would be an object of contemplation which was forcibly disinterested since there was nothing other than contemplation that one could do with it, except perhaps use it as a paperweight. It would almost exactly fit Kant's characterization of beauty as "purposiveness without specific purpose": it would perhaps look too useful to be ornamental, but no one could imagine how.

In any case, a spark plug could not, given the state of art, be a work of art in 1790. Today, in consequence of a revolution engendered by some mischief of Marcel Duchamp circa 1917, it could be, albeit not for reasons of its beauty. The ready-made objects were siezed upon by Duchamp precisely because of their aesthetic nondescriptness, and he demonstrated that if they were art but not beautiful, beauty indeed could form no defining attribute of art. The recognition of that, one might say, is what draws so sharp a line between traditional aesthetics and the philosophy of art, indeed the practice of art, today. That line, of course, was very faint in general consciousness when Duchamp sought to exhibit a urinal at the 1917 exhibition of the Society of Independent Artists, under a false signature and the title *Fountain*. Even members of Duchamp's immediate circle, like Walter Arensberg, thought Duchamp was drawing attention to the white gleaming beauty of the urinal. As if an artist whose philosophical agenda was in part to extrude the aesthetic from the artistic were bent upon reducing works of art to aesthetic objects, in the manner of Kant or Schopenhauer! There is an argument recorded between Arensberg and the artist George Bellows in 1917, in which the former said, "A lovely form has been revealed, freed from its functional purpose, there a man has clearly made an aesthetic contribution."[7] But in 1962 Duchamp wrote to Hans Richter, "When I discovered readymades, I thought to discourage aesthetics. . . . I threw the bottle rack and the urinal in their faces as a challenge, and now they admire them for their aesthetic beauty."[8]

Greenberg, incontestably the foremost Kantian art critic of our time, had little use and less patience with Duchamp as an artist, and I want to discuss Greenberg's achievement against the background of a distinction I regard as crucial between aesthetic objects and works of art which Duchamp made central to his enterprise, but which Greenberg hardly took notice of as philosophically important. Kant, Greenberg conceded, had bad taste and scant experience with art—"Yet his capacity for abstraction enabled him, despite many *gaffes*, to establish in his *Critique of Aesthetic Judgment* what is the most satisfactory basis for aesthetics we yet have."[9] I am anxious to discuss Greenberg from this angle because his

way of doing art criticism has become extremely problematic in an art world almost defined by Duchamp as its generative thinker. Greenberg's aesthetic philosophy is being carried forward by Hilton Kramer and the writers of his journal *The New Criterion*, and it pivots precisely on the issue of "quality in art," which Kramer identifies specifically with aesthetic quality but which Duchamp and his followers—and I must count myself among them—would identify in some other way. I am uncertain that one can come up with a sort of "unified field theory of artistic goodness," nor hence whether one can explain the artistic goodness of works Greenberg prized for their aesthetic goodness in some other terms. But I at least know that it is bad critical practice to dismiss works which lack aesthetic goodness in Greenberg's terms as artistically bad. If a unified theory is not to be had, art criticism is a very divided practice. Whether in addition it needs to be an essentially conflicted practice remains to be decided, and perhaps a close examination of the way Greenberg sought to ground his own critical practice in Kantian aesthetics will facilitate that decision. But the existence of that conflict gives us a reason to examine the background in aesthetic theory from which it arises: a theory which entails a conflict in application must be itself a conflicted theory, just as a set of axioms is inconsistent if it entails a contradiction. The conflict was screened by the historical accident that aesthetics was hammered out as a discipline at a time when art had been singularly stable in its practice and conception over several centuries, and where such revolutions in art as there may have been were in the nature of reversions to earlier conditions—from rococo to neoclassicism in the time of Kant, and from romanticism to pre-Raphaelitism in the time of Schopenhauer. Modernism began insidiously in the 1880s, but it did not especially force aestheticians to rethink their distinctions, which fit fairly readily with Cézanne and Kandinsky and could even, as we saw, be made to fit with Duchamp. Aesthetics seems increasingly inadequate to deal with art after the 1960s—with "art after the end of art" as I have elsewhere termed it—a sign of which was an initial disposition to refuse to consider non- or anti-aesthetic art as art at all. That paralleled the reflex of regarding *abstract* art as not art at all, with which Greenberg, as an advocate of abstraction, had to deal. That momentary crisis was overcome by revising the theory that art must be mimetic, a felicitous move which classical aesthetics facilitated precisely through the weak distinction it insisted upon between artistic and natural beauty, leaving it now open that all that mattered *was* aesthetic quality. But classical aesthetic theory could not be appealed to with "art after

the end of art" precisely because it seemed to scorn aesthetic quality altogether: it was precisely in terms of classical aesthetics that the refusal to call it art was grounded. Once its status as art was established, it was fairly clear that aesthetics as a theory was badly in need of repair if it was to be helpful in dealing with art at all. And in my view that was going to mean overhauling the distinction between the aesthetic and the practical as the default basis of the discipline. But let us return to an aesthetics-based art criticism, and to Clement Greenberg's views.

Greenberg derived two tenets from his reading of Kant. The first was based on a famous formulation of the relationship between the judgment of beauty and the application of rules. "The concept of beautiful art does not permit the judgment upon the beauty of a product to be derived from any rule which has a concept as its determining ground, and therefore has as its basis a concept of the way in which the product is possible. Therefore beautiful art cannot itself devise the rule according to which it can bring about its product."[10] Critical judgment, in Greenberg's view, operates in the abeyance of rule: "Quality in art can be neither ascertained nor proved by logic or discourse. Experience alone rules in this area—and the experience, so to speak, of experience. This is what all the serious philosophers of art since Immanuel Kant have concluded."[11]

So "the most satisfactory basis for aesthetics we yet have" was nothing less than the most satisfactory basis for art criticism as Greenberg believed himself to practice it. Greenberg credited himself with good taste, a matter in part of temperament and in part of experience. "The practiced eye tends always toward the definitely and positively good in art, knows it there, and will be dissatisfied with anything else."[12] It will, in brief, be dissatisfied with anything less that the satisfying *an sich*. The Kantian art critic, pressed for an answer to the question of what good is art—what art is good for—has to deflect the question as reflecting a philosophical misunderstanding. "What does practicality have to do with art?" is the rhetorical retort of those persuaded that art exists for aesthetic satisfaction alone—for satisfaction *an sich*. So the same logical gulf that separates the aesthetic from the practical separates art from anything useful. And Kantian aesthetics has served the contemporary conservative art critic well in setting aside as irrelevant to art any instrumental ambitions artists might have of putting art to work in the service of this human interest or that, and most particularly political interests. "What has art got to do with politics?" the conservative critic asks, as if the question were rhetorical and the answer—"Nothing!"—a foregone certitude.

Greenberg's second Kantian tenet derives from the deep reason in Kant's system that the aesthetic was strictly segregated from the practical. It was because the judgment of beauty had to be tacitly universal, and universality would be incompatible with interest, and hence with practicality. "In all judgments by which we describe anything as beautiful, we allow no one to be of another opinion," Kant writes, not as a prediction that "everyone *will* agree with my judgment, but that he *ought*."[13] Kant invokes a special notion of what he terms "subjective universality" which bases itself on the postulation of a certain kind of *sensus communis* which in turn allows a certain parity of form between moral and aesthetic judgments in his system. Greenberg derived from the tacit universality of aesthetic judgments the thesis that art is all of a piece. He was particularly intent on demonstrating that there is no difference in our aesthetic experience of abstract as against representational art. Remember, he was writing at a time when critics were enough uncertain of abstract painting that they were prepared to argue that experiencing it was different in kind from experiencing representational art. In 1961 he wrote,

> Experience itself—and experience is the only court of appeal in art—has shown that there is both bad and good in abstract art. And it has also revealed that the good in one kind of art is always, at bottom, more like the good in all other kinds of art than it is like the bad in its own kind. Underneath all apparent differences, a good Mondrian or good Pollock has more in common with a good Vermeer than a bad Dali has. [There were no good Dalis for Greenberg.] A bad Dali has far more in common, not only with a bad Maxfield Parrish, but with a bad abstract painting.[14]

And Greenberg goes on to say that people who do not make the effort to experience or appreciate abstract art "do not have the right to pronounce on any kind of art—much less abstract art." They do not because they "have not taken the trouble to amass sufficient experience of it, and it makes no difference in this respect how much experience they have in other fields of art." To be seriously interested in art, we might paraphrase Greenberg as saying, is to be seriously interested in the good in art. "One is not for Chinese, or Western, or representational art as a whole, but only for what is good in it." And Greenberg's second tenet entailed that "the practiced eye" can pick out the good from the bad in art of whatever sort, independently of any specific knowledge of the circumstances of production in the tradition to which the art belongs. The owner of the practiced eye is aesthetically everywhere at home. Recently a well-

known curator boasted that without knowing anything about African art, he could, by means of his good eye alone, distinguish the good, the better, and the best.

Greenberg's strengths and weaknesses as a critic derived from these tenets. It was, for example, his confidence that the good in art is everywhere and always the same that underlay his openness to goodness to which others at the time were largely blind and explains his early identification of Jackson Pollock as a great painter. Little in the way in which abstract painting was produced in the 1940s would have prepared one for Pollock's work, and the ability to sense its artistic goodness—even to proclaim its artistic greatness—at a time when this was far indeed from the received view, gave Greenberg in retrospect credentials of a kind few other critics enjoyed. It also came to constitute a criterion for goodness as a critic that one make discoveries of a parallel sort, which has inevitably had certain pernicious consequences in subsequent critical practice: the critic is supposed to make discoveries in order to validate his or her "practiced eye," and this has defined for the critic a role of champion for one or another artist: one's stature as a critic rises and falls with the reputation of the artist on whose goodness one has staked one's critical reputation. The critic in search of credentials stalks the unknown or the underrecognized, which in part gives hope to the marginal gallery, the fresh talent, the venturesome dealer, and keeps the productive system from rigidification. The reverse of this has been the confession of an insufficiently good eye when the artist a critic opposes turns out after all to have been good or even great. Often, of course, this can be accounted for along the same lines Greenberg adduces in connection with the resistance to abstract art, where it can be argued that the stubborn critic—the terrible John Canaday of the *New York Times* is a case in point—will not open his eyes because of some a priori theory of what art has to be—for example, that it has to be representational. What Greenberg designates as "the opponents of abstract art" will argue that the experience of abstract art is not *artistic* experience "and that works of abstract art cannot be classified as art, properly speaking."[15] And one feels that clearly it must have been certain prior definitions of art which prevented those hostile to impressionism from seeing the goodness of those canvases, or which made it impossible to see the goodness of post-impressionist painting because the drawing was eccentric or the colors arbitrary. The implication is that if people would but *open their eyes* and, equally important, open their minds by allowing the mind to take its cue from what the practiced eye delivers it, there will be, just as Kant suggests, no final

disagreements: "Quality in art is not just a matter of private experience," Greenberg writes. "There is a *consensus* of taste. The best taste is that of the people who, in each generation, spend the most time and trouble on art, and this best taste has always turned out to be unanimous within certain limits, in its verdicts." If each individual cultivates an open mind and, to use a favorite expression of his, *bears down* hard enough, there will be no ultimate major disagreements.

The idea of a mind not closed by theory, and of trusting to sustained visual experience alone, is almost caricatured in Greenberg's mode of confronting a painting. At a memorial meeting a year after Greenberg's death, the painter Jules Olitski—whom Greenberg in later years often celebrated as our finest painter—described the format of a studio visit from the critic. Greenberg would stand with his back to a new painting until it was in place, and then wheel abruptly around to let his practiced eye take it in without giving the mind a chance to interpose any prior theories, as if there were a race between the transmission of visual stimuli and the speed of thought. Or he would cover his eyes until it was time to look. There are innumerable anecdotes of this sort regarding Greenberg, and it became something of a standard posture in studio and gallery. Thomas Hoving describes the setting for the two major acquisitions of his tenure as director of the Metropolitan Museum of Art in just those terms—the portrait by Velasquez of Juan de Pereija, and the *krater* of Europhronios, which came to be known as the Metropolitan's "million dollar pot," but which Hoving defended as the most beautiful artwork of his entire experience. In the former case, he refused to look at the painting until the lighting was just right, and then he commanded, "Hit me!"[16] With the illumination of the work, presumably, his eyes were flooded with preconceptualized beauty. He would not look at the pot until it had been carried out into the light of day. It was on the basis of this first glance that he made the decision to purchase these works, and while there is no doubt that Hoving needed to have the outcome of tests for authenticity of provenance in hand when he went before his board, it was the testimony of the practiced eye that finally counted for him.

Greenberg would say very little other than grunt a kind of approval or disapproval. In a late interview—indeed, in the final text of *The Collected Essays and Criticism*—he voices a corollary of the tenet regarding the authority of experience. Asked to state criteria for the difference between minor and major art, he remarked, "There are criteria, but they can't be put into words—any more than the difference between good and bad in

art can be put into words. Works of art move you to a greater or lesser extent, that's all. So far, words have been futile in the matter. . . . Nobody hands out prescriptions to art and artists. You just wait and see what happens—what the artist does."[17] It is striking that Greenberg sees critical response as of a piece with artistic creation, which is just what we would expect from his suspiciousness toward rules, which was after all a position Kant worked out in connection with artistic genius, granting of course the difference between taste and genius—between what Kant calls "a judging and not a productive faculty." Greenberg's monosyllabic utterances—visceral responses put into words, but words which were themselves visceral responses—were the critic's counterpart to the coming-from-the-guts of painterly gesture in the sort of art with which Greenberg must always be identified: abstract expressionism, though he deplored this as a label. Greenberg could hardly have achieved his tremendous reputation as a critic by grunts and grimaces. It is altogether instructive to read his review in November 1943 of Jackson Pollock's first exhibition at Peggy Guggenheim's Art of This Century Gallery. Of course, he had by then seen a certain amount of Pollock's work through studio visits which were perhaps very similar to those Jules Olitski described, movingly and comically, after his death. But in his review he gave reasons why Pollock's painting was good, even if the ascertaining of its goodness was a function of the eye, and, one might add, without taking a scrap away from any credit due him, a function of the fact that others whose taste he admired—Lee Krasner, Hans Hoffman, Piet Mondrian, Peggy Guggenheim herself—were unanimous in their admiration. In the end the task of the critic was to say what was good and what was not, based always on the deliverances of the eye as a kind of seventh sense: a sense of the beautiful in art, knowing it was art. If we think of this as what I term *response-based* criticism, then the tradition is being carried forward by critics very much less philosophically fortified in their practice than Greenberg was.

Greenberg effectively stopped writing criticism in the late 1960s, and it is difficult not to suppose that he did so because his entire practice as a critic was unable to gain a relevant purchase on an artistic practice governed by the principle, articulated by the two most influential artistic thinkers of that era, Andy Warhol and Joseph Beuys, that anything can be an artwork, that there is no special way that artworks have to look, that everyone can be an artist—a thesis Warhol advanced in his paint-by-the-numbers paintings which look like what anyone can do. Greenberg, ac-

cording to a recollection by William Phillips, was singularly egalitarian—
he really thought that anyone could paint—and he tried to get Phillips to
paint until Phillips's inability to stand the smell of paint got in the lesson's
way. I have heard his widow read from a moving but callow letter, writ-
ten in his thirties, describing his own first efforts at painting. He thought
his work was marvelous; he wrote his correspondent that painting came
as natural to him as "fucking." But he was not an ontological egalitarian,
and he would have dismissed the paint-by-the-numbers paintings of War-
hol as inconsistent with the philosophy of art he had learned from Kant:
they could be achieved by following rules, by putting red where the
numbers said one should. Of course, Warhol followed no particular rule
in making the work, but it would have been altogether consistent with
his impulses as an artist that he follow the rules in a paint-by-the-numbers
kit and exhibit the result. He probably did not, but let us imagine that he
did, and then exhibited the work. The eye, the practiced eye, would not
have been able to tell that an *artist* had filled in the numbered cells, since
the result would have looked like the real thing (something anyone in a
senior citizen's home might have done) and would have inherited what-
ever aesthetic qualities the latter had. And yet Warhol's piece and an
ordinary paint-by-the-numbers painting would have very different artistic
qualities. Warhol might be making the statement that anyone can be an
artist; he might be poking fun at the idea that painting has to be some-
thing that is torn from the artist's soul. The former trolley conductor in
the senior citizen recreation center who paints by the numbers is simply
following the rules in order to make a pretty picture. Warhol, had he read
Kant, could have made a statement about the Third Critique by means of
the paint-by-the-numbers paintings!

Pop art, or much of it, was based on the commercial art—on illustra-
tions, labels, package design, posters. The commercial artists responsible
for these colorful proclamatory images themselves had good eyes. Wil-
lem de Kooning had been a sign painter, and it is difficult to suppose that
in appropriating to the ends of fine art the special equipment of the sign
painter, he did not also employ the eye that made him successful as a sign
painter. An instructive case of the reverse of this was Watteau's appropri-
ating the equipment and the eye that went into his *fêtes galant* when he
executed, as what turned out to be his last work and indeed his master-
piece, a shop sign for his dealer, Gersaint, which actually did hang in front
of the latter's gallery for a time, showing what it looked like inside. The
Ensigne de Gersaint is an incidental counterexample to the first dogma of

aesthetics that art serve no practical use; it probably fit the conventions of the shop signs of Paris in the eighteenth century perfectly. But my only concern is to suggest that such commercial efforts are selected by some-one with a good eye who said, confronting, say, a Campbell's Soup label or a Brillo box design, "That's it!" In making their facsimiles, pop artists appropriated designs that had already passed an aesthetic test of some sort—which were selected because it was supposed they would catch the eye, or convey information about the product, or whatever. But what made pop art high art rather than commercial art had only incidentally to do with the aesthetic qualities that caused it to succeed as commercial art. The art criticism of pop art, which as a genre of art I always found intox-icating, had nothing to do with what met the eye, since what met the eye only explained its interest and value as commercial art. And the eye alone could not account for the difference.

But this is true of much of the art of the sixties and the seventies, and of the nineties as well. (The eighties was a somewhat retrograde mo-ment because painting reasserted itself as the dominant mode of art mak-ing.) The Kantian art critic would have been reduced to silence or to sputtering in the face of the slashed felt, the shattered glass, the spattered lead, the splintered plywood, the crudely twisted wire, the latex-soaked cheese cloth, the vinyl-soaked rope, the neon signs, the video monitors, the chocolate-smeared breasts, the tethered couple, the slashed flesh, the torn garments, or the sundered house with which artistic statements were made in those years and since.

Consider an important work of the sixties, Robert Morris's *Box with the Sound of Its Own Making* (1961). It is a wooden cube of not especially distinguished carpentry inside of which there is a tape of the hammering and sawing noises which went into its manufacture. The tape is like the box's memory of its own coming into being, and the work has at the very least a comment to make on the mind-body problem. Greenberg had no way to deal with this work. In 1969, he wrote with an almost breathtaking obtuseness,

> Art in any medium, boiled down to what it does in the experiencing of it, creates itself through relations, proportions. The quality of art depends on inspired, felt relations or proportions as on nothing else. There is no get-ting around this. A simple unadorned box can succeed as art by virtue of these things; and when it fails as art it is not because it is a plain box, but because its proportions, or even its size, are uninspired, unfelt. The same applies to works in any form of "novelty" art. . . . No amount of phenome-

nal, describable newness avails when the internal relations of the work have not been felt, inspired, discovered. The superior work of art, whether it dances, radiates, explodes, or barely manages to be visible (or audible or decipherable), exhibits, in other words, "rightness of form."[18]

"To this extent," Greenberg goes on to say, "art remains unchangable. . . . It will never be able to take effect *as art* except through quality."[19] Morris's work is brilliant and inspired, and certainly has "quality" as a work of art, but hardly quality as defined by "rightness of form." Greenberg felt that the art of the sixties was, beneath surface appearances, singularly homogeneous and even monotonous. He even ventured to identify the common underlying style as what "Wölfflin would call linear."[20] His tone in this late essay is biting, sarcastic, dismissive. It was the kind of response we recognize whenever a revolutionary moment has occurred in art—that the artists are out to shock, have forgotten how to draw, are behaving like very bad boys and girls. Whether it is to his credit or not, he did not change his mind for the last thirty years of his life. I heard him say these very things in 1992. Art had gone through a revolutionary moment, one that invalidated forever the easy transit from aesthetics to art criticism. The two could be connected again only by revising aesthetics as a discipline in light of the changes in critical practice the revolution of the sixties imposed.

I want now to say something about Greenberg's second Kantian tenet, which led criticism into much the same kind of hot water as the first tenet did, although this did not become quite as apparent until some years later. This tenet asserts the "unchangeableness of art," which Greenberg affirmed in an interview in 1969. He wanted to concede that American taste had matured over the years "but insisted that this is not the same thing as saying that there's been progress in art itself as distinct from taste. There certainly hasn't. Art hasn't gotten better or more 'mature' over the past 5,000, 10,000, or 20,000 years."[21] So taste has a developmental history, but art does not. Greenberg in fact argued that there has been a'"broadening of taste in our time, in the West," and this he believed was "owed in a certain large part to the effect of modernist art." He believed that the ability to appreciate modernist painting makes it easier for us to appreciate traditional art or art from other cultures, since representational art distracts us into thinking about what it shows rather than about what it is. "It's harder, I think, for a beginner to develop his taste with representational than with abstract art, all other things being equal. Abstract art is a wonderful way in which to learn to see art in general. You appreciate

the Old Masters all the more once you can tell a good Mondrian or a good Pollock from a bad one."²² This position, as I have often said, has the tendency to transform all museums into Museums of Modern Art, in which everything is to be appreciated in terms of the one thing art everywhere and always has, and which the eye trained on modernist painting learns how to identify and to grade. All artists are contemporaries, insofar as they are artists. They are not contemporaries on matters irrelevant to art.

This philosophy informed a number of heavily criticized exhibitions in the 1980s, chiefly the 1984 show "Primitivism and Modern Art" at the Museum of Modern Art, which was based upon "affinities" between Oceanic and African works and their formally similar counterparts in the modern movement. As an historical explanatory thesis, this is perhaps unexceptionable, true when it is true, false when it is false. Modern artists really have been influenced by primitive art. But affinities are different from explanations. They imply that the African or the Oceanic artist was driven by the same kind of formal considerations as the modernists. And many critics felt this to reek of what we might call cultural colonialism. Multiculturalism was on the ascendant in 1984, and was to overtake the art world, in America at least, in epidemic proportions in the nineties. According to the multicultural model, the best one can hope to do is try to understand how people within a given cultural tradition appreciated their own art. One cannot, from outside that tradition, appreciate it as it is appreciated from within, but one can at least attempt not to impose one's own mode of appreciation on traditions to which it was alien. This relativization was extended to the art of women, blacks, and minority artists even within our own culture. Small wonder that Greenberg was villainized in the art world of the late eighties and the nineties, as if he himself were to blame for such baleful shows as "Primitivism and Modern Art." When Kantian universalism was replaced with this unforgiving sort of relativism, the concept of quality became odious and chauvinist. Art criticism became a form of cultural criticism, chiefly of one's own culture. In candor, I am no happier as an art critic with this attitude than I was with Greenberg, and it would be altogether wonderful if one could turn to aesthetics as a discipline for guidance out of the chaos. If aesthetics could clarify the condition of criticism, the question of its practicality would be spectacularly established. I agree with Greenberg to this extent: there is a criterion of quality for works such as Warhol's by-the-number paintings and for Robert Morris's chatter-box, and if we worked out the art criticism for these objects, we would be in a better position to appreci-

ate the good and bad in modern works like paintings by Mondrian and Pollock, as well as in the Old Masters. A general theory of quality might then contain aesthetic goodness not as a defining trait but as a special case. For I hope I have shown that aesthetic goodness will not help with art after the end of art.

As an essentialist in philosophy, I am committed to the view that art is eternally the same—that there are conditions necessary and sufficient for something to be an artwork, regardless of time and place. I do not see how one can do the philosophy of art—or philosophy *period*—without to this extent being an essentialist. But as an historicist I am also committed to the view that what is a work of art at one time cannot be one at another, and in particular that there is a history, enacted through the history of art, in which the essence of art—the necessary and sufficient conditions—are painfully brought to consciousness. Many of the world's artworks (cave paintings, fetishes, altar pieces) were made in times and places when people had no concept of art to speak of, since they interpreted art in terms of their other beliefs. It is true that today our relationship to these objects is primarily contemplative, since the interests they embody are not our own, and the beliefs in the light of which they were regarded as effective can no longer be widely held, least of all among those who admire them. It would be a mistake to suppose that contemplation belongs to their essence as artworks, for it is almost certain that the people who made them had little interest in their contemplation. In any case, makeshift notions like satisfaction *an sich* or Schopenhauer's will-less perception, as definitions of the aesthetic have roughly the conceptual finesse of "featherless biped" as a definition of man. One often finds oneself staring out a window, or turning a mustard pot idly in one's hand like a Françoise Sagan heroine, for no particular reason except to kill time. And the mystic's posture of contemplation, which stills the mind, has no special rapport with the aesthetic.

There is, just possibly, a universal aesthetic notion, which had for a time—fatefully the time when the originary works of aesthetic philosophy were framed—a certain application to works of art, so that for that time the work of art was an intersection of crossed universals—the universal which belongs to art by essentialist considerations, and the universal aesthetic which belongs to human, perhaps to animal sensibility through being coded for in the genome. About this I will say a few reckless words to conclude this chapter and then return to my primary concerns.

Recently I have been struck by some empirical work in psychology which strongly supports the thesis that there are perceptions of beauty which cut across cultural lines. A 1994 study in *Nature* reported that both British and Japanese men and women ranked women's faces in order of attractiveness when certain features were exaggerated like large eyes, high cheekbones, and a narrow jaw. Caucasians, moreover, ranked Japanese women's faces the same way Japanese themselves did, and the authors of the article claim that there are "greater similarities than differences in cross-cultural judgments of facial attractiveness."[23] The faces used were generated by computer, and the most attractive faces exaggerated certain traits in such a way as to give empirical support to a thesis of Schopenhauer that the visual arts yield "Platonic" ideas of the beauty found in actual persons. The features in question are exaggerations in much the same way that the tails of peacocks are exaggerations, but they are, in a commentary on the study, said to imply certain highly desirable traits in their owners, perhaps in the same way the tremendous feather display of the peacock does: traits such as resistance to disease, fertility, and youth.[24] And again Schopenhauer has something right when he refers to "the marvelous sense of beauty" of the Greeks

> which enabled them alone of all nations to set up for the imitation of all nations the standards of beauty and grace; and we can say that that which, if it remains unseparated from the will, gives sexual impulse, with its discriminating selection, i.e., *sexual love* ... becomes the *objective sense of beauty* for the human form, when, by reason of the presence of an abnormally preponderating intellect, it detaches itself from the will, and yet remains active.[25]

And needless to add, we have the myth of the sculptor who creates a statue of a woman he would fall in love with if she were real, giving vividness to Kant's idea that natural and artistic beauty are one.

This principle of beauty, as I suggested, at a certain level of abstractness, cuts across not only cultural lines but lines of species.[26] Evolutionary biologists have lately begun to associate symmetry with sexual desirability in a wide variety of species. The female scorpion fly shows invariant preference for males with symmetrical wings. The female barn swallow prefers a male with symmetrical wishbone pattern of feathers the same size and color on both sides of the tail. Asymmetrical antlers will cut the male who has them out of the mating game. Symmetry is perhaps a sign that the male has an immune system resistant to certain parasites which

are known to cause uneven growth. This is a growing field of experimentation, but it suggests, there being nothing more "practical" than sex, that dear old natural selection accounts for aesthetic preferences which the clever Greeks introduced into their art, at which, even when the will is out of play because we know them to be statuary, we enjoy looking with the same prurient eyes we cast on one another. You may not be able to "put it all into words," but you can go a long way in that direction from the perspectives of evolutionary biology. The principles of good design are the same as the outward emblems of health and fertility—a consideration which rejoins the somewhat morally difficult identification of goodness with beauty and badness with its absence, as in the philosophies of Schopenhauer and Nietzsche. Of course, there are complicating factors with human beings. A human male with a disfigurement parallel to the elk with asymmetrical antlers can procure a sexual partner with high cheekbones and a narrow jaw if he happens to have pots of money, a mismatch due to cultural mischievousness which gives rise to the basic situation of comedy. And everyone in the world can specify the physical attributes of the attractive male who makes up the third figure in the eternal triangle. And now that we know that chimpanzees are carnivores, we have also discovered that an ill-favored male with a haunch of monkey-meat to share can secure the sexual favors of the classiest female in the clan.

Schopenhauer denies that symmetry is a necessary condition of beauty, offering as counterexample the case of ruins.[27] One does not idly offer counterexamples: the thesis of symmetry and beauty had to have been in the air, and the move from symmetry to ruin marks the transition in the history of taste from neoclassicism to romanticism. There are ruins and ruins, of course, some more beautiful than others, but it seems to me that with them we more or less leave the sphere in which sexual response is triggered and enter the sphere of meaning. We leave, in Hegel's terms, the sphere of natural beauty for the beauty of art and of what he termed spirit. The ruin connotes the relentlessness of time, the decay of power, the inevitability of death. The ruin is a romantic poem in the medium of dilapidated stone. The ruin is like the cherry tree in bloom when we visit the cherry trees to see the bloom, and think of the transience of the features that give us a leg up in the evolutionary Olympics, the fragility of beauty, and the passage of time. We think of A. E. Housman's springs that will never come again. Even if nobody made the blossoms, someone planted the trees, and, as Hegel puts it in speaking of the work of art, "It

is essentially a question, an address to the responsive breast, a call to the mind and the spirit."[28] And that is true of Morris as of Warhol, of Pollock as of Mondrian, of Hals as of Vermeer.

In the famous passage already cited on the end of art, Hegel speaks of intellectual judgment of "(i) the content of art, and (ii) the work of art's means of presentation." Criticism needs nothing further. It needs to identify both meaning and mode of presentation, or what I term "embodiment" on the thesis that artworks are embodied meanings. The mistake of Kantian art criticism is that it segregates form from content. Beauty is *part* of the content of the works it prized, and their mode of presentation asks us to respond to the meaning of beauty. All of that can be put into words when one does art criticism. Putting all that into words is what art criticism *is*. To its credit, Kantian art criticism was able to dispense with narratives, which meant, since Greenberg is identified with a narrative, that there was a flaw at the heart of his thought. Little matter. Few have achieved as much. How to do art criticism which is neither formalist nor enfranchised by a master narrative is something I shall attend to later.

NOTES

1. Arthur Schopenhauer, *The World as Will and Representation*, trans. E. F. G. Payne (New York: Hafner Publishing Company, 1958), 2:388. Unless otherwise indicated, all reference to Schopenhauer are to this text.

2. Immanuel Kant, *Critique of Judgment*, trans. J. M. Bernard (New York: Hafner Publishing Company, 1951), 45.

3. Ibid., 58.

4. Ibid., 149.

5. Greenberg, "The Identity of Art," *The Collected Essays and Criticism*, 4:118.

6. Art could succeed at the other aim Kant acknowledges, namely "the sublime." But once again, the concept of sublimity cuts across the distinction between art and nature.

7. Steven Watson, *Strange Bedfellows: The First American Avant-Garde*, 313–14.

8. Marcel Duchamp, "Letter to Hans Richter, 1962," in Hans Richter, *Dada: Art and Anti-Art* (London: Thames and Hudson, 1966), 313–14.

9. Greenberg, "Review of *Piero della Francesca* and *The Arch of Constantine*, both by Bernard Berenson," *The Collected Essays and Criticism*, 3:249.

10. Kant, *Critique of Judgment*, 150.

11. Greenberg, "The Identity of Art," *The Collected Essays and Criticism*, 4:118.

12. Ibid., 120.

13. Kant, *Critique of Judgment*, 76.

14. Greenberg, "The Identity of Art," *The Collected Essays and Criticism*, 4:118.

15. Ibid., 4:119.

16. Thomas Hoving, *Making the Mummies Dance: Inside the Metropolitan Museum of Art* (New York: Simon and Schuster, 1993), 256.

17. Greenberg, "Interview Conducted by Lily Leino," *The Collected Essays and Criticism*, 4:308.

18. Greenberg, "Avant-Garde Attitudes: New Art in the Sixties," *The Collected Essays and Criticism*, 4:300.

19. Ibid., 301.

20. Ibid., 294.

21. Greenberg, "Interview Conducted by Lilo Leino," 4:309.

22. Ibid., 310.

23. D. J. Perrett, K. A. May, and S. Yoshikawa, "Facial Shape and Judgements of Female Attractiveness," *Nature* 368 (1994): 239–42.

24. Nancy L. Etcoff, "Beauty and the Beholder," *Nature* 368 (1994): 186–87.

25. Schopenhauer, *The World as Will and Idea*, 2:420.

26. Paul J. Watson and Randy Thornhill, "Fluctuating Asymmetry and Sexual Selection," *Tree* 9 (1994): 21–25.

27. Schopenhauer, *The World as Will and Idea*, 1:216.

28. Hegel, *Aesthetics*, 71.

THE LIBRARY OF THE ARTIST ARMAN. PHTOGRAPH BY JERRY L. THOMPSON.

Painting and the Pale of History:
The Passing of the Pure

THERE ARE few better exercises for those who seek to think philosophically about history—who seek, as I am attempting to do, for objective narrative structures in the way human events unfold—than to attempt to see the way the past saw the future, and hence the way those who saw the future as they did had to see their present as they did. Construing the future in terms of possible chains of events which would intimately depend upon the actions they took or failed to take, the agents sought to organize their present so as to generate chain of events favorable to their perceived interests. And of course it does sometimes happen that the future really, so far as we can tell, happens the way it happens because of what we do or fail to do in the present, and those who successfully give shape to the course of events can congratulate themselves with what philosophers call contrary-to-fact conditionals. They can say, "Had we not done such and such, then so and so would never have happened." But we actually act in the light of conditionals we *believe* true, and it is probably a presupposition of rational action that our actions have reasonably predictable outcomes and that within limits we are able to guide our actions in the light of those anticipated outcomes. On the other hand, there is a great deal to which we are blind, and one value of seeing the past's way of seeing the future is that, knowing how their future looks from *our* own vantage point in history, we can see how it differs from how the agents of the past construed it. They, of course, necessarily lacked our perspective: if they could have seen the present as it would appear to the future, they would have acted differently. The great German historian Reinhart Koselleck wrote a book with the marvelous title *Vergangene Zukunft* (The Futures of the Past), arguing that the futures in the light of which people of the past lived their present are an important part of the past.[1] Think of the belief that the world was going to end in A.D. 1000 as a case in point. There would be

little point in doing much except pray: you would not put up pickles for the winter to come, or repair the pig pen, or buy life insurance, if you thought everything was going to be erased in a blast of angelic trumpets!

From this perspective it is instructive to see the way Greenberg viewed the historical present of the early 1960s, given his powerful narrative, which after all defined the shape of the future as well as his own set of critical practices, grounded as they were by that narrative. What in objective historical fact happened, of course, was that the visual arts began to turn toward a kind of art for which an aesthetics-driven critical practice stopped having much applicability—a turn neither Greenberg's narrative nor his critical practice could easily accommodate. Though Greenberg was aware that art was taking that sort of turn, he tended to regard it as a deviation from the orthogonal of history as he projected it. He continued to see abstract expressionism as the main agency of modernist art history, but at the same time, in the early 1960s, he began to see it faltering, slipping the rails of historical destiny. It did so, one might say, by failing to heed the imperatives of modernism to which Greenberg was totally committed. He had defined the subject of painting as painting—as the creation of physical objects consisting of pigment spread across flat surfaces of a certain shape. But, almost dialectically, it seemed that the abstract expressionists also accepted the materialist imperative of modernism altogether too fervently. And in doing so they violated the larger modernist imperative that each art to stay within the limitations of its own medium and not to usurp the prerogatives of any other art or medium: to Greenberg's eye, abstract expressionism spilled over its defining boundary into the domain of sculpture. "To each its own" was the drive of modernist art history, rather in the way in which the division of labor was the basis of justice in Plato's *Republic*, where injustice consisted in the mismatch of person and position.

In his 1962 essay "After abstract expressionism," Greenberg made a surprising claim. It had to do with what one might have supposed inevitable, given his materialist aesthetics. One would have thought that the abstract expressionist treatment of paint as paint—juicy, viscous, dripping, fat—was just what the theory demanded, that paint would become its own subject. This turned out not to be the case:

> If the label 'Abstract Expressionism' means anything, it means painter-
> liness: loose, rapid handling, or the look of it; masses that blotted and fused
> instead of shapes that stayed distinct; large and conspicuous rhythms;
> broken color; uneven saturations or densities of paint, exhibited brush,

knife, or finger marks—in short, a constellation of qualities like those defined by Wölfflin when he extracted his notion of the *Malerische* from Baroque art.[2]

But, ironically, space in abstract expressionism "could not help becoming once again a matter of *trompe l'oeil* illusion. . . . it became more tangible, more a thing of immediate perception and less one of 'reading.'" As near as I can understand this, it means that as paint became three-dimensional, it took on the identity of sculpture, and space became illusory once again. One would have thought that it became *real*—but in any case, "a good deal of Abstract Expressionist painting began fairly to cry out for a more coherent illusion of three-dimensional space, and to the extent that it did this it cried out for representation, since such coherence can be created only through the tangible representation of three-dimensional objects." Hence Willem de Kooning's *Women* pictures of 1952–55. On Greenberg's view, the only way to carry art forward on its historical mission, since abstract expressionism failed, was through what he called "post-painterly abstraction" in a show he organized for the Los Angeles County Museum or Art in 1964. And in his essay for the catalog he spoke of the decline of abstract expressionism into what he termed a "mannerism." Greenberg began to see the champions of art's progress in Helen Frankenthaler, Morris Louis, and Kenneth Noland; and his disciple, Michael Fried, in a crucial monograph, *Three American Painters*, widened this heroic group to include Frank Stella and Jules Olitski, whom Greenberg also came to admire and to identify as the great hope of art. Sculpture played an auxiliary role: David Smith and Anthony Caro carried the narrative of materialist aesthetics forward, and Greenberg did not hesitate to intervene actively in order to assure that this took place.

Greenberg, so far as I know, nowhere asks why abstract expressionism, "having produced art of major importance, . . . turned into a school, then into a manner, and finally into a set of mannerisms. Its leaders attracted imitators, many of them, and then some of these leaders took to imitating themselves." Was there anything internal to abstract expressionism that made it incapable of sustaining further progress? I am no more certain of the answer to this question than I am of how it was possible for abstract expressionism as a style to make the first artists who took it up into masters overnight: Kline, Rothko, Pollock, and even de Kooning were really quite modest painters until they found themselves abstract expressionists. But I think one answer might have to do with the fact that, by contrast with the painting of the tradition, there was nothing for the

abstract expressionist canvas to be but art. It could play no social role in murals, for example, or fit into the workaday artisanry of traditional painting. It really had only its own drives, externally reinforced by the drives of the market, and hence it existed mainly to be collected. It belonged in the collection, and hence, by contrast with the Vasarian painting, was more and more cut off from life, and lived more and more a segregated existence in the world of art. It really did fulfill the Greenbergian requirement that painting have its own autonomous history, and it collapsed from lack of external input. The next generation of artists sought to bring art back into touch with reality, and with life. These were the pop artists, and in my historical perception, it was pop above all which set the new course for the visual arts. But Greenberg, locked into an historical vision and a critical practice that had no space for pop, was unable to accommodate it to his concepts and categories. He of course was not alone in this. It was very difficult for critics, not to speak of artists, whose future was defined by abstract expressionism and its associated ideals, to perceive pop as anything but a transient blip in the unfolding of that future.

It is in no sense to Greenberg's discredit that he did not see pop art as marking a major historical change. "So far," Greenberg wrote, "it amounts to a new episode in the history of taste, but not to an authentically new episode in the evolution of contemporary art." What Greenberg regarded as a "new episode in that evolution" was the work in his show of post-painterly abstractionism, probably because it thematized the flatness of which he made so much and, since staining rather than brushing became its favored mode of "post-painterly" laying of paint onto surfaces, supported his theory that the brushstoke needed to be eliminated to keep painting "pure." For it remained an axiom that the evolution of contemporary art was to be enacted through the evolution of painting. And what Richard Wollheim has called "painting as an art" was in for some very rough times in the following decade and a half. It was the seeming rebirth of painting, spectacularly in the work of Julian Schnabel and David Salle in the early 1980s, which gave so many the sense that art history was back on track—but *that* proved to be an episode of taste rather than of the evolution of contemporary art; and, as the eighties wore on into the nineties, it became clearer and clearer that painting was no longer the Siegfried of art-historical change.

Greenberg was finally unable to take pop art seriously. He relegated it to the category of novelty art, along with op, minimalism ("'novelty' in the old-fashioned sense of novelties sold in stores," he somewhat meanly

clarifies). But he was not able to take any art seriously after post-painterly abstraction, and his own critical output pretty much came to a halt: the last volume of his collected writings, published in 1993, ends at 1968. He had no way, no serious way, of fitting the new art into his marvelous narrative, and his sour remarks are strikingly similar in tone to those made at the advent of modernism to the effect that modernist artists could not draw or paint, or, if they could, that they were engaged in some hoax or other, and that, surely, once this was seen through, the "threat" it posed would vanish and "real" art would once again prevail. He tried to argue that the new art was "rather easy stuff, familiar and reassuring under all the ostensibly challenging novelties of staging," that it was not really avant-garde, that it was "'hard' and 'difficult' only on the outside," but soft on the inside.[3] Meanwhile there was a saving remnant, "a handful of painters and sculptors between the ages of thirty-five and fifty still produc[ing] high art." In 1967 he cautiously predicted that novelty art would collapse as a movement "as second generation Abstract Expressionism did so suddenly in 1962." And Greenberg speculated on the possibility "of the production of high art in general coming to an end along with the avant garde."

In the summer of 1992, Greenberg spoke for a small group in New York. He claimed that perhaps never in history had art "moved so slowly." Nothing, he insisted, had happened in the past thirty years. *For thirty years* there had been nothing but pop. He found this incredible, and he was extremely pessimistic when someone in the audience asked what he foresaw. "Decadence!" he answered, I think in anguish. He still thought, that is, that painting would somehow save us and that the history of art could be moved forward only through a revolution of painterly invention. I was, I must admit, thrilled to hear history talked about in such grand and sweeping terms. But I also thought that, just as at some point the explanation that modern artists have forgotten how to draw or have all become hoaxers stopped being acceptable and a new narrative was called for, so the explanation that art in the past thirty years is merely the ceaseless effort to satisfy the appetite for novelty had to be surrendered and the art of our period looked at from the perspective of a master narrative as compelling as Greenberg's narrative of modernism was.

Hence my thesis of the end of art.

Let me somewhat self-consciously and somewhat sheepishly invoke the heavy metaphysical conceit that Painting with a capital *P* or Art with a capital *A* exists on a plane with Spirit or Geist in the old Hegelian narratives, and that "what Art wanted" defined the pale of history for a

master narrative of art. I take the notion of "what Art wanted" from an idiom of the American architect Louis Kahn, who, in working out the form of a building, used to ask "what the building wanted," as if there were an internal drive, or what the later Greeks called an entelechy, an end state of fulfillment in which the building found the form through which it fulfilled its being. Employing this conceit, the proposal is that Art identified itself with a certain form of representationalism in the Vasarian era of its biography, and was jolted out of this mistaken identification sometime in the late nineteenth century, and came instead (this is Greenberg's view) to identify itself with its material vehicle, with paint and canvas, surface, and shape, at least in the case of painting. Other art was being made in these eras which did not exactly fit this scheme, but it fell outside the pale of history, so to speak. In his *Italian Painters of the Renaissance*, Bernard Berenson wrote that the painter Carlo Crivelli "does not belong to a movement of constant progress, and is therefore not within the scope of this work."[4] In a fascinating discussion of Crivelli, Jonathan Watkins cites writers who found difficulty in fitting Crivelli into their narrative of "constant progress."[5] Crivelli, according to Roberto Longhi, was incapable of incorporating into his work the "profonda innovazione pittorica e prospettica" of Giovanni Bellini; and according to Martin Davies, he took an "agreeable high-class holiday far away from great pictures and the aesthetic problems they pose." Watkins undertakes to show that Crivelli was using illusion to destroy illusion, and doing so in order to achieve an altogether profound criticism of Renaissance art. Berenson appreciated something profound in Crivelli, but goes on to say that it would be "distorting our entire view of Italian art in the fifteenth century to do full justice to such a painter . . ." So either you can say Crivelli falls outside the pale of history, or, like Watkins, you can say "so much the worse for history" and "feel free to reconstruct [the past] should the need arise." "So much the worse for history" means, surely, so much the worse for narratives. But in fact it is only against a defining developmental narrative that the true originality of Crivelli can be made visible. It is heroic to seek to abolish narratives altogether, but that would at the very least press Hans Belting's question of the end of art history back into the quattrocento. And it would, beyond that, blur what seems to me to be the historical mark of the present—namely, that no master narrative applies.

A similar criticism of the Greenbergian narrative is raised in a powerful critique by Rosalind Krauss, whose book *The Optical Unconscious* discusses with immense sympathy and understanding a number of great

artists whose contributions formalist criticism had, in a nearly psycho-analytical way, consigned by "repression" to a state of critical oblivion.[6] Criticism, especially under the influence of Greenberg, had no way of dealing with Max Ernst, Marcel Duchamp, or Alberto Giacometti, or even with certain works of Picasso. Greenberg had no use whatever for surrealism, which he regarded as historically retrograde. "The anti-formal, anti-aesthetic nihilism of the Surrealists—inherited from Dada with all the artificial nonsense entailed—has in the end proved a blessing to the restless rich, the expatriates, and the aesthetic flaneurs who were repelled by the asceticisms of modern art."[7] Because their aim, as Green-berg sees it, was to shock, the surrealists were obliged to cultivate the kind of virtuosity in naturalistic representation that we find in Dali. On the other hand, it is not easy to see how abstract art could shock except by virtue of its contrast to a reigning norm of naturalistic representation. But the moment when abstraction could be shocking was long past, and so surrealism could achieve its aim only through juxtapositions of realisti-cally rendered objects which can have no natural meeting place in the real, but only in the sur-real world. And, greatest sin of all, given Green-berg's vision of each medium to itself, "it is possible to construct faithful duplicates in wax, papier-mâché, or rubber of most of the recent paint-ings of Ernst, Dali, and Tanguy. Their 'content' is conceivable, and too much so, in other terms than those of paint."[8] So surrealism had to be explained away as outside the pale of history.

In my own version of the idea of "what art wants," the end and fulfill-ment of the history of art is the philosophical understanding of what art is, an understanding that is achieved in the way that understanding in each of our lives is achieved, namely, from the mistakes we make, the false paths we follow, the false images we come to abandon until we learn wherein our limits consist, and then how to live within those limits. The first false path was the close identification of art with picturing. The second false path was the materialist aesthetics of Greenberg, in which art turns away from what makes pictorial content convincing, hence from illusion, to the palpable material properties of art, which differ essentially from medium to medium. Logicians draw a standard distinction between the use and mention of an expression. An expression is used when one wants to talk about what the expression refers to in our language. Thus "New York" is used to refer to the city of New York in the sentence "New York is the home of the United Nations." But we *mention* an expression when the expression itself is what we talk about. Thus the expression "New York" is mentioned in "New York consists of two syllables." In a

way, the shift from a Vasarian to a Greenbergian narrative was a shift from artworks in their use-dimension to artworks in their mention capacity. And criticism, accordingly, shifted its approach from interpreting what works were about to describing what they were. It shifted, in other words, from meaning to being, or, loosely speaking, from semantics to syntax.

One can get a fair sense of the implications of this shift if one thinks of the difference in the way works of art outside the pale of history were addressed. During the course of modernism, African art rose in esteem, making a transition from the museum of natural history and the curio shop to the museum of art and the art gallery. If art historians had difficulty fitting Carlo Crivelli into the great developmental and progressive narrative of art, what possible case could be made for African fetishes and idols? Riegl supposes himself to be "following the spirit of today's natural science" in "assuming that contemporary primitive cultures are the rudimentary survivors of the human race from earlier cultural periods."[9] This justifies him in thinking that "their geometric ornament must represent an earlier phase of development in the decorative arts and is therefore of great historical interest." But so must their mode of representation, on this assumption—which is essentially the assumption of Victorian anthropology—give us an insight into a stage of mimesis earlier by far than any we might know about in European art, and this makes African art of considerable scientific interest. Hence the status of curios and specimens that was assigned to objects collected from so-called primitive peoples by those who studied and classified them. Primitive cultures were, as it were, living fossils in a phylum whose latest and highest exemplars were our own. Or like natural mummies, preserved by change, giving us access to earlier stages of ourselves.

When these objects became pivotal to the history of modernism, spectacularly in the case of Picasso, whose visit to the anthropological museum at Trocadero proved momentous for his own development and the subsequent development of modernist art, critics and theorists began to look at them in a new way, no longer seeing the need to distinguish between modern and "primitive" art, since they were presumed to be comparable at the level of form. Roger Fry wrote a powerful essay on "Negro Sculpture" in 1920 and emphasized the immense change that had taken place from the assumptions of the Victorian anthropology with which Riegl was so unquestioningly comfortable. "We would like to know what Doctor Johnson would have said to any one who had offered him a negro idol for several hundred pounds," Fry reflects. "It would have seemed then sheer lunacy to listen to what a negro savage had to

tell us of his emotions about the human form." Fry contends that some of the objects on view are "great sculpture—greater, I think, than anything we produced even in the Middle Ages."[10] Another formalist thinker, the American eccentric Albert Barnes, had no difficulty whatever in displaying African sculpture along with the modernist artworks he collected. Even more open than that, since he displayed objects of craftsmanship on the walls of his gallery between paintings, as if there was no longer, as indeed on formalist principles there no longer was, a serious basis for discriminating art from craft. But in fact modernism dissolved a great many boundaries, largely by aestheticizing or formalizing objects from diverse cultures which Riegl's contemporaries—not to mention Doctor Johnson's!—would have found beyond the pale of taste.

I think a fascinating study could be done of the way in which earlier periods—those without, for example, the complacent picture provided by Victorian anthropology—responded to "exotic art." The first evidence we have, for example, of the way in which goldwork from Mexico was perceived is striking. The author of the following remarks is Albrecht Dürer:

> I have also seen the things brought to the king from the new golden land: a sun all of gold a whole fathom broad, also a moon all of silver and just as large; also two chambers full of instruments of these people, likewise all kinds of weapons, armor, catapults, wonderful shields, strange garments, bed hangings, and all kind of things for many uses, more beautiful to behold than prodigies. These things were all so precious that they are valued at a hundred thousand gulden. All the days of my life I have not seen anything that gladdened my heart as these things did. For I saw among them wonderful works of art and marvelled at the subtle ingenuity of people in strange lands. I do not know how to express all that I experienced there.[11]

Spanish historian of the New World Petrus Martyr, who saw the objects sent by Moctezume to Charles V in Valladolid the same year Dürer saw them in Brussels, had no difficulty in responding to them aesthetically: "Though I little admire gold and precious stones, I am amazed by the skill and effort making their work exceed the material. . . . I do not recall ever seeing anything so appealing by its beauty to human eyes."[12]

These witnessings took place in 1520. The first edition of Vasari's text was published in 1550, and I suppose it is important to stress the difference in aesthetic response to works of art before the invention of art history, taking Vasari to have founded art history in the sense at least that he saw

art as an unfolding progressive narrative. Neither Dürer nor Petrus Martyr had the task of fitting this work into a narrative, the way Berenson would later have to abandon the hope of dealing art historically with Crivelli, since there was no way of fitting the latter into the story he had to tell. Nor did Fry, Barnes, and Greenberg have to deal with this problem, since modernism enfranchised "exotic art" by liberating its viewers from the obligation to narrativize it. But that is because they could deal with it ahistorically in terms of the transcendental principles—of what Greenberg, following Kant, refers to as taste. But this merits a word or two.

Taste was the central concept in eighteenth-century aesthetics, and the central problem in that era was how to reconcile what appeared to be two undeniable truths about taste: that "de gustibus non est disputandum" (there is no disputing taste), on the one hand, and that there is such a thing as good taste so that taste is not as subjective and relative as the first truth would appear to require. "The great variety of Taste, as well as of opinion, which prevails in the world, is too obvious not to have fallen under everyone's observation," Hume wrote. "But those who can enlarge their view to contemplate distant nations and remote ages, are still more surprised at the great inconsistence and contrariety."[13] Speaking preemptively for his contemporary Doctor Johnson, Hume remarks that "we are apt to call *barbarous* whatever departs widely from our own taste and apprehension." But then, he notes, common sense would also oppose as absurd a claim that the work of a poet like Ogilby is equal to that of Milton—a claim, Hume contends, as extravagant as that a heap of sand is as high as Mount Teneriffe. And if someone should persist in false aesthetic judgments or preferences, that simply manifests a certain indelicacy of taste, and, more important, a defective education of taste. As the term implies, there is little to distinguish aesthetic taste from a refined palate, and in both cases instruction will demonstrate that certain things are in the end more rewarding—are aesthetically better—than others. And Hume draws attention to the existence of critics who, by distancing themselves from practice and liberating their imagination, can be counted on to give the sorts of judgments the rest of us would arrive at were we to undergo a comparable discipline. It is this premise that underlies Kant's extraordinary thesis that to find something beautiful is tacitly to make a universal judgement—that is, to prescribe that everyone will find it beautiful. And it is this idea, as I have tried to show, which underlay Greenberg's own vision of criticism. Hume offers what could be extrapolated as commandments for the critic in *Of the Standard of Taste*. When the critic "has no delicacy," when "he is not aided by practice," "where no comparison has been employed," "where he lies under the

influence of prejudice," and "where good sense is wanting," the critic "is not qualified to discern the beauties of design and reasoning, which are the highest and most excellent." So the ideal critic is delicate, practiced, open, able to compare, and hence possesses knowledge of a wide range of art and is endowed with good sense: "The joint verdict of such, wherever they are to be found, is the true standard of taste and beauty."

All works of art are as one, under this view, and in a sense modernism was the art movement that enfranchised the broadening of taste that enables us to place works of Negro sculpture in museums of fine art, conceived as institutional encyclopedias of form. All museums, as I said, are museums of modern art, to the extent that the judgment of what is art is based on an aesthetic of formalism. The aesthete is at home everywhere, and the Baule mask or the Asanti figure hangs beneath the Pollock and the Morandi in the libraries of discriminating collectors the world round. Form is after all form, and once we are liberated from the Johnsonian disposition to stigmatize African art as barbaric, how easily we accept that the art of Africa rubs elbows with that of Paris or Milan. How easily, indeed, given that so much cosmopolitan art has a geneaology that includes at least some African ancestor. This was the thesis the widely criticized exhibition "Primitvism and Modern Art" at the Museum of Modern Art in 1984 attempted to demonstrate. But was it for the beauty of its design that Picasso was moved by the art he encountered at the Trocadero in 1907? Not according to the testimony of his own recollection.

> When I went to the Trocadero it was disgusting. The flea market. The smell. I was all alone, I wanted to get away. But I didn't leave. I stayed. I stayed. I understood something very important: something was happening to me, right? The masks weren't like other kinds of sculpture. Not at all. They were magical things. And why weren't the Egyptian pieces or the Chaldean? We hadn't realized it: those were primitive [note the voice of Victorian anthropology here], not magical things. The Negro's sculptures were intercessors. I've known the French word ever since. Against everything, against unknown, threatening spirits. I understood; I too am against everything. I too think that everything is unknown, is the enemy. . . . All the fetiches were used for the same thing. They were weapons. To help people stop being dominated by spirits. . . . Les Demoiselles d'Avignon must have come to me that day.[14]

Modernist art is art defined by taste, and created essentially for persons of taste, specifically for critics. But African art was created for its power over the dark forces of the threatening world. "I went to see the carvings,"

Virginia Woolf wrote her sister in 1920. "I found them dismal and impressive, but heaven knows what real feeling I have about anything after hearing Roger discourse. I dimly see that something in their style might be written, and also that if I had one on the mantelpiece I should be a different sort of character—less adorable, as far as I can make out, but somebody you wouldn't forget in a hurry."[15] I salute Woolf's response. But those African carvings have found their way onto numerous mantelpieces as ambassadors of good taste, without in any way changing the character of those who place them there. A wonderful exhibition of contemporary artists who collect African art shows, in fact, that the preexisting character of the artist tends to define what African art means to him or her.[16] But the general point remains that feeling and form, to use the conjunction I first heard made by my teacher Susanne K. Langer, have tended overall to rule one another out. Or rather, in African art feeling rather than taste defines form. The end of modernism meant the end of the tyranny of taste, and indeed, opened room precisely for just what Greenberg found so unacceptable in surrealism—its antiformal, anti-aesthetic side. Aesthetics will carry you no great distance with Duchamp, nor will the kind of criticism Duchamp requires obey Hume's tablet of commandments.

Greenberg understood this perfectly, up to a point. In 1969 he wrote, in an essay on the avant-garde, that "things that purport to be art do not function, do not exist, as art until they are experienced through taste." But he felt that a good many artists at the time were working "in the hope, periodically renewed since Marcel Duchamp first acted on it fifty-odd years ago, that by dint of evading the reach of taste while yet remaining in the context of art, certain contrivances will achieve unique existence and value. So far this hope has proved illusory."[17] Of course it has—if Greenberg is right that nothing exists as art unless experienced through taste. The project would be incoherent, like endeavoring to make art by evading the reach of art. But the *ontological* success of Duchamp's work, consisting as it does in art which succeeds in the absence or the abeyance of the considerations of taste, demonstrates that the aesthetic is in fact not an essential or defining property of art. This, as I see it, not merely put an end to the era of modernism, but to the entire historical project that characterized modernism, namely, by seeking to distinguish the essential from the accidental qualities of art, to "purify" it, alchemically so to speak, of the contaminants of representation, illusion, and the like. What Duchamp did was to demonstrate that the project ought rather to have been to discern how art was to be distinguished

from reality. This, after all, was the problem that animated Plato at the very beginning of philosophy, and which I have often argued gave rise to the great Platonic system nearly in its entirety.[18] Plato knew what Picasso was to discover in an artistic tradition that had not been corrupted by philosophy, that art was a tool of power. In raising the question of art and reality as he did, Duchamp reconnected art with its philosophically disenfranchising beginnings. Plato had the right problem—he just gave a disfiguring answer.

To solve the philosophical problem of the relation of art and reality, critics had to begin analyzing art of a kind so like reality that the differences had to survive the test of perceptual indiscernibility. They had to answer a question like mine: "What distinguishes Warhol's *Brillo Box* from the Brillo boxes in which Brillo comes?" The witty deconstructionist Sam Wiener moved the issue back even further historically by exhibiting a box with real Brillo in it on which he pasted the Magritte-inspired label "This is not a Warhol!" But I did not intend to give Warhol all the credit for this breakthrough to philosophy. It was taking place all across the art world, especially in sculpture. It was happening with the minimalist use of industrial materials, with *arte povera*, with the kind of post-minimalist art that Eva Hesse was making. In an interview, sculptor Ron Jones has spoken of what he terms "Pictures aesthetics," by which he means, I believe, the aesthetic that defines the gallery which represents him— Metro Pictures in Soho. "If there was a preceding generation that Metro artists as a whole respond to (this is a very dangerous statement of course), it would be Warhol." In discussing my own work, particularly as it concerns precisely the difference between artworks and real things, he remarks, "I think he could have just as well have been describing Cindy's work [Cindy Sherman] or Sherrie's work [Sherrie Levine] as Warhol's work."[19] And that means, if true, that the borderline between art and reality was the theme and site of American art from the sixties on into the nineties, when this interview was granted.

Of course, a good many artists in the last thirty years have not engaged in this sort of quest at all, and if I were to apply the exclusionary spirit of philosophies of art history, I would say that they lie outside the pale of history. But that is not the way I view things. In my sense, once art itself raised the true form of the philosophical question—that is, the question of the difference between artworks and real things—history was over. The philosophical moment had been attained. The questions can be explored by artists who are interested in them, and by philosophers themselves, who can now begin to do the philosophy of art in a way that will

yield answers. To say that history is over is to say that there is no longer a pale of history for works of art to fall outside of. Everything is possible. Anything can be art. And, because the present situation is essentially unstructured, one can no longer fit a master narrative to it. Greenberg is right: nothing has happened for thirty years. That is perhaps the most important thing to be said about the art of the past thirty years. But the situation is far from bleak, as Greenberg's cry of "Decadence!" implies. Rather, it inaugurates the greatest era of freedom art has ever known.

I would like to suggest that our situation at the end of art history resembles the situation before the beginning of art history—before, that is, a narrative was imposed on art that made painting the hero of the story and cast whatever did not fit the narrative outside the pale of history and hence of art altogether. Vasari ends his narrative with Michelangelo and Leonardo, and of course Raphael. But though they conclude his narrative, they made art before the idea of that narrative had come to define the centrality of painting and its progressive developmental nature. They after all were close in time to Dürer, who was able to appreciate things like the goldwork of the Aztecs without feeling the slightest conceptual twinge, and without feeling it necessary to say that it was greater than anything in Europe, and without condescension. And Leonardo ended his life at the great court of François I, whose other great import was the master jeweler Benvenuto Cellini. Cellini was a sculptor, but his *Perseus* is not a greater work than the salt dish he fabricated for the king's condiment. There was no invidious distinction before the beginning of art history between art and craft, nor was it necessary to insist that the latter be treated as sculpture in order to be taken seriously as art. There was no imperative that an artist must specialize, and we find, in the artists who best exemplify the post-historical moment—Gerhard Richter, Sigmar Polke, Rosemarie Trockel, and others for whom all media and all styles are equally legitimate—the same protean creativity we find in Leonardo and Cellini. Somehow, the idea of pure art went with the idea of the pure painter—the painter who paints and does nothing else. Today that is an option, but not an imperative. The pluralism of the present art world defines the ideal artist as a pluralist. Much has changed since the sixteenth century, but we are in many ways closer to it than we are to any succeeding period in art. Painting, as the vehicle of history, has had a long run, and it is not surprising that it has come under attack. That attack provides the subject for a later chapter. I need first to situate pop in its historical present.

NOTES

1. Reinhart Koselleck, *Futures Past: On the Semantics of Historical Time* (Cambridge: MIT Press, 1985).

2. Greenberg, "After Abstract Expressionism," *The Collected Essays and Criticism*, 4:123.

3. Greenberg, "Where Is the Avant-Garde?" *The Collected Essays and Criticism*, 4:264.

4. Bernard Berenson, *The Venetian Painters of the Renaissance* (New York: C. P. Putnam, 1894), x. On the other hand, Berenson beautifully observes that "art is too great and too vital a subect to be crowded into any single formula; and a formula that would, without distorting our entire view of Italian art in the fifteenth century, do full justice to such a painter as Carlo Crivelli does not exist" (ibid.).

5. Jonathan Watkins, "Untricking the Eye: The Uncomfortable Legacy of Carlo Crivelli," *Art International* (Winter 1988), 48–58.

6. Rosalind E. Krauss, *The Optical Unconscious* (Cambridge: MIT Press, 1994).

7. Greenberg, "Surrealist Painting," *The Collected Essays and Criticism*, 4:225–26.

8. Ibid., 231.

9. Alois Riegl, *Problems of Style*, 16.

10. Fry, "Negro Sculpture," 88.

11. Cited in George Kubler, *Esthetic Recognition of Ancient Amerindian Art* (New Haven: Yale University Press, 1991), 208, n. 11.

12. Ibid., 43.

13. David Hume, "Of the Standard of Taste," *Essays, Literary, Moral, and Political* (London: Ward, Lock, 1898), 134–49. All references are to this edition, but Hume's essay is a classic of aesthetics and easily found in the main anthologies.

14. Cited in Jack Flam, "A Continuing Presence: Western Artists/African Art," in Daniel Shapiro, *Western Artists/African Art* (New York: The Museum of African Art, 1994), 61–62.

15. *The Letters of Virginia Woolf*, ed. Nigel Nicholson and Joanne Trautman (New York: Harcourt Brace and Jovanovich, 1976), 2:429.

16. I refer to Western Artists/African Art, curated by Daniel Shapiro. See note 14.

17. Greenberg, "Avant-Garde Attitudes: New Art in the Sixties," *The Collected Essays and Criticism*, 4:293.

18. See especially the title essay in my *The Philosophical Disenfranchisement of Art* (New York: Columbia University Press, 1985).

19. Andras Szanto, "Gallery: Transformations in the New York Art World in the 1980s" (Ph.D. diss., Columbia University, 1996). See appendix for interview with Ron Jones.

Jason Seley: *Baroque Portrait, 2,* metal, 57 inches high.

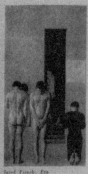

Jared French: *Evasion,* 21 inches high.

Roy Lichtenstein: *The Kiss,* 80 inches high.

even that his talent outstrips his intellect. In either case, they cramp his style. Once, however, the frames are by-passed, his quieter, more reflective reveries bespeak his spirit more genuinely as, *By Night and Solitude,* than in the more accelerated, jazzier *Venice Reflections.* Dodd's titles coincide with the frame problem. The small canvases in single color themes of red and yellow resolve and couple his need for a fever and more immediate response to nature with pensive poetic feeling. Prices unquoted. w.b.

Jason Seley [Kornblee; March 6-24] works with restraint and elegance using a material for his free-standing and relief sculptures which in the hands of somebody else would be called "junk sculpture." In his hands used chromium bumpers from old automobiles have the inevitable sculptural feeling of clay or stone. One overlooks the original use to which the material was put, but concentrates instead on its banana-fingered qualities, its sliding brilliance, its ice-hockey shin-pad prestige. Bumpers on ears are menacing. Converted to other uses they produce results no more menacing than the Winged Victory of Samothrace. One of their advantages is that they reflect as well as modulate light. There is also a pleasing contrast between the light, twisting surfaces, and the dark, clean-rusted inner parts. On looking at them one finds oneself pulling around on the cutting edge of a plane, then jumping agilely from shiny surface to shiny surface, like scrambling over Mantegna rocks. The sculptures are at times humorous, for example *Moose,* but for the most part they are models of elegance. Prices unquoted. l.c.

Roy Lichtenstein [Castelli] disappoints our expectations that an absurd iconography would produce humor. Why shouldn't the comic strips be funny in "serious" painting? A flying ace kissing his chick good-bye from the funnies or a cat from the bubble-gum cartoon or a "how-to-do-it" ad of a hand pouring soap suds into one of our mauve objects, the washing machine—these might well comprise the grotesque necessity that always precedes humor. Certainly they proclaim their intent to be ugly for they are careful blow-ups of their newspaper prototypes—lithography dots, mechanical hatching, acidic color and primitive drawing and macrocephalic heads and BLAM (a direct hit on a plane) are all carefully reproduced. And since the grotesque has already been used successfully for satiric purposes by Jasper Johns and Robert Rauschenberg, among others, one could expect that a grotesque thing that had a comic content in itself would be doubly humorous. But we are doubly disappointed. For here the grotesque is just a painful pivot that is immediately compensated for new dimension, insight and release. It is not transformed by esthetics, it replaces esthetics. So what was grotesque in the funnies, stays grotesque in its replacement—only doubly so. Prices unquoted. s.t.

Jared French [Banacou], a Magic Realist who uses egg tempera with an exactitude worthy of a Paul Cadmus, maintains a fine balance

between his technique, the compositional elements and the literary content. The works shown include early paintings from the 'forties, such as *Evasion,* the meticulous depiction of non-awareness, non-commitment, as well as several of his most recent drawings and sketches for the ultimate product. A characteristic quality which gives him a certain distinction is an undercurrent of somewhat unnerving humor. In *Introduction,* for example, the forms held, poised in a pelvic bone white as chalk, faintly pinkish in the shadows as the light reflects off the placenta, is as formally composed and handled as a flower study might be. Prices unquoted. l.t.

Frank Kupka [Saidenberg; to March 10], a shadowy name, relatively unknown except to scholars and connoisseurs, but a name bitterly attacked and applauded early in the century for the revolutionary tendencies it represented, is gradually emerging to take its place with those of the other great innovators of modern art. For Frank (Frantisek) Kupka, a Czech who emigrated to Paris in the late nineteenth century, began an exploration which led him to reject the use of nature as a direct source of inspiration for his painting and in 1912 to exhibit the first non-figurative paintings shown in France. The following year he showed several more of his monumental abstractions, one of which was *Vertical Planes, 3,* an imposing ascetic painting composed only of six rectilinear planes in space, a precursor of the ideas of Neo-Plasticism. The current show of pastels, gouaches and watercolors is minor Kupka, not sufficiently impressive, perhaps, for those who need an introduction, for without an acquaintance with his paintings, especially the monumental oils, the full force of this extraordinary painter is not communicated. Although many of the works are lovely in themselves, others are fascinating in their relationship to the development of ideas, or as the preparation for a larger statement. Earliest of the group is the figurative pastel *Bather,* a study for a painting; more Art Nouveau in form than the final work, it has both intrinsic charm and interest as an illustration of one of the early sources for his abstract form, the play of light on and in water. A group of the earliest abstractions on view are works from before World War I; *Lights,* a lush pastel, one of a number of variations on a theme that appears in drawings and paintings, *From One Plane to Another,* are a few. From the early 1920s are a group of studies for his woodcuts *Four Stories of White and Black,* one of the handsomest of which is a heart-shaped explosion of white forms. Visually among the most impressive, although less important historically, are the works of the late 1920s based on mechanical forms. The shapes of gears, bearings, screws and wrenches are fused into tightly-knit complex arrangements. Still later are the coolly geometrical studies such as *Plans and Perpendiculars.* Prices unquoted. l.t.

Karl Zerbe retrospective [Whitney Museum; to March 14] is sponsored by the Ford Foundation; it was selected by H. W. Janson, Chairman of the department of Fine Arts at N.Y.U. from the body

14

Pop Art and Past Futures

IF WE ATTEMPT to return to the perspective of artists and critics in the early 1960s, putting in brackets, as it were, the history of art as it worked itself out between then and now, and attempt to reconstruct the *vergangene Zukunft*—the future as it appeared in that past moment to those whose present it was—it must have seemed to the abstract expressionists and their supporters alike, that the future was very much theirs. The Renaissance paradigm had lasted for over six hundred years, and there seemed reason enough to suppose that the New York paradigm might last at least as long. To be sure, the Renaissance paradigm turned out to be developmental and progressive—to sustain a narrative—and though modernism, in the thought of Clement Greenberg, was itself developmental and progressive, it is difficult to suppose that this aspect of Greenberg's thought was widely shared or even widely known. But perhaps an argument for longevity could have been induced from the diversity of the New York School itself, made up, as it was, of figures of such distinctive artistic manners. Pollock, de Kooning, Kline, Newman, Rothko, Motherwell, Still—each was distinctively himself and sufficiently unlike the rest that one would never have been able even to deduce the possibility of Rothko's style, had Rothko himself not found it, from the disjunction of other styles which defined the New York School. So it must have seemed that as new personalities became part of the school, new and utterly unimagined styles, as different from the existing styles as they were from one another, would as a matter of course emerge, with no internal limit to their number and variety.

But if abstraction held the future in its grip, what was to happen to the realists, who still existed in large numbers in America, and indeed in New York? The realists were not prepared to surrender the future to abstract expressionism, and that meant that their present was one of protest and aesthetic battle. They felt their back to the wall, not merely of art history, but of the practical production of art—for abstract expressionism was sweeping the institutional infrastructure of the art world and it seemed as

if abstraction was an enemy to be defeated, or at least repelled, and that one's entire future as an artist—indeed the very question of whether one was going to have a future as an artist—depended upon what one did here and now.

Let us consider the case of Edward Hopper. There is a direct line of descent from Thomas Eakins through Robert Henri to Hopper, in that Henri was Eakins's student and Hopper was Henri's—and Eakins himself descended from the Beaux Arts Academy in Paris and the painter Gérôme. Abstract expressionism, indeed high modernism, intersects this history the way a meteor intersects the orderly swing of planets in the solar system. Hopper would have been altogether content to work out the further implications of Eakins's agenda, just as Henri did. Henri led a battle of the so-called Independent Artists against the practices of the National Academy. In 1913, and even earlier, at Stieglitz's gallery, artists like Picasso and Matisse were but marginal presences, too wild in a way to constitute a serious threat to art as Henri, his followers, and his enemies understood it. But in Hopper's era, abstract expressionism was hardly marginal. Hopper and the artists who understood him, and whom he understood, were marginal, and in danger of being pushed off the board altogether. And the Academy represented no threat or obstacle whatsoever, as it had done for Henri, and, in a way for Eakins. Eakins, indeed, set the agenda that Henri transformed into an aesthetic ideology and which Hopper merely adopted as a matter of course.

Let's just consider the treatment of the nude figure. Eakins reacted, while still a student at the Beaux Arts Academy in Paris, against the artificial way in which the paintings in the Salon of 1868 presented the nude: "The pictures are of naked women, standing, sitting, lying down, flying, dancing, doing nothing," he wrote, "which they call Phrynes, Venuses, nymphs, hermaphrodites, houris, and Greek proper names." He more or less vowed to paint the nude in a real situation, rather than as "smirking goddesses of many complexions, amidst the delicious arsenic green trees and gentle wax flowers. . . . I hate affectation."[1] So he painted the great *William Rush Carving his Allegorical Figure of the Skuylkill River* after his return to Philadelphia, for the Centennial Exhibition of 1876. It showed the nude as model, one of the ways in which a woman might naturally appear undressed. Henri, who founded the so-called Ash Can School, not only showed models as naked women, but did so in an altogether natural way, that is, showing the way real as against idealized women look with their clothes off. And Hopper, when he painted the nude, did so in erotic

situations in which a woman might naturally be undressed, such as *Girlie Show* of 1941 or *Morning Sunshine* of 1952, where one feels the woman is fantasizing. There is nothing especially modern in these paintings of Hopper's: it was, virtually, as if the late nineteenth century continued on, encapsulated in the twentieth century, as if modernism, as we have come to understand it, had never happened—though of course, with their shadows and golden lights, Eakins's pictures have the look of Old Master paintings in a way that Hopper's pictures never do: his pictures are spare and clear, with no unexplained, or so to speak, *metaphysical* shadows.

But modernism is a concept which has itself evolved. Hopper was in fact included in the Museum of Modern Art's second show, "Paintings by Nineteen Living Americans," in 1929. Alfred Barr thought Hopper "the most exciting painter in America" when he gave him a retrospective at that museum in 1933. The show was criticized as "the reverse of that which characterized the modern movement" by the critic Ralph Pearson;[2] and Barr gives us a deep insight into how modernism was understood by the institution most closely associated with it in America and, certainly in 1929, in the world: he accused Pearson of trying "to transform a popular and temporary implication of the word modern into an academic and comparatively permanent label."[3] Modernism circa 1933 was very different from modernism circa 1960, when Clement Greenberg wrote his canonical essay "Modernist Painting." But by then modernism was very nearly over with, and its demise has to be distinguished from the demise of abstract expressionism: Greenberg took a certain pleasure in noting the death of the latter in 1962, but modernism, he felt, would go on, even if it seemed to have become stalled when I heard him speak in 1992. Whatever the case, in 1933, the "modern" stood for a tremendous diversity of art: the impressionists and post-impressionists, including Rousseau; the surrealists, the fauves, the cubists. And of course, there were the abstractionists and suprematists and the nonobjectivists. But they were felt merely part of modernity, which also included Hopper, and as such modernism was no threat to realism. But by the 1950s, and especially in consequence of the immense critical success of abstract expressionism, art of the sort Hopper exemplified was in danger of being swamped by a modernism narrowly defined in terms of abstraction. What had been a part now threatened to become the whole. And the future seemed bleak for art as Hopper and his peers understood it. That defined their present as a field of battle in the style wars of the twentieth century.

Gail Levin narrates the Hoppers' involvement in the campaign against abstraction, or "gobbledegook," as they called it. They supported the action taken by a group of realist painters against the Museum of Modern Art, felt to favor abstraction and "nonobjective art" to the exclusion of realism. They were appalled by the way the Whitney annual of 1959–1960 was marked by the sparsity of realist canvases (a protest reenacted on 29 September 1995). They banded together with other artists, Jo Hopper wrote in her diary, "to preserve existence of realism in art against the wholesale usurpation of the abstract by Mod. Mus., Whitney, and thru them spread thru most of the universities for those who cannot abide not subscribing to le dernier cri from Europe."[4] They helped put out a magazine called *Reality*, which ran through several issues. They felt sincerely that if they did not prevail in these efforts, realist painting was a doomed thing.

I do not think it possible to convey the moral energy that went into this division between abstraction and realism, from both sides, in those years. It had an almost theological intensity, and in another stage of civilization there would certainly have been burnings at the stake. In those days a young artist who did the figure did so with the sense of espousing a dangerous and heretical practice. "Aesthetic correctness" filled the role which has come to be filled by political correctness today, and the actions of the Hoppers and their cohorts convey the indignation and shock that all the conservative books on political correctness do today, although it has to be remembered how the realists were freely consigned to artistic oblivion by those who ideologized abstraction. The realists of course felt their very existence threatened, which is perhaps matched by the way in which professors have been threatened with loss of tenure, or at least have been made fearful of such loss, unless their syllabus and their classroom vocabulary is brought into line.

Whatever the merits of the analogy, the conflict was essentially over in five or six years. Greenberg is an interesting case to examine in this light. In 1939 he saw abstraction as an historical inevitability: abstraction was, as we saw him argue in "Towards a Newer Laocoön," an "imperative [that] comes from history." In "The Case for Abstract Art" of 1959, he implied that representation is irrelevant, that "the abstract formal unity of a picture by Titian is more important to its quality than what that picture images"—a point made earlier in the century by Roger Fry. "It is a fact," Greenberg continues, "that representational paintings are essentially and most fully appreciated when the identifications of what they represent

are only secondarily present to our consciousness." He largely repeated this invidious characterization in his canonical essay "Modernist Painting" of 1960, where he wrote that "modernist painting in its latest phase has not abandoned the representation of recognizable objects in principle. What it has abandoned in principle is the representation of the kind of space that recognizable objects can inhabit." Painting did this in order to set itself logically apart from sculpture, he famously argues, and it is only fair to observe that this distinction, while it might give credibility to an artist like Stuart Davis or Miró, situates Hopper and the realists on a lower rung of historical evolution. But by 1961 he had ascended to a level from which he could say that there is good and bad in all of us, so that even abstraction has lost its note of historical destiny: "there is both bad and good in abstract art." And by 1962 abstract expressionism was all but finished, though this was not in any obvious way immediately apparent to anyone in that year.

Hopper and the realists saw the future as empty of their presence if they did not fight for it, the way, I suppose, the factions in Bosnia must feel about their country. But in just a few years Greenberg was able to say that there was no basic difference at all between the abstractionist and the realist, since there was a level at which all that mattered was quality, not kind, which is very much the situation today. Just as the Armory Show of 1913 made it plain that the differences between the Independents and the academicians were of small moment by contrast with the difference between both of them and cubism or fauvism, so, today, the difference between figuration and abstraction, since both are modes of painting, is of vastly lesser importance than the difference between painting in whatever mode, and video, say, or performance art. By 1911 the future both of the Ash Can painters and the academicians was a *vergangenes Zukunft*, as was, by 1961, the future of the realists and the abstractionists. They identified the future of art with the future of painting. And the future, as it happens, all at once put painting in the position abstraction had occupied in the early years of modernism as defined by the Museum of Modern Art: it was just one of a large number of artistic possibilities. The entire shape of art history had undergone change, however difficult it was to perceive in the early sixties when art and painting were virtually synonymous. And it is striking that neither abstract expressionism's advocates, like Greenberg, nor its opponents, were able to perceive the historical present in which they lived, because each saw the future in a way that proved irrelevant to the way things were.

The cause of the change, in my view, was the emergence of the somewhat unfortunately named pop art, again in my view the most critical art movement of the century. It began somewhat insidiously in the early sixties—insidiously in the sense that its impulses were disguised under drips and dribbles of paint in the manner of abstract expressionism, the emblem of artistic legitimacy at that time. But by 1964 it had thrown off the disguises and stood, in its full reality, as what it was. Interestingly enough, the Whitney decided to mount a Hopper retrospective in 1964. This had certainly little to do with the efforts of the realists, or their magazine *Reality*, or their picket lines in front of museums, or their letters in defense of John Canaday's attacks on abstract expressionism in the *New York Times*. "The decision to organize the retrospective came at a time when younger artists, especially among the pop and the photorealist movements, were taking a renewed interest in realism and in one of its leading exponents."[5] "At a time when younger artists . . . were taking a renewed interest" leaves it open whether this was a cause or merely a coincidence. Even the abstract expressionists "took an interest" in Hopper; at least de Kooning did, though he might be considered a compromised member of the movement due to the use of the figure. "You're doing the figure," Pollock charged. "You're still doing the same goddamn thing. You know you never go out of being a figure painter."[6] And the critical uproar when de Kooning exhibited his *Women* at Sidney Janis Gallery in 1953 is legendary: he had betrayed, or at least imperilled "our [abstract] revolution in painting." But de Kooning said to Irving Sandler in 1959, "Hopper is the only American I know who could paint the Merritt Parkway."[7] Once popular graphic imagery became thematic in pop, scholars found in Hopper a "predecessor," thinking of the way he painted the words "Ex Lax" in his picture of a drugstore, or the logo of Mobil Gas in his celebrated image of a gas station. But these are all externalities. They throw light neither on Hopper nor on pop. We really have to try to think of pop—or at least I think we have to think of pop—in a more philosophical way. I subscribe to a narrative of the history of modern art in which pop plays the philosophically central role. In my narrative, pop marked the end of the great narrative of Western art by bringing to self-consciousness the philosophical truth of art. That it was a most unlikely messenger of philosophical depth is something I readily acknowledge.

I want at this point to insert myself into this narrative, for I am now discussing an event I lived through. Artists, when they show their slides and talk about their work, characteristically report turning points in their

development. It is less common for historians or philosophers to do this, but perhaps it is justified, since my experience of the pop movement was a set of philosophical responses that led to the body of thought that occasioned my having been invited to deliver the lectures on which this book is based. My own *vergangene Zukunft* in the 1950s, so far as painting was concerned, was one in which reality was represented gesturally, exactly in the manner of de Kooning's *Women* and his subsequent landscapes, such as *Merritt Parkway*. So, to the degree that I participated in the controversies, which were in any case unavoidable if one associated with artists in those years, I was too abstract for realists and too realist for abstractionists. I was myself attempting an artistic career in the fifties, and my own work sought to make that future present. But I was also attempting a philosophical career, and I have the most vivid recollection of seeing my first pop work—it was in the spring of 1962. I was living in Paris and working on a book which appeared a few years later under the somewhat daunting title *Analytical Philosophy of History*. I stopped one day at the American Center to read some periodicals, and I saw Roy Lichtenstein's *The Kiss* (printed sideways) in *Art News*, the crucial art publication of those years. I found out about pop the way almost everyone in Europe found out about it—through art magazines, which were, then as now, the main carriers of artistic influence. And I must say I was stunned. I knew that it was an astonishing and an inevitable moment, and in my own mind I understood immediately that if it was possible to paint something like this—and have it taken seriously enough by a leading art publication to be reviewed—then everything was possible. And, though it did not immediately occur to me, if everything was possible, there really was no specific future; if everything was possible, nothing was necessary or inevitable including my own vision of an artistic future. For me, that meant that it was all right, as an artist, to do whatever one wanted. It also meant that I lost interest in doing art and pretty much stopped. From that point on I was single-mindedly a philosopher, and so I remained until 1984, when I began to be an art critic. When I returned to New York, I was keen to see the new work, and began to see the shows at Castelli's and the Green Gallery, though pop paintings and other works were turning up everywhere, including the Guggenheim Museum. And there was a singular exhibition at Janis's. My great experience, often enough described, was my encounter with Warhol's *Brillo Box* at the Stable Gallery, in April of 1964, the year of Hopper's Whitney retrospective. It was a most exciting moment, not least of all because the entire structure of debate which had defined the New York art scene up to that point had

ceased having application. A whole new theory was called for other than the theories of realism, abstraction, and modernism which had defined the argument for Hopper and his allies and his opponents.

As luck would have it, I was invited that year to read a paper on aesthetics for the American Philosophical Association meeting in Boston. The person who had been scheduled to give it dropped out, and the program chairman thought to invite me as substitute. The paper was titled "The Art World," and it was the first philosophical effort to deal with the new art.[8] I take a certain pride that Warhol, Lichtenstein, Rauschenberg, and Oldenberg were discussed in *The Journal of Philosophy*—which published the symposium papers of the APA meeting— well before they were featured in what used to be called "the slicks." And that paper, not once so far as I know cited in the copious bibliographies on pop in later years, really did become the basis for philosophical aesthetics in the second half of this century. Another sign of how distant from one another the worlds of art and philosophy have continued to stand, however deeply related art and philosophy as such must be in the philosophy of what Hegel terms Absolute Spirit.

What struck me in particular with pop at that time was the way it subverted an ancient teaching, that of Plato, who famously relegated art, construed mimetically, to the lowest imaginable rung of reality. The notorious example is set forth in book ten of *The Republic*, where Plato specifies the three modes of reality of the bed: as idea or form, as what a carpenter might make, and then as what a painter might make, imitating the carpenter who has imitated the form. There are Greek vases on which the artist shows Achilles in bed, with the corpse of Hektor prone on the floor beneath it, or Penelope and Odysseus in conversation beside the bed Odysseus had built for his bride. Since you can imitate, Plato wanted to say, without knowing the first thing about the thing you are imitating (as Socrates sought to make plain in an infuriating dialogue with Ion the Rhapsode), artists lack knowledge. They "know" only the appearances of appearances. And now, all at once, one began to see actual beds in the art world of the early sixties—Rauschenberg's, Oldenberg's, and, not long after that, George Segal's. It was, I argued, as if artists were beginning to close the gap between art and reality. And the question now was what made these beds art if they were after all beds. But nothing in the literature explained that. I began to develop something of a theory in "The Art World," which gave rise, among other things, to George Dickie's institutional theory of art. The *Brillo Box* made the ques-

tion general. Why was it a work of art when the objects which resemble it exactly, at least under perceptual criteria, are mere things, or, at best, mere artifacts? But even if artifacts, the parallels between them and what Warhol made were exact. Plato could not discriminate between them as he could between pictures of beds and beds. In fact, the Warhol boxes were pretty good pieces of carpentry. The example made it clear that one could not any longer understand the difference between art and reality in purely visual terms, or teach the meaning of "work of art" by means of examples. But philosophers had always supposed one could. So Warhol, and the pop artists in general, rendered almost worthless everything written by philosophers on art, or at best rendered it of local significance. For me, through pop, art showed what the proper philosophical question about itself really was. It was this: What makes the difference between an artwork and something which is not an artwork if in fact they look exactly alike? Such a question could never occur when one *could* teach the meaning of "art" by examples, or when the distinction between art and reality seemed perceptual, like the difference between a picture on a vase of a bed and a real bed.

It seemed to me that now that the philosophical problem of art had been clarified from within the history of art, that history had come to an end. The history of Western art divides into two main episodes, what I call the Vasari episode and what I call the Greenberg episode. Both are progressive. Vasari, construing art as representational, sees it getting better and better over time at the "conquest of visual appearance." That narrative ended for painting when moving pictures proved far better able to depict reality than painting could. Modernism began by asking what painting should do in the light of that? And it began to probe its own identity. Greenberg defined a new narrative in terms of an ascent to the identifying conditions of the art, specifically what differentiates the art of painting from every other art. And he found this in the material conditions of the medium. Greenberg's narrative is very profound, but it comes to an end with pop, about which he was never able to write other than disparagingly. It came to an end when art came to an end, when art, as it were, recognized that there was no special way a work of art had to be. Slogans began to appear like "Everything is an artwork" or Beuys's "Everyone is an artist," which would never have occurred to anyone under either of the great narratives I have identified. The history of the art's quest for philosophical identity was over. And now that it was over, artists were liberated to do whatever they wanted to do. It was like

Rabelais's Abbaye de Theleme, whose injunction was the counterinjunction "Fay ce que voudras" (do what you like). Paint lonely New England houses or make women out of paint or do boxes or paint squares. Nothing is more right than anything else. There is no single direction. There are indeed no directions. And that is what I meant by the end of art when I began to write about it in the mid-1980s. Not that art died or that painters stopped painting, but that the history of art, structured narratively, had come to an end.

A few years ago I gave a talk in Munich titled "Thirty Years after the End of Art." A student raised an interesting question. For her, she said, 1964 was really not an interesting year, and she was astonished that I made so much of it. The uprisings of 1968 were what interested her, and the emergence of the counterculture. But she would not have found 1964 nondescript had she been an American. It was the year of our "Summer of Freedom," during which blacks, with the support of thousands of whites, busloads of whom converged on the South to register black voters, worked to make civil rights real for an entire disenfranchised race. Racism in the United States did not end in 1964, but a form of apartheid which had sullied political life in our country ended that year. In 1964 a congressional committee on women's rights released its findings, giving support to the tremendous feminist movement detonated with the publication of Betty Friedan's *Feminine Mystique* of 1963. Both liberationist movements became radicalized by 1968, to be sure, but 1964 was the year of liberation. And it cannot be forgotten that the Beatles made their first personal appearance in the United States on the Ed Sullivan show in 1964, and they were emblems and facilitators of the spirit of liberation which swept the country and in time the world. Pop fit into this entirely. It really was a singularly liberating movement outside the United States, via the same channels of transmission as the one through which I first learned about it—the art magazines. In Germany Sigmar Polke and Gerhard Richter's powerful capitalist realist movement was directly inspired by pop. In the then Soviet Union, Komar and Melamid invented Sots art, and appropriated as a painting the design of a cigarette pack logo of the face of the dog named Laika who died in outer space. The painting was a realistic portrait of a stylized representation of a dog, and satisfied the stylistic imperatives of Soviet realist painting while subverting them by portraying a dog as Soviet hero. In terms of art-world strategies, American pop, German capitalist realism, and Russian Sots art could be seen as so many strategies for attacking official styles—socialist realism in the

Soviet Union, of course, but abstract painting in Germany, where abstraction was itself heavily politicized and felt to be the only acceptable way of painting (easily understandable in terms of the way figuration was itself politicized under Nazism), and then abstract expressionism in the United States, which also had become an official style. Only in the Soviet Union, so far as I know, was pop art the object of a repressive attack—in the celebrated "bulldozer" show of 1974, when artists and journalists were chased by police using bulldozers. It is worth mention that it was the worldwide coverage of the event which seemed to bring about a policy of artistic detente in the Soviet Union, allowing in principle everyone to do as they liked, just as it was the intense television coverage of the beatings of civil rights protesters in Alabama which stopped them, the South somehow not being able to tolerate the image of itself that was being internalized by the rest of the world. In any case, it would hardly have been consistent with the liberating spirit of pop art that its artists should have allowed themselves to become victims of their own style. One mark, it seems to me, of artists after the end of art is that they adhere to no single avenue of creativity: Komar and Melamid's work has a spirit of impishness, but no visually identifying style. America has been conservative in this, but Warhol made films, sponsored a form of music, revolutionized the concept of the photograph, as well as made paintings and sculpture, and of course he wrote books and achieved fame as an aphorist. Even his style of dress, jeans and leather jacket, became the style of an entire generation. At this point I enjoy invoking the celebrated vision of history after the end of history that Marx and Engels put forward in *The German Ideology*, under which one can farm, hunt, fish, or write literary criticism, without *being* a farmer, a hunter, a fisherman, or a literary critic. And, if I may bring forward alongside them a true piece of philosophical artillery, this refusal to be any particular thing is what Jean-Paul Sartre calls being truly human. It is inconsistent with what Sartre calls *mauvaise foi* (bad faith), or regarding oneself as an object, and hence as having an identity as a waiter if a waiter, or a woman if a woman. That the ideal of Sartrian freedom is not necessarily easy to live by is I think testified to by the search for identity that is part of the popular psychology of our time, and by the effort to absorb oneself into the group to which one belongs, as in the political psychology of multiculturalism, and certain forms of feminism and of "queer" ideology, all so much part of this moment. But it is exactly the mark of the post-historical moment that the quest for identity is undertaken by those who are after all distant from

their target—who, in a kind of Sartrian way of putting things, are not what they are and are what they are not. The Jews of the *stetel* were what they were, and did not have to *establish* an identity.

The term pop was invented by Lawrence Alloway, my immediate predecessor as art critic for *The Nation*, and though I feel it captures only certain surface features of the movement, it was not a bad designation in terms of its irreverence. Its sound is the noise of abrupt deflation, as of an exploding balloon. "We discovered," Alloway writes,

> that we had in mind a vernacular culture that persisted beyond any special interests or skills in art, architecture, design, or art criticism that any of us might possess. The area of contact was mass-produced urban culture: movies, advertising, science fiction, Pop music. [This, one might observe, is the standard bill of fare in each issue of ArtForum today.] We felt none of the dislike of commercial culture standard among most intellectuals, but accepted it as a fact, discussed it in detail, and consumed it enthusiastically. One result of our discussions was to take Pop culture out of the realm of "escapism," "sheer entertainment," "relaxation," and to treat it with the seriousness of art.[9]

I certainly think these discussions prepared the way for the acceptance of pop, but I would like to draw a few distinctions. There is a difference between pop *in* high art, pop *as* high art, and pop art as such. We must think of this when we try to seek predecessors for pop. When Motherwell used the Gauloise cigarette package in certain of his collages, or Hopper and Hockney used elements from the world of advertising in paintings which were themselves far from pop, this is pop *in* high art. To treat popular arts *as* serious art is really what Alloway is describing: "I used the term, and also 'Pop culture,' to refer to the products of the mass media, not to works of art that draw upon popular culture."[10] Pop art as such consists in what I term transfiguring emblems from popular culture into high art. It requires recreating the logo as socialist realist art, or making the Campbell's soup can the subject of a genuine oil painting which uses commercial art as a painterly style. Pop art was so exciting because it was transfigurative. There were plenty of buffs who treated Marilyn Monroe in the same way they would treat one of the great stage or opera stars. Warhol transfigured her into an icon by setting her beautiful face on a field of gold paint. Pop art as such was a properly American achievement, and I think it was the transfigurativeness of its basic stance that made it so subversive abroad. Transfiguration is a religious concept. It means the adoration of the ordinary, as, in its original appearance, in the Gospel of

Saint Matthew it meant adoring a man as a god. I tried to convey this idea in the title of my first book on art, *The Transfiguration of the Commonplace*, a title I appropriated from a fictional title in a novel by the Catholic novelist Muriel Spark. It seems to me now that part of the immense popularity of pop lay in that fact that it transfigured the things or kinds of things that meant most to people, raising them to the status of subjects of high art.

Erwin Panofsky, among others, has argued that there is a certain unity in a culture's various manifestations, a common tincture affecting its painting and philosophy, for example. Positivistically, it is easy to be skeptical about such notions, but I do think there is a degree of confirmation of Panofsky's basic intuition in the state of the visual arts and of philosophy at the middle of the twentieth century. This is rather rarely commented upon, and I want to sketch the philosophical counterpart of pop. It too is something I lived through and, within limits, believed in.

The prevailing philosophy in the post World War II years, in the English speaking world at least, was something loosely designated "analytical philosophy," which divided into two branches with rather different views of language, and both of which descended in one way or another from different stages in the thought of Ludwig Wittgenstein. However they may have differed, both modes of analytical philosophy were committed to the view that philosophy as it had been traditionally practiced, and most particularly that part of philosophy known as metaphysics, was intellectually suspect if not downright bogus, and that the negative task of both branches of analytical philosophy was to exhibit, to demonstrate, the emptiness and nonsense of metaphysics. The one branch was inspired by formal logic, and was dedicated to the rational reconstruction of language—rebuilding language on solid foundations, themselves defined in terms of direct sensory experience (or observation), so that there would be no way in which metaphysics—which was not based on experience—could infect the system with its cognitive rot. Metaphysics was nonsense because it was radically disconnected from experience, or from observation.

The other branch thought language in no great need of reconstruction, so long as it was employed in a correct way: "Philosophy begins when language goes on holiday" is one of the things Wittgenstein says in his posthumous masterpiece, *Philosophical Investigations*. Under both its aspects, analytical philosophy was tied to common human experience at the most basic level, and ordinary discourse of the kind everyone is master of. Its philosophy was in effect what everybody always knows.

J. L. Austin was for a time the leader of the school of ordinary language philosophy at Oxford, and here is something he said which bears on my speculation. It was something of a credo:

> Our common stock of words embodies all the distinctions men have found worth drawing, and the connexions they have found worth making, in the lifetimes of many generations: these surely are likely to be more numerous, more sound, since they have stood up to the long test of the survival of the fittest, and more subtle, at least in all ordinary and reasonably practical matters, than any you or I are likely to think up in our arm-chairs of an afternoon.[11]

I think that pop art too transfigures into art what everybody knows: the objects and icons of common cultural experience, the common furnishing of the group mind at the current moment of history. Abstract expressionism, by contrast, was concerned with hidden processes and was predicated on surrealist premises. Its practitioners sought to be shamans, in touch with primordial forces. It was metaphysical through and through, whereas pop celebrated the most ordinary things of the most ordinary lives—corn flakes, canned soup, soap pads, movie stars, comics. And by the processes of transfiguration, it gave them an almost transcendental air. Something in the 1960s explains, has to explain, why the ordinary things of the common world suddenly became the bedrock of art and philosophy. The abstract expressionists despised the world the pop artist apotheosized. Analytical philosophy felt that traditional philosophy had come to an end, having radically misconceived the possibilities of cognition. What philosophy was to do henceforward, after the end, is difficult to say, but presumably something useful and of direct human service. Pop art meant the end of art, as I have argued, and what artists were to do after the end of art is also difficult to say, but it was at least a possibility that art, too, might be enlisted in the direct service of humanity. Both faces of the culture were liberationist—Wittgenstein spoke of how to show the fly the way out of the fly bottle. It was then up to the fly where to go and what to do, just so long as it kept out of fly bottles in the future.

The temptation, of course, is to see both art and philosophy at mid-century as reactive—as reactions against. For example, there is a level of taunting of abstract expressionist pretensions in Lichtenstein. But I think both movements were really on a new level altogether, largely because they viewed the philosophy and the art before them as wholes. Analytical philosophy set itself against the whole of philosophy, from Plato through

Heidegger. Pop set itself against art as a whole in favor of real life. But I think, beyond that, that both of them answered to something very deep in the human psychology of the moment, and that this is what made them so liberating outside the American scene. What they answered to was some universal sense that people wanted to enjoy their lives now, as they were, and not on some different plane or in some different world or in some later stage of history for which the present was a preparation. They did not want to defer or to sacrifice, which is why the black movement and the women's movement in America were so urgent, and why, in the Soviet Union, one had to stop celebrating the heros of a distant utopia. Nobody wanted to wait to go to Heaven for their reward, or to take joy in members of the classless society living in a future socialist utopia. Just being left alone to live in the world pop raised to consciousness was as good a life as anyone could want. Whatever social programs there were to be had to be consistent with that. "We don't need another hero," Barbara Kruger writes on one of her posters, putting into a nutshell what Komar and Melamid sought in Sots. It was the perception, through television, that others were enjoying the benefits of ordinary life *now* that brought the Berlin Wall down in 1989.

House Speaker Newt Gingrich, in *To Renew America*, has a sense of history not unlike mine. For him 1965 was the pivotal year, but the precise year can hardly matter.What took place in 1965, according to him was "a calculated effort by cultural elites to discredit this civilization and replace it with a culture of irresponsibility."[12] I cannot believe it was a calculated effort, nor can I believe that artists and philosophers should have effected a revolution which, to the contrary, explains the art and the philosophy. There was a tremendous change in the fabric of society, a demand for liberation which has not ended yet. People decided that they wanted to be left in peace to "pursue happiness," which is on the short list of fundamental human rights according to the enabling documents of our country. It is not likely that a populace dedicated to this can be reconciled to an earlier form of life, however nostalgic some may be for the law and order that defined it, and it is even arguable that wanting to be left alone by a government perceived as overbearing forms part of Representative Gingrich's agenda.

I have sought here to situate pop art in a far wider context than the common art-historical contexts of causal influence and iconographic innovation. In my view pop was not just a movement which followed one movement and was replaced by another. It was a cataclysmic moment

which signaled profound social and political shifts and which achieved profound philosophical transformations in the concept of art. It really proclaimed the twentieth century, which had languished for so long a time—sixty-four years—in the field of the nineteenth century, as we can see in the *vergangene Zukunft* I began with. One by one the terrible ideas of the nineteenth century have been exhausting themselves, though many of the nineteenth-century institutions of repression remain. What will the twentieth century be like once it gets under way? I would like to see an image by Barbara Kruger that says, "We don't need another narrative."

One possible advantage of seeing art in the widest context we can manage is, at least in the present case, that it helps us with a rather narrow problem of differentiating between Duchamp's ready-mades and such pop works as Warhol's *Brillo Box*. Whatever he achieved, Duchamp was not celebrating the ordinary. He was, perhaps, diminishing the aesthetic and testing the boundaries of art. There really is, in history, no such thing as having done something before. That there is an outward resemblance between Duchamp and pop is one of the things it is the achievement of pop to help us see through. The resemblances are far less striking than those between *Brillo Box* and ordinary Brillo cartons. What makes the difference between Duchamp and Warhol is similarly far less difficult to state than what is the difference between art and reality. Situating pop in its deep cultural moment helps show us how different its causes were than those that drove Duchamp half a century earlier.

NOTES

1. Thomas Eakins, quoted in Lloyd Goodrich, *Thomas Eakins: His Life and Work* (New York: Whitney Museum of American Art, 1933), 20.

2. Gail Levin, *Edward Hopper: An Intimate Biography* (New York: Knopf, 1995), 251.

3. Ibid., 252.

4. Ibid., 469.

5. Ibid., 567.

6. *Willem de Kooning Paintings* (Washington, D.C.: National Gallery of Art, 1994), 131.

7. Levin, *Edward Hopper*, 549.

8. Arthur C. Danto, "The Art World," *Journal of Philosophy* 61, no. 19 (1964): 571–84. This was my first philosophical publication on art as well, and remained so until, with a few minor exceptions, the appearance of my *The Transfiguration of the Commonplace* (Cambridge: Harvard University Press, 1981).

9. Lawrence Alloway, "The Development of British Pop," in Lucy R. Lippard, *Pop Art* (London: Thames and Hudson, 1985), 29–30.

10. Ibid., 27.

11. J. L. Austin, "A Plea for Excuses," in *Philosophical Papers*, ed. J. O. Urmson and G. J. Warnock (Oxford: Clarendon Press, 1961), 130.

12. Newt Gingrich, *To Renew America* (New York: HarperCollins, 1995), 29.

HOMO DUPLEX (1993) BY SEAN SCULLY. 100″ BY 90″. OIL/LINEN. COURTESY: MARY BOONE GALLERY, NEW YORK. PHOTOGRAPH © DOROTHY ZEIDMAN.

Painting, Politics, and
Post-Historical Art

IT IS POSSIBLE to place alongside Clement Greenberg's lamentation that nothing had happened in art in the last thirty years—that never in its history had art moved so slowly—a deeply alternative interpretation. This would be that art was not moving slowly but that the very concept of history in which it moved slowly or rapidly had itself vanished from the art world, and that we were now living in what I have been calling "post-historical" times. Greenberg tacitly subscribed to a developmental progressive view of history, which had indeed been the way that art had been conceived since Vasari at least—as a narrative of progress in which gains and breakthroughs were made in the advancement of art's goals. The goals had changed under modernism, but the great narrative Greenberg proposed remained developmental and progressive, and in 1964 he saw color-field abstraction as the next step toward purifying painting. But—pop!—the train of art history was blown off the tracks and has been awaiting repair for thirty years. When on that muggy August afternoon in 1992 someone asked him whether he saw any hope at all, he answered that, well, he had thought for a long time that Jules Olitski was our best painter. The implication was that it was painting that would finally save art, get the train back on its tracks, and move to the next station—we would know we had arrived when we had arrived—in the great progressive advance of modernism.

The alternative view would be that rather than a transit interrupted, art, construed historically, had reached the end of the line because it had moved onto a different plane of consciousness. That would be the plane of philosophy, which, because of its cognitive nature, admits of a progressive developmental narrative which ideally converges on a philosophically adequate definition of art. At the level of artistic practice, however, it was no longer an historical imperative to extend the tracks into the aesthetic unknown. In the post-historical phase, there are countless

directions for art making to take, none more privileged, historically at least, than the rest. And part of what that meant was that painting, since no longer the chief vehicle of historical development, was now but one medium in the open disjunction of media and practices that defined the art world, which included installation, performance, video, computer, and various modalities of mixed media, not to mention earthworks, body art, what I call "object art," and a great deal of art that had earlier been invidiously stigmatized as craft. That painting was no longer the "key" did not mean that something else was to take over from it, for in truth by the early 1990s the visual arts in the vastly widened sense that term now took, no longer had the sort of structure that made a developmental history interestingly thinkable or even critically important. Once we move to some sector of the visual arts other than painting and possibly sculpture, we encounter practices that can doubtless be refined upon, but where the potentialities are lacking for a progressive development of the kind painting had so readily lent itself to over the centuries, in its first phase as the project of achieving increasingly adequate representations of the world, and, in its modernist phase, increasingly adequate attainments of its pure state. The final phase—the philosophical phase—was now to find an increasingly adequate definition of itself, but this, I am claiming, is a philosophical rather than an artistic task. It was as if a great river had now resolved itself into a network of tributaries. And it was the lack of a single current that Greenberg read as the absence of anything happening at all. Or rather, he read all the tributaries as variations of the same theme—what he called "novelty art."

It is possible that Greenberg's narrative of the internal drive toward the essence of art is in fact more widely exemplified than one might have supposed. In his marvelous essay "Style and Medium in Motion Pictures," Panofsky writes the following of Keaton's *The Navigator* of 1924 and Eisenstein's *Battleship Potemkin* of 1925:

> The evolution from the jerky beginnings to this grand climax offers the fascinating spectacle of a new artistic medium gradually becoming conscious of its legitimate, that is, exclusive possibilities and limitations—a spectacle not unlike the development of the mosaic, which started out with transposing illusionistic genre pictures into a more durable material and culminated in the hieratic supernaturalism of Ravenna; or the development of line engraving, which started out as a cheap and handy substitute for book illumination and culminated in the purely "graphic" style of Dürer.[1]

Still, it is interesting to see how the "is" of historical development gets transformed into the "ought" of medium criticism. The modernist idea that art consists in fidelity to a medium's essential features offered a very powerful critical position in arts other than painting. Thus when video began to emerge as an art form, it inevitably developed a purist critical agenda in which works were castigated for not being "video" enough. Artists sought to expunge from their films or tapes whatever was not essential to the medium, new as it was, until a time came when such purism no longer seemed important. By the same token, in the crafts, especially in the so-called first generation of studio furniture makers after World War II, the effort was to let the materials speak for themselves— to emphasize the woodness of the wood, for example, or to thematize the repertoire of joinery that marks the woodworker as craftsperson. When this stopped being important, when craftspersons stopped caring for purity—or even began to attack purity as in a celebrated work by Garry Knox Bennett where, after building a prize confection in impeccably joined and veneered woods, he hammered in a sixteen penny nail, bent it, and left the hammer marks—and began to use whatever means lent themselves to their expressive purposes, even using the illusionist techniques of painting, as in the clever and enchanting cabinetry of John Cedarquist, the grip of the Greenbergian paradigm had clearly weakened. Postmodernism, an authentic style which has emerged within the post-historical period was generally and defiantly characterized by an indifference to the kind of purity Greenberg saw as the goal of an historical development. When there was no such goal, the narratives of modernism had ended, even for painting.

But the power of Greenberg's vision is nowhere better testified to than through the radical critiques of painting itself which began to develop in the 1980s. Ironically, these critiques were more or less based on the Greenbergian account, though advanced by critics for whom Greenberg was anathema. They took it for granted that the production of pure painting was the goal of history, that it had been reached, and hence that there was nothing left for painting to do. Painting had died through its own historical self-fulfillment. Here is a not uncharacteristic statement by one advanced critic, Douglas Crimp, in an essay on French painter Daniel Buren:

> "From today painting is dead." It is now [1981] nearly a century and a half since Paul Delaroche is said to have pronounced that sentence in the face of the overwhelming evidence of Daguerre's invention. But even though

the death warrant has been periodically reissued throughout the era of modernism, no one seems to have been entirely willing to execute it; life on death row lingered to longevity. But during the 1960s, painting's terminal condition finally seemed impossible to ignore. The symptoms were everywhere: in the work of painters themselves, all of whom seemed to be reiterating Ad Reinhardt's claim that he was "just making the last paintings anyone could make" or allowing their paintings to be contaminated with photographic images; in minimal sculpture, which provided a definitive rupture with painting's unavoidable tie to a centuries-old idealism; in all those other mediums to which artists turned as, one after another, they abandoned painting. . . . [Daniel Buren] knows only too well that when his stripes are seen as painting, painting will be understood as the "pure idiocy" that it is. At the moment when Buren's work becomes visible, the code of painting will have been abolished and Buren's repetitions can stop: the end of painting will finally have been acknowledged.[2]

There is all the difference in the world, of course, between Paul Delaroche and Douglas Crimp finding in photography the end of painting. In 1839, Delaroche was referring to the mimetic ambitions of painting and felt that if all the representational skills a painter had to master could now be built into a mechanism that would produce as creditable an imitation as a master painter could, there could be little point in learning to paint. Of course, there is an art to photography as well, but Delaroche had in mind the bare achievement of an image on a surface—painting was clearly still defined in terms of mimesis—which was now built into the photographic apparatus, and no longer required the hand and eye of the painter. Crimp, a political radical, almost certainly had in mind the class associations of painting, the institutional implications of the museum of fine arts, and Walter Benjamin's influential distinction between artworks possessed of an aura and artworks achieved by means of "mechanical reproduction." His argument is political in a way that, so far as I know, Delaroche's could not have been. It is political in a way that almost all proclamations of the end of painting—specifically, the end of easel painting—have been in this century. The Berlin dadaists, the Moscow committees charged with determining the role of art in a communist society, the Mexican muralists (Siqueros called the easel painting "the fascism of art")[3] have all been politically driven in their denunciations of painting. Duchamp's contemptuous characterization of "olfactory artists"—artists in love with the smell of paint—would be an exception, just because it is difficult to ascribe a political agenda to Duchamp at all. But Dali, possibly

in a gesture of aggravated surrealism, declared himself ready to kill paint-
ing off: "Art in its traditional sense, is out of place in our age, there is no
reason for it to exist, it has become something grotesque. The new intel-
ligentsia takes pleasure in killing it off completely."[4] Each of these anti-
painting postures saw painting as belonging to a now discredited form of
life, to be replaced with photomontage, photography, "art into life,"
mural painting, conceptual art, or whatever it was other than painting
that Dali thought he was doing, and the like. Crimp himself was manag-
ing editor of the influential journal *October*, which, not untypically of
American intellectual publication (*The Partisan Review* is the paradigm),
combined a radical critique of contemporary culture with an often elitist
attitude toward art. The difference in the case of *October* is that the art it
supported presupposes institutional frames that oppose those which de-
fine the consumption of art in "late capitalist" society. A society in which
these alternative institutional frames were in fact the defining ones for art
might on the whole be morally preferable to one whose institutions were
made to order for painting: galleries, collections, museums, and art publi-
cations which serve as advertising venues for the shows reviewed in
them. Even Greenberg, as we saw, expressed reservations about painting
in a widely discussed 1948 essay on the crisis of the easel painting, which
he felt was in process of dissolving itself, and in so doing "seems to an-
swer to something deep-seated in contemporary sensibility":

> This very uniformity, this dissolution of the picture into sheer texture,
> sheer sensation, into the accumulation of similar units of sensation . . .
> corresponds perhaps to the feeling that all hierarchical distinctions have
> been exhausted, that no area or order of experience is either intrinsically or
> relatively superior to any other. It may speak for a monist naturalism that
> takes all the world for granted and for which there are no longer either first
> or last things.[5]

Someone who subscribed to this view of painting and its social presuppo-
sitions might find a certain confirmation of it in the tremendous upsurge
of painting in the early 1980s, just when, ironically, Douglas Crimp was
declaring the end of painting. At the onset of the Reagan years and their
total endorsement of capitalist values, a vast quantity of large easel paint-
ings appeared that seemed almost calibrated to the large amounts of dis-
posable capital that fell into large numbers of hands. Ownership of art
seemed an imperative of that form of life, all the more so in that a strong
secondary market virtually guaranteed that in enhancing one's life-style
with art, one was also making a shrewd investment: the art world was the

Reagan philosophy enacted in high culture. The art was all at once there for those who wanted to "get in on the ground floor," either because they had (to change the metaphor) "missed the boat" with abstract expressionism, which was no longer priced within reach, or because they were not around when it was possible to buy at absurdly low prices what was literally worth a fortune today. It did not greatly matter that someone might have undertaken to criticize the values of capitalism in his or her paintings: the mere fact that they were *paintings* implied endorsement of the institutions of the society criticized, or even condemned, in their content. Just wanting to express oneself as an artist in paint could have been perceived as inherently compromising.

My own response to neo-expressionism was extremely skeptical. I did not believe that it was the repetition of an earlier moment in American art, or that history was back on track in the sense that the history of art and the history of painting were identical. My experience of those heady shows of Julian Schnabel and David Salle in Soho in 1981 was, as I have elsewhere written, that they were "not what was supposed to happen next." And that raised the question of what was to happen next. The answer to that question, as I came to see it, was that nothing was *supposed* to happen next because the narrative in which next stages were mandated had come to an end with what I have been calling "the end of art." That narrative ended when the philosophical nature of art attained a certain degree of consciousness. Art after the end of art could of course comprise painting, but the painting in question was not driving the narrative forward. The narrative, rather, was finished. There was no better reason, internal to the history of art for there to be painting, than for there to be art in any other form. Art had attained narrative closure, and what was now being produced belonged to the post-historical age.

There is a marked difference between a declaration in 1981 that painting was dead and earlier declarations to the same effect in the 1920s and 1930s. In 1981 there was, if one cared to see it a certain way, evidence that painting had nowhere further to go, that the all-black paintings of Reinhardt, the all-white paintings of Robert Ryman, or the sullen stripes of Daniel Buren, marked terminal stages of internal exhaustion. While one could, if one wanted to be a painter, content oneself with repeating these solutions, or making marginal variations, there remained a serious question of why one would want to. There were a comfortable number of variables—size, hue, surface texture, edge, even shape—with which to experiment, but this had to be done without the hope or expectation of

an historical breakthrough. Monochrome painting has its pleasures and victories, within the materialist aesthetic of the modernist narrative, but refining on the monochrome would correspond to a kind of wiping up operation in science, when, for example, one might fiddle with new data to get the orbit of the Moon down right. So conceived, science might be neverending, but its victories would have been achieved. And, in painting at least, it might seem that, in Hegel's terms once more, "art, considered in its highest vocation, is and remains for us a thing of the past." Moreover, the basis for a philosophical solution to the problem of art had been established, and was no longer something for artists to seek. That had passed, at last, into the hands of philosophers themselves. So it was a fairly bleak picture for artists, with only the modernist aesthetic to go on. Only if one believed modernism itself was past could one begin to cast about for something else to do. I suppose neo-expressionist painting was one answer. Since that narrative had ended, why not, forgetting about the economic account, simply use painting as a means for self expression? With no narrative to continue, why *not* expression? Under the imperatives of the modernist narrative, expression—for which Greenberg had a singular distaste—was in effect forbidden. Now it was permitted. It was as though a deep revolution in the structure of what philosophers call *deontic modalities* had taken place. I want to explain how this happened, but I first want to offer an analogy.

Professional philosophers of my generation lived through just such a revolution, especially those of us trained in the major American universities. The philosophy departments had been hospitable to a number of refugee philosophers in the war years, whose philosophy, let alone whose race in many cases, was radically unacceptable to fascism. They were logical positivists or logical empiricists, and it was their view that in a certain sense philosophy as it had been known down the centuries had come to an end. It was time that it was replaced by something intellectually responsible, namely, science. The positivists had a very clear idea of what science amounted to. In their view, and in marked contrast to philosophy, something was scientific if it was verifiable through sense experience (i.e., observation) or, to cite an influential variant, if it was falsifiable that way. For reasons somewhat too abstruse to go into here, it was their consensus that the meaning of a proposition consists in the conditions of its verifiability, and hence if a proposition happens to have no verifiable consequences, it is meaningless or, as they bluntly said, was nonsense. And, as I had occasion to say in my first chapter, that meant that

metaphysics was nonsense. The thought was that the verifiability crite-
rion of meaningfulness meant—and it sounds marvelous in German—*die
Uberwindung der Metaphysik*. And that is what we were taught.

This gave philosophers very narrow options. They could leave philoso-
phy and go into science—hence do something meaningful in all senses of
the term—or they could do what possible philosophical work remained
to do, namely, the logical clarification of the language of science. Friends
of my intellectual youth who studied, for example, with Professor Paul
Marhenke in Berkeley were urged to leave philosophy and do something
honest. Wittgenstein himself urged this on those who got close to him,
and he in fact tried to get a position as an industrial laborer in the Soviet
Union. The rest of us worried about dispositional predicates, bridge defi-
nitions, counterfactual conditionals, reduction, axiomatization, and law-
likeness. Like the stripe painter who might have wondered if painting
stripes was why she went into art, young philosophers may very well
have wondered if such scrutiny of minute logical detail was what they
wanted from the philosophical life. But there was the immense prestige
of their teachers, of mathematical logic, and then all the great challenges
the verifiability criterion apparently presented.

That criterion itself, however, faced certain challenges, not from the
muddled metaphysicians who were disenfranchised by it but by the very
thinkers whose agenda it defined. They sought for a rigorous formula-
tion, and the moment they did so, the criterion began to spring leaks. A
number of exceedingly sharp formulations of the seemingly lethal logical
weapon demonstrated that the moment one makes the principle tight
enough to exclude as nonsense the philosophy the positivists sought to
demolish, the principle forthwith excluded a lot of the science they were
anxious to put forward as the very paradigm of meaningfulness. And
when it was loosened up to admit the latter, nonsense kept gushing in. It
became a challenge to fix the criterion up to withstand these linked pres-
sures, but in the end no one found out how. For a time, it stood as a kind
of logical scarecrow, frightening away the timid crows of speculation, but
bit by bit it withered on its cross. The positivists continued to insist upon
it as if it were true and fatal, but finally, except as a stratagem of intimi-
dation, it stopped being interesting. Still, philosophy proceeded as if it
were true.

I have the most vivid recollection of an article on free will appearing in
the British journal *Mind*, in which the author began by saying, in effect,
that since no one knew how to fix up the verifiability criterion, it could
no longer forbid metaphysics. So where, he wanted to know, were the

metaphysicians? And it was all at once clear to me that the criterion had died, though people were acting as if it were still alive and dangerous. There was not exactly dancing in the street, but there began to be metaphysics in the professional journals. Peter Strawson published his crucial book *Individuals*, which was a study in what he termed "descriptive metaphysics." And one by one all the old problems returned. Philosophers still wrote on them as if they were doing symbolic logic: articles bristled with displayed formulae. But these more or less were emblems of philosophical legitimacy on the face of essays which for the most part could have been written in plain English. In the early 1960s something like this happened in art: it became obligatory, however subversive of abstract expressionism one meant one's work to be, that it be dribbled and dripped over with paint. The gym shoes and ladies' panties in Claes Oldenberg's store were thick with dripped paint, which was as inconsistent with the spirit of his works as could be imagined. Warhol's first comic strip panels proclaimed the seriousness of their artistic intentions by smears and runs of paint. It took three years, more or less, for art to outgrow this need for a kind of protective pigmentation. Philosophical prose has not recovered to this day, but that, in my view, is a function of real institutional pressures: the candidate for tenure must establish his or her logical manhood in order to be taken as a serious philosopher, and cannot, for fear of being thought soft, give up the purely ornamental formalisms after tenure is attained.

Verificationism in philosophy was very like modernism in artistic theory, forbidding certain things, constraining acceptable artistic practice in acceptable channels, and defining the way critical practice was to be structured. Criticism on Greenbergian principles, as I suggested earlier, survived even when artistic practice began, in the middle to late sixties, to slip away from it. As late as 1978, Douglas Crimp published his first essay on photography, "Positive/Negative," in which, he confesses in the preface to his 1993 book, *On the Ruins of the Museum*, "I still wanted to discriminate between a 'legitimately' modernist photographic practice and an 'illegitimate' presumption that photography is, as a whole, a modernist aesthetic medium."[6] He argued, on precisely modernist grounds, that certain photographs of Degas were about "photography itself," as modernist painting is about painting. "The very notion—'photography itself'—would later seem preposterous to me," he adds in a parenthesis. His thoughts about painting, the museum, and photography are connected. To think of photography in modernist terms is to think of the production of a self-conscious photograph as destined for inclusion in a

museum's cabinet of photographic art. The photograph would be like a painting, both enfranchised by the same critical theories. But Benjamin liberated him to think about photographs in terms of mechanical reproduction, and hence as capable of existing in as large a number as could be required, which is at odds with the artificially restricted edition that goes with the concept of the museum. His own book is illustrated with the photographs of Louise Lawlor, mechanically reproduced, and there is no invidious distinction between "originals" and "copies" to make the photograph in the book any less artistically valuable than the photograph in the museum. Since photography as mechanical has replaced painting, the museum has lost its point. Crimp might, upon reflection, reach the conclusion that it was not painting versus photography, as he argues in the essay on "The End of Painting," but modernism, whatever the subject, versus another form of criticism, call it postmodernist if you choose, Crimp's criticism being one example. The emergence of photography is seen as an attack on the museum construed as a bastion of a certain kind of politics.

But modernist critical practice was out of phase with what was happening in the art world itself in the late sixties and through the 1970s. It remained the basis for most critical practice, especially on the part of the curatoriat, and the art-history professoriat as well, to the degree that it descended to criticism. It became the language of the museum panel, the catalog essay, the article in the art periodical. It was a daunting paradigm, and it was the counterpart in discourse to the "broadening of taste" which reduced art of all cultures and times to its formalist skeleton, and thus, as I phrased it, transformed every museum into a Museum of Modern Art, whatever that museum's contents. It was the staple of the docent's gallery talk and the art appreciation course—and it was replaced, not totally but massively, by the postmodernist discourse that was imported from Paris in the late seventies, in the texts of Michel Foucault, Jacques Derrida, Jean Baudrillard, Jean-François Lyotard, and Jacques Lacan, and of the French feminists Helene Cixous and Luce Irigaray. That is the discourse Crimp internalizes, and it came to be lingua artspeak everywhere. Like modernist discourse, it applied to everything, so that there was room for deconstructive and "archeological"—in Foucault's sense—discussion of art of every period. It was not, unlike modernist discourse, generated out of a revolution in art. But it did seem to fit art after the end of art to a singular degree. And, inevitably, it got taken up by artists themselves, who were not especially equipped, philosophically, to control the new ways of thinking but to whom it sounded as if it accounted

for what they had stumbled into in their defections from modernism. And it suited to perfection the pathologies of self-pity to which the artistic, or perhaps the creative personality is subject in every clime. There remains a strong current of modernism in criticism, especially in that of journalists, like Hilton Kramer or Robert Hughes or Barbara Rose. Still, however strident and however influential their voices were, the art world of the 1980s spoke a form of broken French, based on the translations of murky texts written in what had until then been regarded as a language inherently lucid: it is worth observing that the texts were *written* in broken French!

I want now to register the way in which artists turned away from art as defined by modernist criteria in the late sixties and through the seventies, as if through their conduct they acknowledged that the tremendous narrative of modernism was over, even though they had no other narrative to put in its place. Nor did a new master narrative emerge in the later part of this era, when artists began to sense a certain relevance to what they were doing in the postmodernist texts that did fill the gap left by what was perceived as the increasingly irrelevance to their projects of modernist art criticism. Indeed, it was a theme of postmodernism, according especially to Lyotard, that there were no more master narratives to be had. The deconstructive spirit saw theories less in terms of truth or falsity than in terms of power and oppression, and since it became the standard question to raise as to who tended to benefit from a theory being accepted, and who was oppressed by it, those very questions very naturally were extended to modernism itself. Leftist critics took the view that modernism, which assumed that painting and sculpture were the vehicles of art-historical development, in fact was a theory calculated to entrench privilege by entrenching the institutions which painting and sculpture presupposed—the museum preeminently (with the sculpture park as a variant), the gallery, the collection, the dealer, the auction house, the connoisseur. The artist was inevitably co-opted, if he or she wanted to succeed, into producing work which reenforced these largely exclusionary institutions. And the museums in turn, subsidized by corporate funding, acted as conservative agents for the status quo. But this then meant that artists who worked "outside the system" could regard themselves as agents for social change and even for revolution, no longer imagined as manning the barricades and heaving paving stones and overturning cars, but as making art which, to use a term which came into favored use, *subverted* the institutional status quo by circumventing the institutions deconstruction showed to be oppressive. Painting itself came

to be represented as the art form par excellence of the group empowered by the institutions in question, and hence, increasingly and inevitably as politically incorrect, and museums came to be stigmatized as repositories of oppressive objects which had little to say to the oppressed themselves. Painting, in brief, became obliquely politicized, and in an odd way, the purer its aspiration, the more political it seemed. What did the allover white painting have to do with women, African-Americans, gays, Latinos, Asian-Americans, and such other minorities as there might be? The all-white painting seemed almost to flaunt the power of the white male artist! It fits this picture precisely that in the most political of recent major exhibitions, the 1993 Whitney Biennial, only seven painters were included. (It says something about political reconciliation that the 1995 Biennial had twenty-seven painters in it.)

The museum, at least in the form we know it, is not a very old institution, and at its inception, in the Musée Napoleon—later the Louvre—its agenda was political in every way. Its intention was to display the works Napoleon brought back as trophies from his conquests, and, in admitting common people to the place of previous privilege—the palace of kings—to give them the sense that in possessing these paintings, they were now the kings of the land, kingship being partially defined in terms of owning a collection of great art. The Altes Museum of Karl Friedrich Schinkel in Berlin was designed in part to receive back the works stolen by Napoleon, and hence to proclaim Prussian might and French defeat, and to give a sense of national identity to the Germans. Most of the great nineteenth-century museums in Europe had parallel missions, and I think it fair to say that the impulse to build museums on the part of newly independent nations today, and to press for the return of "cultural property," has similar motives. The United States, as may be inferred from the lateness with which our government took on the obligations of patronage in the form of the National Endowment for the Arts, and from the clear discomfort our representatives have in keeping it from going under, has never especially identified the national character with art. Our National Gallery has none of the nationalistic connotations of London's National Gallery, which was built under the same guiding values as those of the Altes Museum—as a temple to victory.

The American museum has always seen itself as primarily educational and, so to say, spiritual—a temple of beauty rather than of power. And this relatively modest role of the American Museum is what makes the deconstructionist attack on the museum as an institution of oppression sound so barbaric to those who have always thought of the museum in

the most exalted of terms. But in fact no good clear alternative to the museum has as yet been conceived. And a good many artists who fall under the official deconstructionist category as oppressed sometimes view exclusion from the museum as one form of oppression: their agenda is not to bypass, let alone dissolve, the museum. They want to gain entry. The somewhat paradoxical character of the Guerilla Girls is illustrative of the attitude. The group has been exceedingly radical in its means and in its spirit. It is genuinely collaborative, to the point that the anonymity of its members is a fiercely held secret: appearing in gorilla masks is a metaphor for that. And the art of this superordinate entity is certainly a form of direct action: its members plaster the walls of Soho with brilliant, biting posters. But the message of the posters is that not enough women are represented in museums, in major shows, in important galleries. So it envisages artistic success in the traditional, let us say, using their concept, white male terms. Its means are radical and deconstructive, but its goals are altogether conservative.

I want now to return to my own narrative. In my view, the deconstructionist account, even if true, does not go the heart of the matter—to what I want to think of as the deep structure of art history in the contemporary era. The deep structure, as I see it, is a kind of unprecedented pluralism, understood precisely in terms of the open disjunction of media which at once served a corresponding disjunction of artistic motivations and blocked the possibility of a further developmental progressive narrative of the kind exemplified by Vasari's or by Greenberg's. There was no favored vehicle for development any longer, and that seems to me to be due to the explicit sense that painting had gone as far as it could, and in a way that the philosophical nature of art was at last understood. So artists were liberated to go their diverse ways. Jenny Holzer, with her characteristic wryness, said that, when a student at Rhode Island School of Design, she grew unhappy with "third generation stripe paintings" she was producing, though she was pretty good at them, and said she wanted to get some identifiable content into her paintings. Robert Colescott accepted the modernist narrative under which painting culminates in the all white painting, but he realized that that had been done by Robert Ryman and the story was over, liberating him to undertake a program there was no room for in modernism, namely, as he put it, to "put blacks into art history." I surmise that the true hero of the post-historical artist had to have been Phillip Guston, who abandoned his beautiful, shimmering abstractions to take up a form of political cartooning that for some was intoxicating though for many was a betrayal. And one way of reading this

narrative would be that it all at once stopped seeming important to artists to work under the auspices of a narrative which at most permitted the most minute increments of progress under its auspices. Recall Hegel's powerful statement regarding the end of art. Not only is "art, considered in its highest vocation, is and remains for us a thing of the past," but art "has lost for us genuine truth and life, and has rather been transferred into our *ideas* instead of maintaining its earlier necessity in reality." Now, Hegel said, and he was right, art had "invited us to intellectual contemplation," specifically about its own nature, whether this contemplation was in the form of art in a self-referential and exemplary role, or in the form of actual philosophy. The artists of the late sixties and the seventies felt that having reached this point, it was time to turn back, not to outworn styles, but to precisely "genuine truth and life." So cartoons became an available means for Colescott, and a hybrid of high graphics and poetry became the medium for Jenny Holzer, and Cindy Sherman found in the working photograph a set of associations rich enough in their role as film stills to serve as a fulcrum for raising the deepest questions of what it meant to be a woman in America in the late twentieth century. None of this has much of anything to do with the deconstructionist account. Rather it has to do with the structural pluralism that marks the end of art—a Babel of unconverging artistic conversations.

My own sense of an ending suggests that it was the remarkable disjunctiveness of artistic activity across the entire sector that provided evidence that the Greenbergian narrative was over, and that art had entered what one might call a postnarrative stage. The disjunctiveness became internalized in works of art which also might have included painting. Where Crimp sees evidence for the "death of painting" in painters allowing their work to be "contaminated with photography," I see instead the end of the exclusivity of pure painting as the vehicle of art history. And Ryman's work takes on a very different meaning depending upon whether one sees it as the last stage of the modernist narrative, which after all had painting as its standard-bearer, or as one of the forms painting began to take in the postnarrative era when its peers were not paintings of other sorts, but performances and installations and of course photographs and earthworks and airports and fiberworks and conceptual structures of every stripe and order. The postnarrative era offers an immense menu of artistic choices, and in no sense precludes an artist from choosing as many of these as he or she cares to.

Within the hospitable and elastic disjunction, certainly there is room for painting and even for abstract or for monochrome painting. To say

UNTITLED FILM STILL (1978) BY CINDY SHERMAN. COURTESY OF THE ARTIST AND METRO PICTURES, NEW YORK.

that painting is dead, in the faintly apocalyptic cadences of deconstruction, is not so much to contest modernism as to accept its progressive and developmental narrative, and to say in effect that since that narrative is over with, there is nothing for painting to be—as if, unless it fell under the narrative, it could not really exist. But as Phillip Guston demonstrated, painting, liberated from modernism, has as many functions and can come in as many styles as there are imaginable ends for painting to serve— including, for those interested in it, just the making of beautiful objects or the making of objects which draw out the attenuated threads of a materialist aesthetics in the manner, say, of Robert Ryman.

Abstraction was the meaning of history, considered as a process, in the narrative of modernism: it was a necessity. In post-historical art it is but a possibility, something one can do if one cares to do it. So it is possible to infuse abstract paintings, even paintings of stripes, with the deepest moral and personal meanings, if one is Sean Scully. And it is possible, though an abstractionist, to set up internal references and allusions to distant moments in art history—to baroque and Mannerist painting, for example, if one is David Reed. And Reed can use illusionary space though

not a realist, and Scully can use real space though not a sculptor. And recently, as I discuss in the preface, Reed has used the format of an installation to make plain to viewers the relationship in which he hopes they will come to stand to his works. Neither of these artists consider aesthetic purity a relevant ideal. It might be a relevant ideal for Robert Mangold, for whom surface and shape are themes almost sufficient to constitute him as what one might, somewhat playfully, call neomodernist. But in his work there is so much wit, so much subversion of geometry, that the mishaps of his forms, aspiring to be pure, constitute, within their rarified repertoire of possibilities, something at once tragic and comic. A drawn circle whose circumference does not perfectly meet itself is as tragic a failure as circlehood allows—but it is also as comical as it is possible to expect from circles, which are not one's ordinary candidates for the status of clowns. I do not expect any of these marvelous painters to "save us" the way Greenberg expected Olitski to do, but that is not a judgment of comparative quality. It follows from the fact that we are not in the plight Greenberg supposed we were, from which historical rescue is wanted.

A pluralistic art world calls for a pluralistic art criticism, which means, in my view, a criticism which is not dependent upon an exclusionary historical narrative, and which takes each work up on its own terms, in terms of its causes, its meanings, its references, and how these are materially embodied and how they are to be understood. I want now, against the background of an interesting failure in my own thought, to try to show how art even at its least prepossessing is to be thought about critically. I will deal with monochrome painting misread as the end of painting in our time. And after that I will return to the museum as a politically anathematized institution.

NOTES

1. Erwin Panofsky, "Style and Medium in the Motion Pictures," in *Three Essays on Style*, ed. Irving Lavin (Cambridge: MIT Press, 1995), 108.

2. Douglas Crimp, *On the Museum's Ruins* (Cambidge: MIT Press, 1993), 90–91, 105.

3. "To hear him talk, the *caballete* (easel) is the fascism of art, this monstrous little square of besmirched canvas, pullulating under the skin of rotting varnish, fit prey for those canny userers, the speculating picture dealers of the rue de la Boetie and Fifty-seventh Street" (Lincoln Kirstein, *By With To & From: A Lincoln Kirstein Reader*, ed. Nicholas Jenkins [New York: Farrar, Straus and Giroux, 1991], 237).

4. "According to Joan Miró, he declared himself ready to kill off painting" (Felix Fanes, "The First Image: Dali and his Critics: 1919–1929," in *Salvador Dali: The Early Years* [London: South Bank Centre, 1994], 94).

5. Greenberg, "The Crisis of the Easel Picture," *The Collected Essays and Criticism*, 4:224.

6. Crimp, *On the Museum's Ruins*, 2.

The Historical Museum of
Monochrome Art

IN LATE 1993, a panel on the work of Robert Ryman took place at the Museum of Modern Art, held in conjunction with a retrospective exhibition of that singularly steadfast painter of mainly white squares. Robert Storr, who curated the exhibition and moderated the panel, gave the latter the title "Abstract Painting: End or Beginning?" His point of departure was precisely that position and indeed the very words around which I organized the last chapter: Douglas Crimp's view that painting was dead and that work such as Ryman's, with its archetypal white squares, could be taken in evidence of painting's internal exhaustion. But evidence was not something the thesis of painting's exhaustion ever required, for one could always find reasons for pronouncing its demise. Alice Neel was a robustly figurative painter, her work filled with comment and feeling, but in 1933, she recalls, Philip Rahv and his friend Lionel Phelps, "both radicals," came to her studio and said "'The easel picture is finished.' And 'Why paint just one person?' And I said 'Don't you know that is the microcosm, because one plus one is a crowd.' But they still said: 'Siqueros paints with duco on walls.' But I said 'We're not up to that, duco on walls.'"[1] Monochrome painting, even white—or at least white on white painting—existed in 1933, though it was almost certainly little known and thought of, at best, as a kind of joke. But the Left found reason enough to declare the death of painting even with so expressive an artist as Neel, if only because she used oils rather than duco, canvas rather than walls, and painted individuals rather than the masses. From time to time the death of painting is pronounced by someone, whatever painting itself may look like. Petronius's *Satyricon*, for example, includes a passage in which the narrator laments the decadence of his age, in which "the fine arts had died, and [the art of] painting . . . had left no trace of itself behind," which the author blames on the love of money. I gather the claim is that the art of painting had been cultivated

for its own sake, but no longer is, and that the chase for "pecuniae" had swamped the cultivation of technique, so that artists had "forgotten how" to make pictures of any value: "There is nothing surprising in the decadence of painting, when all the gods and men think an ingot of gold more beautiful than anything those crazy Greeks, Apeles and Phidias, ever did."[2] This in the second century A.D.!

My own claim about the end of art has to be resolutely distinguished from claims regarding the death of painting. Indeed, painting after the end of art has been extremely vital, but I in any case would not care to pronounce its demise on the basis of monochrome canvases, not unless I subscribed, as Crimp clearly did, to the modernist narrative according to which art progressively strives to achieve identity with its own material basis, and the white monochrome square could then be appreciated in terms of its substraction of color, of form other than its own form, and of shapes other than the one simple shape of the perfect square. Then the white square would seem to mark the end of the line, leaving painting nowhere else to go, and nothing much to do. In any case, Storr gave the panel its brief by opposing Ryman's own view to those of Crimp and many other advanced theorists: "From his vantage point painting in general and abstraction in particular—or what he prefers to call realism—are vital and relatively new forms." Hence the question in the panel's title: End or beginning?

It is striking that almost the same confrontation appears to have been enacted with the first appearance of serious monochrome painting in our century. When Malevich's *Black Square* was first displayed at the great 0–10 exhibition in Petrograd from December 1915 to January 1916, hung diagonally in a corner of a room and near the ceiling in the traditional position of the Russian icon, the association with death was irresistible to critics, one of whom wrote, "The corpse of the Art of Painting, the art of nature with make up added, has been placed in its coffin and marked with the Black Square."[3] The latter was identified by another writer as emblematizing "the cult of emptiness, of darkness, of nothingness." Malevich, naturally enough, saw it as a beginning: "The joy of new things, a new art, newly discovered spaces bursting into flower." Of course, he did not neccessarily mean that the *Black Square* itself was the first work of art in an entire new sequence. He saw it really as an erasure, an emblem of a wiping out of the art of the past, and hence of a break in the narrative of art. At one point he compares it with the Biblical flood. That kind of break came naturally to the avant-garde in its early history—it was part

of the rhetoric of the Armory show with its approriation of the flag of the American Revolution as its logo. So the *Black Square* really was an end, though not, for Malevich at least, the end of painting: it rather made way for Suprematism and new worlds to conquer.

It is characteristic of the inwardness of the art world in the late twentieth century that Storr should see in Ryman's white squares a beginning of a new history to which they belonged. It was, I suppose, rather late in the day to suggest that we required liberation from the art of the past: the avant-garde by 1993 carried a long chain of once revolutionary emblems, like Marley's ghost in Dickens's "A Christmas Carol." In the end, Storr wanted to know, "What does Ryman's work suggest in terms of untested painterly possibilities?" And I suppose the question might be interpreted to mean: can we imagine a narrative for abstract art, which is relatively new, which will be as rich as the narrative of illusionist art turned out to be? Of course, no one at the time of Giotto could have imagined a progress of the kind through which painting went, culminating in Raphael and Leonardo, let alone the astonishing illusionist achievements of French academic painting of the late nineteenth century, and the implication of Ryman's position is that we are, in the history of abstract painting, roughly in a situation parallel to that of Giotto's contemporaries. Can we, really, imagine that abstract painting can yield to the internal drives of a progressive developmental history? Is it thinkable that there will, say in three centuries, be an abstract artist whose work stands to Ryman's as Raphael stands to Giotto? That is a daunting test for the imagination, but it is certainly difficult to think of Ryman's work, however we appreciate it, as a beginning in the sense at least in which Giotto was a beginning in the tremendous Vasarian narrative. So neither disjunct seems altogether appropriate. That it is the end is inappropriate unless we accept the modernist narrative, and that it is a beginning is appropriate only against another narrative it is one purpose of the "end of art" theory to call into question. Of course it could, in the spirit of Malevich, be a beginning not so much in the sense of a first member but of a blank page, a tabula rasa, a symbol of a future in which abstract painting might take place but not against the subtractionist and exclusionary imperatives of the modernist narrative. It could be, as it were, the banner of an open future. That would be one way we might slip between the disjunction's horns, treating the white square neither as beginning nor ending, but as embodying a meaning analogous to that embodied by the *Black Square*. But both readings must then reject the suggestion of emptiness which comes

naturally to mind when one contemplates this genre of art. The mono-chrome square is dense with meaning. Or its emptiness is less a formal truth than a metaphor—the emptiness left by the flood, the emptiness of the blank page.

I am not certain, from the perspective of art criticism, that the tabula rasa reading is really at all appropriate to Ryman's work, which after all comes relatively recently in a sequence of white paintings beginning with Malevich and taken up by Robert Rauschenberg in a work done at Black Mountain College which had an immense impact on John Cage and, through Cage, on avant-garde sensibility. Ryman, intending a career as a jazz musician, began to paint at a certain point just to see what it would be like,[4] and it is interesting if not instructive to observe that his first paintings, while monochromatic, were not white but, curiously, orange or green—not even primary colors, as one might have imagined he would have used, were we to think of the austerity of white, taken as a metaphor for purity. The De Stijl movement allowed itself only three colors—red, yellow, and blue—and three noncolors—white, gray, and black. These have a certain metaphysical resonance: the colors are the primaries, and the noncolors define the end and midpoints of the axis through the center of the color cone. But orange and green, for someone with this orientation, are mere secondary hues, as suspect to the purist as diagonal lines were to Mondrian, who despised van Doesberg for indulging himself with them. So one can say that whatever the reasons were for Ryman turning to white, they were like those he held for using orange and green, with no metaphysical cosmological implication whatever. When Jennifer Bartlett executed her dot paintings of the 1960s, she arranged them like Cartesian points on a grid, and employed (shades of Duco!) just black and white and the primary colors as they come from the little bottles of Testor's enamel, used for painting models. But she later confided to her profilist, Calvin Tomkins, that "it always made me nervous just to use primary colors. I felt a need for green! I felt no need for orange or violet, but I did need green."[5] This concession to need immediately negates the Neoplatonic overtones of the primary hues and the geometrical ones of the axis of the cone, and makes plain that we are dealing with impulse and subjective inclination. My sense is that green and orange in the case of Ryman preemptively exclude the implication that the white squares have much to do with the white radiance of eternity. But that means that white is not a progressive development of Ryman's work, but rather a disclosure of a personality. His white paintings would have a very different justification and a very different mean-

ing from, say, Malevich's, and their meaning would be somewhat less declamatory than that the tabula rasa metaphor suggests. To find that meaning out, we would have to look closely at Ryman's own thoughts and motivations. That the paintings are white and square will not tell us much: monochrome paintings underdetermine their interpretations. But this is something perhaps always true of painting, which is why, like it or not, criticism has a role to play in the art of painting it does not especially have in literature, though recent trends in literary theory tend to treat texts so much as if they were paintings that one gets the feeling that the mere ability to read will do as little good in the one case as the ability to see does in the other!

I want now to address monochrome painting, and through it the question of the "death of painting," but not directly. I want to lay out a sort of matrix for my discussion which will indicate the difficulty, which in the end is philosophical, in making judgments about beginnings and endings. Monochrome is a good way to facilitate this discussion, just because, on the face of it, it seems to offer so little to talk about. In 1992, I was invited to deliver a lecture on monochrome painting at the Moore College of Art and Design on the occasion of an exhibition of Philadelphia monochrome painters, of whom the enterprising curator, Richard Torcia, found twenty-three working in what evidently struck them as a very fulfilling way in this seemingly inauspicious mode. Had they not heard of the death of painting? The art world is a place in which news of that sort travels very fast. They felt that there was always more to be said with monochrome paintings, and in this they were, as I want to show, right. But let me embed my remarks in a piece of apparatus that at one time seemed extremely promising to me but which gives the wrong kind of reason for thinking them right. This is the *style matrix*, as I called it when, in 1964, I introduced it in perhaps my most influential text, "The Art World."[6] And let's begin by considering a stylistic characterization of an artist between whom and Ryman one might initially if gingerly suppose, in the language of the docent, an "affinity," namely Piero della Francesca.

One might strengthen the claim of an affinity if one made central Piero's preoccupation with geometry and the fact that he wrote a celebrated treatise on perspective, *De prospectiva pingendi*, and if one took the white square prototype in Ryman as some manifestation, contrary to fact, of Platonistic proclivities. In fact Ryman, a jazzman, has a clearer affinity with John Ashbery than with, say, Reinhardt, Malevich, or Mondrian, who were fairly austere at times in their aesthetics. But part of what I am

after is the danger of basing an attribution of style on what immediately meets the eye, especially in monochrome painting, where you need a lot more to go on than optical data.

The characterization I have in mind comes from that oracular aesthete, Adrian Stokes, in an essay of his titled "Art and Science,"[7] and it is difficult to detach it from the catalog he modestly dismisses as "mechanical" of detail upon detail which illustrate the style that he insists is found "in visual art alone and then solely in visual art-cum-architectural sense of form, an aesthetic communication may be explicit and immediate to the point of rebutting after-thought." The "communication" is in the work rather than between work and viewer, who nevertheless grasps it "explicitly and immediately." I believe this is the quality Stokes refers to as quattrocento, and it is a "demonstration of intellect and feeling." It is, he contends, found in Cézanne ("It is the *realiser* of Cézanne"). But it "also persisted in post-Renaissance art, 'refurbished' by Vermeer, by Chardin, and of course by Cézanne," to speak only of painting (it is a quality, Stokes insists, found "also in drawing, in sculpture, and more particularly, in architecture"). The poet and critic Bill Berkson, in his anniversary essay on Piero for *Art in America*, endeavors to extend the list:

> After Cézanne, as Piero's fame accumulated, the offshoots were mostly 'little masters' like Morandi and bizarre interlopers like Balthus. The legacy also suited the countermodernist taste of sundry neo-classicisms. (In America, starting from the 1890s, it became central to the Beaux Arts mural tradition of Puvis de Chavannes.) . . . Thereafter, one reaches, like Longhi, for parallels and adjuncts in archaic art as well as modern abstraction, and in those few contemporaries—as diverse as Alex Katz and Sol Lewitt, for the more recent practitioners.[8]

Note that we are not talking about "influence." "Only Cézanne, of the later painters, could have known even facsimiles of Piero's work," Berkson writes, meaning, by "later," Stokes's exemplars, Vermeer and Chardin. When art historians lack chains of influence is when they invoke affinity classes, but we have, I think, enough of an idea of what the quality is that Stokes strives to nail down, and have enough examples of it to be able to recognize the quality in others.

I shall, after the manner of philosophers, designate the quality Q, and for my purposes it is not especially important that it be easily defined so long as it be easily recognized, as I think it is. That is what I take Stokes to be saying when he says that it is "explicit and immediate" (in contrast, say, with implicit and mediated by inference). A good many, perhaps all,

aesthetic qualities are of this sort. They are not, as Frank Sibley wrote many years ago in his deservedly famous article "Aesthetic Concepts," *condition-governed.*[9] He meant that one cannot—whether cannot in principle or just cannot easily—specifiy neccessary and sufficient conditions for aesthetic predicates. Thus these predicates seem at once complex and indefinable, which is somewhat paradoxical, since their complexity suggests that definitions ought in principle to be found. Whatever the case with definition, the consoling fact is that any of us, once we are acquainted with Piero, Chardin, Vermeer, and mature Cézanne, can easily distinguish Q works from ~Q, with, naturally, some problems at the borderline. It is hard to imagine any baroque painting that is Q, difficult to suppose anyone would find de Kooning Q or Pollock. Certainly Sanraedem would qualify, but probably not Rembrandt. And we might dither over Modigliani. One of my favorite fantasies is to train pigeons on slides of Piero, Chardin, and Vermeer, and then expose them to a battery of slides where they are rewarded for correctly distinguishing Q from ~Q. Q-ness clearly has nothing to do with goodness or greatness, not even if a case can be made that Piero is great because he is Q. What *is* important is that negative stylistic attributes are aesthetically positive, and, at some cost to perspicuity, we could give positive names to them, as Wölfflin distinguishes *malerisch*, or painterly, from linear, and the like. The cost is that there are cases where it is impossible to say that a work is *malerisch*, and equally impossible to say that it is linear, certain of Ryman's canvases being cases in point. But it is a matter of logic that if it isn't Q, then it is ~Q. There is a further cost as well. With negative stylistic predicates we can form simple matrices, whereas when we simply use "opposites," as "open" and "closed," or "geometrical" and "biomorphic," we lose this possibility.

Allow me to illustrate. Consider once more the rather complex stylistic notion Stokes has introduced, which I shall continue to call Q, and then the stylistic predicate *malerisch*, as used by Wölfflin, which I shall call P (since after all the word means "painterly"). With these terms and their negations, we can characterize every painting there is, albeit crudely: it can be both P and Q, P and ~Q, ~P and Q, and, finally, ~P and ~Q. Cézanne is quattrocento and painterly; Monet is painterly but not quattrocento; Piero is not painterly but is paradigmatically quattrocento; and (let us say) a late-eighties white square by Ryman is neither quattrocento nor painterly. I will admit we can quarrel over cases, but let us forbear: there is always that problem with stylistic terms. The point is that as we add stylistic terms, we get larger matrices: if we have *n* terms, we get a

matrix of 2^n rows. So with three terms we have a matrix with eight rows, with four terms one with sixteen rows, and so on. Obviously it gets pretty unwieldy, but the point is that however large the matrix, every painting can be located somewhere on it, and the more terms we have to work with, the more precise our stylistic characterization of each work. Actually, each stylistic term defines what we might call an affinity class of works, though all we mean by affinity is that there is some property of style which works in different columns but on the same row of the style matrix. But of course the concept of affinity explains nothing. The interesting question is always why any given artist worked in the style he or she did.

One great advantage of thinking of negative stylistic predicates is that we are not committed to the crude concept of binary opposites which we find in writers like Wölfflin, who came up with five pairs. There is a very large, almost indefinitely large number of stylistic terms, and sometimes we have to invent terms for artworks of a kind that never really existed before. Greenberg, who found the term "abstract expressionism" faulty and the term "action painting" detestable, referred to the art those terms referred to as "New York type painting." When journalists and others set about, as they inevitably did, seeking precursors, they were looking for New York type painting in the past, by artists who may never have set foot in New York. At the time, I suppose, the "binary opposite" of "New York type painting" was "School of Paris painting." The advantage of my system is that if we want to construct a matrix with "School of Paris painting" as a stylistic term, we can do so. But for certain purposes it may suffice simply to draw the distinction between New York type painting and its negation, which will merely include School of Paris art, and a great deal more.

The moment we recognize how expansive, how indeterminately large the range of possible stylistic predicates is, the less interested we are likely to be in the sorts of laws for which Wölfflin sought. There is no need to point out the internal difficulties of Wölfflin's system, but one observation is worth making: Meyer Schapiro argues that "it is difficult to fit into his scheme the important style called 'Mannerism' which comes between the High Renaissance and the Baroque."[10] Gombrich recalled, in an interview with Didier Erebon, that

> In Vienna at that time [i.e., the thirties] the burning question was Mannerism. . . . Up till then, even for Berenson and Wölfflin, Mannerism had been a period of decadence and decline. But in Vienna there had been a strong

movement to rehabilitate styles that had been despised. . . . As soon as it was decided that Mannerism was a style in its own right, just like High Renaissance, people stopped calling it "Late Renaissance" and called it Mannerist.[11]

Gombrich is especially instructive in respect to his treatment of Giulio Romano as a Mannerist architect. He argues that Romano had two distinct styles, and Gombrich was influenced in this characterization by Picasso, who had a neoclassical style and "also carried distortion to an extreme." Thus, Gombrich argues, it was possible that "an artist could have different modes of expression."[12] But this brings up two points. First, the moment Mannerism is established as a style in its own right, one can begin in a positive way to characterize any number of works as Mannerist which were made outside the specific period art-historically designated Mannerist that begins with Correggio and extends through Rosso Fiorentino, Bronzino, Pontormo, and Giulio Romano himself. Thus one might unhesitatingly identify as Mannerist certain roman stuccos, El Greco, but also Brancusi and Modigliani. But second, part of what helped firm Mannerism up as a stylistic category comes from modernist art, specifically Picasso, who sheds a certain retrospective light over the seicento. So the style matrix is historically fluid along its forward edge, in terms both of adding stylistic predicates—"New York type painting," for example—or changing older ones in such a way that what had appeared to be a phase of the late Renaissance becomes a style of its own. And who can say in advance whether the category of Mannerism itself is not too crude, that some division in the light of the future of style might not have to be effected somewhere between Correggio and Rosso Fiorentino?

Part of the interest of the style matrix lies in the status it lends to what one might term *latent properties* in paintings, properties of a kind to which viewers contemporary with the painting would have been blind, just because these become visible only retrospectively, in the light of later artistic developments. Correggio is again a good case: the Carracci, a century later, saw him as a predecessor, and hence as early baroque. Indeed, he became keenly appreciated in the eighteenth century, when his reputation was perhaps at its height, for such works as his *Loves of Jupiter*, seen as anticipating the rococo. The features that made Correggio hard to grasp as an artist by his contemporaries suddenly become clarified when the baroque style is invented, and further clarified from the perspective of the rococo. Mannerists prized grace at whatever cost to naturalness, and the disregard of the latter helps explain the term's synonymy today

with a kind of extreme artifice such as we find in Correggio's contemporary Parmigianino. But Correggio, though what was later called a Mannerist, also reacted against what his contemporaries recognized as *maniera* in the direction of something more naturalistic. So Correggio gets reinvented when Mannerism is stabilized as a concept in the twentieth century, just as he was reinvented in the seventeenth and eighteenth centuries, and on each occasion latent features became released and made available to appreciation. In a similar way the late Monet gets to be an early New York type painter. André Breton classed Uccello and Seurat as anticipatory surrealists, but there are any number of others—Archimboldo and Hans Baldung Grien come instantly to mind—who were waiting for surrealism to be invented in order to be adequately appreciated. The heavy criticism the 1984 "Primitivism and Modern Art" exhibition at the Museum of Modern Art came under was partly due to its casual bracketing of pieces of primitive art under the same affinity classes as modern art, which overlooked, as stylistic analysis inevitably must, all the deep differences between primitive and modern art. Thus a tall thin effigy from Africa doubtless has some "affinity" with a characteristic Giacometti, but affinity overlooks the reasons why either of them is tall and thin, and this must do great damage to our perception of either. But that is one of the problems with affinities, and it is, I am afraid, one of the problems, perhaps one of the main problems with the style matrix itself. For all the historical sensitivity of the style matrix, it implies an ahistorical vision of art—and I of all people should have been alert to this. From the beginning of my speculation on art, I have worked with—worked from—examples in which two outwardly similar things may nevertheless differ in so radical a way that the outward similarity proves altogether fortuitous. The African effigy and the Giacometti are not perfect semblables, but even if they were, there would be the fact to contend with that their affinity screens their profound artistic difference. But that shows I had not really thought things through when I first presented the style matrix in 1964, in the same paper in which I laid out the approach using indisernible counterparts and sought to solve the problems to which they give rise. That approach has generated a considerable amount of philosophical esthetics, but the style matrix has lain inert, or pretty much inert, from its debut until the present, apart from one serious criticism of it recently advanced by Noel Carroll.[13]

Suppose we were to construct a style matrix with three columns and eight rows, using Mannerist, baroque, and rococo as our style predicates:

these are more intuitive than such terms as ~ baroque and the like. It would look like this:

STYLE MATRIX

	Mannerist	Baroque	Rococo
1.	+	+	+
2.	+	+	−
3.	+	−	+
4.	+	−	−
5.	−	+	+
6.	−	+	−
7.	−	−	+
8.	−	−	−

Every painting in history will fit somewhere on the matrix, with perhaps some jostling. Van Dyck, influenced by Rubens, is (late) baroque, and, as he is committed to a certain concept of grace in his depiction of figures, which are *svelto*, he comes out Mannerist, whatever his influences. But since I see no trace of the rococo style in him, he belongs on row 2 (+ + −). The Carracci belong on row 6 (− + −), since fully baroque (they invented it), but repudiating Mannerism and far too energized to be rococo. One feels that Malevich's *Black Square* belongs on row 8 (− − −), namely as a sum of negations, the dark hole into which all stylistic qualities disappear. (Malevich descibed one of his black squares as "The embryo of all possibility," which means in effect the absence of all actualities). Malevich's *Black Square*, which explicitly belongs to the iconic tradition—he exhibited it, remember, across a corner of a room, as an icon might be displayed—is neither Mannerist nor rococo, but might just qualify as baroque. An early green monochrome by Brice Marden, titled *Nebraska*, is witty enough to be Mannerist and decorative enough to be rococo, and hence belongs on row 3. Where would Ryman fit? My hunch is that different works of Ryman would fit on different rows. But my objective at this point is merely to indicate that monochrome paintings do not automatically fall to the eighth row by stylistic default.

So much for mock technicalities. The *vision* the style matrix underwrites—or which underwrites it—is the way works of art form a kind of organic community, and release latencies in one another merely by virtue of their existence. I was thinking of the world of artworks as a kind of community of internally related objects. There is no question but that the inspiration for this way of thinking came from T. S. Eliot's essay

"Tradition and Individual Talent," which had a great impact on me at the time. Here is the crucial passage:

> No poet, no artist of any art, has his complete meaning alone. His significance, his appreciation, is the appreciation of his relation to the dead poets and artists. You cannot value him alone, you must set him, for contrast and comparison, among the dead. I mean this as a principle of aesthetic, not merely historical criticism. The neccessity that he shall conform, that he shall cohere, is not one-sided, what happens when a new work is created is something that happens simultaneously to all the works which preceded it. The existing monuments form an ideal order among themselves, which is modified by the introduction of the new (the really new) work among them. The existing order is complete before the new work arrives, for order to persist after the supervention of novelty, the *whole* existing order must be, if ever so slightly, altered, and so the relations, proportions, values of each work toward the whole readjusted.[14]

Indeed, what I meant by the expression "art world" was precisely that ideal community. To be a work of art was to be a member of the art world, and to stand in different kinds of relationship to works of art than to any other kind of thing. I even had a kind of political vision that all works of art were equal, in the sense that each artwork had the same number of stylistic qualities as any other. When a new style row was added to the matrix, everyone got richer by one property. I felt that, in point of stylistic richness, there was nothing to choose between *The Last Judgment* of Michelangelo and any black square of Reinhardt. The art world was radically egalitarian, but also mutually self-enriching. In a way, the principles of the style matrix reflected my experience of teaching the general education courses at Columbia. I was struck by how the *Odyssey*, for example, gets enriched by reading it in the context of Virgil, of the Bible, of Dante, or of Joyce. It fit handsomely the ideas of writerly reading and infinite interpretation that were to come in from Europe.

And finally, it squared with art-pedagogical practices, from the two projector art history lecture, in which works are juxtaposed and compared, however little they may have to do with one another causally or historically, to the common critical practice which nobody can resist, of saying that something reminds him or her of something else. It is to treat all works of art as contemporaries, or as quite outside time. But I am very much less persuaded today of the viability or even the usefulness of these practices. Eliot wrote, "I mean this as a principle of aesthetic, not merely historical criticism." And I think that what concerns me is the separation

of aesthetic from historical in this way. It is a move that closes the distance between artistic and natural beauty. But in doing that it blinds us to artistic beauty as such. Artistic perception is through and through historical. And in my view artistic beauty is historical as well.

That was more or less the main thesis of "The Art World," and what I had not seen at the time was the degree to which it is inconsistent with the motivations of the style matrix. My concern in that essay was with works of art that so resemble ordinary objects that perception cannot seriously discriminate between them. The thesis was enunciated thus: "To see something as art requires something the eye cannot decry—an atmosphere of artistic theory, a knowledge of the history of art: an art world." And you will note that there is reference to the art world built into to this characterization. I now think what I wanted to say was this: a knowledge of what other works the given work fits with, a knowledge of what other works makes a given work possible. My interest was in the somewhat attenuated objects of contemporary art—the *Brillo Box*, or Robert Morris's very uninflected sculpture, which was showing just around that time. These objects had few interesting affinities with anything in the history of art, though I have read discussions of the box which define a history beginning with Donald Judd and which included (I think altogether uninterestingly) the *Brillo Box* ("Warhol was silkscreening Brillo logos on them; Artschwager was making them out of suburban countertop formica," according to Richard Serra),[15] and I have heard formalist art historians include (as if just another box) Morris's *Box with the Sound of its Own Making*. These "boxes" arrived in the art world with such different meanings and explanatory interpretations that there is something willful in bracketing them together under the most minimal formal resemblances. But my thought in "The Art World" was that no one unfamiliar with history or with artistic theory could see these as art, and hence it was the history and the theory of the object, more than anything palpably visible, that had to be appealed to in order to see them as art. And this would be particularly the case for monochrome painting.

Clearly, what I mean by "monochrome" is not merely a single color but a chromatically uniform surface. Mantegna painted his stone and "bronze" painting, evidently meant to imitate carvings and castings, and painters had the option of working in grisaille or in sepia, repressing differences in hue for whatever reason. Today Mark Tansey is a monochrome artist (he told a questioner that he was saving color for his old age). But monochrome painting in the sense I intend cannot go back much before Malevich, and even then one has to make some distinction.

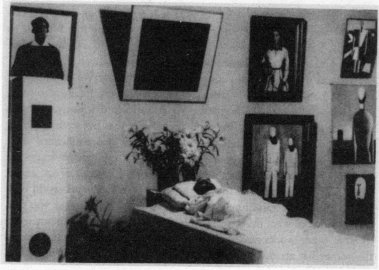

MALEVICH LYING IN STATE. PHOTO CREDIT: JOHN BLAZEJEWSKI.

His extraordinarily beautiful Suprematist *Red Square (Peasant)* of 1915 is in fact a red square on a white ground, hence more a picture of a square than a square or, to be stuffy about it, a self-portraying square. Or, to be really stuffy, it is a squarish shape in red depicting a red square, for the shape does not perfectly echo the shape of the canvas, having an eccentric perimeter. The importance of this eccentricity is brought out in Malevich's *Black Square*, again of 1915, which "acquired the force of a magic formula" in the minds of his contemporaries. Malevich described it thus: "Within the square of the canvas is a square, depicted with the greatest expressiveness and according to the laws of the new art" (i.e., Suprematism). His student Kurlov reported him as saying that he "depicted only a square, perfect in expression and in relation to its sides—a square which does not have a single line parallel to the geometrically correct square canvas and that in itself does not repeat the parallelness of the lines of the sides. It is the formula for the law of contrast, which exists in art in general."[16] But the square had to be something more than a pedagogic illustration: Malevich was buried in a "Suprematist" coffin, and one can see, in a photograph of the funeral, the black square, posed like an icon of the Madonna. It was like the death of painting, in the imagery used by the critic of Suprematism.

It was part of the high-flown purpose of Suprematism that it should remain not abstract but pictorial, depicting what Malevich calls "non-

objective reality." Until Suprematism, monochrome monotonal paintings were thinkable, but only as jokes, as pictures of an objective reality without chomatic differentiation, like an all white painting said to show virgins in their communion garments walking through the snow, or Kierkegaard's witty description of an allover red painting said to depict the surface of the Red Sea, after the Israelites had crossed over and the Egyptian forces were drowned,[17] a funny idea that got me started when I began to write *The Transfiguration of the Commonplace*. But even with Suprematism, one could not easily think of paintings which were not pictures, if not of a monochrome objective reality, then, as, Malevich liked to say, of a nonobjective reality. And indeed I think that the term "nonobjective" carried that latter meaning, of some spiritual or mathematical reality, well into recent times What is now the Guggenheim Museum was called The Museum of Non-Objective Painting and my sense is that the Baroness Hilla Rebay, its director, certainly felt—certainly *believed*— that the paintings over which she presided had metaphysical importance far in excess of anything formalist analysis could hope to accommodate.

In any case, we can imagine two red squares, one executed in the spirit of Kierkegaardian jokes and one in the spirit of Suprematism, which look enough alike that the temptation would be to place them in the same position on the style matrix, but which actually have very different stylistic attributes, not to speak of different interpretations and meanings. But one can also think of monochrome monotonal paintings done in neither of these spirits, and whose stylistic similarities or dissimilarities are purely accidental. I had, as it turned out, been altogether oblivious to contemporary monochrome painting when I wrote *The Transfiguration of the Common Place*, and still thought of it, probably in consequence of having had my attention drawn to it as a possibility through Kierkegaard, as the occasion of vaguely philosophical jokes. Not long after the book's appearance, however, I met Marcia Hafif at a party, and she told me that she was a monochrome painter. She in fact proved to be the leader of a whole school of monochromists, to whom she introduced me at a party she gave for me at her loft. From them, but especially from Marcia Hafif, I learned a great deal about monochrome painting—about the artistic possibilities of what I had written off as a plain red square. The plain red square rendered me an exceptional philosophical service, but I am certain that my appreciation of the differences between outwardly similar red squares, which I learned from Marcia and her collaborators, set me on the path to art criticism.

Here is an extended passage on Hafif's "Chinese Red 33 × 33," which she says is "one painting out of hundreds by the same artist, one painting

out of thousands by hundreds of artists. How does one understand this flatly painted red square? Why is it painted with household enamel? And why on wood, why plywood?"

> First the painting functions as itself. It is red. It is square and not very big. It is placed conveniently at eye level on a wall with enough clear space around it to be able to become a figure on the ground of the wall. It has a title: the name of the commercial color with which it is painted. Looking at it one reacts to it as to any other thing in the world. One sees it and responds silently to its size and shape, to the shiny red surface and the bare plywood edges, to the distance between it and the wall. Then the mind comes in and asks, what is it?
>
> The object is fixed to the wall as though it were a painting. In fact it is painted, it is a painting. What kind of reference does it make as a painting?
>
> By now this fracture of its meaning has produced multiple references: it is seen in the privileged space reserved for a painting, the wooden support comes from the Renaissance . . . the household enamel comes from our everyday lives, the matter-of-fact paint application with a house painting brush could be used to paint a table, the plywood is very ordinary, not precious, the one color surface belongs to the tradition of monochrome paintings, the square shape is neutral and modern, the size is human, being neither large nor small, the one painting is a sample of the artist's work.[18]

That it is painted the way a chair would be painted is an artistically important fact about this monochrome: it is not brushy, the way another monochrome would be, but "neat" and clean. And it is not painted in tempera, the way a painting on a wooden base in the Renaissance would be, but in commercially available enamel. "Chinese Red" is decorator nomenclature, naming a color chosen because of the statement it makes. Of how many red square paintings would all this be true? The eye will not tell you unless and until "the mind comes in, and asks." And the information, so neccessary to the appreciation of the work, so neccessary to the aesthetics of the work, is through and through historical. I don't see how you can separate, as Eliot does, aesthetic and historical criticism. But having unifed them, the premisses of the style matrix collapse. Hegel, in criticizing the philosophy of Schelling, speaks of a certain "mono-chrome formalism" with its concept of the Absolute (here is a nice example of a monochrome joke) "as the night in which, as we say, all cows are black."[19] Under the auspices of the style matrix, all red squares are alike. They can be gotten to yield up their aesthetic differences only through historicization.

The history of monochrome painting remains to be written, with Kazimir Malevich, Alexander Rodchenko, Yves Klein, Mark Rothko, Ad Reinhardt, Robert Rauschenberg, and Stephen Prina taking separate chapters, and the band of monochromists around Marcia Hafif as *chef d'ecole* constituting a valuable chapter, just before the one on the Philadelphia monochromists. And of course Robert Ryman deserves a chapter to himself. What is interesting about his work is the degree to which, for all its blank whiteness, it reflects the times through which the artist lived. The work from the fifties reflects the philosophy of pigment of the abstract expressionists: the artist is alive to pigment and canvas, and forms are applied deliciously, like frosting on a cake. In the confectionary spirit of the work, the signatures are large and celebratory, and even the dates are as prominent as they would be on a birthday cake. In the sixties Ryman becomes minimalist, and in a way materialist, the paintings being surface, support, and pigment and nothing more. By the eighties and into the nineties his work internalizes the pluralism of our times; it begins to incorporate sculptural elements—steel bolts, aluminum fasteners, plastic, waxpaper, and the like. Yet all through these changes, like Candide, the work retains its white simplicity of soul. It is an allegory of steadfastness and of adaption.

Hafif writes of "Chinese Red 33 × 33" that it "takes its place in a stream of some hundreds of paintings and exists for itself alone as well as in the context of the rest of the work." This is no less true of Ryman's work, or, I suppose, of anybody's. The work draws meaning from the body of work within which it is placed, and this makes clear the degree to which the place of painting today is the exhibition, which provides the context in which the work alone is to be judged and appreciated. Not all of the energy and meaning it derives from its placement is perceptual. But the critique to which the style matrix has been here exposed is an effort to say how much our aesthetic involvement with works of visual art derives from what one might, with Malevich, guardedly call nonobjective, or in any case nonperceptual factors. That is to be expected when "the mind comes in, and asks."

I offer this discussion of the monochrome painting as a model of how to think about criticism, once we realize that we have to think, however profound the resemblances between works, of their individual histories. We have to explain how they arrived in the world, and learn to read them in terms of the statements each makes and evaluate them in terms of that statement, deciding whether they are mimetic or metaphysical, formalist, or moralist, and where they might fit on an imagined style matrix and

what their peers might be, if we happen to still be gripped by the idea of affinities. Malevich's *Black Square*, because of its play against the rectitude of its ground, might have some affinity with one of Robert Mangold's squares, which do not quite meet their obligations of perfect vertices, though they seem to live by the code of perfect vertices. But that affinity is only, really, a beginning point in the critical analysis of either work, and as we prolong our critical examinations, it is also a distinct possibility that what they have in common is the least interesting fact about either of them. There could be a museum of monochrome works, could be, indeed, as I sought to imagine at the opening of the *Transfiguration of the Commonplace*, a gallery of red squares, each of them profoundly different from its fellows, but all of them looking exactly alike.

The bare idea of such a museum is of immense philosophical value, as the museum itself would be, were it to exist. To experience the collection, from 1915 to the present, would be to learn a great deal about how to experience art and, in particular, the complex interrelationship between the visual arts and visual experience. But it would, beyond that, demonstrate that the monochrome has little to do with the internal exhaustion of the possibilities of painting, and that the existence of white squares, red squares, black squares—or pink triangles, yellow circles, green pentagons—tells us nothing about the death of painting or, for that matter, the end of art. Each monochrome painting has to be addressed on its own terms, and counted as success or failure in terms of the adequacy with which it embodies its intended meaning.

The "last stage" description of Ryman's paintings was, however, historically accompanied by the circumstance that painting had stopped seeming an adequate medium for the kinds of statements certain advanced and often not so advanced artists were concerned to make. I have in mind that some of the most interesting artists of the middle to late sixties—Bruce Nauman, Robert Morris, Robert Irwin, Eva Hesse—began as painters, but found painting constraining. It is not as though they turned to sculpture as such, for the connotation of sculpture would have been no less constraining at the time. All that the work of these artists had in common with sculpture was a real third dimension, which somehow seems of marginal relevance, the way it is undeniable but also irrelevant that dance is three-dimensional. In a certain way, the work in question was closer in spirit to literature, to a kind of concrete poetry, explicitly so in Nauman's case and in Morris's. Whatever the case, the art of the seventies felt as though painting had been the matrix which the drive towards a wider expressiveness broke asunder, leaving those artists who

persisted as painters as if out of phase with art's evolution. Painting as painting seemed in that decade increasingly marginalized and, given certain ideologies of feminism and multiculturalism, increasingly demonized. It is neither here nor there that "good painting" might have been done in that era. The criteria of goodness that applied to painting had stopped being automatically the criteria for good art.

My own sense of an ending suggests that it was the remarkable disjunctiveness of artistic activity across the entire sector, not the rather reduced formulas of monochrome painting, that provided evidence that the Greenbergian narrative was over, and that art had entered what one might call a post-narrative period. The disjunctiveness became internalized in works of art which also might have included painting. Whereas Crimp sees evidence of the "death of painting" in painters allowing their work to be "contaminated with photography," I see the end of the exclusivity of pure painting as the vehicle of art history. And Ryman's work takes on a very different meaning depending upon whether one sees it as the last stage of the modernist narrative, which after all had painting as its standard-bearer, or as one of the forms painting began to take in the post-narrative era when its peers were not paintings of other sorts, but performances, installations, photographs, earthworks, airports, videos, fiberworks, and conceptual structures of every stripe and order. There is, one might say, an immense menu of artistic choices, and an artist can choose as many of these as he or she cares to, as have Bruce Nauman, Sigmar Polke, Gerhard Richter, Rosemarie Trockel, and any number of others for whom aesthetic purity is not especially a pertinent injunction. If Ryman belongs to this art world, neither is it a pertinent injunction for him.

But I want to conclude this chapter not with that, but with the nature of painting in what I ask you to humor me by thinking of as the early post-narrative phase of the rest of history. My sense is that the pluralism of the art world has inevitably been internalized by painting, which has lost the fierce exclusionary quality it possessed when it perceived itself as the vehicle of historical advance, and necessarily struggled to purge itself of all so to speak counterrevolutionary elements. In the art world of the fifties, as we saw, the pitched controversy was between abstraction and the image. Greenberg articulated this by indicting illusionary space as not proper to painting, as you recall. Painters today have become singularly tolerant by 1950s standards. You can put real forms in real space, real forms in abstract space, abstract forms in real space, and abstract forms in abstract space, to use a simple matrix. There really are no rules. I saw at

the National Gallery a 1987 work by Robert Rauschenberg which uses a Japanese kite as a collage element in what nonetheless feels like a painting. A show of David Reed's work—and he is an almost paradigmatically pure painter—incorporated abstract paintings in an installation composed of a bed and a television set. Let me stress that if there really are no rules, it remains an open possibility that artists might pursue the art of painting in whatever way they care to, and under whatever imperatives they may care to work—it is only that those imperatives are no longer grounded in history. So there is of course room for our marvelous painters—Sean Scully, Dorothea Rockburne, Robert Mangold, Sylvia Plimack Mangold, and others. But alongside the kind of painting we associate with them, there are paintings which increasingly incorporate words into themselves. The constraints of painting which drove the pioneers of the sixties into the invention of forms more accommodating to their thoughts have inevitably relaxed and painting has been redefined so as to admit the equivalent of those new forms and hence the expression of thoughts of comparable power. It must be admitted that those constraints once gave a great power to the art of painting, which had to find ways of working within them. But accommodation is the key to survival in an art world in which everything goes. Admittedly, to take a somewhat comical analogy from contemporary American politics, it is a bit like the Democrats incorporating into their so-called vision all those things once thought of as Republican—cutting taxes, cutting spending, small government, etc. Hardly what we think of as Democrat—but perhaps needed for political survival. The politics of paintings may be like that in the era we—Hans Belting and I at any rate—have come to think of as the end of art.

With this I turn to the subject of the museum, from whose ruins Douglas Crimp pronounced the death of painting. In fact there were, in the 1970s, all sorts of reasons, most of them political, for art theorists to have thought the museum dead, and there would have been a clear connection in the minds of many between the death of the museum and the death of painting, chiefly because museums and paintings seemed internally related to the point where, if painting is dead there is no further reason for museums to exist. But then, if painting is not dead, it has certainly undergone transformations of the kind I have been dwelling on, having become simply one of the forms artistic expression in the post-historical period can take, and this raises the question of the role of the museum with the other forms. Or is the connection between painting and museum exactly as tight as the critics of both have insisted, so that the museum itself is no more the unique forum for the display of art than

painting is the favored form for artistic expression itself? And if painting has lost its uniquely privileged position in the making of art, does this entail that the museum, too, has lost the uniquely priveleged position which after all came with its status as the vehicle of art history? The end of art means *some* kind of demotion of painting. So does it also mean the demotion of the museum? These are matters I can only begin to touch upon in the pages that remain to me.

NOTES

1. Patricia Hills, *Alice Neel* (New York: Abrams, 1983), 53.

2. Petronius, *The Satyricon*, trans. William Arrowsmith (New York: New American Library, 1983), 205.

3. Larissa A. Zhadova, *Malevich: Suprematism and Revolution in Russian Art, 1910–1930* (London: Thames and Hudson, 1982), 43.

4. Robert Storr, *Robert Ryman* (New York: Museum of Modern Art, 1993), 12.

5. Calvin Tomkins, *Jennifer Bartlett* (New York: Abbeville Press, 1985), 15.

6. Arthur C. Danto, "The Art World," *The Journal of Philosophy* 61, no. 19 (1964), 580–81.

7. Adrian Stokes, *Art and Science: A Study of Alberti, Piero della Francesca, and Giorgione* (New York: Book Collectors Society, 1949), 112.

8. Bill Berkson, "What Piero Knew," *Art in America* 81, no. 12 (December 1993), 117.

9. Frank Sibley, "Aesthetic Concepts," *Philosophical Review* (1949), 421–50.

10. Schapiro, "Style," 72.

11. E. H. Gombrich, *A Lifelong Interest: Conversations on Art and Science with Didier Eribon* (London: Thames and Hudson, 1993), 40.

12. Ibid., 41.

13. Noel Carroll, "Danto, Style and Intention." *Journal of Aesthetics and Art Criticism*, 53.3 (Spring, 1995), 251–57.

14. T. S. Eliot, "Tradition and Individual Talent," in *Selected Essays* (New York: Harcourt Brace, 1932), 6. Noel Carroll astutely sees in this essay the source of the style matrix. But I cite it already in *Analytical Philosophy of History* (Cambridge: Cambridge University Press, 1965) and in *Narration and Knowledge* (New York: Columbia University Press, 1985), 368, n. 19.

15. Richard Serra, "Donald Judd 1928–1994," *Parkett* 40/41 (1994), 176.

16. *Kazimir Malevich* (Los Angeles: Armand Hammer Museum of Art and Cultural Center, 1990), 193.

17. Soren Kierkegaard, *Either/Or*, trans. D. F. and L. M. Swenson (Princeton: Princeton University Press, 1944), I:22.

18. Robert Nickas and Xavier Douroux, *Red* (Brussels: Galerie Isy Brachot, 1990), 57.

19. G. W. F. Hegel, *The Phenomenology of Mind*, trans. J. B. Baillie (London: George Allen and Unwin, 1949), 78.

THE SCOTTISH SYMPHONY: CELTIC KINLOCH RANNOCK (1980) BY JOSEPH BEUYS. COURTESY: RONALD FELDMAN FINE ARTS, NEW YORK. PHOTO CREDIT: D. JAMES DEE.

Museums and the Thirsting Millions

IN HENRY JAMES'S novel *The Golden Bowl*, one of the main characters, Adam Verver, is a wealthy art collector who accumulates artworks of the highest quality and in great quantity in order to stock a visionary museum in his own city—"American City," as James somewhat flatly calls it. He imagines an immense thirst for beauty on the part of the countless workers through whose labor he has become the wealthy man he is. As if in fulfillment of that debt, he will set up a "museum of museums"—a house on a hill "from whose doors and windows, open to grateful, thirsty millions, the higher, the highest, knowledge, would shine out to bless the land."[1] The knowledge was in effect the knowledge of beauty, and Verver must have belonged to a generation that still resonated to the stirring thought that beauty and truth were identical, and that "release from the bondage of ugliness" meant release from the bondage of ignorance, and hence that exposure to beauty was equivalent to a curriculum of knowledge. I think it unlikely that Verver greatly analyzed the theory that drove him, but "the urgency of release from the bondage of ugliness he was in position to measure," James tells us, for until Verver discovered the deep reality of artistic beauty, he had been "comparatively blind." At a certain moment, with the force of revelation, he discovered his own desire for perfection, to which he had previously been blind. His "museum of museums" was to be a "receptacle of treasures sifted to positive sanctity." The people of American City were to be the beneficiaries of what it took time and struggle for him to discover. I think it fair to say that something like the Verver spirit is palpable in the great museums erected in America in the *Golden Bowl* years (the novel was published in 1904).

The Brooklyn Museum, opened to the public in 1897, is a good example of Verver's spirit. It was designed by the great New York architectural firm of James's time, McKim, Mead, and White—they were responsible for Columbia University on Morningside Heights and many of the opulent structures of the city in that optimistic era—and was meant as a

museum of museums in two senses: it was to be the largest museum structure in the world, hence a museum of museums in the augmentative sense in which we speak of the "king of kings"; and it was a museum of museums in the aggregative sense, since it was to be made up of museums, each devoted to some department of knowledge (there was even, I learned, to be a museum of philosophy under its vast multidomed vault). It was to be set on the highest point in Brooklyn, and though only the west wing of the projected structure was in fact erected, it transmits its meaning through the classical temple inserted into its facade, with its eight colossal columns. There was something almost touching in the disparity between its architectural proclamation of grandeur and the limited extent of its fine arts holdings when it opened nearly a century ago. There is also something touching in the disparity between its vision and its incomplete state. The Brooklyn community clearly never rose to the tremendous vision embodied in its great architectural fragment. Its museum's circulating exhibitions are visited by the Manhattan art world; its permanent holdings are of the highest scholarly significance; its public collections are on the agenda of the Brooklyn public schools; it is a valuable resource for the increasing population of artists who live in Brooklyn but who would prefer, all things considered, to live in Manhattan if they could afford it. Yet Brooklynites who are neither artists nor scholars show no great evidence of the thirst that the high-minded Ververs of Brooklyn had in mind when they decided to build a museum "worthy of [Brooklyn's] wealth, her position, her culture and her people."[2] Aside from the throngs of schoolchildren that sweep through like flocks of shorebirds, its galleries are the kind of vast empty spaces those of a certain age are nostalgic for in the museums of their youth.

For the moment I want to leave aside the thirsting millions of the borough of Brooklyn—and of all the communities in the nation which possess largely unvisited museums erected in the spirit of the museum of museums—and reflect on what the Ververs of the nation must have supposed justified their beliefs in the museum's value. Verver had certainly experienced art before he attained his revelation—before, in James's words, "he scaled his vertiginous peak." But he had not experienced it, as we might say, using an unfashionable word, existentially or transformatively. By this I mean that he had not experienced it in a way that provided him a vision of the world and of the meaning of living in the world. There are such experiences with art, none more compelling than the one Ruskin describes to his father in a letter of 1848. It took place in Turin, where Ruskin was distracting himself with copying a de-

tail of Veronese's *Solomon and the Queen of Sheba* in the municipal gallery. He wrote the letter after hearing a sermon, preached in the Waldensian faith, and the juxtaposition of sermon and the painting served to "unconvert" him.

> One day when I was working from the beautiful maid of honor in Veronese's picture, I was struck by the gorgeousness of life which the world seems constituted to develop, when it is made the best of. . . . Can it be possible that all this power and beauty is adverse to the honor of the Maker of it? Has God made faces beautiful and limbs strong, and created these strange, fiery, fantastic energies, and created the splendor of substance and the love of it, created gold and pearls, and crystal, and the sun that makes them gorgeous, and filled human fancy with all splendid thoughts; and given to the human touch its power of placing and brightening and perfecting, only that all these things may lead His creatures away from Him? And is this mighty Paul Veronese . . . a servant of the devil; and is the poor little wretch in a tidy black tie, to whom I have been listening this Sunday morning expounding Nothing with a twang—is he a servant of God?[3]

Ruskin underwent, through experiencing a great painting, a transformation of vision, and he acquired a philosophy of life. James has left us, so far as I can tell, no comparable episode for Adam Verver, though my sense is that it would probably have been equivalent in some way, even if it involved "the splendor of substance and the love of it—gold and pearls and crystal." Verver courts his second wife by taking her to Brighton to view a collection of Damascene tiles. James *does* describe these: "The infinitely ancient, the immemorial amethystine blue of the glaze, scarcely more meant to be breathed upon, it would seem, than the cheek of royalty." Perhaps because Adam Verver is going to propose to a young and beautiful woman, he thinks "perhaps for the first time in his life, of the quick mind alone, the process really itself, as fine as the perfection perceived and admired."[4] In any case, being struck by the gorgeousness of substance, Verver simultaneously sees the circumambient ugliness which, I at least infer, he must suppose irremediable, or he would, given his vast energies, have found some way to change those conditions directly. Instead he thinks of art as something that reveals and at the same time redeems the bleakness of ordinary life. He feels a certain bleakness even in his own widowed existence, for he would not otherwise risk so much in embarking on a second, dangerous marriage—unless he saw the beauty he would acquire as equivalent to what a great work of art would bring into his life.

These are not what one might call routine experiences of art or, in the case of Ruskin, a routine museum experience. Verver and Ruskin have encountered works of art in some existential context which the art then throws into perspective, like a piece of philosophy read at just the right moment. It is difficult to know if any other works in Turin's Municipal Gallery would have done the trick, or the Damascene tiles at any other time. It is also worth observing that the experience did not especially make either man a better person. Verver really did try to use the model of the artwork and of the museum as a model for human relationships, marrying his daughter off to what she describes as a *morceau de musée*, and turning his own ornamental wife into a sort of docent for the museum of museums. The museum is probably a very poor model for a happy life. And Ruskin's sad, unconsummated marriage with the luscious Effie Gray suggests that the robust hedonism underwritten by Veronese did not dissolve his sexual inhibitions. Doubtless a psychologist would find it significant that the "detail" that obsessed him was the flounce on the maid of honor's skirt. Notwithstanding that their lives fell short of the art that redeemed them, both men felt it imperative to extend to ordinary men and women the benefits of art—Verver through the museum of museums, Ruskin through his writings and his teaching of drawing at the Working Men's College in London. Both were aesthetic missionaries.

I think it is the possibility of such experiences as those I have described that justifies the production, the maintenance, the exhibition of art, even if the possibility, for whatever reason, is unactualized for most persons. Experiences of art are unpredictable. They are contingent on some antecedent state of mind, and the same work will not affect different people in the same way or even the same person the same way on different occasions. This is why we go back and back to the great works: not because we see something new in them each time, but because we expect them to help us see something new in ourselves. *Solomon and the Queen of Sheba* is difficult to find in color reproduction because it is now, as a result of scholarship, believed to be mainly or altogether the work of Veronese's workshop: it does not figure as one of the mandatory Veroneses. And one wonders, had Ruskin known that, whether he could have been transformed as he was. There is, so far as I know, no special condition an artwork must satisfy in order to catalyze the reaction: few works have meant as much to me as Warhol's *Brillo Box*, and I have spent a fair portion of my waking time in working out the implications of my experience of it. I would only say that art can mean very little to someone who has so far been, as Adam Verver had been while he was amassing his

great fortune, "blind" and numb to art, even if they have experienced it or even lived with it. And the museum itself is justified through the fact that whatever else it does, it makes these kinds of experiences available. They have nothing to do with art-historical scholarship, nor with "art appreciation," whatever the virtues of these. And in truth the experiences can take place outside museums as well: I sometimes think my entire involvement with painting was abruptly determined when, as a soldier in the Italian campaign, I came across a reproduction of Picasso's blue period masterpiece, *La Vie*. I thought I would understand something profound if I understood that work, but I also know that I formed the resolution to make the pilgrimage to experience the painting itself, in Cleveland, whenever I were to return to civilian life. Still, typically, it is in museums that most of us encounter the works that affect us in the way the Veronese affected Ruskin. At a press event, not long ago, someone confessed to the curator of an exhibition of difficult photographs that he could not envision living with one of them, and her response seemed to me very deep. She observed that it was after all wonderful that we have museums for work like that, work that demands too much of us to be able to contemplate having it confront us in our homes.

At the same time, these experiences now seem to many to make the museum vulnerable to a kind of social criticism. They are not what the thirsting millions thirst for. With this I return to the vast populations of Brooklyn for whom the museum is at best a childhood memory, or, at worst, an architectural pile on Eastern Parkway of no particular significance to their lives. There is a radical vision in the air these days, certainly in the United States, which shares at least a premiss with that of Adam Verver: the thirsting millions thirst for art. The art for which they thirst, however, is not something the museum has so far been able to provide them with. What they search for is *an art of their own*. In an exceptionally searching essay into what is called "community-based art," Michael Brenson writes,

> Modernist painting and sculpture will always offer an aesthetic experience of a profound and indispensable kind, but it is one that can now do very little to respond to the social and political challenges and traumas of American life. Its dialogues and reconciliations are essentially private and metaphorical, and they now have limited potential to speak to those citizens of multicultural America whose artistic traditions approach objects not as worlds in themselves but as instruments of performances and other rituals that take place outside institutions. . . . Certainly images whose homes are

galleries and museums can do very little to respond to the present crisis of infrastructure in America.[5]

This essay appears in a volume which describes and celebrates a rather extraordinary exhibition which took place in Chicago in 1993 called *Culture in Action*. For the exhibition, a number of groups about as far in social distance from, let's say, The Art Institute of Chicago, as it is possible to imagine, were led by artists to create an "art of their own," which in its turn was about as far in terms of artistic distance as could, with qualifications, be imagined from what that great and imposing structure houses as great and imposing art. Brenson, who had been a distinguished art critic for *The New York Times*, is spiritually at home in such institutions, and he speaks about the art they contain, even in this essay, in ways that Adam Verver and John Ruskin would recognize and endorse:

> A great painting is an extraordinary concentration and orchestration of artistic, philosophical, religious, psychological, social, and political impulses and information. The greater the artist, the more each color, line, and gesture becomes both a current and a river of thought and feeling. Great paintings condense moments, reconcile polarities, sustain faith in the inexhaustible potential of the creative act. As a result they become emblems, inevitably, of possibility and power.
>
> . . . To audiences who love painting, the experiences this kind of concentration and coherence offers can be not only profound and poetic but also ecstatic, even mystical. Spirit is incarnated in matter. . . . Not only does an invisible spiritual world seem to exist, but it seems accessible, within the reach of anyone who can recognize the life of spirit in matter.
>
> Painting points toward the promise of healing.

This is a fairly exalted characterization of the art of the museum, and there can hardly be any measure by which it can be rendered commensurable with "an art of their own" of the kind to which *Culture in Action* dedicated itself. Probably the most controversial such art was a candy bar that Local 552 of the The Bakery, Confectionary, and Tobacco Workers' International Union of America developed in consultation with artists Christopher Sperandio and Simon Grennan. Named *We Got It!*, the confection is described in the text as "The Candy of their Dreams." There is, as I say, no scale which would have this at one location and Veronese's *Solomon and the Queen of Sheba* at another. There is a response to this, which I regard as dangerous, but it has to be faced. It is the response that renders all art compatible through relativization: Veronese is to the group represented by Verver and Ruskin—and by Brenson in one of his

aspects—what *We Got It!* is to the group represented by the workers of Local 552. So just as the candy bar is "an art of their own" for the latter group, *Solomon and the Queen of Sheba* is an art of *their* own for—let us use the familiar expletives—the well-off white males for whom, in Brenson's explicit terms, painting is, as well as an emblem of possibility, an emblem of *power.* This position has the instant consequence of tribalizing the museum. It is valid for the group for whom the objects in it constitute an "art of their own"—and this leaves out that vast population of Brooklyn I described earlier who thirst, according to the premises of this position, for an art of their own.

Because of the issues it raises, it seems to me that *Culture in Action* was a landmark exhibition. It crystallized so many of the issues which divide us into factions today that I hope it will be discussed until those issues are resolved. Some of them involve the museum, inevitably, and it is these about which I want to make a few comments. They are issues in which I myself have been involved in various ways, and so in part I am speaking out of my own experience.

1. *Public Art.* There has always been a certain kind of public art in America, namely, the erection of commemorative monuments. But in relatively recent times the Verver spirit has sought to meet the fact that public would not go to the museum by getting the museum to go to the public, putting nonmonuments in public spaces to which the public was to respond in the same way—aesthetically—as they would respond to works in the museum. This strategy was subtly architectural, in that it created a museum without walls by colonizing spaces in the name of the museum, ostensibly for the benefit of the public. The public itself had no say in the choice of art, which was determined by what I term the curatoriat—art experts who knew, as the public in general did not, what was good and what was not. There can be no question that this could be read as a play for power on the curatoriat's part, and it emerged as such in one of the great artistic dramas of our time, the conflict over Richard Serra's *Tilted Arc* in Federal Plaza in New York. I am fairly proud that I argued for the sculpture's removal in my column in *The Nation*—a position I think could not have been argued for in any art publication in America. I remember Tony Korner, the publisher of *ArtForum*, saying that a great many there agreed with me, but there was no way the magazine could say as much. The art world drew its wagons in a circle at the hearings over the matter, though to no effect: the piece was removed, and the ugly emptiness of Federal Plaza was restored to the public for its own unexalted uses. In my own view, that controversy did more than

any single event to reveal the power component in museum reality to the larger public. Well, temples have always been emblems of power, but in a way disguised by the spirituality of their practices and their claims. As long as the museums were represented as temples to truth-through-beauty, the realities of power were invisible.

2. *The Public's Art.* There would be two ways to address this issue. One would be to give the public some greater say in the art that it was going to have to live with in extramuseal spaces. This should not present inordinate difficulties: it should indeed be one of the places where participatory democracy might in fact have a chance. The public to be involved with the artwork should participate in the decisions that are to affect their aesthetic lives. Christo engages the relevant public all the time, and indeed the decision-making process is part of the work he does, which is also, and importantly, ephemeral—later generations are not stuck with it. This decision is still, however, based upon the idea of the museum, which is wherever the art in question is to be: the extramuseal spaces are, for the duration of the art, detached museum precincts, the responses are museum responses, and the public has had input primarily as a consulting body—as a body of experts, in effect, on the subject of their own wishes, preferences, and desires. The response of some of the California land-owners to Christo's *Running Fence*—which was achieved partly through their allowing it to be achieved—compare in poetry and intensity to Ruskin's response to Veronese, for those who have seen them in the Meisels Brother's film. I will return to the idea of participatory aesthetics later on.

Before turning to the other alternative—to create nonmuseal art by transforming the public into its own artist—one should recognize that once the public has been given entry to the decision-making processes of the museum, both museum and public are going to have to determine where if anywhere a line can be drawn in what can and cannot be exhibited. In the United States, our public has been greatly exercised over art with sexual content, and the concomitant issues of censorship. But in Canada, recently, there was a tremendous outcry over the acquisition of art of the most critically esteemed order—Barnett Newman's *Voice of Fire* and Mark Rothko's *Number 16*. Now one clear advantage of tribalizing the museum—of saying in effect that the museum is for *their own art* for a given "they"—is that it is up to "them" to determine what "their" art should be, and this is not the business of the public that stays out of the museum. This might make an end run around the issue of censorship and

the like, except that the burden of taxation falls on all the "theys" alike. This would not have been a problem with the museum of museums, which the Ververs of the community could support out of their deep pockets. They would have to deal with their consciences in allocating their dollars to art rather than to other good things. On the other hand, not even shows like *Culture in Action* could take place without tax considerations involving groups other than those empowered by the funding to produce an art of their own. There was major support from the National Endowment for the Arts, not to speak of a pageful of tax-exempt organizations. The text does not give us the budget for the entire operation, so I have no idea what it cost the taxpayers to produce *We Got It!* candy bars. The latter did not make much money, for all the effort that was made to sell them to the candy-hungry population of Chicago. They tasted not one bit the better for being art. On the other hand, the candy could not have been made as art had the candy-making plant not been in place, which the confectioners were able to use for the time it took to produce *We Got It!* Of course, Richard Serra was not obliged to set up a steel-rolling plant in order to get the immense plates of weathering steel *Tilted Arc* required. But that is by the way.

Now there is one feature of contemporary art that distinguishes it from perhaps all art made since 1400, which is that its primary ambitions are not aesthetic. Its primary mode of relationship is not to viewers as viewers, but to other aspects of the persons to whom the art is addressed, and hence the primary domain of all such art is not the museum itself, and certainly not public spaces constituted as museums by virtue of having been occupied by works of art which are primarily aesthetic, and which do address persons primarily as viewers. In an essay in *ArtForum* in 1992, I wrote as follows: "What we see today is an art which seeks a more immediate contact with people than the museum makes possible . . . and the museum in turn is striving to accommodate the immense pressures that are imposed upon it from within art and from outside art. So we are witnessing, as I see it, a triple transformation—in the making of art, in the institutions of art, in the audience for art."[6] I was not surprised to see this passage quoted as an enabling text in *Culture in Action.* In part I was unsurprised because my thought was in some measure inspired by the previous endeavor of the chief mover of the exhibition, Mary Jane Jacob, an independent curator of immense energy and social vision, whose exhibition of site-specific art in Spoleto-USA I thought remarkable.

Extramuseal art ranges from certain genres not easily regarded as belonging to museums, like performance art, or through art—*We Got It!* is

a signal example—which is addressed to a particular community defined along racial, economic, religious, sexual, ethnic, or national lines—or along such other lines as may come to identify communities. The notorious Whitney Biennial of 1993 was an anthology of extramuseal art suddenly given exhibition space in a museum which acknowledged through that exhibition the trend I had in mind. I am afraid that, ready as I was to support such art, I hated seeing it in the museum. But that shows my politically retrograde nature. The natural outcome of an art of their own is almost certainly a museum of their own—a special interest museum, typified by the Jewish Museum in New York in its return to tribalism, or in the National Museum of Women in the Arts in Washington, where the experience of the art is connected to the way individuals identify with the community whose art it is, and which split the audience into those whose art it is and the others.[7] (The claim that "the" museum is already tribalized rests on the claim that it is just like museums-of-their-own for various "theys"—splitting the audience between the white male or empowered class on one side and the disempowered and marginal on the other.)

3. *But Is It Art?* Part of what makes community-based art possible, at least of the sort exemplified by *We Got It!*, are certain theories which really had not been articulated before the early seventies, or the late sixties at the earliest, though an argument can be made that the ground was laid for these theories as early as 1915, when Marcel Duchamp advanced his first ready-mades. The most radical statement of the enfranchising theories would be Joseph Beuys's, who believed not only that anything could be a work of art, but, even more radically, that everyone was an artist (which of course is different from the idea that anyone can be an artist). The two theses are connected. If art is narrowly understood in terms, say, of painting or sculpture, then the latter thesis is that everyone is a painter or a sculptor, and this is as false on the face of it as that everyone is a musician or a mathematician. No doubt everyone can learn to draw or model up to a certain point, but usually rather short of the point at which painting or sculpture as art begin. There is, so far as I can tell, no room for such invidious gradations in the Beuysian enfranchisement. It is art if it is art, otherwise it is not art. There may be special criteria by which we can tell *We Got It!* from other candy bars, but certainly not the criteria by which candy bars themselves are graded into better and worse—by taste, size, nutritional considerations, or whatever. *We Got It!* may fall short of these on all candy-bar criteria and still be art while *they* are merely candy

bars. A candy bar that is a work of art need not be some especially good candy bar. It just has to be a candy bar produced with the intention that it be art. One can still eat it since its edibility is consistent with its being art. And it is worth observing that the first in a series of what are called "multiples" by Beuys consisted in a piece of chocolate mounted on a piece of plain paper. There would certainly be a value in working out the differences between this work and *We Got It!*—and between both of these and the immense block of chocolate the young conceptual artist Janine Antoni incorporated into her 1993 work *Gnaw*. It is to begin with a difference between subsistence, snacking, and gluttony, and hence between the nutritive conditions of a soldier, someone with a sweet tooth, and a bulemic. Meanwhile, it is something of an irony that there is a sense of "quality" which derives from connoisseurship and the dynamisms of the secondary market, where someone might advertise one of Beuys's chocolates as of "especially high quality." This would mean, among other things, that the corners are sharp and the edges clean. But that has nothing, one would think, to do with the spirit of the multiple as art. It would be like asking a high price for Duchamp's snow shovel on the grounds that "they don't make shovels like that any more"—i.e., on grounds of its workmanship and the thickness of its metal. Nor has it much to do with the array of meaning made available to art when artworks themselves are made out of chocolate.

It is easy to see that "quality" has nothing to do with being art under Beuysian considerations, and it is in these terms that "quality" was questioned in a famous, controversial piece by Brenson in *The New York Times*, published under the title "Is Quality an Idea whose Time has Gone?" It is worth stressing, I think, that the irrelevance of the concept of quality is not as such a mark of "an art of their own." Women's art—and I am thinking not of the fine art women have made but of traditional women's art like quilts, which did not gain initial entry into museums of fine art— was clearly subject to assessment by reference to quality. Because of iconoclast prohibitions, Jews and Muslims did not produce painting and sculpture, but there can be little doubt that what they did produce as art was marked by criteria of quality. Even the work of Beuys, "the most prophetic voice," according to Brenson, for *Culture in Action*, is sometimes better than at other times, by criteria that the repudiation of the idea of quality threw into question. I think there would be consensus on which of Beuys's works were best and why, and what makes them good when they are good. And indeed, Beuys's work provides experiences of the same order as that provided by the Damascene tiles or Veronese's

Solomon and the Queen of Sheba. In 1970, for example, Beuys put on a performance (he used the term "action") called *Celtic (Kinloch Rannoch) Scottish Symphony* at the Edinburgh College of Art. There is a photographic record of him, in his characteristic felt hat and hunter's vest, standing in a large bleak room, or kneeling on its paint-encrusted floor, surrounded by some electronic equipment. Here is a description of part of the performance:

> His actions are reduced to a minimum: he scribbles on a board and pushes it around the floor with a stick in a forty-minute circuit of Christiansen [i.e., the pianist], shows films by himself (not entirely successful as the editing destroys the rhythm), and of Rannoch Moor drifting slowly past the camera at about 3 mph. He spends something over an hour and a half taking bits of gelatin off the walls and putting them on a tray which he empties over his head in a convulsive movement. Finally he stands still for forty minutes.
>
> Thus told it sounds like nothing, in fact it is electrifying. And I am not speaking for myself alone: everyone who sat through the performance was converted, although everyone, needless to say, had a different explanation.[8]

I draw attention to the word "conversion," which echoes Ruskin's "unconversion." And I think everyone who reads the description wishes they had been there to experience it for themselves. There is sometimes a tendency to think about Beuys as if he were someone who had been influenced by Beuys's ideas. But he was an astonishing artist with a compelling style and capable of amazing effects on people.

There is a response to these objections. It might be argued that members of marginalized communities that produce art to which value is relevant have internalized the values of the dominant but essentially alien artistic culture, and that Beuys, for all that he was a prophet, remained contaminated by the institutions that formed him. True community-based art is subject to criteria, but they are not of the kind that apply to the dominant artistic culture enshrined in museums and their satellite institutions.

But it is not my aim here to protract the argument. It is possible to suppose that the kind of art the museum defines has had its day and that we have lived into a revolution in the concept of art as remarkable as the revolution with which that concept emerged, say around 1400, and which made the museum an institution exactly suited to art of that kind. I myself argue here, and in a number of places, that the end of art has come,

meaning that the narrative generated by that concept has come to its internally projected end. When art changes, the museum may fall away as the fundamental aesthetic institution, and extramuseal exhibitions of the sort *Culture in Action* exemplifies, in which art and life are far more closely intertwined than the conventions of the museum allows, may become the norm. Or the museum may itself become aesthetically marginalized as it becomes tribalized to what might still remain the dominant artistic culture, understood now as the province of certain sexual, economic, and racial types. That would certainly take a lot of pressure off the museum, but at something of a price.

Before speaking of that, let me take up the "But is it art?" question, with reference particularly to such works as *We Got It!* It is certainly not art by "museum of museums" criteria, but to the degree that we allow the possibility of conceptual revolutions in art, that need not count for a lot. What we can say is that there has to be some extrahistorical concept of art for there to be conceptual revolutions in, and the analysis of this is a task for the philosophy of art, a task in which I feel some steps have been taken, some by me, and that enough is understood to be able to say that *We Got It!* quite plausibly qualifies as art under an adequate philosophical definition which nobody so much as surmised had to be given before relatively recent times. There will be a lot missing from it by criteria appropriate to the concept of art that has prevailed for some centuries. But then there may be a lot missing from work enfranchised by that older concept which *We Got It!* has got by criteria suited to the concept of art that work like it enables us better to understand.

4. *The Museum and the Public.* In saying that the museum is limited in what it is able to do for multicultural America, I tend to think the museum is a bit undersold. I do not think the experiences communicated by Ruskin to his father, or by James to us in describing Adam Verver, or by the witness to Beuys's action in Edinburgh in 1970 really are quite as restricted by class, gender, race, and the like as the theses of multiculturalism make out. One needs of course to have some knowledge in order to have those experiences, and that is the kind of knowledge that has to be conveyed to people if they are to have those experiences. That is knowledge of a different order altogether than art appreciation of the sort transmitted by docents, or by art historians, or by the art education curriculum. And it has little to do with learning to paint or sculpt. The experiences belong to philosophy and to religion, to the vehicles through which the meaning of life is transmitted to people in their dimension as

human beings. And at this point I return to Adam Verver's conception of the thirsting millions. What they thirst for, in my view, what we all thirst for, is meaning: the kind of meaning that religion was capable of providing, or philosophy, or finally art—these being, in the tremendous vision of Hegel, the three (there are only three) moments of what he terms Absolute Spirit. I think it was the perception of artworks as fulcrums of meaning that inspired the templelike architectures of the great museums of James's time, and it was their affinity with religion and philosophy that was sensed as conveying knowledge. That is, art was construed as a fount rather than merely an object of knowledge. I think other expectations must have replaced it, reflected in other architectures, like that of Rogers and Peano's masterpiece in Paris, the Centre Pompidou. These other expectations, whatever they may be, are probably good and valid reasons for making, supporting, and experiencing art, but perhaps the museum is more and more an obstacle to be gotten round, predicated as it is on the possibility of the kind of meaning I have sought to illustrate. My own sense is that these expectations are dependent upon that kind of meaning, and hence on the museum as dedicated to making it available. The museum has meanwhile sought to be so responsive to so many other matters that it is a tribute to Adam Verver's intuition—that there is something for which the millions thirst—that their galleries are still hung with paintings, their cases filled with marvelous objects of the kind he negotiated for with his intended betrothed in Brighton a century ago.

5. *Art after the End of Art.* That *We Got It!* should be a work of art and not a mere bar of chocolate is possible only after the end of art, enfranchised as such by certain powerful theories which emerged in the 1970s to the effect that anything can be a work of art and everyone is an artist. Its being "community-based" art rather than the work of a single individual is the achievement of certain enfranchising political theories which held, as one of their programmatic corollaries, that groups of individuals alleged to find no meaning in the art of museums should not be deprived of the meanings art might confer upon their lives. *We Got It!* does not redeem for the status of art every candy bar in creation, anymore than Duchamp made artworks of every snow shovel by making an artwork of one. Having conceded as much, let us ask ourselves where the museum stands after the concept of "an art of their own" has been accepted,

I think the first thing to be said is that not everyone for whom *We Got It!* was art belonged to that group for which the bar of chocolate was an "art of its own." As with all such cases, the work split the audiences

between those whose identity as a community was embodied in the art, and those who were no part of that community but who perhaps believed in community-based art—like Michael Brenson, for example, or the various art-world-based individuals who worked with the various communities to facilitate the different artworks which made up the exhibition *Culture in Action*. These were individuals who were themselves thoroughly at home in the world of the museum and the art gallery, the art exhibition and the art periodical. *We Got It!* was in no sense an art of *their* own. And indeed, they stood to *We Got It!* in very much the same sort of relationship in which Ruskin stood to Veronese's *Solomon and the Queen of Sheba* or in which Adam Verver did to the blue tiles of Damascus, which instantly helps to detribalize that art: it was not an "art of their own" for comfortable white males. They just happened to be the ones who appreciated it, the way the not altogether uncomfortable white men and women who formed the audience for works such as *We Got It!* appreciated that work, to be sure not on aesthetic but on moral and political grounds. So *We Got It!* is in no sense an art exclusively to those for whom it is an art of their own. It belongs to everyone, as it should, being art. Indeed, it is fair to say that while the art world did not make the chocolate bar, they made it possible for it to be art when the confectioners made it under certain auspices, and at a certain moment in history—i.e., after the end of art, when in a sense everything is possible. Whether *We Got It!* will ever yield anyone the kind of experience *Solomon and the Queen of Sheba* yielded Ruskin is quite unpredictable—after all, to how many did that very painting yield an experience comparable to Ruskin's? To someone who knows the art history of the candy, it is imaginable that they should be moved to think of all those men and women, far from the art world, thinking of what gave meaning to their lives and deciding that they could make art out of that and at the same time the best candy bar in Chicago! The mere possibility of that more than justifies putting the work in the museum. How else are we to preserve it for the edification of future generations?

NOTES

1. Henry James, *The Golden Bowl*, ed. Gore Vidal (London and New York: Penguin English Library, 1985), 142–43.

2. Linda Ferber, "History of the Collections," in *Masterpieces in the Brooklyn Museum* (Brooklyn: The Brooklyn Museum, 1988), 12. See also "Part One: History," in *A New*

Brooklyn Museum: The Master Plan Competition (Brooklyn: The Brooklyn Museum and Rizzoli, 1988), 26–76.

3. John Ruskin, communication to his father, in Tim Hilton, *John Ruskin: The Early Years* (New Haven: Yale University Press, 1985), 256.

4. James, *The Golden Bowl*, 220.

5. Michael Brenson, "Healing in Time," in Mary Jane Jacob, ed., *Culture in Action: A Public Art Program of Sculpture Chicago* (Seattle: Bay Press, 1995), 28–29.

6. Arthur C. Danto, *Beyond the Brillo Box: The Visual Arts in Post-Historical Perspective* (New York: Farrar, Straus and Giroux, 1992), 12.

7. I discuss this in my "Post-Modern Art and Concrete Selves," in *From the Inside Out: Eight Contemporary Artists* (New York: The Jewish Museum, 1993).

8. Caroline Tisdale, *Joseph Beuys* (New York: The Solomon R. Guggenheim Museum, 1979), 195–96.

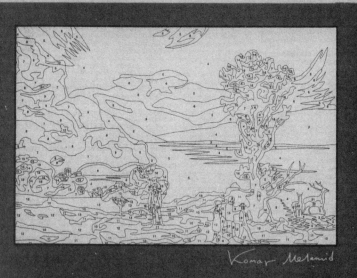

The Nation.

March 14, 1994 $2.25 U.S./$2.75 Canada

Painting by Numbers

The Search for a People's Art

COVER PAGE, *THE NATION*, MARCH 14, 1994. REPRODUCED BY PERMISSION. GRAPHICS COURTESY OF
PAUL CHUDY.

Modalities of History:
Possibility and Comedy

Somewhat earlier in my analysis, I declared myself, with a certain bravura, an essentialist in the philosophy of art, notwithstanding the fact that in the polemical order of the contemporary world, the term "essentialist" has taken on the most negative of connotations. Especially in feminist discourse, merely to entertain the thought that there is some fixed and universal feminine identity is to acquiesce in a form of oppression. But I have evidently been perceived as an antiessentialist in the philosophy of art, and hence on the side of angels. David Carrier, for example, wrote not long ago that "the target of Danto's critical analysis is the claim that art-as-such has an essence."[1] Now I would have taken the entire burden of my major work on the subject, *The Transfiguration of the Commonplace*, to have been to underwrite essentialism in the philosophy of art, since that book takes as its program a definition of art which pretty much implies that there is, after all, a fixed and universal artistic identity. The difficulty with the great figures in the canon of aesthetics, from Plato through Heidegger, is not that they were essentialists but that they got the essence wrong. It was never an inference of mine that "if *Fountain* and *Brillo Box* can be artworks, then no longer is there some distinctive sort of thing constituting art," as Carrier evidently believes. The point is that if they can be artworks, then pretty much all the attempted definitions of the essence of art have got it wrong, not that those who made the attempts were wrong in making them. Still, if a critic as astute as Carrier has misperceived my views, I cannot be badly out of line in making the effort to state them once more, particularly since, together with the endorsement of essentialism, I claimed to be an historicist in the philosophy of art. For how these views can be compatible may be difficult for readers to grasp, and exhibiting their consistency may accordingly be a philosophical contribution in its own right, going beyond the mere satisfaction of setting the record straight.

There are two ways to think of essence: with reference to the class of things denoted by a term, or to the set of attributes the term connotes: *extensionally* and *intensionally*, to use the old terms in which the meanings of terms was often given.[2] One is functioning extensionally when, by induction, one endeavors to elicit the attributes common and peculiar to the items which form the term's extension. The extreme heterogeneity of the term *artwork*'s extension, especially in modern times, has at times formed the basis of the denial that the class of artworks has a defining set of attributes, and hence the affirmation, commonplace when I began my investigations into the philosophy of art, that art must, like games, be at best a family-resemblance class. Something along those lines, if my surmise is right, must underlie Ernst Gombrich's original intention in saying that "there really is no such thing as Art,"[3] though my overall sense is that Gombrich was not among those who took Duchamp seriously.[4] My contribution, if it was one, was precisely not to be misled by the heterogeneity in the term's extension which Duchamp and Warhol now made radical. They made it radical because from their work being classed as art, it immediately followed that one could no longer tell which were the artworks by observation, nor, in consequence, could one hope to arrive at a definition by induction over cases. My contribution was that a definition now must be found which was not only consistent with the radical disjunctiveness of the class of artworks, but even explained how that disjunctiveness was possible. But, like all definitions, mine (which was probably only partial) was entirely essentialist. By "essentialist" I mean that it set out to be a definition through necessary and sufficient conditions, in the canonical philosophical manner. So, incidentally, did Dickie's institutional theory of art set out to be essentialist in that way. Both of us set ourselves resolutely against the Wittgensteinian tides of the time.[5]

The only figure in the history of aesthetics I found to have grasped the complexities of the concept of art—and who had almost an a priori explanation of the heterogeneity of the class of artworks, since unlike most philosophers he had an historical rather than an eternalist view of the subject—was Hegel. Symbolic art, in his scheme, had to look different from classical art, as well as romantic art, and it was clear in consequence that any definition of art he might give had to be consistent with that degree of perceptual disorder and inductive impotency. In the marvelous passage where Hegel sets out his ideas on the end of art, he writes, "What is now aroused in us by works of art is not just immediate enjoyment but our judgment also, since we subject to our intellectual consideration (i) the content of art, and (ii) the work of art's means of presentation, and

the appropriateness or inappropriateness of both to one another."[6] At the conclusion of chapter five, I suggested that we need little more than (i) and (ii) to map the anatomy of criticism. There is, to be sure, the matter of sensuousness, through which stigma Hegel assigns to art a lower station in the realm of Absolute Spirit than philosophy, which is pure intellection, unsullied by the senses, though he may have had sensuousness built into his idea of "means of presentation." But it also seems to me that with all its pyrotechnics of imaginary examples and its methodology of indiscernible counterparts, *The Transfiguration of the Commonplace*, in its effort to lay down a definition, hence chart the essence of art, did little better than come up with conditions (i) and (ii) as necessary for something having the status of art. To be a work of art is to be (i) *about* something and (ii) to *embody its meaning*. Embodiment goes beyond, or falls outside, the distinction between intension and extension as capturing the dimensions of meaning, and it will not be until Frege introduced his important but undeveloped notion of *Farbung* to supplement *Sinn* and *Bedeutung* that philosophers of meaning found (and quickly lost) a way of handling artistic meaning. In any case, my book ekes out two conditions, and I was (and am) insufficiently convinced that they were jointly sufficient to have believed the job done. But I did not know where to go next, and so ended the book. In Carrier's terms, it seems to me, I captured part of the essence of art, and hence vindicated my philosophical belief that art is an essentialist concept.

The difference, philosophically, between an institutionalist like Dickie and myself is not that I was essentialist and he was not, but that I felt that the decisions of the art world in constituting something a work of art required a class of reasons to keep the decisions from being merely fiats of arbitrary will.[7] And in truth I felt that according the status of art to *Brillo Box* and to *Fountain* was less a matter of declaration than of discovery. The experts really were experts in the same way in which astronomers are experts on whether something is a star. They saw that these works had meanings which their indiscernible counterparts lacked, and they saw as well the way these works embodied those meanings. These were works simply made for the end of art inasmuch as there was very little to them in terms of sensuous presentation, and a sufficient degree of what Hegel terms "judgment" to license the admittedly somewhat reckless claim I sometimes made that art had nearly turned into philosophy.

There is a further consideration bearing on the institutional account, and which has played a considerable role in my thinking about art, namely, that an object precisely (or precisely enough) like one accorded

the status of artwork in 1965 could not have been accorded that status in 1865 or 1765. The concept of art, as essentialist, is timeless. But the extension of the term is historically indexed—it really is as if the essence reveals itself through history, which is part of what Wölfflin may be taken to have implied in saying, "Not everything is possible at all times, and certain thoughts can only be thought at certain stages of the development."[8] History belongs to the extension rather than the intension of the concept of art, and, again with the notable exception of Hegel, virtually no philosophers have taken seriously the historical dimension of art. Gombrich, on the other hand has, and it is to his great credit that he specified that the purpose of his epochal book *Art and Illusion* "was to explain why art has a history."[9] He really explains why pictorial representation has a history, not why *art* has a history, which is why he had such difficulty in fitting Duchamp into his account, since, after all, *Fountain* has nothing to do with making and matching. Had he not taken over his colleague Popper's scorn for Hegel,[10] he might have seen that both content and means of presentation are themselves historical concepts, though the faculty of the mind to which they answer is not perception but, once again, "judgment." And in view of the historical constraints on the two, let us call them Hegelian, conditions, *Fountain* (which in any case was epicyclical on the history of plumbing) and *Brillo Box* (which alludes to the history of manufacture not to mention the history of standards of domestic cleanliness) could not have been works of art at any earlier moment. (We might define their historical moment as any time in which they could have been works of art.)

The term "essentialist" has become anathema in the postmodern world primarily in contexts of gender and secondarily in contexts of politics. Certain views of the essence of womanhood have been felt (rightly) to be oppressive to women at certain stages in the history of humankind; and the idea of participating in a single essence of Arabism has, in a celebrated polemic of Edward Said, obscured the differences among Arabs to Western eyes (let us overlook the essentialism of "Western"). So it has been viewed as morally and politically better to deny the existence of a female essence (for example) than to undertake the search for one. Or to say, of human beings generally, that our existence is our essence, following Sartre's subversion of the medieval distinction. Now I am uncertain what value it would be to try to fix essentialist definitions of women, Arabs, or human beings generally, but if we see the advantage, let alone the urgency, of doing so in the case of art, we may see that there are certain built-in safeguards against the kinds of abuses the polemiciza-

tion of essentialism was intended to identify. Given that the extension of the term "artwork" is historical, so that works at different stages do not obviously resemble one another, or at least do not have to resemble one another, it is clear that the definition of art must be consistent with all of them, as all must exemplify the identical essence. And as much may be said of the extension of *artwork* across the various cultures which have had a practice of making art: the concept of art must be consistent with everything that is art. It immediately follows that the definition entails no stylistic imperatives whatever, irresistible as it has been, at moments of artistic revolution, to say that what has been left behind "is not really art." Those who have relished denying the status of art to certain works have tended to elevate an historically contingent feature of art into part of the essence of art, which is a philosophical error it has evidently been difficult to avoid, especially when there has been lacking a robust historicism to go with the essentialism. In brief, essentialism in art entails pluralism, whether pluralism in fact is historically realized or not. I mean that I can imagine circumstances in which, by means of political or religious enforcement, works of art are externally forced to comply with certain standards. We see this happening with the attempts at legislating the National Endowment for the Arts into socially acceptable grooves.

The application to other concepts with historical extensions is immediate and clear. The concept of womankind, for example, has a very complex history, so that what counts as fitting for women varies sharply from period to period and place to place. (It is no less true that "man" has an historical extension as well). This, no more than with the concept of art, entails that there is no such thing as an essence that all and only women exemplify. It means, rather, that the essence cannot contain anything that is historically or culturally contingent. Hence essentialism here, as elsewhere, entails a pluralism of gender traits, male and female, leaving it a matter of social and moral policy which if any traits to incorporate into the ideals that go with gender. These will not be part of the essence for obvious reasons, for what belongs to essences, in art or in gender, has nothing to do with social or moral policy.

The conjunction of essentialism and historicism helps define the present moment in the visual arts. As we seek to grasp the essence of art—or to speak less portentously, of an adequate philosophical definition of art—our task is immensely facilitated by the recognition that the extension of the term "work of art" is now altogether open, so that in effect we live in a time when everything is possible for artists, when in the phrase I have taken over from Hegel, there is no longer a "pale of history." What

are we now to say in response to Heinrich Wölfflin's claim, cited more than once in this text, that not everything is possible at every time? "Every artist," he specifies, "finds certain visual possibilities before him, to which he is bound," so that "even the most original talent cannot proceed beyond certain limits which are fixed for it by the date of its birth." Surely this must be as true of artists born into a pluralistic art world, and for whom everything *is* possible, as for artists born into the art world of Periclean Athens or the Florence of the Medicis. One does not escape the constraints of history by entering the post-historical period. So in whatever way it is true of the post-historical period in which we find ourselves that everything is possible, this must be consistent with Wölfflin's thought that *not* everything is possible. The gamey whiff of contradiction must be dispelled by making distinctions between the everything that is possible, and the everything that is not. And that in part is the task of this last chapter.

The sense in which everything is possible is that in which there are no a priori constraints on what a work of visual art can look like, so that anything visible can be a visual work. That is part of what it really means to live at the end of art history. This means in particular that it is altogether possible for artists to appropriate the forms of past art, and use to their own expressive ends the cave painting, the altarpiece, the baroque portrait, the cubist landscape, Chinese landscape in the Sung style, or whatever. So what is it that is *not* possible? It is not possible to relate to these works as those did in whose form of life those works played the role they played: we are not cavemen, nor are we devout medievals, baroque princelings, Parisian bohemians on the frontiers of a new style, or Chinese literati. Of course, no period can relate to the art of earlier life-forms in the way those who lived those life-forms did. But neither could they, as can we, make those forms ours. There is a difference to be drawn between the forms and the way we relate to them. The sense in which everything is possible is that in which all forms are ours. The sense in which not everything is possible is that we must still relate to them in our own way. The way we relate to those forms is part of what defines our period.

When I say "all forms are ours" I do not mean that there are not forms distinctive of our period. Looking through the catalog of the 1995 Biennale in Istanbul, for example, one cannot but be struck by the fact that virtually nothing pictured could have been done as art as recently as a

decade ago. Most of it is in the form of installations, and the artists allow themselves no limits in the media they employ. There is a sense in which the works express our times, and this will almost certainly continue to be true: the Istanbul Biennale of 2005 will almost certainly contain works we cannot today imagine. That is a consequence of the pressures on artists constantly to come up with something new, which the open extension of the term "work of art" facilitates. And it is an overall corollary of the unknowability of the historical future. Were we to imagine ourselves as visitors to the biennals of ten years hence—the 105th Venice Biennale, the 5th Johannesburg Biennale, the 10th Istanbul Biennale, the Whitney Biennial of 2005—we know almost certainly that there will be things in them different in ways we cannot imagine in any interesting detail from what we could have seen in 1995. But we also know that our definition of art is already sufficiently in place that we will have no hesitation in accepting it all as art. If that definition should differ from what we have today, that will be through the progress of philosophical aesthetics, perhaps stimulated by the unforeseen history of the future of art, but perhaps not.

Let me then return to the point that while all forms are indeed ours, we cannot relate to them the in the same way as those could whose forms they originally were. This is a special kind of price we pay for our freedom to appropriate those forms, and since it is an incapacity which helps define the historical present, it is worth spending a bit of time in analyzing the difference between the post-historical period and all previous periods in the history of art. We cannot do better than use Wölfflin, with his keen sense of historical modalities—of possibility and impossibility—as our guide.

Wölfflin's strategy is exceedingly cunning. He brackets together artists contemporary with one another who seem prima facie to be stylistically very distant, and suggests that they have in fact a great deal more in common than first meets the eye: "Grunewald is a different imaginative type from Dürer, though they are contemporaries," he writes, but "seen from a longer range, these two types re-unite in a common style, i.e., we at once recognize the elements which unite the two as representatives of their generation."[11] Or again,

> There are hardly two artists who, although contemporaries, are more widely divergent by temperament than the baroque master Bernini and the Dutch painter Terborch. Confronted with the turbulent figures of Bernini, who will think of the peaceful little pictures of Terborch? And yet,

if we were to lay drawings by the two masters side by side and compare the general features of the technique, we should have to admit that here is a perfect kinship.[12]

There is, in brief, a common visual idiom which cuts across national and religious boundaries at a given time, and to be an artist at all is to participate in this vision. But "vision also has a history": the common visual language inevitably changes. However Bernini and Terborch differ from one another, they are far closer than either of them is to Botticelli, or to Lorenzo di Credi, who belong on a different stratum altogether: the "revelation of these visual strata must be regarded as the primary task of art history," Wölfflin thought. And of course Wölfflin's well-known "revelation" here is that Botticelli and di Credi are linear while Terborch and Bernini are painterly. And when he says that not everything is possible at every time, he means, I think primarily, that it not a possibility for those on the linear stratum to "say what they have to say" in painterly terms. Wölfflin asks, only to dismiss, the question of how Bernini would have expressed himself in linear style of the sixteenth century—"he needed the painterly style to say what he had to say." "Saying what he had to say" clearly goes beyond the history of vision, unless we accept that visual forms may be used to express beliefs and attitudes which are in no sense visual in their own right: "vision has a history" only because visual representations belong to forms of life that are themselves related to one another historically. Terborch's messages were erotic and domestic, Bernini's cosmic and dramatic. It was just that the painterly style enabled them each to say what they wanted to say in ways the linear style would not have. The forms of life to which the two artists respectively belonged overlapped in ways which neither of them overlapped with the forms of life the linear style expressed.

The art of the Counter-Reformation had as its charge to depict the sufferings of the martyrs, the agonies of Christ, the grief of Mary at the foot of the Cross.[13] The operative psychology was that those who saw the works would share the feelings, and in identifying with those who express them, have strengthened the faith for the sake of which those personages underwent so much. They had not merely to see that there was suffering, not merely to infer that someone in the situations depicted would in fact suffer: they had to feel the suffering. And ways had to be found to convey this all by means of paint and carving. But once the stylistic strategies of the baroque had evolved, they could be put to other uses—to cause viewers to feel, for example, the warmth of a room or the

cool slickness of a satin garment. And so the imperatives to which Ber-
nini's art was a response allowed Terborch to say things inaccessible to a
"linear" artist who may not even have entertained the thought that such
things *could* be said. There is a philosophically instructive asymmetry in
thinking of the way in which sixteenth-century artists could not so much
as conceive of expressing certain things in art that really required the
painterly vocabulary of the baroque style, and in thinking of how a ba-
roque artist would be frustrated were he obliged to try to say whatever
he had to say in the linear style of his immediate predecessors. How
would Caravaggio have expressed himself—"said what he had to say"—
in the style of Pinturrichio, and how would Courbet have managed with
the constraints which defined the stratum on which Giotto worked?
Viewers might have seen or inferred suffering, agony, and grief in linear
figures, but *feeling* these, and bonding with those who undergo them,
requires a different sylistic strategy. (Comic strips, which essentially use
linear styles of drawing, resort to words or to symbols: "Ouch!" or stars
in orbits around someone's bashed head.) But the constraints work in the
other historical direction as well: of what use to Giotto would have been
what Wölfflin describes as "the energy of the baroque handling of
masses?" How would that in any way correspond to what he wanted to
say through his art? There is, in brief, a certain internal correspondence
between message and means.

The philosopher Paul Feyerabend once stated that "historical periods
such as the Baroque, the Rococo, the Gothic Age are unified by a con-
cealed essence that only a lonely outsider can understand. . . . We can
admit that times of war produce warlike writers—but that does not ex-
haust their nature. One must also study those who were untouched by
the patriotic fervor and were perhaps averse to it; they too represent their
age."[14] The notion of an historical essence is certainly far from clear, but
neither, I think, have we any particular grasp on the substance of history
if we do not recognize the existence of realities to which the notion
corresponds. We can speak of these as "periods" if we choose to, so long
as we recognize that a period is not simply an interval of time, but rather
such an interval in which the forms of life lived by men and women have
a complex philosophical identity, as something lived and known about
in the way we know about things by living them; as something that can
be known about but not lived; and as something that can both be lived
and known about, in the case of individuals who are gifted with an histor-
ical insight into their own times—who are inside and outside their period
at once. We can know about the baroque period as scholars or, to use

Feyerabend's romantic words, as "lonely outsiders," but it is no longer available to us as something we can live. Or, in a way, we can live it only in the mode of pastiche and pretense, and that is not really living it since no one lives it with us. The paradigm of someone endeavoring to live a period in this way is of course Don Quixote, who is humored or exploited by individuals who do not really share the Don's form of life (since no one can), but who can come to know about it externally, the way most of us get to know about the lives lived in former times.

We really know very little about future forms of life, and if we try to live futuristically, we are almost certainly going to merely represent our own time's vision of the future. The futurist counterpart of Don Quixote will almost certainly be some variant of the cosmonaut which has tended to emblematize the future since perhaps the 1930s, when Buck Rogers and Wilma Dearing flitted from star to star. A fin de (vingtième) siècle Cervantes could write a novel about someone trying to live the life of the future now, but it will look as quaint when the future comes as Buck Rogers does today. He—or she, since folly knows no gender—would almost certainly resort to the kind of costume we learn about through films such as *2001*. There is nothing more sobering than the way the 1990s was perceived from the vantage point of the 1960s: we are very far indeed from yesterday's tomorrow.[15] Still, there is a deep difference in the way the future is impossible for us, and the way the past, which we can know about, is impossible for us. This asymmetry is the structure of historical being. If it were possible for someone to know the future, it would be useless knowledge, for that person could not live the form of life which defines the future since no one else does. If other people lived it, it would be present, after all.

The expression "form of life" of course comes from Wittgenstein: he said, "To imagine a language is to imagine a form of life."[16] But the same thing must be said about art: to imagine a work of art is to imagine a form of life in which it plays a role. (Try to imagine Terborch trying to imagine a form of life in which the typical installation in the 1995 Istanbul Biennale plays a role!) In my discussion of monochrome painting, I sought to imagine different forms of life in which paintings which outwardly look the same play different roles, have different meanings, and hence are subject to different art criticisms. To treat works of art purely in aesthetic terms was thought, by modernists especially, to strip them of their rootedness in forms of life and to treat them on their own. What was not recognized was that the works of art made to be addressed that way did so in forms of life in which something like artistic beauty had a role to

play. Without the form of life in which it has a meaning, in which works are made for their aesthetic qualities, our relationship to aesthetics is so external that one can seriously wonder what the point and purpose of such art can be. To ask today, in the terms of a name given to a colloquium I once participated in, "What Ever Happened to Beauty?" is to ask where in our form of life something like artistic beauty has a role. But I must not allow myself to be distracted. Rather, I want heavily to stress a philosophical point about forms of life: a form of life is something lived and not merely known about. For art to play a role in a form of life, there must be a fairly complex system of meanings in which it does so, and belonging to another form of life means that one can grasp the meaning of works of art from an earlier form only by reconstituting as much of the relevant system of meanings as we are able. One can without question imitate the work and the style of the work of an earlier period. What one cannot do is live the system of meanings upon which the work drew in its original form of life. Our relationship to it is altogether external, unless and until we can find a way of fitting it into our form of life.

With this let us return to Wölfflin. The painting styles of Giotto, Botticelli, and Bernini belonged to different forms of life so intimately that it is difficult to feel that it is valid to see them as constituting a kind of progressive series, as Vasari almost surely would have, and so related to one another that Giotto, had he been given a glimpse of Botticelli through a time warp, would immediatly have appropriated its innovations—as if Botticelli had succeeded in doing what Giotto would have done had he known how. And so with Botticelli, had he been given a glimpse of Bernini or Terborch. No time-warp fiction is required to imagine Bernini knowing Botticelli, or Botticelli knowing Giotto, for the work was there to be seen. And we do know that the later artists could not have painted in the manner of their predecessors, not for reasons of skill or knowledge, but because there would not be room in the form of life of Counter-Reformation Rome or Medici Florence for painting in the older styles: Bernini fits, as Botticelli does not, with Saint Ignazio Loyola's *Spiritual Exercises*; Botticelli fits, as Giotto could not have, with Lorenzo di Medici's poetry. The later artists could only have painted in the earlier manner were it part of their endeavor to paint pictures which showed paintings from the time of one of their predecessors, the way, to use my earlier example, Guercino found an archaic style for the painting of which his Saint Luke is so exultant. Had Guercino done a painting about the life of Giotto, he would have been sure, in view of his historical sensitivity, to paint the latter in what he takes Giotto's style to have been,

and not in his own: Giotto would not, and really could not, have painted like Guercino, so Guercino would have been careful, in the case described, to adjust his style to that of his subject.

Let us consider a painting in which the artist does not possess Guercino's sensitivity. There is an extremely ambitious painting, done in 1869 by the German artist Anselm Feuerbach,[17] which depicts the climactic moment of Plato's *Symposium* at which Alcibiades, drunk and surrounded by a rowdy company, bursts into the feast of reason in which one after another the guests had described and praised love. It is a vast canvas, with the figures life-size, and a certain amount of art-historical scholarship has gone into the identification of the individual guests. It is relatively easy to pick out Socrates and Agathon, and Alcibiades, of course. The remaining identifications have to be argued for, but it is inconsistent with Feurbach's high-mindedness that he would paint a kind of anonymous banquet scene. Too much thought has gone into the details—the lamps, the robes, the physiognomies, the gestures—to have settled for some anonymous extras rather than Pausanias, say, or Aristodemus. Feuerbach lived in an atmosphere which celebrated the classical world—his father had written a text on the Apollo Belvedere. And for all the raucousness of the moment depicted, the *Symposium* itself celebrates the highest and most abstract ideals of, as it happens, the intellectual as against the physical love of beauty. We know that Feuerbach aspired to a painterly style commensurate with these *beaux ideals*. He was an exponent of the so-called "Grand Manner" enunciated in the seventeenth century, in Italy, in the writings of Giovanni Bellori and embodied in the paintings of Poussin and the Bolognese masters, and given its classical statement in Reynolds' discourses. What is important to observe is that the Grand Manner was deemed suitable to historical painting, and in the ranking of the academy, historical painting is the highest and most exalted of the genres. Small wonder Feurerbach regarded himself as a very great painter indeed, and small wonder again that he was embittered by the failure of the world to share that exceedingly high opinion. Certainly, Feuerbach's painting, what he would unhesitatingly call his masterpiece, was possible in 1869 when it was painted. (But so was Manet's *Olympia* and his *Dejeuner sur l'herbe* of 1863, which was "art fallen so low it hardly merits reproach," and so were the paintings of the impressionists—the first impressionist exhibition took place in 1874.) Feuerbach's work, though he would hardly have seen it that way, was already dated, even if the Grand Manner as he had mastered it was the Grand Manner of the

mid-nineteenth century, and would perhaps have been seen by him as continuous with but having gone far beyond the work of, say, Poussin. Within his masterpiece, Feuerbach painted a painting, also of a symposium, namely the event described by Xenophon, in which the subject was again love. This painting shows Dionysus and Ariadne, hence divine and mortal love. The problem is that, for all his extraordinary historical and archeological knowledge, Feurbach painted the painting within the painting in the same Grand Manner in which he painted everything else in it, disregarding the rule which Guercino grasped and Wölfflin expresses, that, once more, "vision has a history." To be historically consistent, Feuerbach would have had to paint the painting within his painting in a style historically appropriate to ancient Greece, even if everything else in his painting is in the Grand Manner he commanded. We in fact know almost nothing about what Greek painting looked like, though one must assume that for artists like Apeles or Parahesios to have earned their extraordinary reputation as illusionists, their art must have been closer in style to the marbles of Praxiteles than to the vase paintings of Eurphronios. Plato would scarcely have regarded the vase painters as dangerous seducers of visual belief! We do not even know if there would have been paintings on the wall, as Feuerbach shows. But we ought at least to be able to infer that if there were, they would not have been in the Grand Manner.

Logicians draw a crucial distinction between the *use* and the *mention* of an expression.[18] We use the expression "Saint Paul" when we make a statement about Saint Paul. We mention "Saint Paul" when we use it to make a statement about that expression. The same distinction is available with pictures. We use a picture to make a statement about whatever the picture shows. But we mention a picture when we use it to make a picture of it which in effect says, "That picture looks thus!" Mentioned expressions typically occur within quotation marks. "'Saint Paul' is the name now given to Saul of Tarsus." Mentioned pictures typically occur as pictures within pictures. It is not available to Guercino to use the style he ascribes to Saint Luke to paint his pictures in, unless bent upon forgery. It is only available to him to "mention" that style, by painting a picture as he imagines Saint Luke would have painted it, using the style of his time. The main use of pictorial mention is in paintings about painters, but of course also in paintings of interiors in which paintings hang as objects of interior decoration. Vermeer's style was sufficiently accommodating that he could paint the pictures within his pictures in his own style,

which also showed the style of those paintings, close in any case in style to his own. If we could represent the art of the future, we could at best mention it pictorially, since the form of life to which it belongs is not available to us to live.

In saying that all forms are ours, then, I want to distinguish between their use and their mention. They are ours to mention in many cases, but not to use. Consider the case of Hans Van Meegeren, the remarkable forger of Vermeers in the 1940s. Van Meegeren's motives as a forger were connected with his belief that the critics did not take him as seriously as he took himself as an artist, and his aim was to paint what the experts agreed was a Vermeer. That secured, he meant to reveal the truth that he had painted what, had it instead been painted by Vermeer, the critics would have had to acknowledge was a major work. And, as the painter of a major work, Van Meegeren would have had to be considered as great as Vermeer was. The structure of implicit argument has something of the shape of Alan Turing's test for machine intelligence: it would be inconsistent to ascribe intelligence to a literary critic but not to a machine if there were no grounds for discriminating between their "outputs"—i.e., the answers to certain questions put to a source whose identity was hidden. Of course, the human all-too-human took over with van Meegeren: the money was more delicious than the revenge. Think what one may of van Meegeren's *Christ at Emmaeus*, which hangs today in the Boymans-van Beuningen Museum in Rotterdam, it contributed nothing whatever to the reevaluation of van Meegeren's own paintings, though the later began to acquire a certain extra-artistic interest, the way the water-colors of Hitler or the oil paintings of Sir Winston Churchill have done. Indeed, let us imagine, contrary to fact, that viewers of van Meegeren's rather lame canvas think as well of it, as a painting, as they do of one of Vermeer's own paintings from his early Baroque phase, e.g., his *Christ in the House of Mary and Martha* (in truth immeasurably more vibrant than van Meegeren's fabrication). This would but show that van Meegeren would have been a better painter in the seventeenth century than he was in the twentieth. Unfortunately, that style, in which he might have flourished, could only be "mentioned" in his own time and not "used." He could but pretend to use it by pretending it was by Vermeer—that is, as a forger.

It is not difficult to see what would have been the case had van Meegeren simply painted his *Christ at Emmaeus* in 1936 and sought to exhibit it in Amsterdam in those years as his own. But there was, to use the

expression I have had recourse to, no room in the art world of Amsterdam in 1936 for a painting like that, even if, had people believed it by Vermeer, there would have been room in the Delft art world of 1655 for something like it (though my sense is that when we put it alongside the *Christ in the House of Mary and Martha* of that year, it would have looked pretty awful). There is in a way room in the art world of 1995 for a work like that, but only within the framework of the mention-function. It could not be accepted within the framework of use. It would have to make a statement about the kind of painting it exemplified, and not a statement about what a painting of Christ at Emmaeus is about.

The American painter, Russell Connor, recombines pieces of familiar masterpieces to make new paintings. He took the women from Picasso's *Les demoiselles d'Avignon*, for example, and substituted them for the women in Rubens's paintings of the *Rape of the Daughters of Leucippus*, giving it the witty title *The Kidnapping of Modern Art by the New Yorkers*. His title of course refers to Serge Guilbaut's *How New York Stole the Idea of Modern Art*. The result is a postmodern masterpiece of interlocked allusions, a kind of cartoon of crossed identities, in which, of course, Connor does not pretend to be Rubens or Picasso, or even pretend to the kind of art-historical scandal Guilbaut claims to have uncovered. For Connor's paintings to work, his subjects have to be familiar and even overfamiliar. He is mentioning these famous works only to use them in new ways. A witty man, in person as well as in his art, Connor once told an audience that when he explained to his father that he intended to be a painter, his father said it would only be all right if "he painted like Rembrandt." And that he took this as a parental order. He in fact is a marvelous painter, and a tremendous visual mimic. For my purposes, however, the important fact is that he shows one way in which one can paint like Rembrandt in the post-historical moment and get away with it.

I refer to Connor here because someone who simply tried to "paint like Rembrandt" would have, despite the fact that everything is possible, a very difficult go of things today. I received a letter from just such a person not so long ago. He spoke of having been profoundly inspired by having seen some Rembrandts at a certain moment in his life. He saw, in "the self-portrait and the Rabbi, images of a dignified noble humanity that transcends its own age and ours, revealed from within a rich matrix of paint applied with the utmost intelligence." He resolved, on the basis of this "epiphany," to devote himself to the study of painting, and, from what I can gather, he succeeded in "painting like Rembrandt" to at least

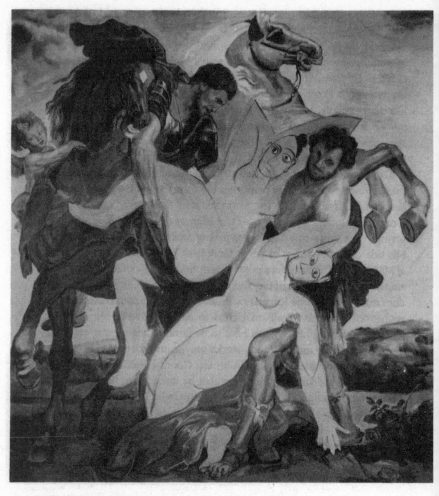

THE KIDNAPPING OF MODERN ART BY THE NEW YORKERS (1985) BY RUSSELL CONNOR.
COURTESY OF THE ARTIST.

the degree that his work could, in his view, "stand any reasonable test of quality," notwithstanding which he was told, by a curator of contemporary art in a major museum that his picture "were not for our time." He was genuinely puzzled by this, especially in view of the fact that the art world is supposed to be so open. And having read my writings he appealed to me to answer his question: "If the one thing not allowed will be

the kind of art that is measurable by traditional criteria, the very kind of art, in fact, that a great many people, if not most, still prefer?" This was rather a powerful communication, which I sought to answer as well as I could, and about which I have thought enough to have wanted to build this last chapter of my text around it.

Let us first address this artist's epiphany. I am quite prepared to accept his claim regarding Rembrandt's message to us regarding a "dignified, noble humanity that transcends its own age and ours." That message, like the one received by Ruskin from Veronese, is altogether valid, and there would be little reason to look at painting it if it did not now and again communicate such truths, valid for our time and for the time at which the painting was done. Still, it does not follow that the painting itself, as painting, "transcends its own age and ours." Rembrandt's painting, like Vermeer's, was very much of its own time and place, even if his message was less historically indexed, and speaks as fluently to us as to his contemporaries. I do not, of course, deny that the means and the message are connected, here as elsewhere. Rembrandt's heavy darks and mysterious lights almost certainly contribute to the force of his message. Still, his style is too closely identified with him, and with his time, to be available to us for use. The message indeed "transcends its own age and ours." But to transmit that message ourselves, we must find means other than those he used. We can but mention him, from across an unclosable historical distance. It is always open to us to find ways of expressing the sort of message we can derive from Rembrandt. But we shall have to find ways of doing so which *are* for our time. And unfortunately Rembrandt cannot help us there, beyond showing us that historically circumscribed art is capable of historically transcendent messages.

As far as the art that a "great many people, if not most, still prefer," the post-historical masters Vitaly Komar and Alexander Melamid have a great deal to tell us about this through a work which in its own way typifies the comedy and tragedy of art in our age. Komar and Melamid are emigré artists from what was once the Soviet Union, who achieved a certain celebrity in New York in the 1980s by exploiting the comic possibilities of socialist realist painting, mocking the mock heroics of Lenin and Stalin from the relative safety of the New York art scene, where they were appreciated for their wit as much as for their predicament. And, in a way which had been pioneered by Andy Warhol, they became, simultaneously, celebrities and critical successes. Their work was accessible as well as esteemed. I can think of few more delicious comic achievements than their *The Origins of Socialist Realism* of 1982–83,

which illustrates the legendary episode in which a Corinthian girl is said to have invented the art of drawing by outlining the shadow of her lover's head on the wall behind him—except that the lover in this case is Joseph Stalin, whose profile is being inscribed by young woman in classical garments. The painting itself is in the high socialist realist manner, and the malice comes only in part from using socialist realism to satirize itself and its scary inspirer who was so often the subject of its turgid celebrations. The project of cannibalizing Soviet art culminated in a spectacular May Day installation at the Palladium in New York in 1987, but, with the spirit of *glasnost* and *perestroika*, and with the breakup of the Soviet Union and the end of the Cold War, Komar and Melamid all at once lost their best and, in a sense, their defining subject. Such are the ironies of history that the collapse of communism coincided with the collapse of the art world in the West, and the question even for the most successful artists of the eighties was, to use the title which they borrowed in 1988 from a major text of Lenin, "What Is to Be Done?"

The true genius of Komar and Melamid revealed itself when, artistic freedom being restored in their native land, they took as their subject the concept of the market, accepted by former apparatchiks with the unquestioning conviction with which the latter's ancestors accepted the rituals and disclosures of Greek orthodoxy. With the support of the Associates of *The Nation* Magazine, they decided to conduct a piece of actual market research in order to find what was termed on the cover of the 14 March 1994 issue, "a people's art," namely, the kind of art people really wanted. Once this was known, supply could be adjusted to demand in the pre-established harmony discovered by the classical economists, and society—or, since linguistic habit dies hard, "the people"—would get the art they wanted, and the artists who knew what the people wanted should be able to make a decent living. I cannot altogether imagine that this knowledge could be put into industrial practice, since it might very well be that people want art be produced in the old-fashioned one-at-a-time way, brush-to-canvas, by an artist in a beret standing before the easel. But who knew? No one had ever tried to find out. Meanwhile, painting for the American market must have seemed the way to achieve their own transformation from Russian to American artists.

The social science used was state-of-the-art.[19] There were focus groups and impeccably weighted polls, in which American households, randomly selected, were asked to respond to a set of questions regarding aesthetic preferences. The results are certified as statistically accurate "within a margin of error of ±3.2 percent at a 95 percent confidence level."

The sample was stratified according to state. Gender quotas were observed. And the answers themselves constitute a singularly interesting piece of aesthetic sociology. Blue, for example, is by far America's favorite color (44 percent), and is most appealing to people in the central states between forty and forty-nine years of age, conservative, white, male, making $30,000 to $40,000, and who don't go to museums at all. In a comparable poll, but with what I think must be incomparably higher monetary stakes, the manufacturers of M&M candy undertook to change the spectrum of colored coating by adding a new hue, and sought to find out which was the most highly preferred color which, I suppose to no one's great surprise, turned out to be blue. The appeal of blue falls off as level of education increases, but black is increasingly appealing as income drops: people making less than $20,000 are three times as likely to prefer black as those with incomes over $75,000, who are three times more likely to prefer green than those making less than $20,000. But consumers of M&Ms are not likely to be in the over $40,000-a-year class, though all their income, from baby-sitting and the like, is probably discretionary. On the basis of this massive amount of data, Komar and Melamid produced what they title "America's Most Wanted," a painting that incorporates as many of the preferred qualities as the artist could incorporate into a single canvas.

As luck would have it, the book review section of *The New York Times*, 15 January 1995, advertises "the new bestseller," by Doris Mortman, *True Colors*, with "everything you want in a novel," itemized as "family, love, betrayal, rivalry, talent, triumph." It is clearly about an artist—the full-page ad shows us a vase with brushes and some twisted tubes laid out on a piece of exotic fabric. "*True Colors* sweeps you into the international art scene, where the intense pressures of success compete with the deeper dictates of the heart." It is worth speculating whether anyone conducted a poll to find out what the people most wanted to have in a novel, but my sense is that most people want novels to come from sources other than scientifically impeccable opinion polls: they want the novel to come from the heart, from the guts, or at least the experience of the novelist—and my own sense, to be sure based on intuitions rather than science—is that the moment one learned that "everything you want in a novel" is in the novel only because you want it there, you would lose interest in the novel. This of course has to be qualified: readers of at least two sorts of novels—romances and pornographic novels—are probably only interested in "the bottom line" in compliance with a formula, and do not give two cents for creativity. The interesting question is to what degree this is

true of paintings. The artist, whose brushes and paint-tubes one sees on the jacket of the "most wanted novel" could not really be an artist whose paintings are as they are because the people want them to be that way. It should be the other way around—that the people want them to be that way because the artist is such a great success in the "international art world." It could not be the "most wanted novel" whose artist-hero or heroine traded inspiration in for opinion polls: artistic inspiration goes hand in hand with the panting romanticism, the finding of true love, in which the most wanted novel must trade.

It would have been interesting, thus, to have asked if people preferred paintings which resulted from finding out what they most wanted in a painting or paintings in which the artist painted from inspiration. People—I continue to speak without the backing of any scientific evidence—want artists to be like Buchumov, a fictive painter invented by Komar and Melamid at an earlier stage in their career, and in whose name they painted a number of exceedingly moony landscapes and kept a romantic diary. My sense, then, for what it may be worth, is that the most wanted painting is incompatible with what most people want of a painting. But that may be different from what most people want *in* a painting. Whatever the case, I have never seen *True Colors* on the *New York Times* best-seller list. I infer that something can be a "best-selling novel" without being a best-seller. A "best-selling novel" must be a kind of novel, defined by what it has in it. My parallel intuition is that something can be "the most wanted painting" even if nobody wants it.

I have the most vivid memory of the carnavalesque inaugural exhibition of "The Most Wanted Painting" at the Museum of Alternative Art on Broadway. I had been somewhat privy to the processes by which the artists had arrived at this work, inasmuch as it had been under the *Nation*'s auspices that the social science part of the undertaking was subsidized, and I was kept pretty well informed by those who worked with Komar and Melamid. But there are few secrets in the art world, and the crowds were significant. Everyone went to see what Americans most deeply wanted in our heart of aesthetic hearts, if the survey research was accurate, though it would have been exceedingly difficult, given the questions asked, to imagine that a painting like Barnett Newman's *Who's Afraid of Red, Yellow, and Blue*, or Robert Motherwell's *Elegy for the Spanish Republic*, or Mark Rothko's *Number 16* would have emerged as exemplifying what America most wanted in a painting. A different kind of survey would have been needed to see what the art world would have wanted as the most wanted painting. The audience that evening, drinking blue

vodka (to emblematize the triumph of blue in the chromatic sweep-stakes), exchanging gossip and wisecracks, was too skewed a population to feel anything save superiority to the implied aesthetics of the common man and woman presumably objectified in the "genuine oil painting" in the gilded frame. But would Mr. or Ms. Whoever cry out "That's it!" when presented with their presumed dream painting, so far as they dream of paintings at all?

I think that almost certainly in terms of its painterly style, Komar and Melamid's *Most Wanted Painting* really must represent what people like who "don't know much about art but know what they like." It is executed in what one might term a modified Hudson River Biedermeier style—with about 44 percent blue—and shows figures in a landscape. Somewhat surprisingly, Komar and Melamid have conducted polls and painted the *Most Wanted Painting* in a variety of countries, from Russia and the Scandinavian countries to France and Kenya, and now China, where, as I write this, poll-takers are doing a selected door-to-door canvass, as the current distribution of telephones in China would badly skew the results. The results have been surprisingly congruent, in the sense that the *Most Wanted Painting* for each country looks like, give or take a few details, all the *Most Wanted Paintings* of the other countries. There is a more saturated blue, but less of it, in *Russia's Most Wanted*. It is unclear what China's *Most Wanted Painting* will look like, but I would be rather astonished were Komar and Melamid to produce something which resembled a Sung watercolor. And it is at the very least cause for comment that what randomly selected populations the world round "most want" are paintings in the generic all-purpose realist style the artists invented for *America's Most Wanted Painting*. When I suggested to them that the paintings all looked pretty much alike, the artists granted as much, pointing out that national differences show up in the *Least Wanted Painting*. Invariably abstract and using sharp angles, it varies in colors from gold, orange, mauve, or fuschia, to teal—to scrape the bottom of Kenya's chromatic scale—and its sizes differ. *American's Least Wanted Painting* is small and mean, the French *Least Wanted* is large and vapid. But the style is invariant, national differences showing up in the details. The most wanted painting, speaking transnationally, is nineteenth-century landscape, the kind of painting whose degenerate descendents embellish calendars from Kalamzoo to Kenya. The 44 percent blue landscape with water and trees must be the a priori aesthetic universal, what everyone who thinks of art first thinks of, as if modernism had never happened.

AMERICA'S MOST WANTED (1994) BY VITALY KOMAR AND ALEXANDER MELAMID. COURTESY: RONALD FELDMAN
FINE ARTS, NEW YORK. PHOTO CREDIT: D. JAMES DEE.

It is possible, of course, that everyone's concept of art *was* formed by
calendars, even in Kenya, which now constitute a sort of paradigm of
what everyone first thinks of when they think of art. The psychologist
Eleanor Rosch and her associates have developed a branch of psychology
known as category theory, based on the way in which information is
stored.[20] Most people will answer "robin" when asked to name a bird, or
"dog" when asked to name an animal. Few will answer "coot" to the first
or "ardwaark" to the second. Asked to name a kind of dog, most people
will mention "police dog" rather than "Lhasa apso." Americans, but no
Chinese, will answer "George Washington" when asked the name of a
famous historical person. Nobody is likely to answer "hippopotamus" to
"wild animal": the usual answers are "elephant," "lion," and "tiger." It is
altogether likely that what Komar and Melamid have unearthed is less
what people prefer than what they are most familiar with in paintings. I
would wager that the unrepresentive population at the opening share the
same paradigms. That would be why, when anything deviates signifi-

cantly from the predominantly blue landscape through history, the spontaneous response is that it is not art. Why else would the Kenyans, for example, come out with the same kind of painting as everyone else even when seventy percent of them answered "African" to the question, "If you had to choose from the following list, which type of art would you say you prefer?" The other choices were Asian, American, and European. There is nothing in the least African about the Hudson River Biedermeier style of landscape with water. But it may be exactly with reference to such images that the Kenyans learned the meaning of art. It is no accident that in the Kenya questionnaire, in response to the question of what type of art people had in their homes, 91 percent mentioned prints of calendars (though in fairness, 72 percent mentioned "prints or posters").[21]

Where the differences come in is in the figures with which these landscapes are populated, and it is here that Komar and Melamid began to be mischievous. Since people prefer landscapes to nonlandscapes, and paintings with famous people to paintings without famous people, Komar and Melamid give them landscapes with famous people in them. It would be little likely that what the Russians most want is George Washington or the Chinese Jesus Christ or the Kenyans Napoleon, and it is here that the national differences begin to emerge—but so does the mischief. People, for example, cite a preference for paintings with animals, and indeed wild animals—but it would hardly have occurred to them that what they wanted was a landscape with a famous person and a wild animal unless there were some internal connection between the famous person and the animal, as between Samson and the lion, or Pasiphaë and the bull, or Jonah and the whale. There is no way in which George Washington and the hippopotamus can be connected up that way—no way really George Washington and a hippopotamus would share a pictorial environment if it is meant to be a realistic picture. And neither of them co-occur on the same level either in one of Rosch's schematisms, since Washington would be a paradigm famous person but the hippopotamus far from the paradigm wild animal (though unquestionably a wild animal). Putting Washington together with a typical American family in camping clothes violates another law of consistency, since it violates the unity of time.

What is striking about *America's Most Wanted* is that I cannot imagine anyone really wanting it as a painting, least of all any of the least-common-denominator population its taste it is supposed to reflect. No one who wants a painting of wild animals or who wants a painting of George Washington wants a painting of George Washington *and* of wild

animals. Komar and Melamid have transformed disjunctions into conjunctions, and the conjunction can be displeasing even if the conjuncts are pleasing, taken one by one. Everyone, to use a political parallel, would like tax cuts, the elimination of the federal deficit, efficient government services with few government regulations, but it is not clear that you can have all these things at once. House Speaker Newt Gingrich's "Contract with America" is the political counterpart to the *Most Wanted Painting*. There may or may not be a parable of political philosophy in this, but the painting supposed to reflect the integrated aesthetic utility curves of everyone in fact reflects the artistic utility curve of no one at all. The painting has the seeming structure of a rebus puzzle, with disjointed components thrust into the same conjoining frame. But unlike a rebus, there is no solution. There is no explanation of why anything is there other than the fact that it came up first in a question on a questionnaire. Nothing has anything in terms of meaning or causality to do with anything else. Like the Contract with America, it may be basically incoherent, and my overall view is that once everyone registers the fact that the style is what they all like, the painting would rapidly be despised because of its incoherence. Had they been questioned whether they prefered coherence over incoherence in a painting, the *Most Wanted Painting* might never have been painted.

In American English the expression "most wanted" is used to describe criminals whose apprehension the FBI considers the highest priority, not the wish list of the National Gallery. In any case, the "second most wanted" painting would not be, say, Gainsborough's *Blue Boy* or the *Mona Lisa*, but a painting by Komar and Melamid incorporating the second most highly prized aesthetic qualities. In fact, *America's Most Wanted* only belongs on a list which includes paintings by Komar and Melamid based on the same data as it. As a painting it has no place in the art world at all. What does have a place in the art world is the performance piece by Komar and Melamid which consists in the opinion poll, the painting, the publicity, etc. *That* work is probably a masterpiece. *That* work is about people's art without itself being people's art at all. That work is "postmodern, humorous, and iconic," as one observer said, as is, derivatively, the *Most Wanted Painting* itself. That the work looks unmistakably Hudson River Biedermeir shows, in point of expression, the nostalgia of these marvelous artists, but in point of identity it shows the truth that we are forever exiled from the aesthetic motherland where painting pretty pictures was the defining artistic imperative. It also shows how little dis-

tance our eyes will carry us in finding our way about in the art world of postmodern times. But finally it shows how great the distance is between where art is today and where the population is so far as, until the mischief began, its taste is captured in the *Most Wanted Painting*. The dissonances in the painting are indices of that distance.

I have been discussing two kinds of tragic artists and two kinds of comic artists. Van Meegeren is tragic because he felt he could achieve success only by painting like Vermeer, but the moment he revealed that truth, he failed because a forger. The artist who learned to paint like Rembrandt discovered that the world had no room for his gifts, which belong to another period altogether. One can be part of the present art world and paint like Rembrandt only if, like Russell Connor, one does so from the perspective of mention rather than of use, and in the spirit of the joke. The true heros of the post-historical period are the artists who are masters of every style without having a painterly style at all, namely Komar and Melamid, whose temperament is anticipated by Hegel in his discussion of comedy: "The keynote is good humour, assured and careless gaiety, despite all failure and misfortune, exuberance and the audacity of a fundamentally happy craziness, folly, and idiosyncrasy in general."[22] My sense is that these modes of artistic tragedy and comedy define the end of art, which in itself of course is not the tragedy it sounds as if it must be, but rather is the scene of the kinds of comedy that exemplify it. The comedy of Connor, or of Komar and Melamid, happens to be funny, but it is not essential to comedy that it be funny, only that it be happy. It is wholly consistent that the kind of comedy in which the end of art consists can express itself on tragedy tragically, as Gerhardt Richter does when he paints, in the appropriated blur of bad photographs, the violent deaths of the Baader-Meinhof leaders, for the comedy is in the means and not the subject.

"Now, with the development of the kinds of comedy we have reached the real end of our philosophical inquiry,"[23] Hegel writes in the penultimate paragraph of his colossal philosophy of art. It behoves me to make this the end of my inquiry as well. The history of art is a true epic, and epics in their nature end, like Dante's *Divine Comedy*, on notes of ultimate brightness. How many philosophical works not only have endings but happy ones? With all this happiness, it would be wonderful if this were a Golden Age of art, but probably the conditions of comedy are the guarantee of tragedy, if the latter means that our age is not a Golden Age. You can't have everything!

NOTES

1. David Carrier, "Gombrich and Danto on Defining Art," *Journal of Aesthetics and Art Criticism* 54, no. 3 (1995), 279.

2. "A term may be viewed in two ways, either as a class of objects (which may have only one member), or as a set of attributes or characteristics which determine the objects. The first phase or aspect is called the *denotation* or *extension* of the term, while the second is called the *connotation* or *intension*. Thus the extension of the term *philosopher* is "Socrates," "Plato," "Thales," and the like; its intension is "lover of wisdom," "intelligent," and so on. Morris R. Cohen and Ernest Nagel, *An Introduction to Logic and Scientific Method* (New York: Harcourt, Brace and Company, 1934), 31. The distinction is standard in traditional logic texts.

3. E. H. Gombrich, *The Story of Art* (London: Phaidon, 1995), 15.

4. "There are horribly many books, which I do not read, about Marcel Duchamp, and all this business when he sent a urinal to an exhibition and people said he had 'redefined art' . . . what triviality!" (E. H. Gombrich, *A Lifelong Interest: Conversations on Art and Science with Didier Eribon* [London: Thames and Hudson, 1993], 72). I think what he meant to say was "many horrible books," and that, speaking in the Nabokovian mode to which Carrier and I are addicted, he was letting me know that he had not read *The Transfiguration of the Commonplace*. Or he had read it enough to consider it trivial.

5. George Dickie, "Defining Art," *The American Philosophical Quarterly* 6 (1969), 253–56. Dickie has polished away at his original definition over the years. For a full bibliography of his wriitngs and those of his critics, see Steven Davis, *Definitions of Art* (Ithaca: Cornell University Press, 1991).

6. G. W. F. Hegel, *Hegel's Aesthetics: Lectures on Fine Art*, trans. T. M. Knox (Oxford: Clarendon Press, 1975), 11.

7. See my "The Art World Revisited," in *Beyond the Brillo Box: The Visual Arts in post-Historical Perspective* (New York: Farrar, Straus and Giroux, 1992) for a detailed discussion.

8. Heinrich Wölfflin, "Foreword to the Sixth Edition," *Principles of Art History* (New York: Dover Books, 1932), ix.

9. E. H. Gombrich, *Art and Illusion: A Study in the Psychology of Pictorial Representation* (Princeton: Princeton University Press, 1972), 388.

10. In Karl Popper, *The Open Society and Its Enemies* (Princeton: Princeton University Press, 1950), esp. chap. 12.

11. Wölfflin, *Principles of Art History*, viii–ix.

12. Ibid., 11.

13. Rudolph Wittkower, *Art and Architecture in Italy: 1600–1750* (Harmondsworth: Penguin, 1958), 2. "Many stories of Christ and the saints deal with martyrdom, brutality, and horror, and, in contrast to Renaissance idealization, an unveiled display of truth was now deemed essential; even Christ must be shown 'afflicted, bleeding, spat upon, his skin torn, wounded, deformed, pale and unsightly.'"

14. Paul Feyerabend, *Killing Time: The Autobiography of Paul Feyerabend* (Chicago: University of Chicago Press, 1995), 49. Feyerabend is quoting from a lecture he gave as a soldier in 1944, and it is difficult to know to what degree he subscribed to this view at the time he wrote about his early views late in his life.

15. For exactly such a sobering list, see Rose deWolf, "Endpaper: Yesterday's Tomorrow," *New York Times Magazine* (24 December 1995), 46. The author quotes the sociologist David Riesman from *Time* (21 July 1967): "If anything remains more or less unchanged, it will be the role of women."

16. Ludwig Wittgenstein, *Philosophical Investigations*, trans. G. E. M. Anscombe (New York: Macmillan, 1953), sec. 19.

17. For a beautiful discussion of Feuerbach's painting, see Heinrich Meier's "Einfuhrung in das Thema des Abends," in Seth Berardete, *On Plato's Symposium* (Munich: Carl Friedrich von Siemans Stiftung, 1994), 7–27.

18. For a lucid discussion of the distinction, see Willard Van Orman Quine, *Methods of Logic* (New York: Henry Holt, 1950), 37–38.

19. All references here are to "Painting by the Numbers: The Search for a People's Art," *The Nation* (14 March 1994). The tabular data are presented in *American Public Attitudes Towards the Visual Arts: Summary Report and Tabular Reports*, prepared by Martila and Kiley Inc. for The Nation Institute and Komar and Melamid, 1994.

20. E. Rosch and C. B. Mervin, "Family Resemblances: Studies in the Internal Structure of Categories," *Cogniive Psychology* 7 (1975), 573–605; and E. Rosch, C. D. Mervin, W. D. Gray, D. M. Johnson, and P. Boyes-Braem, "Basic Objects in Natural Categories," *Cognitive Psychology* 8 (1976), 382–439.

21. Taina Mecklin, "Contemporary Arts Survey in Kenya," *Research International* (16 May 1995).

22. Hegel, *Aesthetics*, 1235.

23. Ibid., 1236.

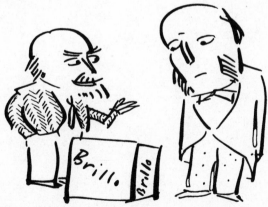

PROFESSOR ARTHUR DANTO SHOWING THE PEAK OF LATE 20TH CENTURY PHILOSOPHY TO HIS COLLEAGUE, DR. HEGEL, BY ANTHONY HADEN-GUEST. REPRODUCED BY PERMISSION FROM *ART & AUCTION*, JUNE 1992.

INDEX

Note: Entries followed by *f* refer to illustrations.

abstract art: critical viewpoint and, 54; definition of art and, 36; Greenberg on, 26–27, 87, 120–121; history of art and, 9, 26–27, 155; invention of, 54; material vs. formal, 72–73; meaning and, 73; modernism and, 27, 73, 149; post-historical reactions to, 147–148; in post-narrative stage, 148, 149; realism as opposed to, 117–118, 120; as "true road" for art, 26–27

abstract expressionism: continuation of, 33; end of movement, 24, 41; Greenberg and, 90, 102–104, 117, 160; history of art and, 9, 13, 102–104; metaphysics and, 130; pop art and, 41, 42, 117–118, 130; realism and, 117–118, 121, 122

abstraction, color-field: history of art and, 9, 13, 135

abstraction, hard-edged, 13

abstraction, "post-painterly," 103, 104

abstract painting, modernist painting vs., 8

academic painting, history of art and, 8–9

Academy. *See* National Academy of Design

action painting, Greenberg and, 160

"Aesthetic Concepts" (Sibley), 159

aesthetic objects, artworks vs., 84

aesthetics: affinity and, 158–160, 164–165; African art and, 111–112; art criticism and, 53, 54; communication and, 158; condition-governed, 159; era of art and, 25, 94–95; market research on, 210–211; materialist, 107; of meaning, 77; modernism and, 85–86; multiculturalism and, 94; in nature, 96–97; participatory, 182; philosophy and, 33; pop art and, 77, 92; post-historical artists and, 150; symmetry and, 96–98; taste and, 110–113; temporal boundaries and, 202–203; universality and, 95–96, 110; utility vs., 81–83, 86, 87

aesthetic vs. historical criticism, 168

affinities among artworks, 42–43, 158–160, 165, 199–202. *See also* temporal affinity

African-American artists, post-historical pluralism and, 147

African art: art criticism and, 94, 108–109; broadening of taste and, 111–112; Picasso and, 111; Western art and, 45, 94

"After Abstract Expressionism" (Greenberg), 102–103

Age of Manifestos, 29, 30, 31; freedom from, 37; mimesis and, 46; modernist philosophy and, 70; philosophical view of, 34, 35

Alloway, Lawrence, 42; pop art and, 128

Altes Museum (Berlin), 146

America's Most Wanted (Komar and Melamid), 211, 212–217, 214*f*

Analytical Philosophy of History (Danto), 38n.2, 43, 123

ancient art, definition of art and, 36

anthropology, primitive art and, 108, 109

antifoundationalism, 67

Antoni, Janine: *Gnaw*, 185

"Approaching the End of Art" (Danto), 17n.1

appropriationist art, 12, 15

Archimboldo, Giuseppe, 162

architecture: Mannerist, 161; narrative of art and, 48, 49, 106; postmodern, 15

Arensberg, Walter: Duchamp and, 84

Arman, photograph of library of, 100*f*

Armory show of 1913, 5, 121, 154–155

art: aesthetic communication in, 158; aesthetic theory and, 85–86, 112–113 (*see also* aesthetics); art outside narrative of, 8–9, 9, 12–15, 13, 47–48, 105–107, 109–110; beauty and, 83; before and after beginning of, 4, 18n.2; choice of technique and, 41–42; "community-based," 179–180, 182–184, 188; crafts as, 64, 114, 136; decoration and, 34–35, 36, 61–62, 63–64; definitions of, 27, 35, 36, 37, 184–187 (*see also* concept of art); edible, 185 (see also *We Got It!*); "era" of, 2–4, 17n.1; ideology and, 28, 29, 46, 47; illustration and, 34–35, 36; imitation as, 46, 47; manifestos and, 28, 29, 30, 31, 33, 34, 35; "object," *see* art: crafts as; "official" narrative and concept of, 8–9, 13, 18n.1, 27–

art (cont.)

28; philosophy and concept of, 13–14, 15–16, 30–36, 66, 95–98, 136; as political tool, 23–24, 86, 126–127, 145–146, 196; post-historical concept of, 16–17, 113–114; power and, 113, 181; "Primitivism and Modern Art" exhibition, 94; public vs. public's, 181–187; pure vs. impure, 9, 67–68, 69–70, 114; reality vs., 71, 112–114, 124–125; as subject of art, 7, 67, 76–77; transformative experiences with, 176–178; transhistorical essence in, 28–29; "true," 26–27, 28, 34, 45; "what Art wanted," 105–106

"Art and Science" (Stokes), 158

art appreciation: modernist critical practice and, 144; museums and, 179; post-historical concept of, 187–188

art-as-art, 27

art collecting: abstract expressionism and, 104; definitions of art and, 56; market fluctuations and, 22; painting revival and, 139–140; politics and, 146

art critic: author as, 25, 123; as manifesto writer, 29

art criticism: abstraction and, 54; aesthetic vs. historical, 168; basic elements of, 98; contemporary responses to modernism, 52–57, 64–66; "end of art" and, 25–26, 27–28, 37, 47–48, 94–95; essentialism in, 69, 193–198; experience and, 87–89; Greenberg and, 84–95, 107, 110, 112; Hegel and, 98, 196; heresy and, 29; ideology and, 47; leftist, 145–146; master narrative and, 47, 54, 98, 145; materialist vs. formal aesthetic in, 72–73, 107–108; modernism and, 143–145; monochrome painting and, 157, 169–171; philosophical self-consciousness and, 66, 67; pluralism and, 37, 150; politics and, 138, 139; pop art and, 123–124; postmodernist, 144, 145; practicality and, 86; "primitive" art and, 108–109; purity as focus of, 69–70; revolutionary change and, 93; rules and, 86; style as language and, 54–55; surrealism and, 107; taste and, 110–113; transhistorical essence and, 28–29; Vasarian model and, 51–52, 53, 54, 55, 61, 63, 64, 66

art education: community of artworks and, 164–165; modernist critical practice and, 144; as museum role, 146

arte povera, 13

Artforum, manifestos in, 29

Art and Illusion (Gombrich), 48, 196

Art Institute of Chicago, Culture in Action show, 180–181, 183, 185, 186, 189

artist, artists: affinity among, 158–160; beginning of concept of, 2; 1980s art market and, 21, 22; pluralism and opportunities for, 147–150, 171; post-historical role for, 13–14, 47, 48, 127, 145–146; postmodernist discourse and, 144–145; specialization and, 114; tragic vs. comic, 217

art magazines, influence of, 123, 126

art making: art market as separate from, 24; "end of art" and, 25–26, 188–189; historical imperative and, 26–27; philosophy and, 32

art market: abstract expressionism and, 104; art making as separate from, 24; "end of art" and, 21–22; sociological research on, 210–211

Art News, pop art and, 123

art nouveau, 63–64

art objects: appropriationist art and, 15; conceptual art and, 13; in modernism, 16; post-historical art and, 15, 16. See also object of representation

Art of This Century Gallery, Pollock exhibit at, 70–71, 90

art schools, expectations of success and, 21

Artschwager, Richard: boxes by, 165

art subsidies, aesthetics vs. utility and, 82

artworks: aesthetic objects vs., 84; art as subject of, 7, 67, 76–77; characteristics of, 35; community and, 163–164; essentialist definitions of, 196–197; ideas as basis of, 50; post-historical view of, 14, 188–189; real objects vs., 71, 124–125; styles of, 46; transformative experiences with, 176–179. See also concept of art

art world: as community, 163–164; white males and, 181, 189

"The Art World" (Danto), 124, 132n.8, 157, 165

Ashbery, John: Ryman and, 157

Ash Can School, 118, 121

Austin, J. L., on language, 130

avant-garde: definitions of art and, 71; mono-
chrome painting and, 155, 156
"Avant-Garde and Kitsch" (Greenberg), 71
Aztec art, 109, 114

Baader-Meinhof leaders, Richter's painting of,
217
Bakery, Confectionary, and Tobacco Workers'
International Union of America, Local 552:
We Got It!, 180–181, 183, 184, 185, 187, 188–189
Barnes, Albert, 109, 110
Barnes collection, useful objects displayed in, 82
baroque art: affinities and, 200–201; in style ma-
trix, 162–163
Barr, Alfred, 119
Bartlett, Jennifer, 156
Baudrillard, Jean, 144
Beatles, spirit of liberation and, 126
beauty: cross-cultural perceptions of, 96–97;
Kant on, 84, 110; in nature vs. art, 83, 96–97;
utility and, 81–83. See also aesthetics
Beaux Arts Academy (Paris), realism and, 118
Beckson, Bill: on affinity of painters, 158
Being and Time (Heidegger), 66
Bellini, Giovanni, 106
Bellori, Giovanni, 204
Bellows, George, 84
Belting, Hans: antifoundationalism and, 67; on
art before beginning of art, 3, 4, 18n.2, 18n.3,
25, 62–63; on art as narrative, 5; The End of
Art History?, 17n.1, 62; Likeness and Presence,
18n.2, 18n.3, 25, 62–63; paraphrased, 6; on rep-
resentational accuracy, 52; on shift between
eras, 11–12, 19n.15; use of narrative and, 106;
Vattimo and, 18n.1
Benglis, Linda, 13
Benjamin, Walter, 138, 144
Bennett, Gary Knox, 137
Berenson, Bernard: on Crivelli, 106, 110, 115n.4;
Mannerism and, 160
Berlin: dada exhibition in, 27f; Hegel lectures
in, 31
Berlin dada movement: historical narrative
and, 5, 26; political motives in, 138
Berlin Wall, 131
Bernini, Giovanni: temporal affinities and, 199–
200, 201, 203

Beuys, Joseph: concept of art and, 14, 90, 125,
184–186; Greenberg and, 90; "multiples," 185;
The Scottish Symphony, 174f, 186, 187
Bidlo, Mike: Not Andy Warhol (Brillo Box), 2f;
"posthistorical" art by, 12
biennial exhibitions, international relations and,
23, 38n.1
Bildungsroman, beginnings after endings in,
4–5
black artists, post-historical pluralism and, 147
Black Painting (Reinhardt), 20f
Black Square (Malevich), 154–155, 163, 166, 170
Blakelock, 72
Blunt, Wilfred Scawen, 56
Bois, Yves-Alain, 24, 38n.3
Botticelli, Sandro, 200, 203
Boucher, François: historical narrative and, 64
Box with the Sound of Its Own Making (Morris),
80f, 92–93, 94, 165
Brancusi, Constantin, 72, 161
Braque, Georges, 30
Brenson, Michael: on "community-based art,"
179–180, 189; on painting and power, 181; on
quality in art, 185
Breton, André, on pre-surrealism surrealists,
162
Brillo Box (Warhol), aesthetics and, 92; affinities
and, 165; author's reaction to, 35, 123–124,
178; concept of art and, 13, 14, 35, 71; history
of art and, 24, 36, 196; philosophy of art and,
36, 71, 113, 124–125, 193, 195
Bronzino, Agnolo: Mannerism and, 161
Brooklyn Museum, 175–176; Kosuth installation
at, 6
brushstroke visibility, 74–76
"bulldozer" show, 127
Buren, Daniel, 4, 137–138, 140

Cage, John: monochrome painting and, 156
calendar art, 213–214, 215
"camp," postmodernism and, 11
Campbell Soup label: aesthetics and, 92; trans-
figuration of, 128
Canaday, John, 88, 122
Capital (Marx), 36
Caravaggio, da, 201
Caro, Anthony: Greenberg and, 103

Carracci brothers: Correggio and, 161; historical narrative and, 64; in style matrix, 163
Carrier, David: on author's views, 193, 195
Carroll, Noel: style matrix and, 162, 173n.14
"Cartesian linguistics," 7
cartoons, 147, 148. See also comic strips
"The Case for Abstract Art" (Greenberg), 120–121
Castelli's, pop art at, 123
Castiglione, Father, 42
category theory, 214, 215
Cedarquist, John, 137
Cellini, Benvenuto, 49, 114
censorship, museums and, 182–183
Centre Pompidou (Paris), 188
Cervantes, Miguel de: temporal affinities and, 202
Cézanne, Paul: aesthetic communication and, 158; aesthetic theory and, 85; contemporary reaction to, 56; Greenberg on, 72–73, 74; as modernist, 7, 74; "Q-ness" and, 159
Chagall, Marc, 16
Chardin, Jean-Baptiste, 158, 159
Chicago, Art Institute of: Culture in Action show, 180–181, 183, 185, 186, 189
Chinese art: choice of technique in, 42; imitation in, 48
"Chinese Red 33x33" (Hafif), 167–168, 169
Chomsky, Noam, 7, 19n.11
Christ at Emmaeus (van Meegeren), 206–207
Christian art: concept of art and, 2, 18n.2, 18n.3; graven images and, 63
Christ in the House of Mary and Martha (Vermeer), 206, 207
Christo: public involvement in artwork and, 182; Running Fence, 182
Cimabue, Giovanni, 61
Cixous, Helene: postmodernist criticism and, 144
Colescott, Robert, post-historical art by, 147, 148
Collage, 5
The Collected Essays and Criticism (Greenberg), 89
collecting. See art collecting
Cologne, Germany: Reed retrospective in, xvii
colonialism, cultural, 94
color, in monochrome painting, 156

color-field abstraction, history of art and, 9, 13, 135
colorito, disegno and, 32
Columbia University, Danto lecture at, 17n.1
comic strips, linear style used in, 201. See also cartoons
commercial art, pop art and, 91–92
Communist Manifesto (Marx and Engels), 36
community: art world as, 163–164; arts funding and, 182–183
"community-based" art, 182–184; definitions of art and, 184–187; museums and, 179–180, 186–187, 188; search for meaning and, 188
Complexity and Contradiction in Architecture (Venturi), 12
concept of art: art outside narrative, 8–9, 13, 47–48, 105–107; Beuys and, 14, 90, 125, 184–186; color blue and, 214–215; "community-based art" and, 184–187; Duchamp and, 184, 185, 188, 194, 195; essentialism and, 196–198; Hegel and, 13–14, 30–31, 97–98, 194–195; historical viewpoint and, 195–196; philosophy and, 13–14, 15–16, 30–36, 66, 95–98, 107–108, 193–198; pluralism and, 194; politics and, 86; pop art and, 90, 91, 124–125; post-historical, 16–17, 113–114, 125–126, 187; symmetry and, 97–98; Warhol and, 37, 90, 91, 124–125, 194
conceptual art: critical reactions to, 16; end of painting and, 139; as post-historical, 13
conceptual revolutions, 187
condition-governed aesthetics, 159
Cone, Etta and Claribel, 55, 56
conflict resolution, types of, 37
Confucius, on choice, 42, 57n.1
Connor, Russell: The Kidnapping of Modern Art by the New Yorkers, 207, 208f; pictorial mentions used by, 207, 217
contemporary art: definitions of, 10, 17; modern art vs., 5, 10–11, 15, 19n.15; museum role and, 5–6, 11, 16, 17, 183; as outside narrative, 5, 8–9, 10; shift from modern art to, 9–10
"Contract with America" (Gingrich), 216
contrary-to-fact conditionals, 101
Correggio, Antonio da: historical narrative and, 64; Loves of Jupiter, 161; Mannerism and, 161, 162
Counter-Reformation art, 200–201, 218n.13

Courbet, Gustave, 201
crafts: as art, 64, 114, 136; emphasis on media in, 137
Crimp, Douglas: on painting, 137–138, 139, 148, 153, 154, 171; on photography, 143–144; postmodernist discourse and, 144
"The Crisis of the Easel Picture" (Greenberg), 72
critic. See art critic
criticism. See art criticism
Critique of Aesthetic Judgment (Kant), 84
Critique of Pure Reason (Kant), 9
Crivelli, Carlo, 106, 110, 115n.4
cubism: beginnings of, 24, 38n.3; continuation of, 33; historical narrative and, 64; modernism and, 119; seen as language, 54, 55; "true art" and, 28
Cubo-Futurism, 26
cultural colonialism, 94
cultural exchanges, international relations and, 23
"cultural property," nationalism and, 146
culture: aesthetics and, 95–96; art as part of, 65; modernism in, 69. See also multiculturalism
Culture in Action show (Art Institute of Chicago), 180–181, 183, 185, 186, 189
"curatoriat," power and, 181

dada exhibition, Berlin (1921), 27f
dadaists: "end of art" and, 5, 26; motivations of, 64
Daguerre, Louis, 75
Daidalos, Praxiteles and, 50
Dali, Salvador: end of painting and, 138–139, 151n.4; Greenberg and, 97, 107
Damascene tiles, transformative experience and, 177, 178, 189
dance, movement vs., 35
Danto, Arthur: Analytical Philosophy of History, 38n.2, 43, 123; "Approaching the End of Art," 17n.1; as art critic, 25, 123; as artist, 123; "The Art World," 124, 132n.8, 157, 165; Beyond the Brillo Box, 183, 190n.6; The Death of Art, 4; Encounters and Reflections, 17n.1; "The End of Art," 17n.1, 24, 25; as essentialist, 193; Grand Street, 17n.1; on museums and contemporary art, 183; "Narrative and Never-Endingness,"

57–58n.4; "Narratives of the End of Art," 17n.1; The Philosophical Disenfranchisement of Art, 38n.4; The State of the Art, 17n.1; "Thirty Years after the End of Art," 126; The Transfiguration of the Commonplace, 38n.4, 129, 167, 170, 193, 195
Das Ende der Kunstgeschichte (Belting), 17n.1
Davies, Martin: on Crivelli, 106
da Vinci. See Leonardo da Vinci
Davis, Stuart, 121
The Death of Art (Danto), 4
The Death of Art (Lang), 17n.1
"The Death or Decline of Art" (Vattimo), 17–18n.1
deconstructionists: museums and, 146–147; post-historical art and, 148–149
decoration, 13; art and, 34–35, 36, 61–62, 63–64
definitions of art, 27, 35, 36, 37; avant-garde and, 71; community-based art and, 184–187; essentialism and, 196–198; material vs. formal abstraction and, 72–73; modernism and, 36, 51; style and, 46–47. See also concept of art
Degas, Edgar: photographs of, 143
"de gustibus non est disputandum," 110
Déjeuner sur l'herbe (Manet), 204
de Kooning, Willem: as commercial artist, 91; historical narrative and, 117; Hopper and, 122; Merritt Parkway, 123; "Q-ness" and, 159; success of, 103; Women series, 103, 122
Delacroix, Eugène: 32, 64
Delaroche, Paul, 75, 137, 138
Les demoiselles d'Avignon (Picasso), 24, 38n.3, 41, 111
deontic modalities, end of painting and, 141
de Pereija, Juan: Velasquez portrait of, 89
Derain, André, 53, 57
Derrida, Jacques: antifoundationalism and, 67; concept of ecriture, 54; postmodernist criticism and, 144
Descartes, René: on dream vs. waking experience, 35; "modern" philosophy and, 6–7, 8, 35
"descriptive" metaphysics, 143
De Stijl movement, color use by, 156
devotional art: concept of art and, 2, 18n.2, 18n.3; historical narrative and, 62–63; mimesis in, 46

Dickie, George, 124, 194, 195, 218n.6
Dick Tracy comic books, pop art based on, 43
di Credi, Lorenzo, 200
disegno, colorito and, 32
"disinterested satisfaction," role of beauty and, 82
diversity: art criticism and, 37; media and tolerance of, 127; in modernism, 119; in post-historical art, 125–126, 127, 147–150, 171. *See also* pluralism
dogmatism, modernism and, 70
Don Quixote, temporal affinities and, 201–202
Duchamp, Marcel: aesthetic theory and, 84, 85, 112–113; concept of art and, 184, 185, 188, 194, 195, 196, 218n.4; *Fountain*, 84, 193, 195, 196; Greenberg and, 84, 85, 107, 112; on "olfactory artists," 138; pop art and, 132
Dürer, Albrecht: affinities with contemporaries of, 199; evolution of media and, 136; on New World art, 109, 110, 114

Eakins, Thomas, 118, 119; *William Rush Carving His Allegorical Figure of the Schuylkill River*, 118
Eastern art, definition of art and, 36
edible art, 185. See also *We Got It!*
education. *See* art education
Elegy for the Spanish Republic (Motherwell), 212
El Greco, Mannerism and, 161
Eliot, T. S.: aesthetic vs. historical criticism and, 168; on art world as community, 163–164; style matrix and, 173n.14
embodiment of meaning, 194, 195
Encounters and Reflections (Danto), 17n.1
"The End of Art" (Danto), 17n.1, 24, 25
The End of Art History? (Belting), 17n.1, 62
"The Endless Future of Art" (Margolis), 57n.4
The End of Modernity (Vattimo), 17–18n.1
"The End of Painting" (Crimp), 144
Engels, Frederick: post-historical society described by, 36–37, 44, 45, 127
Ensigne de Gersaint (Watteau), 91–92
entelechy, 106
"era of art," 2–4, 17n.1–17n.1; before and after beginning of, 4, 18n.2, 25, 62–63; end of, 24–25
Erebon, Didier, 160
Ernst, Max, 5, 107

An Essay Concerning Human Understanding (Locke), 69
essentialism: in art criticism, 69, 193–198; concept of art and, 95, 196-198; defined, 194; definitions of gender and, 197; politics and, 196
ethnic cleansing, 37, 70
European art, African art and, 45, 94
Europhronios *krater*, acquisition of, 89
event descriptions, narrative sentences and, 24, 38n.2
exhibitions: as context for painting, 169; "end of art" and, 26, 38n.5; international relations and, 23–24
experience: analytical philosophy and, 129; art criticism and, 87–90
expression, imitation of reality vs., 65–66
expressionism. *See* abstract expressionism; neo-expressionism
expressions, use vs. mention of, 205
extension, defined, 194, 218n.2

La famille des saltimbanques (Picasso), 41
Farbung, concept of, 195
fauvism, 28, 119
female artists, post-historical pluralism and, 147, 148
Feminine Mystique (Friedan), 126
feminism: essentialism and, 193, 196; painting and, 171
Feuerbach, Anselm: *Symposium*, 204–205
Feyerabend, Paul, 201, 202
figurative art, definition of art and, 36
Fiorentino, Rosso, 161
forgeries, temporal affinities and, 206–207
formal vs. material abstraction, 72–73
Foster, Hal, 9
Foucault, Michel, 144
Fountain (Duchamp), 84, 193, 195, 196
Fragonard, Jean Honoré, 64
Frankenthaler, Helen, 103
Frankfurt School, Vattimo and, 18n.1
Freedberg, David: *The Power of Images*, 63, 77n.4
freedom: as driving force of history, 33; 1964 and, 126; pluralism and, 37; post-historical art and, 45–46, 47, 114, 125–126; search for identity and, 127–128
Freeman, Phyllis, 28

Frege, Gottlob: philosophy of meaning and, 195
French academic painting, 8–9, 155
French classicism, critical viewpoint and, 53–54
French neorealism, 13
French postmodern criticism, 144–145
French Revolution, end of history and, 33
Fried, Michael, 103
Friedan, Betty, 126
Fry, Roger: on "abstraction," 54, 120; on African art, 108–109; critical viewpoint of, 53–54, 55, 56–57, 64, 65–66, 110; on post-impressionism, 52–53
funding resources: aesthetics vs. utility and, 82; community and, 182–183
furniture, as art, 64, 137
future: Greenberg's view of, 102–105; as seen by past, 101–102, 117, 161–162, 202, 206
futurist manifesto, 28

galleries, 1980s art market and, 21
Gallery 291: Henri and, 118; Picasso exhibition at, 32
Gauguin, Paul, 8, 63, 64
Gauloises collages, by Motherwell, 42, 43
Gehry, Frank: as postmodernist, 12
gender, essentialist definitions of, 197
The Geneology of Morals (Nietzsche), 83
genius: taste vs., 90; usefulness of works of, 81
genre, refusal to be bound by, 45
The German Ideology (Marx and Engels), 37, 44, 127
Germany: abstract painting in, 127; capitalist realism in, 126
Gérôme, Jean Léon, 118
Giacometti, Alberto, 107, 162
Gilot, Francoise, 28, 30
Gingrich, Newt, 131, 216
Giotto: affinities of style and, 201, 203–204; future of painting and, 155; Masaccio and, 41–42; representational adequacy and, 50, 61; Vasari on, 51, 52
Girlie Show (Hopper), 119
Gnaw (Antoni), 185
The Golden Bowl (James), 175, 176, 177
Gombrich, Sir Ernst: Art and Illusion, 48, 196; narrative of art and, 48–50, 51, 62, 194, 196, 218n.4; on styles of painting, 160–161

Gopnick, Adam, 16
government funding, aesthetics vs. utility and, 82
Grafton Galleries London, post-impressionist exhibition at, 52, 54, 56
"Grand Manner" style, 204–205
Grand Street (Danto), 17n.1
"graven images," in devotional art, 63; subjects of artwork and, 185
Gray, Effie: Ruskin and, 178
The Greater Hippias (Plato), 50
Greenberg, Clement: on abstract art, 26–27, 87, 120–121; abstract expressionism and, 90, 102–104, 117, 160; "After Abstract Expressionism," 102–103; art outside narrative and, 105–107; on art as unchangeable, 28; attachment to media of, 104–105, 107, 135, 136; "Avant-Garde and Kitsch," 71; on beginning of modernism, 63, 76; Beuys and, 90; "The Case for Abstract Art," 120–121; Clement action painting and, 160; "The Crisis of the Easel Picture," 72; on critical response, 89–90; critical viewpoint of, 84–95, 107, 110, 112, 125; criticism based on, 143–144; Dali and, 97, 107; Davis and, 121; Duchamp and, 84, 85, 107, 112; end of modernism and, 14, 77; end of painting and, 139, 150, 171; Ernst and, 107; on experience, 89; future as seen by, 102–105, 114; Giacometti and, 107; historical narrative and, 102–105, 125, 135, 150; Kantian aesthetics and, 86–87, 90, 93, 110; Kramer and, 85; on Manet, 73, 74; methodology of, 89; Miró and, 72, 121; "Modernist Painting" essay, 7, 19n.12, 70, 73–74, 119, 121; on Mondrian, 87; on Morris, 92–93; multiculturalism and, 94; museum role and, 16; as narrativist of modernism, 7–8, 57, 76–77; on natural vs. artistic beauty, 83; neo-expressionism and, 141; New York School and, 70; Olitski and, 89, 103, 135, 150; painting defined by, 102; philosophical self-consciousness and, 66, 67, 68; Picasso and, 71, 72, 107; on Pollock, 70–71, 72, 87, 88, 90; pop art and, 104–105; purity as focus of, 69–70; on representation, 120–121; surrealism and, 9, 16, 107, 112; on terminology, 160; "Toward a Newer Laocoön," 26–27, 73, 120; Warhol and, 90, 91
Green Gallery, pop art at, 123

Grien, Hans Baldung, 162
Grünewald, Matthias: Dürer and, 199
Guercino: representational accuracy and, 51–52;
 temporal affinities and, 203–204, 205
Guerilla Girls, 147
Guernica (Picasso), 73
Guggenheim, Peggy, 90. *See also* Art of This
 Century Gallery
Guggenheim Museum, 123, 167
Guitar (Picasso), 38n.3
Guston, Phillip: post-historical art by, 147, 149
gut, schlecht vs., 83

Hafif, Marcia: "Chinese Red 33x33," 167–168,
 169; monochrome painting and, 167, 169
Hanson, Duane: representational accuracy by,
 52
Hare, David, 29
Hausmann, Raoul, 5
Hegel, Georg Wilhelm Friedrich: art criticism
 and, 98, 196; *Bildungsroman* format used by,
 5, 18n.5; on concept of art, 13–14, 30–31, 97–
 98, 194–195; denial of philosophy and, 34; on
 "monochrome formalism," 168; "pale of his-
 tory" concept by, 9, 26, 197; philosophy of
 art and, 31–33, 34, 47, 66, 141, 148, 195; on
 sources of meaning, 188; on Spirit, 26, 29,
 97–98, 124, 188, 195
Heidegger, Martin: on authentic vs. inauthen-
 tic, 35; *Being and Time*, 66; as modernist, 67;
 "The Origins of the Art Work," 31–32; on phi-
 losophy of art, 31–32; on revision of basic
 concepts, 66
Henri, Robert, 32, 118
heretics, concept of, 29
Hesse, Eva, 13, 113, 170
"High and Low" show (1990), 16
historical painting, "Grand Manner" and, 204–
 205
historical vs. aesthetic criticism, 168
history: after end of, 127; "end" of, 32–33, 44;
 freedom as driving force of, 33; heretics and,
 29; limitations imposed by, 44–45; "pale" con-
 cept, 9, 26; prediction vs. prophecy, 43
history of art: abstract expressionism and, 9, 13,
 102–104; abstraction and, 9, 26–27, 155; aes-
 thetics and, 25; affinities and, 42–43, 158–160,

165, 199–202; architecture and, 48, 49; art criti-
 cism and, 25–26, 27–28, 37, 47–48; before and
 after, 4 (*see also* "era of art"); contemporary
 art as outside of, 5, 8–9; devotional painting
 and, 62–63; essentialism and, 195–196, 197–
 198; future as seen by past and, 101–102, 117,
 161–162, 201–202; Greenberg and, 102–105,
 125, 135; history of science compared to, 49–
 50; iconology and, 65; manifestos and, 28, 29,
 30, 31, 33; modernism in, 7–9, 11, 14, 29, 53–54,
 63–66, 76–77, 119; modernist critical practice
 and, 144–145; museums and, 16; as narrative,
 4–5; 1960s, 13–14, 15–16; 1970s, 12–13, 14–15;
 openness of, 36; "pale of history" concept
 and, 9, 12, 26; paradigm shift in, 29–30; philos-
 ophy and, 13–14, 66; pop art and, 104–105,
 122–132; postmodernism in, 11, 12; postnarra-
 tive stage in, 148–150; progress and, 48–49,
 61–62; realists and, 117–118, 121; recognizing
 styles, 11–12; representational art and, 48, 49,
 61, 196; Riegl on, 61, 62, 63; sculpture and,
 49; self-consciousness and, 15, 36, 68–69; style
 matrix and, 162; temporal boundaries and,
 24–25, 199–203; Vasari and, 109–110, 125. *See
 also* narrative; post-historical art
history of science, history of art compared to,
 49–50
Hitchcock, Alfred: *Vertigo* image, iif
Hockney, David: Motherwell collages and, 42–
 43; pop art and, 128
Hoffman, Hans, 90
Holzer, Jenny, 12, 147, 148
Homo Duplex (Scully), 134f
Hopper, Edward, 118–121; *Girlie Show*, 119; mod-
 ernism and, 119, 121; *Morning Sunshine*, 119;
 pop art and, 128; treatment of nude figure
 by, 118–119; Whitney retrospective (1964), 122
Hopper, Jo: on realists' protests, 120
Houseman, A. E., 97
Hoving, Thomas: acquisition decisions by, 89
Hughes, Robert: as modernist critic, 145
Hume, David: surrealism and, 112; on taste and
 aesthetics, 110–111

iconology, 65; *Black Square* and, 163
icons, art vs., 2
idea, art preceded by, 50

identity, search for: freedom and, 127–128
ideology: art and, 28, 29, 46, 47; art criticism and, 47; painting and, 171
illusionism, brushstroke invisibility and, 75, 76
illustration, art and, 34–35, 36
The Image before the Era of Art (Belting), 2
imitation: in Chinese painting, 48; era of, 46, 47; expression vs., 65–66. *See also* mimesis
Impressionism: brushstroke visibility in, 75–76; critical viewpoint and, 55; cubists' reaction to, 28; modernism and, 74, 76, 119; philosophy and appreciation of, 33
Impressionists: as modernists, 7; temporal affinities with, 204
Improvisation 30 (Cannons) (Kandinsky), 54
Independents, style wars of, 32
Individuals (Strawson), 143
Ingres, Jean, 32, 64
intension, defined, 194, 218n.2
international relations, cultural exchanges and, 23
intolerance, modernism and, 70
invisibility of events, 24
Irigaray, Luce, 144
Irises (Van Gogh), 23
Irwin, Robert: end of painting and, 170
"Is Quality an Idea whose Time has Gone?" (Brenson), 185
Istanbul Biennale, 198–199
Italian Painters of the Renaissance (Berenson), 106

Jacob, Mary Jane: *Culture in Action* and, 183
James, Henry: museums and, 175, 176, 177, 188
Janis Gallery: de Kooning's *Women* at, 122; pop art at, 123
Jena, Battle of: end of history and, 32–33
"Jess," 43
Jewish Museum (New York), 15, 184
Jews, religion and art among, 185
Johannesburg biennial exhibition, 23
Jones, Ron, 113
Judd, Donald, 165

Kahn, Louis, 106
Kahnweiler, Daniel-Henry: critical viewpoint of, 56–57, 64–65; Picasso portrait of, 40*f*, 55; on style as "language," 54–55

Kandinsky, Wassily, 16; abstract art and, 54; aesthetic theory and, 85; Greenberg on, 72; *Improvisation 30 (Cannons)*, 54
Kant, Immanuel: on aesthetics vs. practicality, 87; on Age of Enlightenment, 9; art criticism and, 53, 84; on beauty, 84, 110; *Critique of Pure Reason*, 9; on genius, 81, 90; Greenberg and, 86–87, 90, 93; "modern" philosophy and, 8; modernist thought and, 7, 67; on moral action, 35; on natural and artistic beauty, 82, 83; on taste, 81, 82, 88–89; Warhol and, 91
The Kidnapping of Modern Art by the New Yorkers (Connor), 207, 208*f*
Kierkegaard, Soren: monochrome painting and, 167
The Kiss (Lichtenstein), 116*f*, 123
Klee, Paul: Greenberg on, 72
Klein, Yves: monochrome painting and, 169
Kline, Franz, 103, 117
Kojève, Alexandre: on "end" of history, 32–33
Kölnischer Kunstverein, Reed retrospective at, xvii
Komar, Vitaly: aesthetic sociology by, 210–211; *America's Most Wanted*, 211, 212–217, 214*f*; Buchumov paintings by, 212; *Least Wanted Paintings* by, 213; *Most Wanted Painting* projects by, 213–215; *The Origins of Socialist Realism*, 209–210; performance art by, 216–217; post-historical art by, 45, 126, 127; Sots and, 126, 131
Korner, Tony: *Tilted Arc* and, 181
Koselleck, Reinhart: *Vergangene Zukunft* (The Futures of the Past), 101
Kosuth, Joseph: "The Play of the Unmentionable," 6; on role for artist, 13–14
Kramer, Hilton, 85, 145
Krasner, Lee, 90
Krauss, Rosalind: on Greenberg, 9, 106–107
Krens, Thomas, 16
Kruger, Barbara: on philosophy of art, 131, 132; post-historical art by, 12
Kuhn, Thomas: paradigms and, 29
Kurlov, on Malevich, 166

Lacan, Jacques, 144
landscape painting, as "most wanted," 215

Lang, Berel: *The Death of Art*, 17n.1
Langer, Suzanne K.: on feeling vs. form, 112
language: analytical philosophy and, 129; concept of self and, 6–7; philosophy and, 129, 130; style of art as, 54–55
language learning, perceptual matching vs., 54
Lascaux caves, 62
The Last Judgment (Michelangelo), 164
latent properties, future as seen by past and, 161
Lawlor, Louise, 144
Least Wanted Paintings (Komar and Melamid), 213
Lectures on Modern Idealism (Royce), 18n.5
leftist art criticism, 145–146
Leonardo da Vinci: art outside narrative and, 114; history of art and, 61, 155; *Mona Lisa*, 51; Vasarian criticism and, 51
Le Va, Barry, 13
Levin, Gail: on Hopper, 120
Levine, Sherrie: art vs. reality and, 113; post-historical art by, 12, 45
Lichtenstein, Roy: *The Kiss*, 116f, 123; reactive art and, 130
Life magazine, on Pollock, 10–11, 60f, 70
Likeness and Presence (Belting), 18n.2, 18n.3, 25, 62–63
linear vs. *malerisch* style, 159
linear vs. painterly style, 200–201
linguistic structures, theory of innate thought and, 7, 19n.10, 19n.11
The Linguistic Turn (Rorty), 19n.10
literature, writing vs., 35
Lives of the Most Eminent Painters, Sculptors, and Architects (Vasari), 48
Local 552 (Bakery, Confectionary, and Tobacco Workers' International Union of America), *We Got It!*, 180–181, 183, 184, 185, 187, 188–189
Locke, John, on self-understanding, 69
logical positivism, pseudo-questions and, 34, 39n.18
Longhi, Roberto: on Crivelli, 106
Los Angeles County Museum of Art, 1964 "post-painterly abstraction" show at, 103
Louis, Morris, 103
Loves of Jupiter (Correggio), 161
Lyotard, Jean-Françeois, 144, 145

McKim, Mead, and White: Brooklyn Museum designed by, 175
magazines, influence of, 123, 126
malerisch vs. linear style, 159
Malevich, Kazimir, 26, 28; *Black Square*, 154–155, 163, 166, 170; funeral photo of, 166f; monochrome painting and, 156, 165–166, 169; *Red Square (Peasant)*, 166; Ryman and, 157; on Suprematism, 166–167
Mallarmé, Stéphane, 65
Manet, Edouard: *Déjeuner sur l'herbe*, 204; Greenberg on, 73, 74; historical narrative and, 64; as modernist, 7, 8, 63, 73–74, 77; *Olympia*, 204; temporal affinities and, 204
Mangold, Robert: affinities of work by, 170; post-historical art by, 150, 172; postmodernism and, 12
Mangold, Sylvia Plimack: post-historical art by, 172
manifestos: art and, 28, 29, 30, 31, 33, 34, 35; post-historical art and, 37
Mannerism, 8; abstract expressionism and, 103; historical narrative and, 161–163; in style matrix, 162–163
Mannerist architecture, 161
Mantegna, Andrea: monochrome painting by, 165
Marc, Franz: on modernism, 69
Marden, Brice: *Nebraska*, 163; in style matrix, 163
marginalization, of museums, 187
Margolis, Joseph, 57n.4
Marhenke, Paul, 142
market research, on aesthetic preferences, 210–211
Martyr, Petrus, on New World art, 109, 110
Marx, Karl: on end of history, 36–37, 44; post-historical society described by, 37, 45, 46, 127
Maryland Historical Museum, Wilson installation at, 6
Masaccio, Giotto and, 41–42
Maschinekunst, 26
materialism: historical narrative and, 61–62, 63, 107; in modernism, 73–74
material vs. formal abstraction, 72–73
Matisse, Henri: contemporary reaction to, 56; Greenberg on, 72; Picasso and, 32; on possibilities, 44

Matiushin, 26

meaning, search for: "community-based" art and, 188

meaning in art, 194, 195

media: Greenberg and, 104–105, 107; post-historical art and, 135–136, 137, 148, 171; tolerance of diversity and, 127, 147, 148, 171. *See also* materialism; painting

Meisels Brothers, film on *Running Fence*, 182

Melamid, Alexander: aesthetic sociology by, 210–211; *America's Most Wanted*, 211, 212–217, 214*f*; Buchumov paintings by, 212; *Least Wanted Paintings* by, 213; *Most Wanted Painting* projects by, 213–215; *The Origins of Socialist Realism*, 209–210; performance art by, 216–217; post-historical art by, 45, 126, 127, 209–210; Sots and, 126, 131

mentions: pictorial, 205–206; uses of expressions vs., 205

Merritt Parkway (de Kooning), 123

metaphysics: abstract expressionism and, 130; analytical philosophy and, 129; concept of death of, 18n.1; "descriptive," 143; logical positivists and, 34; verifiability criterion and, 141–143

Metro Pictures (Soho), 113

Mexican art: Aztec, Old World's response to, 109, 114; Pollock influenced by, 71

Mexico, political role of art in, 138

Michelangelo: art outside narrative and, 114; history of art and, 61; *The Last Judgment*, 164

mimesis: in architecture, 48; brushstroke invisibility and, 75; modernism and, 29–30, 46, 51, 52, 54, 57, 64; movement to expression from, 65–66; philosophy of art and, 124–125; photography and, 138; as traditional paradigm of art, 29, 46, 51. *See also* imitation

Mind, on verifiability criterion, 142–143

minimalist art, 13, 169

Miró, Joan: on Dali, 151n.4; Greenberg and, 72, 121; *Still Life with Old Shoe*, 73

modernism, modern art: abstract art and, 27, 73, 149; aesthetic theory and, 85–86; African art and, 111; appreciation of art and, 93–94; beginning of, 63, 76, 77; contemporary art vs., 5, 10–11, 15, 19n.15; continuation of, 33–34; critical practice based on, 143–145; critical viewpoints on, 52–57, 66–67; cubism and, 119; cultural boundaries and, 109; definition of art and, 36, 51; diversity in, 119; era of, 11; fauvism and, 119; in historical narrative, 7–9, 11, 14, 53–54, 57, 63–66, 73–74, 76–77, 125; Hopper and, 119; Impressionism and, 74, 76, 119; manifestos and, 29; materialist view of, 73–74; mimetic paradigm and, 29–30, 46, 50–51, 52, 57, 64; multiculturalism and, 179–180; photography, 143–144; politics and, 70; post-historical art and, 12; post-impressionism and, 119; postmodern art and, 11–12; postmodernist criticism and, 144; as revision of basic concepts, 66; self-consciousness and, 68–69; shift to post-historical art from, 14, 15–16, 64; shift from "premodern" to, 9–10, 64; surrealism and, 119; taste and, 111–112; utility and, 81–82

"Modernist Painting" (Greenberg), 7, 19n.12, 70, 73–74, 119, 121

"modern" philosophy, ancient philosophy vs., 6–7

Modigliani, Amedeo, 159, 161

Mona Lisa (Leonardo da Vinci), Vasarian criticism and, 51

Mondrian, Piet: critical viewpoint and, 94–95; geometrical Neo-Plasticism and, 71; Greenberg and, 72, 87, 90; Miró on, 73; Ryman and, 157; on "true art," 26, 28, 45

Monet, Claude, 159, 162

monochrome painting, 153–173; color use in, 156–157; criticism and, 157, 169–171; definition of, 165; end of painting and, 140, 148, 153, 154, 155, 170; historical narrative and, 140–141, 154–155, 169; politics and, 146; style matrix and, 163, 167

The Monochrome Show (Westman), 152*f*

Monroe, Marilyn: transfiguration of, 128

monuments, as public art, 181

Moore College of Art and Design, monochrome show at, 157

moral criticism: essentialism and, 69; multiculturalism and, 37

morality, choice and, 42, 57n.1

Morning Sunshine (Hopper), 119

Morris, Robert: affinities and, 165; *Box with the Sound of Its Own Making*, 80*f*, 92–93, 94, 165; end of painting and, 170

Mortman, Doris: *True Colors*, 211, 212

Moscow artists: "end of art" and, 26; politics and, 138

Most Wanted Paintings (Komar and Melamid), 213–215

Motherwell, Robert: *Elegy for the Spanish Republic*, 212; expressionism and, 65; historical narrative and, 117; pop art and, 42, 43, 128

movement, dance vs., 35

movements: historical narrative and, 64; temporal boundaries and, 24–25

multiculturalism: artistic possibilities and, 45; cultural colonialism vs., 94; dogmatism and, 70; essentialism and, 196–197; modernism and, 109; moral criticism and, 37; museums and, 179–180, 187–188; painting and, 171; search for identity and, 127

"multiples" (Beuys), 185

Munich, Germany: New Artists' Association exhibition (1909), 56, 69

Municipal Gallery (Turin, Italy), 176–177, 178

mural painting, end of painting and, 139

Musée Napoleon (Louvre), politics and, 146

Museum of Alternative Art (New York), *America's Most Wanted* at, 212

Museum of Modern Art: conceptual art in, 16; "High and Low" show (1990), 16; Hopper and, 119; modern vs. contemporary art and, 10, 11, 16; "Paintings by Nineteen Living Americans" (1929), 119; "Primitivism and Modern Art" exhibition, 94, 111, 162; realists and, 119, 120, 121; useful objects displayed in, 81

museums, 175–189; censorship and, 182–183; "community-based" art and, 179–180, 186–187, 188; contemporary art and role of, 5–6, 11, 16, 17, 183; deconstructionists and, 146–147; educational role of, 146; funding issues, 183; justification for, 179; modernist critical practice and, 144; multiculturalism and, 179–180, 187–188; politics and, 146; post-historical role for, 171–172; power and, 181–182; progress in taste and, 93–94; social criticism and, 179–180; special interest, 184; transformative experiences and, 176–179, 180; tribalization of, 184, 187

music, noise vs., 35

Muslims, religion and art among, 185

Napoleon, end of history and, 32–33

narrative: art criticism and, 47, 54, 98, 145; art outside of, 8–9, 13, 47–48, 105–107, 109–110, 114; criticism and, 47, 54; era of art as, 4–5; future as seen by past and, 101–102; materialism and, 61–62, 63, 107; minimalism in, 169; modernism in, 7–9, 11, 14, 53–54, 57, 64–66, 76–77, 125; monochrome painting and, 140–141, 154–155, 169; neo-expressionism and, 140; painting in, 61–64, 104, 105–106, 135; philosophical self-consciousness and, 66; post-historical art and, 12–15, 47, 114, 147–150, 171; prediction vs. prophecy, 43; realists and, 121; sculpture and, 49, 102; Vasari and, 48, 51–52, 125. *See also* history of art

"Narrative and Never-Endingness: a Reply to Margolis" (Danto), 57n.4–58n.4

narrative sentences, event descriptions and, 24, 38n.2

"Narratives of the End of Art" (Danto), 17n.1

The Nation: Alloway at, 128; *America's Most Wanted* and, 210, 212; author's work for, 25; cover page (March 14, 1994), 192*f*

National Academy of Design, Independents and, 32, 118

National Endowment for the Arts: censorship and, 183; essentialism and, 197; nationalism and, 146

National Gallery (London), 146

National Gallery (Washington, D.C.), 146; traveling exhibition in Soviet Union, 23

nationalism, art as tool of, 146

National Museum of Women in the Arts (Washington, D.C.), 184

nature, aesthetic view of, 83, 96–97

Nauman, Bruce, 45, 170, 171

Nazarenes, 28

Nazism, politicization of art under, 127

Nebraska (Marden), 163

Neel, Alice, 153

"Negro Sculpture" (Fry), 108–109

neo-expressionism, 13; historical narrative and, 140, 141; self-expression and, 141

Neo-Plasticism, Mondrian and, 71

neorealism, French, 13

New Artists' Association, Munich exhibition (1909), 56, 69

The New Criterion: aesthetic philosophy in, 85; manifestos in, 29

Newman, Barnett: *Voice of Fire*, 182; *Who's Afraid of Red, Yellow, and Blue*, 212

New Sculpture, 13

New World art, Old World's response to, 109, 114

New York School: Greenberg and, 70; Monet and, 162; pop art and, 42, 117–118

"New York type painting," 160, 161

Nietzsche, Friedrich: denial of philosophy and, 34; philosophy of art and, 31, 83, 97

1950s, abstract expressionism in, 169

1960s: minimalism in, 169; philosophy of art and, 13–14, 15–16, 92, 93; post-historical art and, 145

1964, symbolic meaning of, 126

1970s: end of painting and, 170–171; post-historical art and, 12–13, 14–15, 145

1980s: art market in, 21, 22; critical viewpoints in, 56, 144–145; painting revival in, 139–140

1984, symbolic meaning of, 21, 22–24, 25, 36

1990s: art market in, 21; pluralism in, 169

1993 Whitney Biennial, 146, 184

1995 Whitney Biennial, 146

noise, music vs., 35

Noland, Kenneth, 103

"nonmimetic features" of painting, 7–8

nonobjective painting, modernist painting vs., 8

Not Andy Warhol (Brillo Box) (Bidlo), 2f

nouveau realism. *See* neorealism

Novak, Kim, iif, xvii

"now," importance of, 131

nude figure: Eakins and, 118; Hopper and, 118–119

Number 16 (Rothko), 182, 212

"object art," 136. *See also* crafts

object of representation: conceptual art and, 13; means of representation as, 7. *See also* art objects

Oceanic art, affinities with vs. explanatory thesis on, 94

October: manifestos in, 29; political viewpoint of, 139

Of the Standard of Taste (Hume), 110–111, 115n.13

Oldenberg, Claes, 124, 143

"Olfactory artists," Duchamp on, 138

Olitski, Jules: Greenberg and, 89, 103, 135, 150; on Greenberg's critical response, 89, 90

Olympia (Manet), 204

On the Ruins of the Museum (Crimp), 143

The Optical Unconscious (Krauss), 9, 106–107

"The Origins of the Art Work" (Heidegger), 31–32

The Origins of Socialist Realism (Komar and Melamid), 209–210

Orozco, José Clemente, 71

Orwell, George, 22, 23, 24, 36

painterly vs. linear style, 200–201

painting: abstract expressionism and, 102–104; brushstroke visibility in, 74–76; color-field, 9, 13, 135; "death" of, 4; devotional, 18n.3; end of, 74, 137–139, 140–141, 153–154, 170–171; essence of, 68; exhibition as context for, 169; Greenberg's definition of, 102; historical narrative and, 61–64, 104, 105–106, 135; ideology and, 171; latent properties in, 161–162; modernist, 7–8, 14, 68, 120–121; monochrome, *see* monochrome painting; obligatory styles of, 143; photography and, 138, 139, 144, 148; "P-ness" of, 159; politics and, 138, 139, 146, 153; post-historical art and, 13, 125–126; in post-narrative stage, 148–149, 171–172; pure, 67–68, 69, 70, 104; "Q-ness" of, 159; realist, *see* realists; representational adequacy in, 61; representation in, *see* representation; sculpture and, 49; as self-expression, 141; social power and, 181; style matrix and, 160–165, 162–163; as subject of painting, 67, 76–77; transformative experiences through, 176–179, 180; woodworking combined with, 137

"Paintings by Nineteen Living Americans" (1929), 119

"pale of history" concept, 9, 26; art outside of, 8–9, 13, 47–48, 105–107; pluralism and, 197–198; post-historical art and, 12

paleolithic painting, 62

Panofsky, Erwin: critical viewpoint of, 65, 66, 136; on cultural unity, 129

Panza collection, Museum of Modern Art, 16

paradigm, mimesis as, 29

paradigm shift, 29–30
Paris, "School of," 160
Paris Salon, decorative art and, 64
Parmigianino, 162
participatory aesthetics, Christo's *Running Fence* and, 182
The Partisan Review, critical viewpoint of, 139
past, future as seen by, 101–102, 117, 161–162, 202, 206
Pattern Art, 13
Pearson, Ralph, 119
perceptual matching, language learning vs., 54
performance art: by Beuys, 174f, 186, 187; by Komar and Melamid, 216–217
perspective, discovery of, 41–42
Petrarch, beginning of Renaissance and, 24, 77
Petrograd, Malevich's *Black Square* shown in, 154
Petronius, on end of painting, 153–154
Phaedrus (Plato), 68–69, 78n.9
Phelps, Lionel, 153
The Phenomenology of Spirit (Hegel), 5
Phillips, William, 91
The Philosophical Disenfranchisement of Art (Danto), 38n.4
Philosophical Investigations (Wittgenstein), 129
philosophy: aesthetic enjoyment and, 33; aesthetics vs. utility, 81–82; analytical, 129–131; antifoundationalism, 67; art vs. reality, 112–114; art making and, 32; concept of art and, 13–14, 15–16, 30–36, 66, 107–108, 136, 193–198; deontic modalities, 141; language and, 129, 130; linguistic representation and, 19n.10; of meaning, 195; metaphysics and, 129, 141–143; "modern" vs. ancient, 6–7; modernist vs. contemporary, 8, 67; pop art and, 122–132; positivism, 141–142; post-historical art appreciation and, 187–188; post-historical artists and, 148; pseudo-questions in, 34; style wars, 32; verifiability criterion in, 141–143
philosophy of history, prediction vs. philosophy and, 43
photography: brushstroke invisibility and, 75; Crimp on, 143–144; modernist, 143–144; painting and, 138, 139, 144, 148, 171; philosophy of art and, 148
photomontage, end of painting and, 139

Piano, Renzo, 188
Picasso, Pablo: African art and, 111; contemporary reaction to, 56; critical viewpoints on, 54, 57; on cubism as "true" art, 28; *Les demoiselles d'Avignon*, 24, 38n.3, 41, 111; *La famille des saltimbanques*, 41; Greenberg and, 71, 72, 107; *Guernica*, 73; *Guitar*, 38n.3; impact of, 32; Kahnweiler portrait, 40f, 55; Mannerism and, 161; on "new order," 30; styles used by, 161; *La Vie*, 179
picture frames, elimination of, 16
Piero della Francesca, 157–158, 159
Pinturrichio, affinities of style and, 201
Plato: art vs. reality and, 113, 124, 125; on basis of justice, 102; denial of philosophy and, 34; on perceptual differences, 50; *The Republic*, 45, 114; on self-consciousness, 68–69; style contemporary with, 205
"The Play of the Unmentionable" (Kosuth), 6
pluralism: art criticism and, 37, 150; concept of art and, 194; essentialism and, 196–197; monochrome painting and, 169; in post-historical art, 125–126, 127, 147–150, 171–172; temporal affinity vs., 207–209. *See also* diversity
poetry, in post-historical art, 148
pointillism, brushstroke invisibility and, 75
politics: art as tool of, 23–24, 86, 126–127, 145–146, 196; art collecting and, 146; end of painting and, 138, 139, 146, 153; essentialism and, 196–197; modernism and, 70; museums and, 146; pluralism and, 37. *See also* multiculturalism
Polke, Sigmar: pop art and, 126; post-historical art by, 45, 114, 171
Pollock, Jackson, 10–11, 60f; critical viewpoint and, 94–95; on de Kooning, 122; Greenberg on, 70–71, 72, 87, 88, 90; historical narrative and, 117; "Q-ness" and, 159; success of, 103
Pontormo, Jacopo da, 161
pop art, 13, 117–132; abstract expressionism and, 41, 42, 117–118, 130; aesthetics and, 77, 92; attacks on, 127; author's reaction to, 123–124; commercial art and, 91–92; concept of art and, 90, 91, 124–125; definition of art and, 37, 41; emergence of, 122; end of art and, 24; Greenberg and, 104–105; historical affinities and, 42–43; New York School and, 42, 117–

118; philosophy and, 122–132; pop culture vs., 128; pop *in* art vs., 128; predecessors for, 128; realism and, 122; transfiguration of commonplace in, 128–129, 130

pop culture, pop art vs., 128

Popper, Sir Karl: Gombrich and, 196; history of science and, 49, 50; on prediction vs. prophecy, 43

"Positive/Negative" (Crimp), 143

positivism: "end of philosophy" and, 141–142; philosophy of history and, 43; pseudo-questions and, 34, 39n.18

possibilities, in post-historical art, 43, 44, 45, 197–199

poster art, 147

post-historical art, 12–15, 43, 113–114; comedy in, 217; condition for, 43–44; diversity in, 125–126, 127, 147–150, 171, 172, 197–199; freedom in, 45–46, 47, 114, 125–126; manifestos and, 29, 37; media and, 135–136, 137, 171; museums and, 186–187; neo-expressionism and, 140; possibilities in, 43, 44, 45, 197–199; quality and, 185–186; self-consciousness and, 15, 36; shift from modernism to, 15–16; sociology and, 210–211; styles and, 46–47

post-impressionism: contemporary reactions to, 55–56; critical viewpoint and, 52–53, 55; modernism and, 119

postmodern art, 11; reaction against "pure" art in, 137; recognizing, 12

postmodernist criticism, 144; essentialism and, 196–197

postnarrative stage, 148–150, 171; painting in, 148–149, 171–172. *See also* post-historical art

"post-painterly" abstraction, 103, 104

Poussin, Nicholas, 53, 57, 204, 205

power: art and, 113, 181; museums and, 181–182

The Power of Images (Freedberg), 63, 77n.4

practicality, aesthetics vs., 81–82, 86, 87

Praxiteles, Daidalos and, 50

prediction, prophecy vs., 43

pre-Raphaelites, 28

primitive art: art criticism and, 108–109; definition of art and, 36; stylistic affinity and, 162

"Primitivism and Modern Art" exhibition (Museum of Modern Art), 94, 111, 162

Prina, Stephen, 169

Principles of Art History (Wölfflin), 44

Problems of Style (Riegl), 61, 62

production of art. *See* art making

prophecy: prediction vs., 43; as revelation of present, 46

pseudo-questions, 34

public art, 181–182

public engagement in artworks, 182

pure painting, 67–68, 69, 70

pure vs. impure art, 9, 67–68, 69–70, 114; postmodernism and, 137

purity: racial, 70; refusal to be bound by, 45

"Q-ness," 158–160

quality, 87–88, 185–186. *See also* aesthetics

quattrocento, 158; painterly-ness vs., 159

Quine, Professor, 77

Rabelais, Franèois, 126

Rahv, Philip, 153

Raphael, historical narrative and, 61, 64, 114, 155

Rauschenberg, Robert: monochrome paintings by, 156, 169; post-historical art by, 171–172; as postmodernist, 12; realism and, 124

Reagan era. *See* 1980s

realism, socialist, 126–127

realists: abstract expressionism and, 117–118, 121, 122; abstraction opposed by, 117–118, 120; Museum of Modern Art and, 119, 120; pop art and, 122; protests by, 120, 122

reality: art vs., 71, 112–114, 124–125; formal vs. objective, xvii

Reality magazine, 120, 122

Rebay, Countess Hilla, 167

Red Square (Peasant) (Malevich), 166

Reed, David: painting #328, iif, xvii, xviii, xix; post-historical art by, 149, 150, 172

Reinhardt, Ad: on abstract art, 27, 28; *Black Painting*, 20f; end of painting and, 138, 140; logical positivism and, 34; monochrome painting and, 169; Ryman and, 157; style matrix and, 164

relics, art and, 18n.2

religion, post-historical art appreciation and, 187–188

religious art. *See* devotional art

Rembrandt van Rijn: "Q-ness" and, 159; temporal affinities and, 207, 209

Renaissance: imitation and, 48; invisible beginning of, 24, 77; style matrix and, 161

Renaissance paradigm, New York paradigm and, 117

representation: abstract expressionism and, 103; accuracy and power of, 52; brushstroke invisibility and, 75; Greenberg on, 120–121; history of art and, 48, 49, 61, 196; material vehicle vs., 106; means of as object of, 7; in mimetic paradigm, 46; in modernism vs. premodernism, 8; pop art and, 124–125

representational painting: appreciation of abstraction and, 93–94; modernism vs., 7–8; Vasari and, 7, 49, 50–51, 52

reproductions, transformative experiences through, 179

The Republic (Plato), 102, 124

revolutionary change: art criticism and, 93; artists outside system and, 145–146; conceptual, 187

Reynolds, Sir Joshua, 204

Richter, Gerhard: pop art and, 126; post-historical art by, 45, 114, 171, 217

Richter, Hans, 84

Riegl, Alois: on history of art, 61, 62, 63; primitive art and, 108, 109

Roche, Kevin: Jewish Museum addition, 15

Rockburne, Dorothea, 172

rococo art, in style matrix, 162–163

Rodchenko, Alexander, 169

Rogers, Richard, 188

Romano, Giulio, as Mannerist architect, 161

Rorty, Richard: antifoundationalism and, 67; The Linguistic Turn, 19n.10

Rosch, Eleanor: category theory of, 214, 215

Rose, Barbara: as modernist critic, 145

Rothko, Mark: historical narrative and, 117; on modernism, 29–30; monochrome painting and, 169; Number 16, 182, 212; success of, 103

Rousseau, Henri, 53, 119

Royce, Josiah, 18n.5

Rubens, Peter Paul, 163

rules, criticism and, 86

Running Fence (Christo), 182

Ruskin, John: transformative experience and, 176–177, 178, 189, 209

Russia, Malevich's Black Square shown in, 154

Ryder, Albert Pinkham, 72

Ryman, Robert, 4; end of painting and, 140, 148, 153, 170, 171; monochrome painting and, 169; Museum of Modern Art retrospective, 153, 154; Piero della Francesca and, 157–158; post-historical art and, 149, 155, 171; "Q-ness" and, 159; in style matrix, 163; use of color by, 156–157

Said, Edward: on essentialism, 196

Salle, David: historical narrative and, 140; painting as art and, 104; as postmodernist, 12

Salon d'Automne, contemporary response to, 55

Sandler, Irving, 122

Sanraedem, Pieter: "Q-ness" and, 159

Sartre, Jean-Paul, 127, 196

Schapiro, Meyer: on "nonmimetic features" of painting, 7–8; on styles of painting, 160

Schinkel, Karl Friedrich: Altes Museum of, 146

schlecht, gut vs., 83

Schnabel, Julian: historical narrative and, 140; painting as art and, 104; as postmodernist, 12

Schopenhauer, Arthur: on aesthetics vs. utility, 81, 82–83; on standards of beauty, 96, 97

science, history of: compared to history of art, 49–50

science, positivist philosophy and, 141–142

The Scottish Symphony (Beuys), 174f, 186, 187

Scully, Sean: Homo Duplex, 134f; on "pale," 9; post-historical art by, 149, 150, 172

sculpture: abstract expressionism and, 102, 103; narrative of art and, 49; postnarrative stage and, 150

Segel, George, 124

self-consciousness: in art criticism, 66, 67; contemporary vs. modern art and, 6; in modernism, 68–69; philosophical, 6, 66; post-historical art and, 15, 36; "true" art and, 28

self-expression, end of painting and, 141

Semper, Gotfried, 61, 63

Serra, Richard, 13; on box art, 165; Tilted Arc, 181, 183

Shaker furniture, as useful and beautiful, 82
Sherman, Cindy: art vs. reality and, 113; post-historical art by, 12, 148; *Untitled Film Still*, 149*f*
Sibley, Frank, 159
Sidney Janis Gallery, de Kooning's *Women* at, 122
Siqueros, David: end of painting and, 153; painting denounced by, 138, 150n.3
Smith, David: Greenberg and, 103
social criticism, museums and, 179–180
socialist realism, 126–127
social power, art and, 181
Society of Independent Artists, Duchamp exhibit of urinal at, 84
sociology, aesthetics and, 210–211
Solomon and the Queen of Sheba (Veronese), 176–177, 178, 180, 181, 186, 189
Sontag, Susan: on "camp," 11
Sots art, 126, 131
South Africa, biennial exhibition in, 23, 38n.1
Soviet Union: Komar and Melamid and, 209–210; National Gallery exhibition in, 23; political role of art in, 138; pop art attacked in, 127; Sots art in, 126–127
Spanish Civil War, artistic expression and, 73
Spark, Muriel, 129
spark plug analogy, 82, 83–84
specialization, post-historical art and, 114
Spengler, Oswald, 74
"Spirit," in art making, 26, 29, 97–98, 105–106, 124
Spoleto-USA exhibition, 183
Stable Gallery (New York), Warhol exhibition, 24, 35, 123
The State of the Art (Danto), 17n.1
Stein, Gertrude, 56
Stella, Frank, 103
Stieglitz, Alfred, 21, 32
Still Life with Old Shoe (Miró), 73
Stokes, Adrian, 158, 159
Stone Age painting, 62
Storr, Robert: Ryman retrospective and, 153, 154, 155
Strawson, Peter, 143

"Style and Medium in Motion Pictures" (Panofsky), 136
style matrix, 160–165; aesthetic vs. historical criticism and, 168; community of artworks and, 164; construction of, 162–163; monochrome painting and, 163, 167, 169–170
style of art: affinities and, 158–160, 162, 199–202. (*see also* temporal affinity); criticism and, 37; definition of, 46; as "language," 54–55; linear vs. painterly, 200–201; mimesis as, 46; obligatory dripped paint, 143; post-historical freedom and, 44, 46–47; recognizing, 11–12; terminology used for, 159–160
style wars, 32; Hopper and, 119
stylistic terminology, 159–160
subjectivity, in modern vs. ancient philosophy, 6
subject matter of art, art as, 7, 67, 76–77
Suprematism: Malevich and, 166; monochrome painting and, 166–167
surrealism: aesthetics and, 112; Greenberg and, 9, 16, 107, 112; history of art and, 9, 16; modernism and, 119; pre-surrealist artists, 162
surrealist manifesto, 28
symmetry, aesthetics and, 96–98
Symposium (Feuerbach), 204–205

Tanguy, Yves, 07
Tansey, Mark, 165
taste: aesthetics and, 110–113; experience and, 89; genius vs., 90; Kant on, 81, 82, 88–89; progress in, 93
Tatlin, Vladimir, 26
temporal affinity: aesthetics and, 202–203; forgery and, 206–207; pluralism vs., 207–209; stylistic alternatives and, 199–202
temporal boundaries, 24–25
Terborch, Gerard: temporal affinities and, 199–200, 201, 202, 203
Teriade, Matisse conversations with, 44, 57n.3
theater, illusion in compared to art, 76
"Thirty Years after the End of Art" (Danto), 126
Thompson, Jerry L.: photograph by, 100*f*
Three American Painters (Greenberg), 103
#328 (Reed), ii*f*, xvii, xviii, xix

Tilted Arc (Serra), 181, 183
Titian, abstract art and, 120
Tomkins, Calvin, 156
Torcia, Richard, 157
totalitarianism, modernism and, 70
"Toward a Newer Laocoön" (Greenberg), 26–27, 73, 120
Tractatus Logico-Philosophicus (Wittgenstein), 34
transfiguration: definition of, 128–129; in pop art, 128–129, 130
The Transfiguration of the Commonplace (Danto), 38n.4, 129, 167, 170, 193, 195
transformative experiences, 176–178; museums and, 176–179, 180; reproductions and, 179; temporal affinities and, 207–209
tribalization, 184, 187
Trockel, Rosemarie, 45, 114, 171
"true" art, 26–27; "end of art" and, 27–28, 45; manifestos and, 28, 29, 34
True Colors (Mortman), 211, 212
Turin, Italy, Municipal Gallery, 176–177, 178
Turing, Alan, 206
Tuttle, Richard, 13

Uccello, Paolo, 162
universality, aesthetics and, 95–96, 110
Untitled film Still (Sherman), 149f
urinal: exhibit of, 84, 218n.4. See also Duchamp, Marcel
uses vs. mentions, 205
utility: aesthetics vs., 81–83, 86, 87; commercial art, 91–92

van Doesberg, Theo, 156
Van Dyck, Sir Anthony, 163
Van Gogh, Vincent: contemporary reaction to, 56; Irises, 23; as modernist, 8, 63
Van Meegeren, Hans, 206–207, 217
Varnedoe, Kirk, 16
Vasari, Giorgio: art outside of narrative and, 114; concept of artist and, 2; critical viewpoint and, 51–52, 53, 54, 55, 61, 63, 64, 66; history of art and, 109–110, 203; Lives of the Most Eminent Painters, Sculptors, and Architects, 48; representational painting and, 7, 49, 50–51
Vattimo, Gianni: "The Death or Decline of

Art," 17–18n.1; on end of art, 17–18n.1; The End of Modernity, 17–18n.1
Velasquez, Diego: portrait of Juan de Pereija, 89
Venice Biennale, South Africa in, 38n.1
Venturi, Robert: on recognizing style, 12
Vergangene Zukunft (Kosseleck), 101
verifiability criterion, philosophy and, 141–143
Vermeer, Jan: aesthetic communication and, 158; Christ in the House of Mary and Martha, 206, 207; pictorial mentions by, 205–206; "Q-ness" and, 159; temporal affinity and, 209
Veronese, Paul: Solomon and the Queen of Sheba, 176–177, 178, 180, 181, 186, 189
Vertigo, use of image from, iif, xvii
La Vie (Picasso), 179
Voice of Fire (Newman), 182

Warhol, Andy: Brillo Box, 13, 14, 24, 35, 36, 71, 92, 113, 123, 124, 165, 178, 193, 195; concept of art and, 37, 90, 91, 124–125, 194; critical viewpoint and, 94–95, 123–124; diversity of work by, 127; Greenberg and, 90, 91; Kant and, 91; Marilyn Monroe transfigured by, 128; paint use by, 143; Stable Gallery exhibition, 24. See also Brillo Box
Watkins, Jonathan: on Crivelli, 106
Watteau, Jean: commercial art by, 91; Ensigne de Gersaint, 91–92
We Got It! (Bakery, Confectionary, and Tobacco Workers' International Union of America, Local 552), 180–181, 183, 184, 185, 187, 188–189
Western art: African art and, 45, 94; definition of art and, 36; Oceanic art and, 94
Westman, Barbara: The Monochrome Show, 152f
"what Art wanted" concept, 105–106
white males, art world and, 181, 189
Whitney Museum of American Art: "Approaching the End of Art" lecture at, 17n.1; Hopper retrospective, 122; 1993 Biennial, 146, 184; 1995 Biennial, 146; post-historical art exhibit by, 16; realists and, 120, 122
Who's Afraid of Red, Yellow, and Blue (Newman), 212
Wiener, Sam: art vs. reality and, 113

William Rush Carving his Allegorical Figure of the Schuylkill River (Eakins), 118

Wilson, Fred: Maryland Historical Museum installation, 6

Wittgenstein, Ludwig: analytical philosophy and, 129, 130; concept of art and, 194; "end of philosophy" and, 142; on imagining forms, 202; on pseudo-questions, 34

Wölfflin, Heinrich: Greenberg on, 102–103; Mannerism and, 160; on possibilities, 44, 45, 197–198; on styles, 159, 160; on stylistic affinities, 199–200, 201, 203; on temporal affinities, 205

Wollheim, Richard: on painting, 50–51, 104

Women series (de Kooning), 103, 122

woodworking, as art, 137

Woolf, Virginia: on African art, 111–112

works of art. *See* artworks

The World as Will and Idea (Schopenhauer), 81

writing, literature vs., 35

THE ANDREW W. MELLON LECTURES IN THE FINE ARTS
Delivered at the National Gallery of Art, Washington, D. C.

1952 Jacques Maritain, *Creative Intuition in Art and Poetry*
1953 Sir Kenneth Clark, *The Nude: A Study of Ideal Form*
1954 Sir Herbert Read, *The Art of Sculpture*
1955 Etienne Gilson, *Art and Reality*
1956 E. H. Gombrich, *The Visible World and the Language of Art*
1957 Sigfried Giedion, *Constancy and Change in Art and Architecture*
1958 Sir Anthony Blunt, *Nicolas Poussin and French Classicism*
1959 Naum Gabo, *A Sculptor's View of the Fine Arts*
1960 Wilmarth Sheldon Lewis, *Horace Walpole*
1961 André Grabar, *Christian Iconography and the Christian Religion in Antiquity*
1962 Kathleen Raine, *William Blake and Traditional Mythology*
1963 Sir John Pope-Hennessy, *Artist and Individual: Some Aspects of the Renaissance Portrait*
1964 Jakob Rosenberg, *On Quality in Art: Criteria of Excellence, Past and Present*
1965 Sir Isaiah Berlin, *Sources of Romantic Thought*
1966 Lord David Cecil, *Dreamer or Visionary: A Study of English Romantic Painting*
1967 Mario Praz, *On the Parallel of Literature and the Visual Arts*
1968 Stephen Spender, *Imaginative Literature and Painting*
1969 Jacob Bronowski, *Art as a Mode of Knowledge*
1970 Sir Nikolaus Pevsner, *Some Aspects of Nineteenth-Century Architecture*
1971 T.S.R. Boase, *Vasari: The Man and the Book*
1972 Ludwig H. Heydenreich, *Leonardo da Vinci*
1973 Jacques Barzun, *The Use and Abuse of Art*
1974 H. W. Janson, *Nineteenth-Century Sculpture Reconsidered*
1975 H. C. Robbins Landon, *Music in Europe in the Year 1776*
1976 Peter von Blanckenhagen, *Aspects of Classical Art*
1977 André Chastel, *The Sack of Rome: 1527*
1978 Joseph W. Alsop, *The History of Art Collecting*
1979 John Rewald, *Cézanne and America*
1980 Peter Kidson, *Principles of Design in Ancient and Medieval Architecture*
1981 John Harris, *Palladian Architecture in England, 1615–1760*
1982 Leo Steinberg, *The Burden of Michelangelo's Painting*
1983 Vincent Scully, *The Shape of France*
1984 Richard Wollheim, *Painting as an Art*
1985 James S. Ackerman, *The Villa in History*
1986 Lukas Foss, *Confessions of a Twentieth-Century Composer*
1987 Jaroslav Pelikan, *Imago Dei: The Byzantine Apologia for Icons*

1988 John Shearman, *Art and the Spectator in the Italian Renaissance*

1989 Oleg Grabar, *Intermediary Demons: Toward a Theory of Ornament*

1990 Jennifer Montagu, *Gold, Silver, and Bronze: Metal Sculpture of the Roman Baroque*

1991 Willibald Sauerländer, *Changing Faces: Art and Physiognomy through the Ages*

1992 Anthony Hecht, *On the Laws of the Poetic Art*

1993 Sir John Boardman, *The Diffusion of Classical Art in Antiquity*

1994 Jonathan Brown, *Kings and Connoisseurs: Collecting Art in Seventeenth-Century Europe*

1995 Arthur C. Danto, *Contemporary Art and the Pale of History*

About the Author

Arthur C. Danto, Johnsonian Professor
Emeritus of Philosophy at Columbia
University, is Art Critic for *The Nation*.
His books include *The Transfiguration of
the Commonplace, Embodied Meanings,
Beyond the Brillo Box*, and *Encounter and
Reflections*, winner of the National Book
Critics Circle Prize in Criticism.